Between Two Cultures

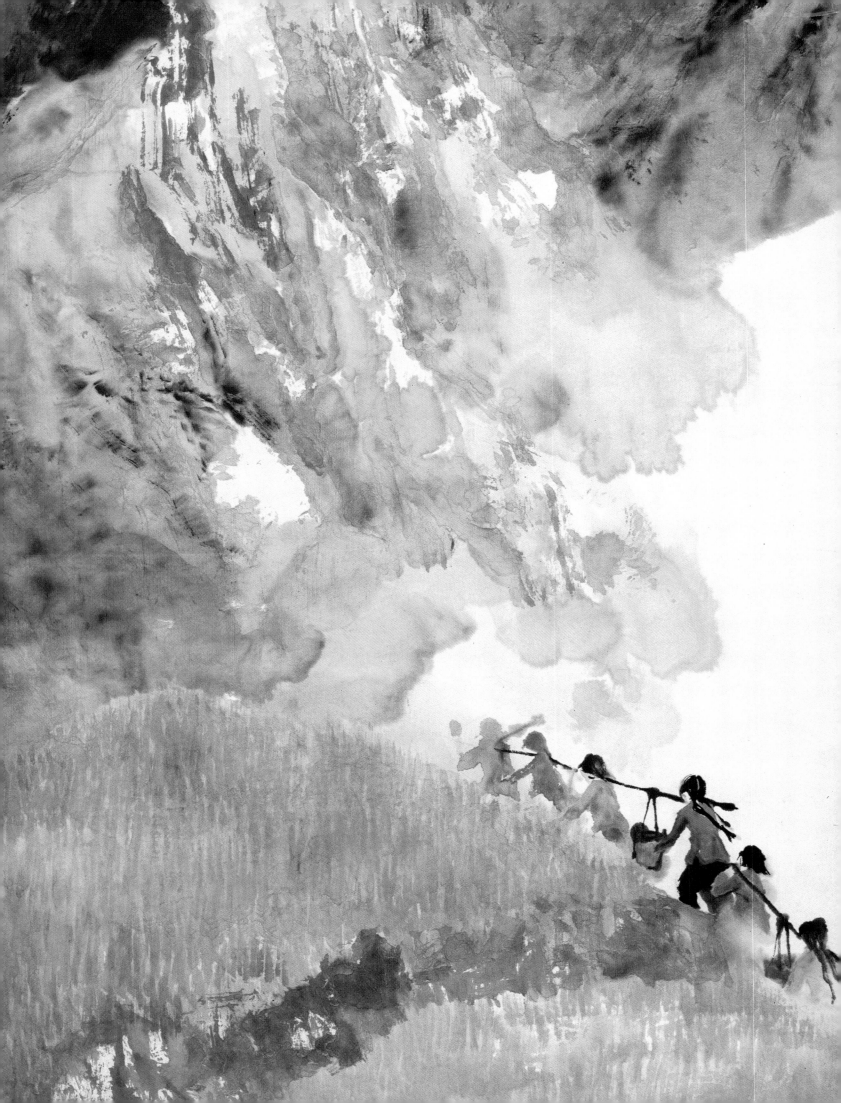

Between Two Cultures

Late-Nineteenth- and Twentieth-Century Chinese Paintings
from the Robert H. Ellsworth Collection in The Metropolitan Museum of Art

Wen C. Fong

The Metropolitan Museum of Art, New York
Yale University Press, New Haven and London

This volume is published in conjunction with the exhibition "Nineteenth-and Twentieth-Century Chinese Paintings from the Robert H. Ellsworth Collection in The Metropolitan Museum of Art," held at The Metropolitan Museum of Art, New York, January 30 – August 19, 2001.

The exhibition and the accompanying catalogue are made possible by The Dillon Fund.

Published by The Metropolitan Museum of Art, New York
John P. O'Neill, Editor in Chief
Emily Walter, Editor
Joseph Cho and Stefanie Lew, Binocular, Design
Peter Antony, Megan Arney, and Merantine Hens, Production
Minjee Cho, Desktop Publishing
Jean Wagner, Bibliographic Editor

Map by Anandaroop Roy

The color photographs in this publication are by Bruce Schwarz; the black-and-white comparative illustrations are by Mark Morosse, The Photograph Studio, The Metropolitan Museum of Art.

Typeset in Fairfield
Printed on Mitsubishi Deluxe Real Art, Matte, 157 gms
Color separations by Nissha Printing Co., Ltd., Kyoto
Printed and bound by Nissha Printing Co., Ltd., Kyoto

Jacket/cover illustration: Zhang Daqian (1899–1983), *Buddha's Manifestation of Joyfulness*, dated 1946. Detail of plate 71

Frontispiece: Shilu (1919–1982), *Mountain Rain is Coming*, dated 1960. Detail of plate 88

Library of Congress Cataloging-in-Publication Data

Fong, Wen C.
Between two cultures: late-nineteenth- and twentieth-century Chinese paintings from the Robert H. Ellsworth collection in the Metropolitan Museum of Art / Wen C. Fong.
 p. cm.
 Includes bibliographical references and index.
 ISBN 0-87099-984-2 (hc.)—ISBN 0-87099-985-0 (pbk.)—
ISBN 0-300-08850-7 (Yale University Press)
 1. Painting, Chinese—20th century—Catalogs. 2. Painting, Chinese—Ming–Qing dynasties, 1368–1912—Catalogs. 3. Painting—New York (State)—New York—Catalogs. 4. Ellsworth, Robert Hatfield, 1929—Art collections—Catalogs. 5. Metropolitan Museum of Art (New York, N.Y.)—Catalogs. I. Metropolitan Museum of Art (New York, N.Y.) II. Title.

ND1045.F66 2001
759.951'074'7471—dc21 00-068727

To my wife, Constance,
and to our children, Laurence, Peter, and Serena,
who have been a continuing source
of encouragement and support

Contents

Director's Foreword ix

Acknowledgments x

Map of China xii

Introduction: East Meets West 3

1. Painters in Shanghai and Guangdong 23

2. The Westernizers 75

3. Three Great Traditionalists 137

4. Mainland Chinese Painting, 1950s–1980s 205

Epilogue: Reflections on Chinese Art and History 253

List of Artists 262

List of Plates 263

Bibliography 269

Index 280

Photograph Credits 285

Director's Foreword

Until the early 1970s, Chinese painting and calligraphy, together constituting one of the world's great artistic traditions, was sadly underrepresented in the Metropolitan Museum's encyclopedic collections. Today, the Museum's holdings in this rare and difficult field rank among the finest in the world and are regarded as one of the truly representative collections of the history of Chinese visual arts in a Western art museum.

We owe this success in part to the fortuitous circumstances of history. After the Manchu conquest of China in the seventeenth century, the Qing emperor, Qianlong, who was an insatiable collector, gathered all available surviving ancient masterworks of calligraphy and painting into one vast collection in the Forbidden City. As a result, ancient Chinese masterworks became inaccessible to the general public. It was not until 1912, after the fall of the Qing dynasty, that works from the imperial collection appeared on the international art market. Out of the turmoil of the early twentieth century, two great private collections of early Chinese painting and calligraphy, the finest in Chinese history dating from before the Qing dynasty, were created by the artist-connoisseurs Zhang Daqian and C.C. Wang. These eventually became the basis of the Metropolitan's collection of early Chinese painting and calligraphy through the eighteenth century.

The force behind this remarkable achievement has been the Honorable C. Douglas Dillon, Trustee Emeritus, whose leadership and generosity have stimulated and brought along other major patrons and donors, including John M. Crawford Jr., John B. Elliot, Robert H. Ellsworth, Earl Morse, members of the P.Y. and Kinmay W. Tang family, and the Oscar Tang family. During the past thirty years, the Museum's

curatorial programs, built around the Douglas Dillon Galleries for the display of and studies in Chinese painting and calligraphy, have not only broadened the appreciation of Chinese art and culture in the West but also produced a number of landmark scholarly publications.

The Robert H. Ellsworth Collection, which comprises works in the traditional medium of Chinese brush and ink on paper and in the traditional formats of hanging scrolls, handscrolls, album leaves, and fans, grew out of a group of paintings by Qi Baishi acquired from the late Alice Boney, who purchased them in the 1950s and 1960s. It is the first comprehensive survey of the subject in the West, one that provides the opportunity for us to continue our study of Chinese painting in these tumultuous times that are modern China.

We would like to offer our deep gratitude to Wen C. Fong, Douglas Dillon Curator Emeritus of Chinese Painting and Calligraphy at the Metropolitan, who has, with this volume, forged a new path in the study of Chinese art history. We wish especially to thank Mr. Ellsworth, who over the years has done much to advance the field of Chinese painting and calligraphy in this country.

The exhibition and the accompanying catalogue would not have been possible without the generous assistance of The Dillon Fund.

Philippe de Montebello
Director
The Metropolitan Museum of Art

Acknowledgments

The present volume on late-nineteenth- and twentieth-century Chinese paintings is the final chapter of my study of the history of Chinese painting and calligraphy. Michael Sullivan, the leading expert in the modern Chinese art field, has expressed the view that the time may be premature for this kind of broad introduction of the subject, and I have therefore approached my task with a certain amount of trepidation. Nevertheless, my efforts have proved to be an appropriate finish of a personal journey that began more than half a century ago, when I studied under Master Li Jian, a leading calligrapher in Shanghai during the 1940s, before coming to the United States to receive an education that prepared me for my work in Chinese art history.

I wish to acknowledge with special thanks Professor Sullivan, now at Oxford University; Professor Emeritus F.W. Mote and Professors Robert Bagley and Susan Naquin of Princeton University; Professor Jerome Silbergeld of the University of Washington; and Professor Wan Qingli of the University of Hong Kong for reading and commenting on different parts and drafts of the manuscript. Professors Mote's and Silbergeld's thoughtful comments on the Introduction were particularly helpful for sharpening as well as clarifying my thoughts on East–West cultural exchange, problems of modernization, and the practice of historical studies. Professor Wan gave me special insights into the works of Li Keran and Pan Tianshou. I am grateful to Dr. Shih Shou-chien, Deputy Director of the National Palace Museum, Taipei, for assistance in securing books published in Taiwan; Professor Fu Shen of the National Taiwan University helped me with information on the work of Zhang Daqian; and Professor Wan was also extraordinarily generous with his time and efforts in helping to locate difficult source materials, and in making photographs from his own extensive archive available to me. To these good friends and wonderful colleagues I owe a deep and lasting debt of gratitude for their encouragement and unstinting support for my entering into a hitherto new and unfamiliar field.

At the Metropolitan Museum, I owe my special thanks to Philippe de Montebello, Director, and to James C.Y. Watt, Brooke Russell Astor Chairman, Department of Asian Art, for their warm support of the project. I also wish to express my great appreciation to John P. O'Neill, Editor in Chief, under whose guidance and wise leadership I have been privileged to publish a number of finely produced books on Chinese art during the past twenty-five years. I am especially grateful to my longtime editor, Emily Walter, whose uncommon gift of language and ability to wrest meaning out of my balky mind, have made working with her both a pleasurable experience and an education. I am also grateful to Jean Wagner, bibliographer extraordinaire, for her meticulously precise work in straightening out the footnotes. Also at the Metropolitan, I owe a special debt of thanks to many of my devoted friends and former colleagues in the Department of Asian Art: Maxwell K. Hearn, Judith G. Smith, Masako Watanabe, and Yangming Chu for helping with essential details of a book that attempts an understanding of crosscultural values. I also wish to thank three younger colleagues for assisting with bibliography and illustrations: Yiguo Zhang was extremely helpful in the early stages of research on the subject; Dora Ching was indispensable in the preparation of illustrations

for publication; and Ping Foong was responsible for fact check-
ing and for assisting with the Chinese translations in the
bibliography. I wish to thank Frank Chance at the Marquand
Library and Gonul Yurdakul at the Gest Oriental Library
at Princeton University, and Dr. David Sensabaugh, Curator at
Yale University Art Gallery, for their generous assistance with
books and information. I offer my thanks and congratulations
to Joseph Cho and Stefanie Lew for bringing a fresh, new, and
sensitive design to this book. Finally, I wish to express my grat-
itude to the production team of Peter Antony, Merantine Hens,
and Megan Arney; and Minjee Cho for the desktop publish-
ing. Without the professional skills and dedicated work of all
those involved at the Metropolitan, we could not have achieved
the high standards of excellence this beautiful book represents.

Wen C. Fong
Douglas Dillon Curator Emeritus of Chinese
Painting and Calligraphy

December 2000, Princeton, New Jersey

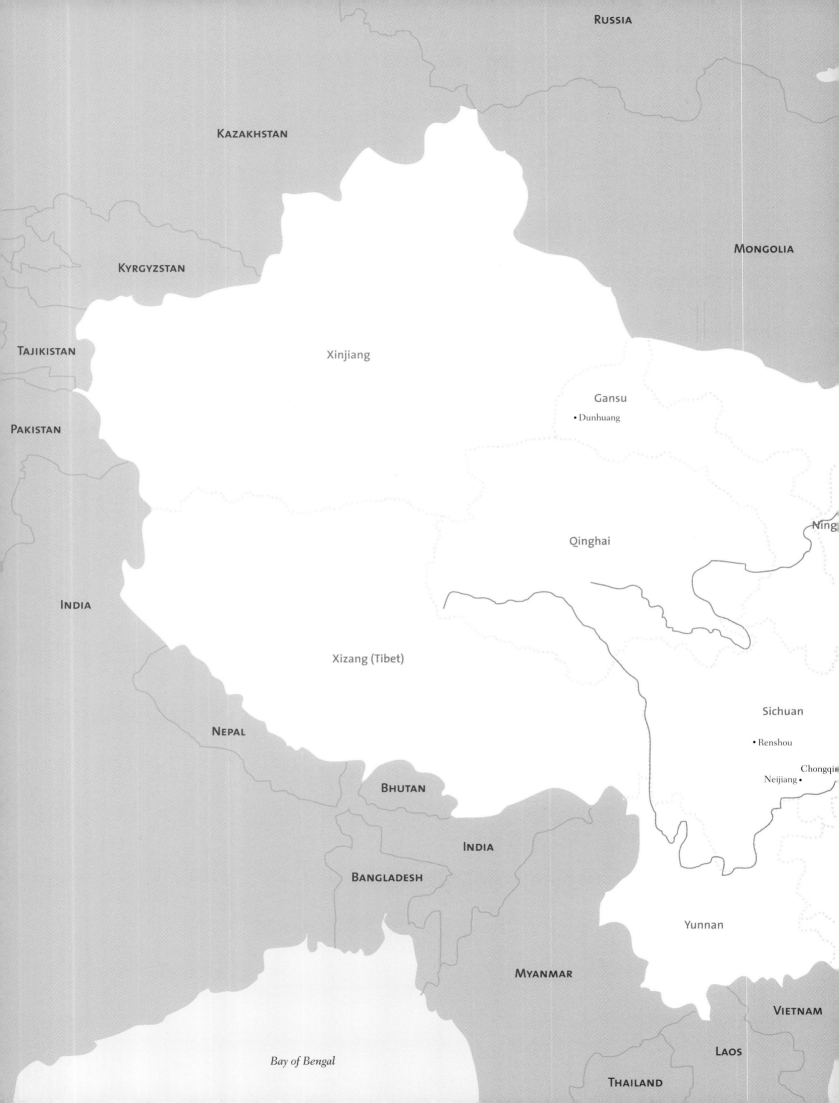

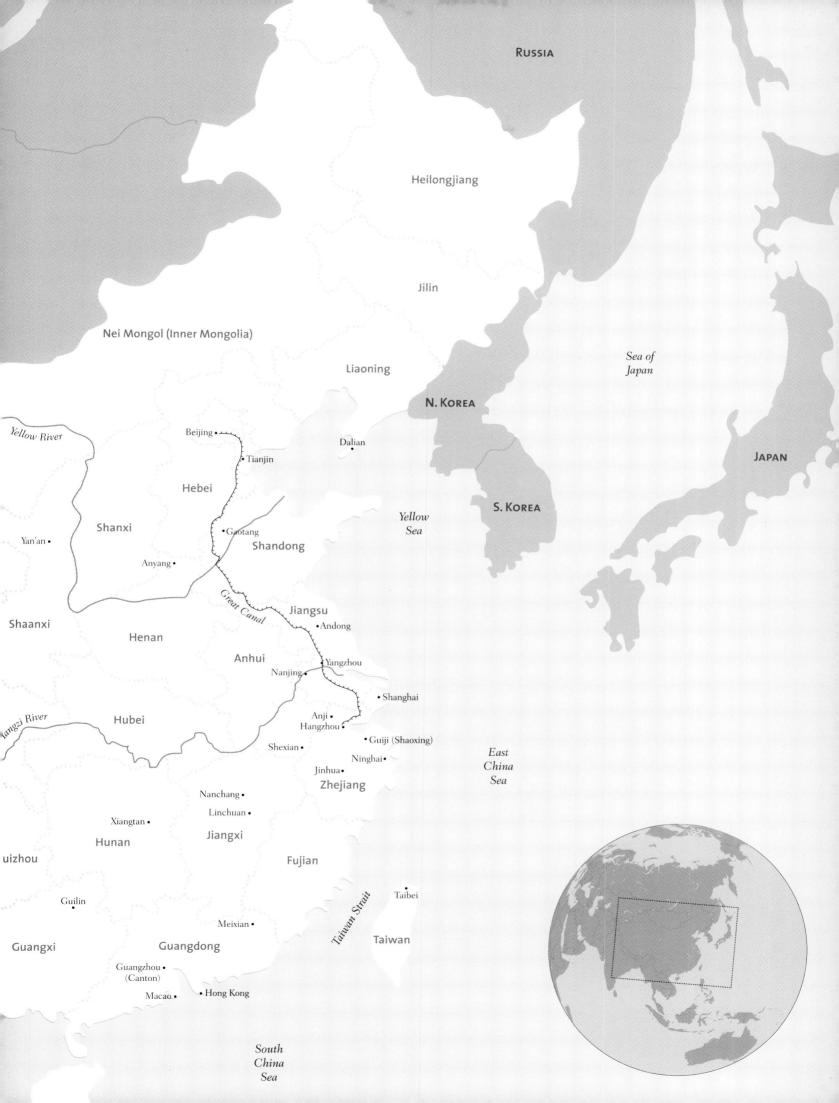

Russia

Heilongjiang

Jilin

Nei Mongol (Inner Mongolia)

Liaoning

Yellow River

Beijing
• Tianjin

Hebei

Shanxi

Yan'an •

• Gaotang

Shandong

Anyang •

Great Canal

Shaanxi

Henan

Jiangsu

Anhui

• Andong

Yangzhou
Nanjing •

Yangzi River

Hubei

• Shanghai

Anji •
Hangzhou •

• Guiji (Shaoxing)

Shexian •

Ninghai •

Jinhua •

Zhejiang

Nanchang •

Linchuan •

Xiangtan •

Hunan

Jiangxi

Fujian

uizhou

Guilin •

Taibei •

Meixian •

Taiwan

Guangxi

Guangdong

Taiwan Strait

Guangzhou •
(Canton)

Macao •

• Hong Kong

N. Korea

*Sea of
Japan*

Japan

S. Korea

*Yellow
Sea*

Dalian •

*East
China
Sea*

*South
China
Sea*

Between Two Cultures

Introduction

East Meets West

4　The development of modern Chinese painting is inextricably bound to the study of Chinese art history, which, thanks to archaeological discoveries, the forming of museum collections and international art exhibitions, and a thriving international art market, has gained increasing recognition and influence both in China and abroad during the twentieth century. For many modern Chinese painters, the impetus for innovation derives not from new pictorial models but from calligraphy, the premier Chinese art form, which, in the nineteenth and early twentieth century, was inspired by the archaeological study of ancient bronze and stone monuments. Unlike earlier Chinese painting dating from before 1800, which has commanded in-depth study from a learned and sophisticated audience in the West, Chinese painting of the nineteenth and twentieth centuries, perhaps because it was produced during a complex moment in history, has been little studied until recent years. While museum exhibitions and symposia have stimulated public interest in contemporary avant-garde experimentation in China, the crucial period in Chinese painting, from the 1860s to about 1980—both the works of early-twentieth-century modernizers and of traditional-style masters—has not received the attention it deserves.[1]

With the opening of treaty ports by Western powers along the China coast after the Opium War of 1839–42, Shanghai, at the mouth of the Yangzi River, in southern Jiangsu Province, supplanted Yangzhou, imperial China's center of north-south commodities exchange in northern Jiangsu, as the richest commercial city in China. In Shanghai, as a confident middle class emerged under the impact of a Westernizing capitalist economy, the demands of a newly rich consumer population of managers, brokers, accountants, and pawnshop owners led to the increased production of such accoutrements of refined living as calligraphy and painting. It was to this cosmopolitan city that the brightest artistic talents from all over China were drawn. In the late nineteenth and the early twentieth century, the Shanghai school of professional painters developed commercially successful styles from three artistic sources: calligraphy based on seal and clerical inscriptions engraved on ancient bronze and stone monuments, which was the focus of renewed interest among scholars; the richly colored flower paintings in a bold calligraphic style made in the eighteenth century by the so-called Eight Eccentrics of Yangzhou; and the highly stylized, linear manner of the late-Ming narrative illustrator Chen Hongshou (1598–1652), who specialized in paintings and woodblock-printed illustrations of quasi-religious images, mythology, ancient history, and popular fiction.

After the founding of the Republic of China in 1912, Chinese intellectuals—many of whom studied in Japan and Europe—were intent on reforming China to build a modern nation-state. In this pursuit they sought to import Western technology and learning, and in art to absorb a realistic style of representation. Viewing Chinese art from a Western perspective, they found traditional Chinese figure, landscape, and flower paintings inadequate for portraying modern life. Yet even as the "reform" of Chinese art became part of the young republic's agenda, it is significant that Xu Beihong (1895–1953), the most influential educator of the Westernizing Chinese art movement from the late 1920s through the early 1950s, after receiving training at the École des Beaux-Arts in Paris, followed the conservative Western academic

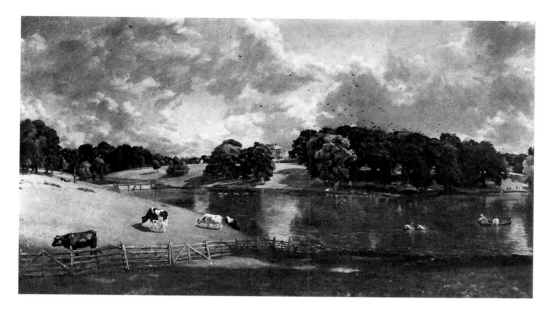

FIGURE 1
John Constable (1776–1837), *Wivenhoe Park, Essex*, dated 1816. Oil on canvas, 22⅛ × 39⅞ in. (56.1 × 101.2 cm), National Gallery of Art, Widener Collection, Washington, D.C. (1942.9.10)

style over the more adventurous avant-garde. Raised in the Confucian tradition with its didactic and utilitarian views of art, Xu and his supporters were shocked and bewildered by the Fauves, the Cubists, and the Dadaists, all of whom they regarded as "empty formalists."[2] In this regard, Chinese painters of the early twentieth century differed considerably from Japanese artists who had gone to Paris, for the Japanese enthusiastically embraced whatever style was in fashion, albeit for nationalistic reasons.[3] Chinese painters, on the other hand, worked on reinventing Chinese painting by grafting Western techniques—notably chiaroscuro modeling and linear perspective—onto Chinese traditions, and using Chinese materials they brushed onto paper their interpretations of European styles. With this background in mind, we can understand their embrace under the Communist rule of mainland China after 1949 of Soviet-style Social Realism, which in turn echoed the didactic Confucian view of art.[4]

TWO TRADITIONS OF REPRESENTATIONAL PAINTING

One might think that after more than a century during which Chinese intellectuals had gone abroad to learn Western science, technology, and culture, the adoption of Western techniques would have been a natural evolution in the visual arts as well. But the history of modern Chinese painting reveals the tremendous cultural and psychological obstacles Chinese painters faced in practicing in a Western idiom, for their own linguistic and cultural universe was in many ways remote from Western sensibilities, leaving them unprepared for any major change in their approach to art.

The study of modern Chinese painting offers important lessons on the complexities of crosscultural influences in the modern world. The comparative study of Chinese art inevitably involves such generalized dual concepts as East versus West and modern versus traditional. When the Chinese first encountered Western culture, with its military power and technological innovations, they used the compound *zhong-wai*, "native-foreign," to describe the contrast between the culture of the West and that of China. They spoke of a monolithic West in much the same way as the nineteenth-century German philosopher Georg Wilhelm Friedrich Hegel had regarded a "changeless" China as the perpetual "other" that existed "outside the world's history."[5] *Zhong-wai* is clearly present in the styles of contemporary Chinese painters. As in translating foreign literature, however, adopting styles from another culture can never be an innocent act of transference. An examination of the lives and works of modern Chinese painters reveals not only a tangled skein of debate but also the paradox that many Chinese artists turned to European realism at the same moment that European art was heading in the opposite direction. The Western-style realism of Xu Beihong is essentially academic and therefore elitist and conservative, whereas the work of traditionalist painters such as Qi Baishi (1864–1957) and Zhang Daqian (1899–1983), though it draws on Chinese traditions, is in fact populist and modern in style and content.

Chinese painting and Western painting are the result of two opposing traditions of representational painting. Norman Bryson has characterized the differences in *Vision and Painting* (1983):

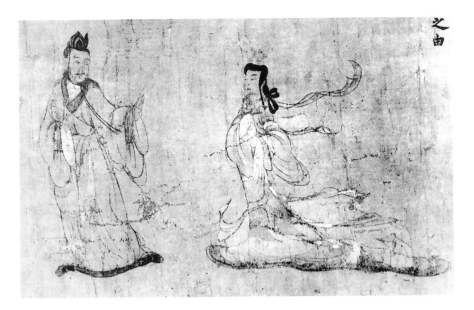

 6 *If China and Europe possess the two most ancient traditions of representational painting, the traditions nevertheless bifurcate, from the beginning.... Chinese painting has always selected forms that permit a maximum of integrity and visibility to the constitutive strokes of the brush: foliage, bamboo, the ridges of boulder and mountain formations, the patterns of fur, feather, reeds, branches.... [In a Chinese landscape painting] landscape is certainly the subject, but equally the subject is the work of the brush in "real time" and as extension of the painter's own body; and if that is true for [an] early, Northern Sung painting, it will be true to an even greater extent with Chinese painting after Tung Ch'i-ch'ang [1555–1636].... The work of production is constantly displayed in the wake of its traces; in this tradition the body of labour is on constant display, just as it is judged in terms which, in the West, would apply only to a performing art.... Yet through much of the Western tradition oil paint is treated primarily as an erasive medium.... Whereas with ink-painting everything that is marked on the surface remains visible, save for those preliminaries or errors that are not considered part of the image, with oil even the whites and the ground-colours are opaque: stroke conceals canvas, as stroke conceals stroke.... Picasso's technique of image-construction is only the extreme statement of what is in fact the habitual, the ancient process: a first stage is placed on canvas in order to induce in the painter a reaction that will replace it; this second stage in turn will generate a third, a twentieth image; yet at no point is the durational temporality of performance preserved or respected.*[6]

Influenced by the concept of mimesis, or imitation, Western pictorial representation beginning in the Renaissance was directed toward the mastery of realistic appearance. In this quest, the painter attempted to achieve the illusion of nature by concealing the pictorial medium. Western painting, writes E.H. Gombrich, "has indeed been pursued as a science. All the works of this tradition...apply discoveries that are the result of ceaseless experimentation."[7] In *Art and Illusion* (1961), in a careful analysis of the English painter John Constable's *Wivenhoe Park, Essex,* (fig. 1) dated 1816, Gombrich quotes from Roger Fry's *Reflections on British Painting* (1934), which is concerned with Constable's place in art history:

From one point of view the whole history of art may be summed up as the history of the gradual discovery of appearances.... European art from the time of Giotto progressed more or less continuously in this direction, in which the discovery of linear perspective marks an important stage, whilst the full exploration of atmospheric color and color perspective had to await the work of the French Impressionists. In that long process Constable occupies an important place.[8]

While he agrees that representational art has a history, Gombrich questions Fry's use of the term "discovery"—since "you can only discover what was always there"—and, drawing on modern perceptual psychology, he argues that "we are born with the capacity to interpret our visual impressions...in terms of space and light."[9] He then concludes:

Indeed, the true miracle of the language of art is not that it enables the artist to create the illusion of reality. It is that under the hands of a great master the image becomes translucent. In

FIGURE 3

Unidentified artist. *Prancing
Horse*, Western Han dynasty
(206 B.C.–A.D. 9). Rubbing of a
stamped tomb tile from Loyang,
Henan Province

FIGURE 4

Attributed to Han Gan (active ca.
742–56), *Night-Shining White*,
detail. Handscroll, ink on paper,
12⅛ × 13⅜ in. (30.8 × 34 cm).
The Metropolitan Museum of
Art, Purchase, The Dillon Fund
Gift, 1977 (1977.78)

*teaching us to see the visible world afresh, he gives us the illusion
of looking into the invisible realm of the mind—if only we
know, as Philostratus says, how to use our eyes.*[10]

Unlike the Greeks, who saw the goal of art as mimesis,
the Chinese view pictorial representation as the attempt to
achieve neither the illusion of reality nor formal beauty alone.
The fifth-century scholar Yan Yanzhi (384–456) described three
kinds of graphic signs (*tuzai*) devised by the ancient Chinese
to convey meaning: the magical hexagram, from the *Book of
Changes*, which represents nature's principles (*tuli*); the writ-
ten character, or ideogram, which represents concepts (*tushi*);
and painting, which represents nature's forms (*tuxing*).[11] A
Chinese painting, like the Chinese written script, is built up
with conventionalized brushstrokes. It is thus conceived as a
graphic sign or diagram that conveys meaning. In Chinese
art history, calligraphy and painting have both a represen-
tational and a presentational function. The key to Chinese
painting is its calligraphic brushwork, which bears the artist's
personal "trace," or imprint. For a Chinese artist to conceal
or erase the medium in order to achieve illusion would be at
odds with an artistic practice in which both calligraphy (writ-
ing the character) and painting (Norman Bryson's "constitu-
tive strokes of the brush") are intimately linked to the body
and the psychology of the artist. In describing a Chinese
painting, it is therefore necessary to refer both to the work
and to the physical and spiritual condition of the artist.

Lothar Ledderose has described how the Chinese writ-
ing system, which is based on a script of some fifty-thousand
characters rather than an alphabet, has "profoundly affected

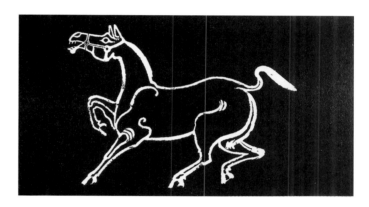

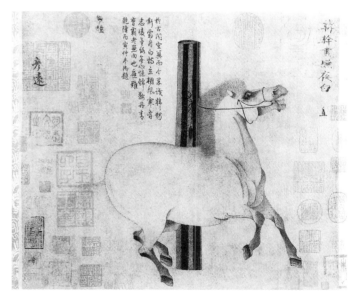

the pattern of thought in China."[12] "[While] the letters of the
alphabet are symbols of sound...characters are symbols of
meaning.... Because they record the meaning of a word, not
its sound,... [an] educated Chinese can read most texts writ-
ten in all parts of the empire at any time in history.... Script

FIGURE 5

Guo Xi (ca. 1000–ca. 1090), *Early Spring*, signed and dated 1072. Hanging scroll, ink and color on silk, 62½ × 42⅝ (158.3 × 108.1 cm). National Palace Museum, Taipei

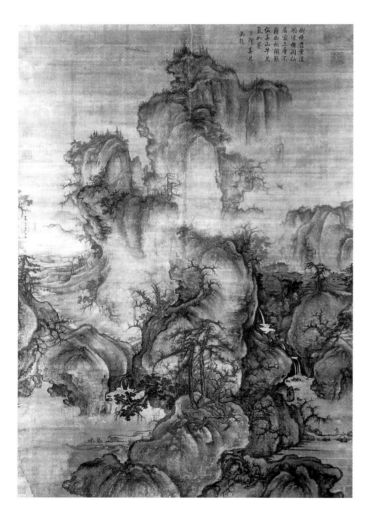

in China thus became the most powerful medium for preserving cultural identity and stabilizing political institutions."[13]

To better appreciate why calligraphy has been regarded as the highest of all art forms in China, it is useful to remember the fundamental difference that exists between the European languages and Chinese. In European cultures, the spoken language is privileged over written language, which, in its phonetically represented form, is often considered merely a transcription of the spoken word. In the Chinese language, the written character, which embodies both the thing (a pictograph) and the idea (an ideograph) to which it refers, projects meaning as both image and word. While oratory reigned supreme in ancient Greece and Shakespearean England, on the imperial monuments of ancient China grandiloquence is expressed with calligraphic style as well as with word.

Because the key to Chinese painting is calligraphic brushwork, the integrity and cohesion of Chinese art theory and the practice of calligraphy are based not on the priority of either representation or nonrepresentation but on the essential harmony between the two. A case in point is the fourth-century figure painter Gu Kaizhi (ca. 344–ca. 406; fig. 2), who sought to "capture the spirit beyond form-likeness" (*yixing xieshen*).[14] Gu's view of form-likeness reflects prehistoric principles of magical representation, by which the image, through the Law of Similarity, is perceived as the prototype itself.[15] The fifth-century theorist Xie He (active ca. 479–502) formulated six principles that should be followed in painting. The first principle, "breath-resonance life-motion" (*qiyun shengdong*), refers to both the painter and the painting—that is to say, when the *qi* (breath or energy) of the painter resonates

FIGURE 6

Zhao Mengfu (1254–1322), *Twin Pines, Level Distance*, early 1300s, detail. Handscroll, ink on paper, 10½ × 42¼ in. (26.9 × 107.4 cm). The Metropolitan Museum of Art, Ex coll.: C.C. Wang Family, Gift of The Dillon Fund, 1973 (1973.120.5)

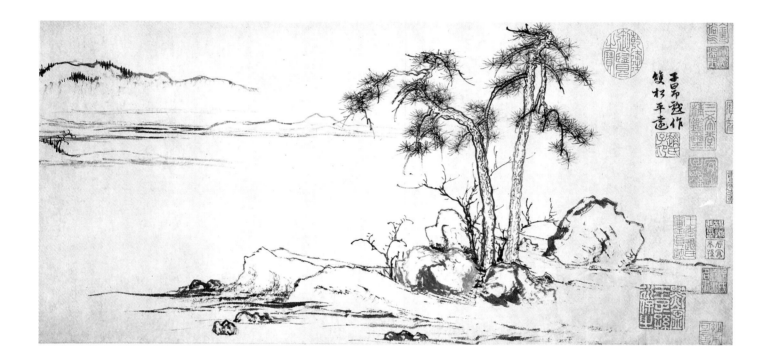

with the *qi* of the depicted object, life-motion is expressed in the painted image.[16] The second principle deals with the technique of "the bone method and the use of the brush" (*gufa yongbi*), while the third principle states that "by responding to an object, [the artist] depicts its form-likeness" (*yingwu xiangxing*). In other words, the painter creates an expressive image through a sympathetic response (*ganying*) to his subject, producing the prototype itself through the Law of Similarity.[17] Furthermore, quoting Zhang Yanyuan (ca. 815–ca. 880), "If a painter seeks breath-resonance in his painting, form-likeness will naturally be present in his work."[18] As we

shall see, this dual emphasis on mimetic representation and subjective expression has remained the fundamental dialectic by which the Chinese artist has attempted to define modernity in Chinese painting.

Although Chinese painters developed neither an anatomical approach to figural representation nor an approach to space based on linear perspective, they nevertheless incorporated in their work skills in representational art that had gradually evolved from the Western Han (206 B.C.–A.D. 9) through the end of the Song period (960–1279) in the late thirteenth century. In a process Gombrich calls "schema and

FIGURE 7
Attributed to Guanxiu (832–912),
Sixteen Lohans, detail. 18th-
century ink rubbing on paper.
Shengyin si, Hangzhou

FIGURE 8
Chen Hongshou (1598–1652),
"A Morning Drink," from the
album *Sixteen Views of Living in
Seclusion*, dated 1651. Album of
twelve paintings and four leaves
of calligraphy, ink and light color
on paper, each leaf 8⅜ × 11¾ in.
(21.4 × 29.8 cm). National Palace
Museum, Taipei

10

correction," early Chinese figural representation developed by "making before matching [reality]."[19] In the first-century B.C. representation of a prancing horse (fig. 3), a rubbing from a stamped tomb tile from the Western Han period, the engraver has applied tautly energetic thickening-and-thinning lines to depict the fluid but compact form of a horse, suggesting muscular movement. Once established, this archaic image became the basic schema for the representation of horses, and it was followed, with only refining modifications, by all later Chinese artists. In *Night-Shining White* (fig. 4), attributed to Han Gan (active ca. 742–56), the elegant brushline, with only a minimum of shading, describes with precision the bulging contours of the horse's powerful body and musculature. Between the late sixth and the early eighth century, Chinese figural representation in sculpture and painting underwent a development similar to that of the fifth-century B.C. Greek "miracle of awakening," when the representation of the human figure evolved from one of archaic frontality to one of natural movement in space.

In spatial representation, Chinese painters developed between the eighth and the fourteenth century a number of pictorial conventions that suggested three-dimensional relationships on a two-dimensional plane. One device that evolved in pre–eighth-century landscape painting was the use of overlapping triangles to suggest recession in space.[20] By the late eleventh century, as seen in Guo Xi's (ca. 1000–ca. 1090) *Early Spring* (fig. 5), dated 1072, spatial continuity is suggested through a modeling technique that gives an impression of diffused atmosphere. The thickening-and-thinning outlines of modeling strokes and rock and tree forms, in values

ranging from transparent blue gray to charcoal black, are applied one on top of the other so that the ink tones run together to create a wet, blurry surface.

In the late eleventh century, during the late Northern Song period, form-likeness and individual expression came to be viewed as conflicting approaches to painting, and a new kind of art arose. Known as scholar painting (*shidafu hua* or *wenrenhua*), it was produced by scholar-officials at court, who were primarily calligraphers and amateur painters. Scholar painting was distinct from the professional painting of the academy as well as from the official orthodoxy, which was based on mimetic representation. Realism was soon repudiated as decorative illustration, in much the same way that disdain was shown in the West toward the nineteenth-century Paris Salon or such twentieth-century American painters as Maxfield Parrish and Norman Rockwell. Su Shi (1037–1101), in his famous dictum, "Anyone who judges painting by form-likeness shows merely the insight of a child," exemplifies this attitude.[21] In a statement that bears a striking resemblance to the twentieth-century Western discussion of "the end of the history of art,"[22] Su Shi pronounced that progressive art history, with an evolutionary development from ancient to modern, had come to an end.[23] His solution to this predicament was to look to history in order to seek renewal through the revival of ancient styles.

By the late-thirteenth and early-fourteenth century, Guo Xi's representational brushwork had been transformed into a calligraphic idiom by Zhao Mengfu (1254–1322), the leading calligrapher and painter of the early Yuan, as exemplified in his *Twin Pines, Level Distance* (fig. 6), dating from the early

1300s. In this work, Zhao uses Guo Xi's landscape idiom—with "cloud-scroll" texture pattern and "crab-claw" tree branches—as a symbolic language that treats style as subject matter to allude to history and to connote meaning.[24] Compared with the more representational trees and rocks of Guo's work, Zhao's abstract forms, removed from their natural context and isolated against a neutral white ground, are images in which calligraphic brushstrokes are gestural movements more expressive of the artist's own emotions. Zhao thus initiated a fundamental redirection in Chinese painting, displacing realistic representation with calligraphic self-representation. Between Guo Xi's *Early Spring* and Zhao Mengfu's *Twin Pines, Level Distance*, there is a distinctive shift in artistic function as well as artistic intention, from the embodiment of cosmic beliefs in academic painting to one of subjective expression. Known as *xieyi*, or the "writing of ideas and feelings," the true subject of scholar painting is the artist's inner response to the world.

In combining word, image, and calligraphy in a single work of brush and ink on paper, Zhao's art differs radically from modern Western abstract painting. Whereas Zhao's work depends on the spontaneous performance of the artist's own calligraphic rhythm and energy, image construction in oil on canvas, as Norman Bryson notes, "is treated primarily as an erasive medium...[and] at no point is the durational temporality of performance preserved or respected."[25] This approach of spontaneous performance was continued in Ming and Qing scholar painting. In the seventeenth century, the late-Ming painter and illustrator Chen Hongshou (1598–1652) developed a highly charged expressionistic figure style to depict quasi-religious images, historical and fictional subjects, and real people in real situations by borrowing a linear idiom of archaistic grotesqueries attributed to the late-ninth-century Chan Buddhist monk Guanxiu (832–912; fig. 7). In "A Morning Drink" (fig. 8) an inebriated scholar, lounging languorously by a stone table, sips from a lotus-leaf-shaped cup. Using a masterly iron-wire calligraphic technique with an unerring sense of graphic space and composition, Chen grasps the essence of his subject, defining the poetic moment with easy but controlled sweeping brushstrokes.

A more advanced stage in the development of the self-expressive "writing of ideas" in Chinese scholar painting occurred in the late seventeenth century, after the fall of the Ming dynasty (1368–1644), when the great individualist masters Bada Shanren (1626–1705) and Shitao (1642–1707) created an art form that combined in a single work the simultaneous expression of word, image, and calligraphic abstraction. On two small facing album leaves, "On the Mountain Peak" (fig. 9), dating from 1695, Shitao evokes in calligraphy, poetry, and painting his vision of the grandeur of Yellow Mountain in Anhui, where, as a "leftover citizen" of the Ming, he spent his early years in solitude in the mountain wilderness. The bold writing on the left reads:

High on the mountain the colors are cold,
The flying white clouds cease looking white.

The calligraphy echoes the heroic image of the two mountain peaks, which are built up with a conventionalized texture pattern (*cunfa*). The calligraphic stroke with a centered

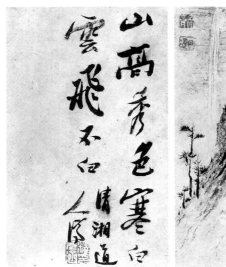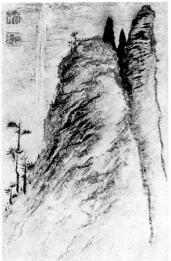

 tip is brushed vigorously onto the paper in a manner that re-calls the robust style of the Tang-dynasty calligrapher Yan Zhenqing (709–785; fig. 10). The painting and calligraphy together unite the medium with the message: the wind, the movement of the clouds, and the frigid air described in the poem are echoed in the "flying-white" brushstrokes, in which the white of the paper shows through the marks of the brush.

The last great era of Chinese painting was the early-Qing dynasty, during the reign of the Kangxi emperor (r. 1662–1722). Leading orthodox masters such as Wang Hui (1632–1717) and Wang Yuanqi (1642–1715), who based their works on the classical styles of the Song and Yuan masters, and in-dividualist masters such as Bada Shanren and Shitao, who created their own styles, achieved in different ways a syn-thesis of inherited traditions. In the eighteenth century, dur-ing the reigns of the Yongzheng (r. 1723–35) and Qianlong (r. 1736–95) emperors, while court painters in Beijing, in the north, continued to follow the orthodox styles of Wang Hui and Wang Yuanqi, professional painters in the south, in the thriving city of Yangzhou, emulated the bold brush styles of Bada Shanren and Shitao.

The leading merchant families of Yangzhou affected a lavish lifestyle, competing with one another in conspicuous spending by building great mansions and garden estates, breeding horses and exotic flowers, indulging in nightly feasting, singing, and theatrical performances, and collect-ing curios and works of art. The colorful Eccentric Painters of Yangzhou, catering to the popular taste for the idiosyn-cratic and the colorful, developed China's first successful commercial art style aimed at a growing urban public. Many of the Eccentrics were failed scholar-officials who seemed to flaunt their bold, unconventional styles in angry defiance against the loss of social status that came from becoming professional painters.[26]

THE MODERN STUDY OF CHINESE ART HISTORY

While earlier Chinese painting through the eighteenth century followed a cyclical pattern of ebb-and-flow, growth-decline-and-revival, in the nineteenth and twentieth centu-ries, China's protracted struggle for modernization under the impact of Western culture seems to have threatened the very continuity of the ancient Chinese representational tradition. After the founding of the Republic in 1912, ancient Chinese painting dating from before 1800, along with traditional Chi-nese learning and the literary style of writing (*wenyan*), came to be regarded as part of the classical Chinese heritage (*gu-dian*).[27] And with the establishment of the National Palace Museum in Beijing in 1925, the hitherto inaccessible impe-rial household treasures became, for the first time, available for viewing and study by the public.[28] The reclaiming of the traditional past, however, was opposed by the New Culture Movement (Xinwenhua yundong) advocated by reform lead-ers such as Chen Duxiu (1879–1942) and Hu Shi (1891–1962) at Peking University (Beijing daxue), the center of in-tellectual ferment in the late 1910s and 1920s, who sought to reform Chinese culture by importing Western science and technology.[29] Traditional Chinese painting was referred to as the national style (*guohua*), as opposed to the Western style (*xiyanghua*). This distinction played a major role in the

12

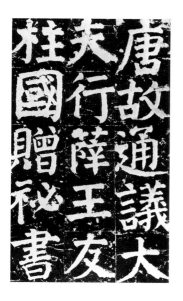

crosscultural discourse between East and West concerning
the identity and value of traditional Chinese culture, as West-
ernizers turned to Western models to reform Chinese paint-
ing, while traditionalists looked to Chinese art history for
self-definition and inspiration.[30]

The early years of the twentieth century were a critical
time for China, the culmination of which was the revolution
of 1911 that led to the collapse of the Manchu Qing empire
and the founding of a precarious fledgling republic. What
were desperate years for China politically turned out to be
exciting years for China in art and archaeology. In 1900, a
sealed library chamber at the Thousand Buddhas Caves in
Dunhuang, in northwestern Gansu Province, was discovered
by a mendicant Daoist priest named Wang Yuanlu. This dis-
covery brought European, Japanese, and Chinese explorers,
scholars, and artists to the region to study the Dunhuang
paintings, which ranged in date from the fifth through the
fourteenth century. With the founding of the Republic, a great
number of fine Chinese paintings and antiquities were taken
to Japan by former officials of the Qing court, ushering in
a great period of Chinese art collecting in Japan during
the Taishō era (1912–26). Luo Zhenyu (1866–1940), a well-
known antiquarian and the doyen of the Qing expatriates in
Japan, was befriended by the leading Japanese Sinologist
Naitō Konan (1866–1934), who became the principal adviser
to many prominent collectors among Japan's new industrial
and banking elite. Among them were Abe Fusajirō (1868–
1937), Yamamoto Teijirō (1870–1937), and Ogawa Chika-
nosuke, whose collection is now in the Osaka Municipal
Museum of Art.

The influx of Chinese art gave the Japanese scholars their
first look at leading Chinese scholar-painters of the Yuan and
Ming periods since the publication in the fifteenth century
of the *Kundaikan sayū chōki*, a compilation of Song and Yuan
paintings collected in Japan before and during the Ashikaga
period (1392–1573). In 1922 and 1923, Naitō Konan delivered
a series of lectures on the history of Chinese painting at
Kyoto Imperial University.[31] Emending an earlier Japanese
view of Chinese painting that was based largely on medieval
Japanese collections of Southern Song Buddhist and academic
works, Naitō's new history focused on Chinese scholar paint-
ing of the Yuan (1279–1368) and Ming (1368–1644) dynasties.
Between 1921 and 1931, six Sino-Japanese art exhibitions were
organized with the support of the Japanese government, with
the last two, those of 1928 and 1931, showing only works by
classical masters.[32] As a result of these exhibitions, Japan
became the principal foreign market for Chinese painting
and the careers of many contemporary Chinese masters, such
as Wu Changshuo (1844–1927), Qi Baishi (1864–1957), and
Zhang Daqian (1899–1983), were galvanized.

The introduction of the newly available masterpieces of
early Chinese painting into Taishō-period Japan coincided
in that country with the rise of nationalism and a return to
traditional values in response to the Westernization of the
preceding Meiji era (1868–1912). The ensuing enthusiasm
for Chinese studies not only nurtured a generation of great
Japanese Sinologists but also led to a revival in Japan of the
Chinese scholar style of painting (*bunjinga*; in Chinese,
wenrenhua). Also known in Japan as Nanga, or painting of
the Southern school, as defined by the late-Ming critic and

13

painter Dong Qichang (1555–1636), it had been followed by traditional Japanese ink painters (mostly through copybook illustrations of Chinese models) since the seventeenth century. Another important contribution to this Easternization was an essay written in 1921 by the eminent Japanese historian of Chinese art Ōmura Seigai (1867–1927), a professor at the Tokyo School of Fine Arts (Tōkyō bijitsu gakkō). Entitled "The Revival of Scholar Painting," it identifies the scholar painting style as the authentic pan-Asian (Tōyō, meaning Chinese and Japanese) artistic tradition and it contrasts Eastern "spirituality" with Western realism, which Ōmura compares with photography, a symbol of the industrialized machine world:

Western-style painting appeals easily to the common eye. . . . [Today] many reformers insist on naturalism, believing that drawing from life will correct the mistakes [of traditional scholar painting]. . . . For depicting the detail and delicacy of nature, painting can of course never equal photography. But to suggest that the mechanical devices of glass lenses and photosensitive chemicals can produce something better than painting is pure foolishness. . . . If the representation of nature were the sole aim of art . . . then the invention of photography would mean the end of painting. . . . But in fact this has not happened, and painting will become more important than ever Because it reaches beyond representation, painting shall always maintain its own power and its own dominion.[33]

Ōmura took the traditional view of the Chinese scholar, namely, that painting should transcend mimetic form-likeness and surface beauty, two characteristics he equated with Western realism, and attain Xie He's first principle, breath-resonance life-motion.[34] Because of the influence of Ōmura and other writers, two of the most expressive individualist masters of the seventeenth century, Shitao and Bada Shanren, became the most admired painters among Japanese artists and collectors. In 1926, the Nanga painter Hashimoto Kansetsu (1883–1945) published a book on Shitao, illustrating it with reproductions of some of the artist's best-known works in Japan. These included the album *Returning Home*, which includes the leaf "On the Mountain Peak" (fig. 9), then belonging to the well-known Japanese collector Kuwana Tesujō (1864–1938) and now in The Metropolitan Museum of Art. In a colophon at the end of the album, Tomioka Tessai (1837–1924; fig. 11),[35] a leading Nanga master and an ardent admirer of Shitao, transcribes an appreciation of the artist by one of the Eccentric Painters of Yangzhou, Zheng Xie (1693–1765), thereby acknowledging the historical lineage of scholar painting in eighteenth-century China and its transformation into Nanga in modern Japan.[36]

In 1922, the year after Ōmura's essay appeared, Chen Hengke (1876–1923), a leading art teacher and theorist in Beijing, published an essay entitled "The Values of Scholar Painting," to which he appended a Chinese translation of Ōmura's essay.[37] Of Chinese painting Chen wrote:

What defines painting is its spiritual quality, its idealism, and its life and movement. It is not mechanical and it is never simplistic. Otherwise, it would be just like photography, repetitive and uniform, and indistinguishable from it. . . . As for the essential ingredients of Chinese scholar painting, first, it is moral character,

FIGURE 11

Tomioka Tessai (1837–1924), colophon to Shitao's *Returning Home*. Ink on paper, width of double page 10⅝ in. (27 cm). The Metropolitan Museum of Art, Ex Coll.: P.Y. and Kinmay W. Tang Family; Gift of Wen and Constance Fong, in honor of Mr. and Mrs. Douglas Dillon, 1976 (1976.280a–n)

second is learning, third is talent and feeling, and fourth is idealism. Only he who possesses all these four qualities shall attain perfection. This is because what defines art is the artist's ability to affect his viewer, and to elicit a sympathetic response with his own spirit. Only when an artist experiences a response himself can he move his viewer to respond to what he feels.[38]

Chen's exegesis sets the tone for modern Chinese discourse on traditional-style Chinese painting.

The regeneration and study of the Chinese tradition was not limited to China and Japan. In the United States, in the 1890s, Ernest Fenollosa (1853–1908; fig. 12) started to build a great collection of Japanese and Chinese art at the Museum of Fine Arts, Boston.[39] Fenollosa had gone to Japan in 1878 as an instructor of philosophy and political economy at the Imperial University of Tokyo precisely at the moment that Japanese enthusiasm for Western art had reached its zenith, in the late 1870s.[40] Instantly enamored of traditional Japanese art, he railed against the indiscriminate Westernization of Japanese painting. In 1887, he was appointed head of both the Imperial Museum in Tokyo and the Tokyo School of Fine Arts.[41] Named curator in the Department of Asiatic Art at the Museum of Fine Arts, Boston, in 1890, he set about establishing Boston as the leading center outside Japan for the display and study of Japanese art. He was succeeded in 1897 by his Japanese protégé, Okakura Kakuzō (1862–1913; fig. 13), a nationalistic Japanese art activist. Arriving in Boston in 1904, Okakura devoted himself to building the museum's superb collection of Chinese art, and gained renown for his books *Ideals of the East* (1903) and *The Book of Tea* (1906).

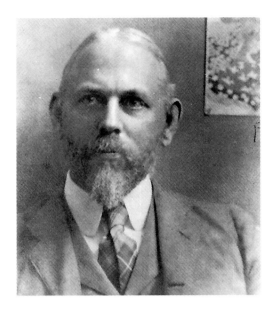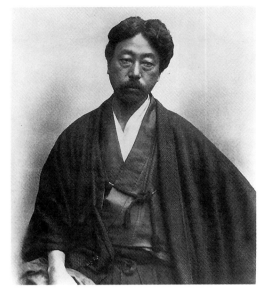

16 While Fenollosa and Okakura were building collections in Boston, the self-made millionaire Charles Lang Freer (1856–1919) was creating his own collection of Chinese and Japanese art, one that he presented in 1906, together with funds for the erection of the Freer Gallery of Art in Washington, D.C., to the Smithsonian Institution. A natural proselytizer, Freer did his best to persuade museums across the country to acquire fine Asian art. In the 1910s, when the Boston Museum of Fine Arts was collecting Chinese art under the guidance of Okakura, the museum's president, Gardiner M. Lane, is said to have "lived in constant fear that The Metropolitan Museum of Art in New York, backed by J.P. Morgan's money, would enter the competition for Chinese art."[42] In 1912, John C. Ferguson (1866–1945), a Methodist missionary and a scholar and collector of Chinese painting living in China, convinced the Metropolitan to name him its purchasing agent in China. By late 1913 the museum, on the advice of Freer, concluded an arrangement with Ferguson to accept, on a part-purchase part-gift basis, the Chinese painting collection Ferguson had amassed. During the 1930s and in the decades following World War II, the exceptional talent and devotion of two connoisseur-directors, Laurence Sickman (1906–1988) and Sherman E. Lee (b. 1918), enabled The Nelson-Atkins Museum of Art, Kansas City, and the Cleveland Museum of Art to establish outstanding collections of Chinese art.

Serious study of Chinese painting in the West began in the 1930s, about the time of the first Chinese government loan exhibition of Chinese art abroad, which opened at Burlington House, London, in November 1935. At first, interest was focused on Song painting, as was the early collection at the Boston Museum of Fine Arts, which was assembled according to Japanese taste. In 1949, an exhibition organized by the Wildenstein Gallery in New York, "Great Chinese Painters of the Ming and Ch'ing Dynasties," caused a major shift of interest to later Chinese painting.[43] The first great exhibition of Chinese art in this country came from the Chinese National Palace Museum, which had by this time been moved to Taipei. The exhibition, which traveled to five cities from 1961 to 1962, sparked an explosion of interest in the study of Chinese painting in the United States.[44]

WHAT IS "MODERN" IN TWENTIETH-CENTURY CHINESE PAINTING?

What is considered "modern" in nineteenth- and twentieth-century Chinese painting? Some view modernity as the Westernization of Chinese art, while others search for elements of early modernity in Chinese painting history.

Western academic study of twentieth-century Chinese painting began with Michael Sullivan's *Chinese Art in the Twentieth Century*, published in 1959, followed by *The Meeting of Eastern and Western Art* by the same author, published in 1973,[45] and in 1996 his most useful volume, *Art and Artists of Twentieth-Century China*, which surveys the development of the arts within the context of the social and political turbulence of contemporary China.[46] For Sullivan, the modernization of Chinese painting means Westernization. Following the official division of the art academies in China into national and Western instruction, Sullivan tracks the Westernization in Chinese art and contrasts it with the revival of traditional painting.

Recently, Wan Qingli has made an appeal for a China-centered approach.[47] Wan echoes Paul Cohen's book of 1984, *Discovering History in China*, which describes three kinds of West-centered study: the Western impact and Chinese response model, the tradition versus modernity model, and the Western imperialist model.[48] Wan argues that modern Chinese art history should be seen from a Chinese point of view and within the context of Chinese culture; that it should not be judged from the perspective of Western modern art and theories; and that it should be examined in terms of a broad humanism that encourages a comparative study of the cultures of China and the West.[49]

When late-Qing calligraphers, inspired by early-Qing evidential scholarship, began their archaeological studies of the epigraphic style of calligraphy (see pages 26–35, 52–56), they assumed a distinctly "modern" stance of viewing the development of ancient calligraphy as a historical phenomenon. Unlike Su Shi and Zhao Mengfu, who revived earlier styles as part of a continuing, living tradition, the artists of the epigraphic school in the late Qing and early Republic viewed archaeologically discovered ancient writings as historically detached from the contemporary world. Implicit here is the assumption that twentieth-century Chinese art reformers, including the "Westernizers," shared this belief. Modern painters such as Li Keran (1907–1989) and Shilu (1919–1982) have continued to explore the expressiveness of epigraphic calligraphy in defining "modernity" in their art. At the same time, because mimetic realism in ancient Chinese painting had reached its zenith during the Tang and Song periods, twentieth-century imitators of Tang and Song styles

could view themselves as modernists who had restored realism to Chinese painting. This perception would allow Zhang Daqian (1899–1983) to imitate and re-create Tang and Song styles with impunity.

The evolution of realistic representation to calligraphic self-expression, or "the writing of ideas and feelings," that occurred in fourteenth-century scholar painting in China also finds a distinct parallel in the displacement of the mimetic by the expressive by such early-twentieth-century Western artists as Paul Cézanne and Pablo Picasso.[50] This shift was not lost on modern Chinese theorists, who were fully aware that painters in the West had themselves rebelled against, and abandoned, mimetic realism. As Chen Hengke wrote at the time:

Western painting can be said to have attained extreme form-likeness. Since the nineteenth century, it has pursued [the effects of] light and color according to the principles of science, and experimented with every aspect of representation. Yet more recently, post-Impressionism has reversed this course in order to de-emphasize the objective and focus on the subjective. Now, Cubism, Futurism and Expressionism have, one after another, demonstrated the continuing changes in ideas and imagination. These only show that form-likeness alone can never exhaust what art can do; one must always seek alternative paths.[51]

The discarding of the mimetic by modern Western artists suggests a possible convergence of the artistic traditions of East and West. This convergence is perhaps best understood

in terms that Clement Greenberg described as the phenomenon of art calling attention to art:

Realistic, illusionist art had dissembled the medium, using art to conceal art. Modernism used art to call attention to art. The limitations that constitute the medium of painting—the flat surface, the shape of the support, the properties of the pigment—were treated by the Old Masters as negative factors that could be acknowledged only implicitly or indirectly. Modernist painting has come to regard these same limitations as positive factors that are to be acknowledged openly.[52]

This phenomenon can be observed in Chinese painting of the early fourteenth century, as exemplified in *Twin Pines, Level Distance* (fig. 6), by Zhao Mengfu, in which rhythmic energy is created on the flat surface by purely calligraphic

brushwork. The focus shifts from mimetic representation or, to use Greenberg's terminology, "realistic, illusionist art," to the medium itself, to "the flat surface . . . the properties of the pigment," expressed through the conventions of pictorial and ideographic language.

The purpose of such an example is not to suggest that Zhao Mengfu was "winning the race [with Europe] to be 'modern.'"[53] Rather, it is an attempt to understand the change from realism to abstraction that occurred in both traditions. But while this development was for painters in the West "the last desperate revolt against illusion,"[54] Chinese painters did not create a nonobjective art. By focusing on the visual evidence of works of art and placing them in the context of Chinese art history and comparative cultural values, we hope to better understand the lives and careers of some of the leading modern painters in this most turbulent period of Chinese history.

NOTES

1. Julia F. Andrews and Kuiyi Shen, *A Century in Crisis: Modernity and Tradition in the Art of Twentieth-Century China* (exh. cat., New York: Guggenheim Museum Soho; Bilbao: Guggenheim Museum, 1998); "Conflict and Consensus in Twentieth-Century Chinese Art," symposium, Solomon R. Guggenheim Museum, New York, May 23, 1998; Gao Minglu, ed., *Inside/Out: New Chinese Art* (exh. cat., San Francisco: San Francisco Museum of Modern Art; New York: Asia Society Galleries, 1998); Wu Hung, *Transience: Chinese Experimental Art at the End of the Twentieth Century* (exh. cat., Chicago: David and Alfred Smart Museum of Art, University of Chicago, 1999), to name a few.

2. Qiu Dingfu, *Zhongguohua jindai gejia zongpai fengge yu jifa zhi yanjiu* (A Study of Modern Chinese Painting, Its Schools, Styles, and Techniques) (Taipei: Chinese Culture University, 1984), p. 76.

3. Shūji Takashina, J. Thomas Rimer, and Gerald D. Bolas, *Paris in Japan: The Japanese Encounter with European Painting* (exh. cat., Tokyo: Japan Foundation; Saint Louis: Washington University, 1987).

4. Michael Sullivan, *Art and Artists of Twentieth-Century China* (Berkeley and Los Angeles: University of California Press, 1996), pp. 91–106, 135–39.

5. Georg W.F. Hegel, *The Philosophy of History* (New York: Dover, 1956), p. 116.

6. Norman Bryson, *Vision and Painting: The Logic of the Gaze* (New Haven: Yale University Press, 1983), pp. 89, 92.

7. E.H. Gombrich, *Art and Illusion: A Study in the Psychology of Pictorial Representation*, 2d ed. (New York: Bollingen Foundation, 1961), p. 34.

8. Ibid., p. 292.

9. Ibid., pp. 326–27.

10. Ibid., p. 389.

11. Zhang Yanyuan, *Lidai minghua ji* (Record of Famous Paintings in Successive Dynasties; completed 847), in *Huashi congshu* (Compendium of Painting Histories), edited by Yu Anlan (Shanghai: Renmin Meishu Chubanshe, 1963), vol. 1, *juan* 1, p. 1.

12. Lothar Ledderose, *Ten Thousand Things: Module and Mass Production in Chinese Art* (Princeton: Princeton University Press, 2000), p. 1.

13. Ibid., p. 23.

14. For Gu Kaizhi, see Zhang Yanyuan, *Lidai minghua ji*, in *Huashi congshu*, vol. 1, *juan* 5, p. 71.

15. According to Sir James Frazer, in *The Golden Bough*, part 1, *The Magic Art and the Evolution of Kings* (London: Macmillan, 1913), p. 53, the Law of Similarity suggests "like produces like": "the magician infers that he can produce any effect he desires merely by imitating it." See also, David Freedberg, *The Power of Images: Studies in the History and Theory of Response* (Chicago: University of Chicago Press, 1989), pp. 272–74.

16. Wen C. Fong, "Ch'i-yün-sheng-tung: 'Vitality, Harmonious Manner, and Aliveness'," *Oriental Art*, n.s., 12, no. 3 (autumn 1966), pp. 159–64.

17. Kiyohiko Munakata, "Concepts of *Lei* and *Kan-lei* in Early Chinese Art Theory," in *Theories of the Arts in China*, edited by Susan Bush and Christian F. Murck (Princeton: Princeton University Press, 1983), pp. 106ff.

18. Zhang Yanyuan, *Lidai minghua ji*, in *Huashi congshu*, vol. 1, *juan* 1, p. 15; see also William R.B. Acker, *Some Tang and Pre-Tang Texts on Chinese Painting* (Leiden: E.J. Brill, 1954), p. 149.

19. Gombrich, *Art and Illusion*, pp. 3, 116, passim.

20. For the development of spatial representation in Chinese landscape painting, see Wen C. Fong, "Pictorial Representation in Chinese Landscape Painting," in *Images of the Mind: Selections from the Edward L. Elliott Family and John B. Elliott Collections of Chinese Calligraphy and Painting at The Art Museum, Princeton University*, by Wen C. Fong et al. (exh. cat., Princeton: The Art Museum, Princeton University, 1984), pp. 20–22; see also Wen C. Fong, "*Riverbank*: From Connoisseurship to Art History," in *Issues of Authenticity in Chinese Art*, edited by Judith Smith and Wen C. Fong (New York: The Metropolitan Museum of Art, 1999), pp. 261–73.

21. Susan Bush, *The Chinese Literati on Painting: Su Shih (1037–1101) to Tung Ch'i-ch'ang (1555–1636)* (Cambridge, Mass.: Harvard University Press, 1971), p. 26.

22. See Hans Belting, *The End of the History of Art?*, translated by Christopher S. Wood (Chicago: University of Chicago Press, 1987).

23. Su Shi observed that artistic development, having reached its pinnacle as early as the eighth century, was ready for radical and unprecedented change. He wrote: "The learning of superior men and the skills of a hundred kinds of craftsmen, having originated in the Three Eras [Xi, Shang, Zhou] and having passed through the Han and Tang dynasties, had reached a state of completion. By the time poetry had produced a Du Fu, prose writing a Han Yu, calligraphy a Yan Zhenqing, and painting a Wu Daozi, the stylistic variation of past and present as well as all technical possibilities were fully available." See Su Shi, "Shu Wu Daozi huahou" (Writing on a Painting by Wu Daozi), in *Dongpu tiba* (Colophons by Su Shi), in *Yishu zongbian* (Collected Works on Chinese Art) (Taipei: Shijie Shuju, 1962), vol. 22, *juan* 5, p. 95. Su developed his notion of the end of art from the Buddhist theory of

20 four *kalpas* (world periods): birth, maturity, transformation, and destruction. For a discussion of Su's statement, see Fong, *Images of the Mind*, pp. 7–9; and Peter K. Bol, *"This Culture of Ours": Intellectual Transitions in Tang and Sung China* (Stanford: Stanford University Press, 1992), pp. 297–98.

24. For Zhao's expressed reference to Guo Xi, see Shane McCausland, "Zhao Mengfu (1254–1322) and the Revolution of Elite Culture in Mongol China" (Ph.D. dissertation, Princeton University, 2000), pp. 170–75.

25. See above, p. 6 and n. 6.

26. Wen C. Fong, "The Time of Qianlong (1736–1795)," in *Chinese Painting under the Qianlong Emperor: The Symposium Papers in Two Volumes*, edited by Ju-hsi Chou and Claudia Brown, *Phœbus* 6, no. 1 (Tempe: College of Fine Arts, Arizona State University, 1988), pp. 9–16.

27. For the use of the term "classical" for Chinese painting, see John Hay, "Some Questions Concerning Classicism in Relation to Chinese Art," *Art Journal* 47, no. 1 (spring 1988), pp. 26–34.

28. Chang Lin-sheng, "The National Palace Museum: A History of the Collection," in *Possessing the Past: Treasures from the National Palace Museum, Taipei*, by Wen C. Fong and James C.Y. Watt (New York: The Metropolitan Museum of Art; Taipei: National Palace Museum, 1996), p. 3.

29. For the revolution in Chinese art, see Maiching Kao, "The Beginning of the Western-Style Painting Movement in Relationship to Reform of Education in Early Twentieth-Century China," *New Asia Academic Bulletin* 4 (1983), pp. 373–400.

30. See Aida Yuen Yuen, "Inventing Eastern Art in Japan and China, ca. 1890s to 1930s" (Ph.D. dissertation, Columbia University, New York, 1999).

31. Published posthumously in 1938; see Yuen, "Inventing Eastern Art," pp. 55–61. For an evaluation of Naitō's connoisseurship and the critical value of his "History of Chinese Painting" see Kohara Hironobu, "Riben de Zhongguohua shoucang yu yanjiu" (The Collection and Studies of Chinese Painting in Japan), *Duoyun*, no. 40 (January 1994).

32. Yuen, "Inventing Eastern Art," pp. 72–96.

33. For a Chinese translation, see Chen Hengke, *Zhongguo wenrenhua zhi yanjiu* (A Study of Chinese Scholar Painting) (reprint, Tianjin: Tianjin Guji Shudian, 1992), pp. 8–23.

34. See discussion in Yuen, "Inventing Eastern Art," pp. 110–14.

35. For Tomioka Tessai, see Tarō Odakane, *Tessai: Master of the Literati Style*, translated and adapted by Money Hickman (Tokyo: Kodansha International, 1965); and James Cahill, *Tessai: The Works of Tomioka Tessai* (exh. cat., International Exhibitions Foundation; Berkeley: Art Museum, University of California, 1968).

36. Wen C. Fong, *Returning Home: Tao-chi's Album of Landscapes and Flowers* (New York: George Braziller, 1976), pp. 85–86.

37. Chen Hengke, *Zhongguo wenrenhua zhi yanjiu*.

38. Ibid., pp. 3, 7.

39. Warren I. Cohen, *East Asian Art and American Culture: A Study in International Relations* (New York: Columbia University Press, 1992), pp. 27–49.

40. Lawrence W. Chisholm, *Fenollosa: The Far West and American Culture* (New Haven: Yale University Press, 1963); Van Wyck Brooks, *Fenollosa and His Circle, with Other Essays in Biography* (New York: E.P. Dutton, 1962).

41. For the Tokyo School of Fine Arts, see Ellen P. Conant, "The Tokyo School of Fine Arts and the Development of Nihonga, 1889–1906," in *Nihonga: Transcending the Past. Japanese-Style Painting, 1868–1968*, by Ellen P. Conant, with Steven D. Owyoung and J. Thomas Rimer (exh. cat., Saint Louis: Saint Louis Art Museum; Tokyo: Japan Foundation, 1995), pp. 25–35.

42. Cohen, *East Asian Art and American Culture*, pp. 48, 212 n. 18.

43. Laurence Sickman and Jean-Pierre Dubosc, *Great Chinese Painters of the Ming and Ch'ing Dynasties, XV to XVIII Centuries* (exh. cat., New York: Wildenstein, 1949).

44. For a survey of post–World War II Chinese art scholarship, see Jerome Silbergeld, "Chinese Painting Studies in the West: A State-of-the-Field Article,"

Journal of Asian Studies 46 (November 1987), pp. 849–97.

45. Michael Sullivan, *Chinese Art in the Twentieth Century* (Berkeley and Los Angeles: University of California Press, 1959); Michael Sullivan, *The Meeting of Eastern and Western Art* (1973; 2d ed., Berkeley and Los Angeles: University of California Press, 1989).

46. Another important early study of modern Chinese painting is Chu-tsing Li, *Trends in Modern Chinese Painting: The C.A. Drenowatz Collection* (Ascona, Switzerland: Artibus Asiae, 1979).

47. Wan Qingli, *Huajia yu huashi* (Painters and Painting History) ([Hangzhou]: Zhongguo Meishu Xueyuan Chubanshe, 1997), pp. 6–13.

48. Paul Cohen, *Discovering History in China: American Historical Writing on the Recent Chinese Past* (New York: Columbia University Press, 1984).

49. Wan Qingli, *Huajia yu huashi*, pp. 6–13.

50. Wen C. Fong, "Modern Art Criticism and Chinese Painting History," in *Tradition and Creativity: Essays on East Asian Civilization: Proceedings of the Lecture Series on East Asian Civilization*, edited by Ching-I Tu (New Brunswick: Rutgers, State University of New Jersey, 1987), pp. 98–108.

51. Chen Hengke, *Zhongguo wenrenhua zhi yanjiu*, p. 7.

52. Clement Greenberg, "Modernist Painting," in *Modern Art and Modernism: A Critical Anthology*, edited by Francis Frascina and Charles Harrison (New York: Harper and Row, 1982), p. 6.

53. Craig Clunas, *Pictures and Visuality in Early Modern China* (Princeton: Princeton University Press, 1997), p. 10.

54. See Gombrich, *Art and Illusion*, p. 281.

Chapter One

Painters in Shanghai and Guangdong

Few moments in Chinese history can have been as tumultuous and complex as that between the late Qing and the early years of the Republic, a time during which China was continually threatened by foreign domination and internal rebellion and Chinese intellectuals, artists, and writers seemed to have lost their traditional moorings.

The Opium War of 1839–42 forced China to make humiliating concessions to foreign powers, including the ceding of Hong Kong to Great Britain and the opening of five treaty ports to Western trade and commerce. In 1851 the Taiping uprising broke out, and until the Taiping armies were defeated in 1864, much of China's heartland in central and southeast China was devastated and the end of the Celestial Empire was inevitable. It is estimated that 20 million Chinese died over the thirteen-year period. In the same years foreign intervention continued, with British and French forces attacking Beijing and burning the Summer Palaces in 1860, and the Japanese taking Taiwan in 1895. For one hundred days in 1898, the Guangxu emperor (r. 1875–1908), acting on the advice of the scholar-officials Kang Youwei (1858–1927) and Liang Qichao (1873–1929), made a futile attempt at reform, which resulted in the imprisonment of the emperor by the Empress Dowager Cixi (r. 1898–1908) and the execution of six reform leaders. Dowager Cixi's reactionary policies and the inciting of nationalistic sentiments culminated in the disastrous Boxer Uprising (1898–1901), which led to the occupation of Beijing by the joint expeditionary forces of eight foreign powers in 1900. With the revolutionary movement gaining force under the leadership of the Alliance Society, founded by Sun Yat-sen (1866–1925) in 1905, the discredited

Manchu rule collapsed in 1911. The new republic's first president, Yuan Shikai (1859–1916), however, tried but failed to restore the old regime and install himself as emperor, and China was torn apart by regional warlords. Concurrent with these events the Treaty of Versailles (1919), which brought World War I to an end, mandated the transfer of all former German territories in China to Japan. Students protesting the terms of the treaty rioted in Beijing, ushering in the May Fourth Movement, a period of political awakening and intellectual ferment. Meanwhile, inaugurated by the founding of the magazine *New Youth* (*Xin Qingnian*), in 1915, by the radical intellectual Chen Duxiu, the New Culture Movement marked the entry of Chinese culture into the modern world.[1]

In his study of late-Qing fiction from 1849 to 1911, David Wang writes:

The recognized truth about late Qing fiction is that it is both a relentless exploitation of oriental conventions and an unrestrained adaptation of Western impressions; it is both traditional and anti-traditional. In no way does it manifest a consistency between what it does and what it means to do, much less what it says it means to do. Its (limited) virtues notwithstanding, late Qing fiction contains too much "waste": excessive tears and laughter, hyperbole, high-strung propaganda, and the like.[2]

The same can be said of late-nineteenth- and early-twentieth-century Chinese painting, in that in modern Chinese visual expression there is a tendency for "waste," hyperbole, and propaganda; indeed, it intensified rather than subsided after the May Fourth Movement.

In analyzing late-Qing fiction, Wang also cites mimicry (or theatrics) "as a major trope that marks both the historical condition of the late-Qing period and the formal pattern with which late Qing writers described that condition."[3] Wang attributes the cause of this popular use of mimicry in late-Qing fiction to the loss of "a grip on the realistic devices of traditional narrative, as manifested by such classics as *The Water Margin*, *Golden Lotus*, and *The Story of the Stone*." According to Wang,

The breakdown of the traditional representational system — thanks to the decline of imperial power, the invasion of foreign cultures, the collapse of the law of verisimilitude, and the like — actually provided writers an unusual pretext for recasting their visions of the real. Even without such a pretext, ambitious writers may have been ready to reinterpret narrative reality.[4]

All that was to change, writes Wang, "[when] the May Fourth writers developed their discourse of the real into an 'order of mimesis' — a moral and formal imperative to regulate or even 'police' the way one sees and writes the real in the name of objective representation."[5] Wang observes, "The canons of Western modernism never won the mainstream position in the discourse of modern Chinese literature; what writers and readers thought was modern often turned out to be outdated in the European context. The Chinese literary 'modern' can be discussed only with the sense of belatedness."[6]

As the writings of Omura Seigai and Chen Hengke had shown earlier (see pages 14–15, 17), the debate about mimetic realism versus inner reality was also the central issue in the discourse on representational painting between East and West in the early twentieth century. Typical of this debate was its adoption of late-nineteenth-century Western "scientific" (mimetic) realism as a revolutionary imperative to "reform" modern Chinese painting. The first exhibition of modern Chinese painting was held at The Metropolitan Museum of Art in 1943. Hu Shi, an early New Culture leader and later Nationalist China's ambassador to the United States, in his introduction to the exhibition catalogue, expressed his view that "neither slavish glorifying of the past nor unintelligent conservatism will lead [modern Chinese painting] anywhere.... [Instead, an] art renaissance in China can come only through a mastery of the fundamental technique common to the graphic and plastic arts of all civilizations," by which he meant Western realism based on mimesis. Hu disparaged "artists who copy the old masters," and he concluded that "the only way to paint real pictures [was for the artist] to go out every day to the mountains and the rivers to get material for their painting."[7]

In focusing on mimetic realism, however, Hu, as a New Culture critic, chose to ignore Su Shi's admonition that "anyone who judges painting by form-likeness shows merely the insight of a child."[8] Ever since the late Northern Song period, the discourse on classical Chinese painting had revolved around the issue of form-likeness (*xingsi*), or realism, versus non-representation (*busi*), or what the scholar painters called *xieyi*, the "writing of ideas and feelings." While Song academic painting, as a public art that served the state and its official beliefs, advocated realism, the scholar aesthetic sought to express the artist's inner reality and beliefs. Nevertheless, academic painting and scholar painting shared one important

FIGURE 14

Yang Qitang, *Portrait of Zhao Zhiqian* (1829–1884), dated 1870. Ink rubbing on paper.

characteristic: both were based on an art-historical tradition that derived its authority not only from historiography but also from an assumption of the viewer's familiarity and identification with it.[9]

But what is a modern scholar-painter? As holders of official degrees and governmental positions, Song scholar-officials were part of the ruling elite. Ming and Qing scholar painters, on the other hand, were often commoners without official degrees. Earning their living by the brush, they were professional artists frustrated by their loss of social status. In late-nineteenth- and early-twentieth-century Chinese painting, both erudite scholars-turned-professionals and populist professionals sought new ways to recast their personal visions of the real.

THE EPIGRAPHIC SCHOOL OF PAINTING

The pursuit of individualism during the late-Ming and early-Qing period, in the seventeenth and early eighteenth century, stimulated experimentation in the arts and a fascination for the strange and the eccentric. In this pursuit, painters such as Fu Shan (1607–1684/85) and Bada Shanren (1626–1705) delved into the antiquarian study of seal and clerical scripts found on ancient bronze and stone monuments and learned to use obscure forms of characters that they discovered in early etymological and archaeological dictionaries.[10]

Under the draconian rule of the Manchu Qing government, when scholarship and literature were placed under surveillance for suspected seditious activity, etymology and the study of ancient ritual bronzes and stone monuments were

among the few politically safe subjects for scholars to explore. Known as metal-and-stone scholarship (*jinshi xue*), this passionately pursued new field of learning went hand in hand with evidential scholarship (*kaozheng xue*), whose practitioners attempted to recover uncorrupted early texts of the ancient classics.[11] The new critical standard applied to authenticating classical texts also led scholars to question the traditional attributions of many famous works, which were reproduced in rubbings that appeared in popular anthologies. The scholar Wang Shu (1668–1743), for example, argued that the *Memorial for Recommending Jizhi*, a composition widely accepted since its circulation in 1185 as the work of the early-third-century calligraphic master Zhong You (151–230), was in fact a forgery by the eleventh-century painter Li Gonglin (ca. 1041–1106).[12]

The metal-and-stone scholars argued that the model-book letter-writing (*tie*) style, which had originated in southern China during the Eastern Jin period (317–420) with the calligrapher Wang Xizhi (ca. 303–ca. 361) and was later preserved in rubbings, had become devitalized through the centuries by repeated copying and recutting of the stone. In contrast, the writing style of the monumental stone engravings (*bei*) of the Northern Wei (386–534), which were found on Buddhist and mortuary steles in northern China, were original works and thus embodied forms of nature that had inspired the early calligraphers. In the late-Qing period, the study of stone engravings dominated the practice of calligraphy. Two important scholarly essays, "Theory on the Southern and Northern Traditions of Calligraphy" (ca. 1819), by Ruan Yuan (1764–1849), and "Two Oars of the Ship of Art" (1848), by Bao Shichen

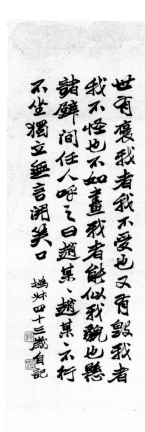

世有褒我者我不受也又有毀我者
我不怪也不如盡我者能似我貌也懸
諸壁間任人呼之曰趙某、趙某、不行
不坐獨立無言閉其口
趙叔四十三歲自記

同治辛未秋八月山陰王緁寫

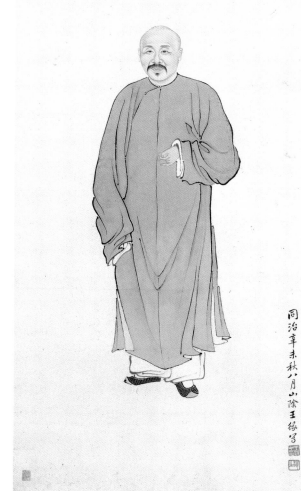

PLATE 1

Wang Yuan (active ca. 1862–1908),
Portrait of Zhao Zhiqian, dated
1871. Hanging scroll, ink and
color on paper, 41¾ x 13¼ in.
(106 × 33.7 cm). Gift of Robert
Hatfield Ellsworth, in memory of
La Ferne Hatfield Ellsworth, 1986
(1986.267.30)

(1775–1855),[13] provided a theoretical basis for the epigraphic school. Ruan Yuan argued that the monumental style of the Northern Wei was superior to that of the effete Eastern Jin in the south, the latter followed by the official calligraphers at the conservative Qing court. Similarly, Bao Shichen, a pupil of the seal carver and calligrapher Deng Shiru (1743–1805),[14] who specialized in the Han-dynasty monumental stele style, also advocated the adoption of engraved stele inscriptions as models for aspiring young calligraphers. By insisting on empirical research and rigorous analysis of bronze and stone archaeological monuments, the metal-and-stone scholars spearheaded a modern renaissance in the study and practice of calligraphy.

The seemingly arcane labors of the bibliophiles and antiquarians toward the end of the Qing dynasty also had political ramifications in the context of institutional reform. Eighteenth-century Chinese evidential scholarship, with its skeptical approach to authentication and its use of an inductive approach based on a broad range of sources, was cited by New Culture leaders such as Hu Shi as the basis of a "scientific method" in Qing intellectual life. By the end of the nineteenth century, the New Text school of literary criticism, which attempted to uncover forgeries of and editorial tampering with the ancient classics, had led the Confucian reformer Kang Youwei to proclaim in 1898 that Confucius himself was a great reformer. Indeed, he had created the classics as a means of invoking the authority of the ancients in order to implement institutional change.[15] Similarly, metal-and-stone scholarship, which was practiced by high government officials as well as by commoner artists and scholars, had a strongly revisionist—if not revolutionary—political

FIGURE 15

Zhao Zhiqian (1829–1884),
*Couplet with Verses by Wang
Mian*, ca. 1870. Paired hanging
scrolls, ink on paper.

impact. Ruan Yuan who at age twenty-seven, in 1791, had served as an editor of the Qianlong catalogue of the imperial collection, was governor-general at Canton (Guangdong) in the crucial decade from 1817 to 1826, when the disastrous conflict with the British was taking shape just before the Opium War. And Kang Youwei, the future reform adviser to the Guangxu emperor, wrote a collection of essays in 1889 entitled "Expanding on [Bao Shichen's] Two Oars of the Ship of Art." The collection extolled the virtues of studying monumental stone inscriptions as a way of perfecting the art of calligraphy, of which Kang was a well-known practitioner.[16] Turning to history to guide his efforts to reform China and Chinese culture, Kang noted, in particular, the art-historical importance of the Northern Wei inscriptions in the development from clerical to standard script, their influence on Tang and Song calligraphy, and how they exemplify both the Tang emphasis on structure and the Song excellence in expressiveness.[17] For Kang, who saw China's malaise as a spiritual and cultural as well as a political crisis, the reform of calligraphy constituted as crucial a need as the drastic social and institutional reforms.

There was a geographical factor as well in the development of the metal-and-stone school of calligraphy, which was pursued and led mostly by southern Chinese scholars. The "south" referred to all of China south of the Yangzi River, especially historic Jiangnan, the rich lower Yangzi delta covering southern Jiangsu, northern Anhui, and northern Zhejiang. Ruan Yuan was from Jiangsu, Bao Shichen from Anhui, and Kang Youwei from the southernmost province of Guangdong. Both the Kangxi and the Qianlong emperors were

FIGURE 16
Record of a Statue Donated by Shi Pinggong, dated 498, detail. Engraved inscription, ink rubbing from Guyang Cave, Longmen, Henan Province

impressed by the cultural life in the south, and they encouraged southern scholars to join the government officialdom. While southerners often considered themselves intellectually more sophisticated than northerners, arriving at the capital in the north to take the civil service examination and embarking on a career at court were like arriving in a foreign country. The whole culture was new—the climate, the spoken dialect, even the food. The sight of the thousands of monumental stone carvings in the Buddhist cave temples at Longmen (Loyang, Henan) in the north was an exhilarating experience. A century later, they would also have a profound effect on the American collector Charles Lang Freer, who in 1910 wrote, "In color, line composition and unfettered imagination handled simply and sympathetically they seem to me to surpass anything I have heretofore seen."[18]

For the southern Chinese, especially those whose mental horizons had been broadened by their introduction to Western learning in the southern seaports, the encounter with the monumental inscriptions engraved on stones in the Yellow River basin areas meant a journeying back to the civilization of ancient China. Kang Youwei, who noted that European languages are written with symbols of sound whereas Chinese written characters are symbols of meaning, concluded that the consolidation of ancient Chinese scripts was central to the creation of a cultural identity and the stabilizing of political institutions.[19] By the turn of the twentieth century, the research of the metal-and-stone scholars was expanded by studies of oracle script through the discovery of Shang oracle bones in Anyang (Henan) and by original examples of clerical and cursive-clerical scripts found in seal clays and

bamboo slips from northwest China.[20] An entire generation of antiquarian scholars—including Liu E (1850–ca. 1910), Luo Zhenyu (1866–1940), Wu Dacheng (1835–1902), and Wang Guowei (1877–1927)—all southerners from Jiangsu and Zhejiang, devoted themselves to collecting objects, making rubbings, and publishing scholarly catalogues. Basing their work on archaeologically discovered objects and documentary evidence, they studied the history of Chinese script from oracle, seal, clerical, cursive-clerical to regular, which, in turn, stimulated a parallel study of the history of Chinese painting, with an emphasis on connoisseurship. This tradition was later exemplified by Wu Hufan (1894–1968), a grandson of Wu Dacheng and a well-known painter, connoisseur, and collector in Shanghai, who was the teacher of the contemporary painter-connoisseurs Wang Jiqian (C.C. Wang; b. 1907) and Xu Bangda (b. 1911).

The first master of the epigraphic school to apply the new aesthetic to painting was Zhao Zhiqian (known also by his sobriquet, Huishu; 1829–1884).[21] A native of Guiji (Zhejiang) and born into a merchant family that had suffered financial reverses, Zhao was fascinated by seal carving and calligraphy at an early age.[22] Studying to become a scholar-official, he served as a secretary to the prefect of Hangzhou and earned his provincial *juren* (selected scholar) degree in 1859. During the Taiping uprising (1851–64), after the sack of Hangzhou, Zhao lost his wife and daughter and six other members of his family, as well as his ancestral home in Guiji. In late 1862 he went north to Beijing, where he remained for nearly ten years, supporting himself by selling his work. Three times he tried to pass the capital examination for the *jinshi* (presented

FIGURE 17
Seals of Zhao Zhiqian (1829–1884).

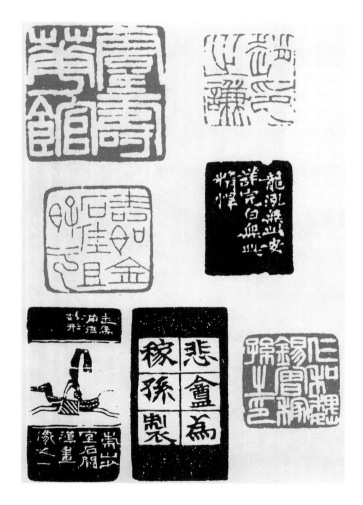

scholar) degree. Then in 1872, through the help of influential friends, he was posted to Jiangxi Province as district magistrate. He died there in 1884.

An individualist, Zhao wrote the following inscription on a portrait of him, dated 1870, by Yang Qitang (fig. 14):

If people trash my work, they cannot trash me.
I shall not seek revenge.
They may praise my work, but that is not praise for me.
I take no pleasure in their praise.
Only a painter can capture my likeness
So that those who do not know me may see me.
I cock my head to listen,
With half-open mouth I smile.[23]

Another version of the portrait (pl. 1), signed by Wang Yuan (active ca. 1862–1908) and dated one year later, in 1871, bears a modified inscription signed by Zhao:

If the world praises me, I shall not accept its praise.
Of those who try to destroy me, I shall not complain.
Only the painter can capture my likeness.
Hanging on the wall it will inspire people to call out,
 "It is Zhao! It is Zhao!"
I neither walk nor sit but stand alone, and with a smile
 say nothing.[24]

Zhao's independent spirit is reflected in his calligraphy (fig. 15) which, in contrast to the neat and elegant chancellery style (*guange ti*) favored by the Qing court, shows the broad

PLATE 2

Zhao Zhiqian (1829–1884), *Peony*, dated 1862. Folding fan mounted as an album leaf, ink and color on gold-flecked paper, 7 × 20¾ in. (17.8 × 52.7 cm). Gift of Robert Hatfield Ellsworth, in memory of La Ferne Hatfield Ellsworth, 1986 (1986.267.27)

PLATE 3

Zhao Zhiqian (1829–1884), *Peony and Peach Blossoms*, ca. 1862. Folding fan mounted as an album leaf, ink and color on gold-flecked paper, 7½ × 21½ in. (19.1 × 54.6 cm). Gift of Robert Hatfield Ellsworth, in memory of La Ferne Hatfield Ellsworth, 1986 (1986.267.28)

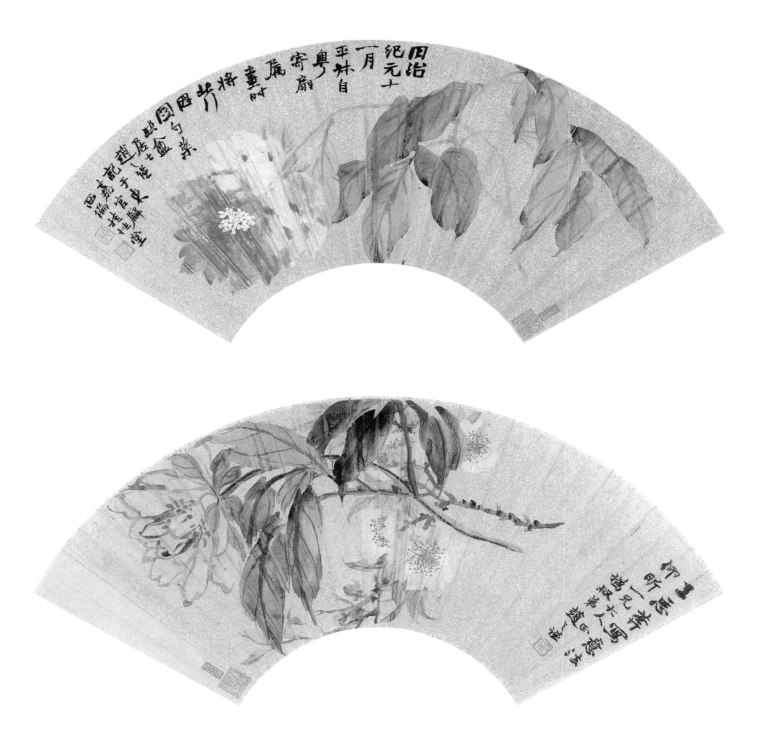

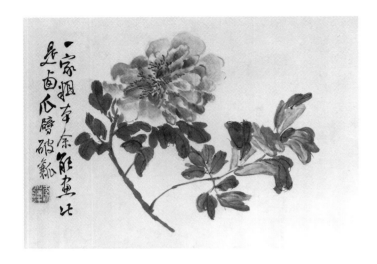

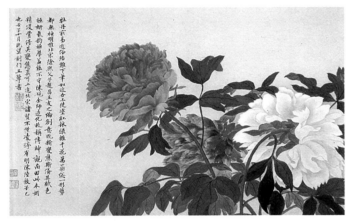

FIGURE 18

Li Shan (active ca. 1711–62), "Peony," from the album *Flowers and Birds*, dated 1731. Album leaf, ink and pale colors on paper, approx. 11¼ × 15¼ in. (28.7 × 38.7 cm). The Art Museum, Princeton University, Gift of John B. Elliott, Class of 1951 (y1976–42 f)

FIGURE 19

Yun Shouping (1633–1690), "Peonies," from the album *Landscapes and Flowers*, dated 1762. Album leaf, ink and color on paper, each leaf 11¼ × 17 in. (28.5 × 43 cm). National Palace Museum, Taipei

32

forms rendered in strong wedge-shaped strokes that were inspired by the engraved inscriptions of the Northern Wei (fig. 16). When Zhao was seventeen he read a treatise on ancient stone steles in northern China and became engrossed in the study of the ink rubbings of stone inscriptions, in particular those of the fifth- and sixth-century cave temples in Longmen. After his move to Beijing in 1862, he visited the caves and collected rubbings, publishing a list of them in 1864.[25] Zhao first studied seal carving in his native Zhejiang Province, with carvers who had received their inspiration from seal inscriptions of the Qin and early Han periods, in which the characters are rectangular, evenly spaced designs done with a stylus.[26] In his own seals designs (fig. 17), Zhao incorporated the clerical script of the later Han, which was written with a brush, and added engraved colophons with writings in the style of the Northern Wei. Because Zhao's seals derive from writings done with a brush, they present a new style of carving that is "beyond seal carving."[27] While the calligraphy of earlier seal carvers was two-dimensional,

with even spacing and a static balance between horizontal and vertical strokes, Zhao's is a dynamic interaction between the individual brushstrokes within a character, which increases with the internal movement of the brushwork the tension within each stroke. In this way, he creates characters that appear three-dimensional, and which are animated by the incorporation of the spaces in and around the figural design.

Like many Qing calligraphers, Zhao had started his career by following the Tang-dynasty model in standard script by Yan Zhenqing (fig. 10), whose round, centered brush technique keeps the point of the brush contained within each stroke. In about 1860, he began to emulate the work of an earlier seal carver and metal-and-stone calligrapher, Deng Shiru (1743–1805),[28] developing a brush technique with wedge-shaped strokes, the hard-edged black forms of which are enlivened by intricately balanced white spaces around and between them. For the first time since the eighth century, large standard-script calligraphy had regained its primordial liveliness.[29] In turning to the wedge-shaped—square or oblique—brush method of the monumental Northern Wei model (fig. 16), Zhao used the angular momentum of his brushwork to drive each stroke and to form the characters. This oblique, angular brush force gives a brash and imperious quality both to Zhao's calligraphy and to his painting. The calligraphy, in particular, seems strikingly modern as attention-grabbing gestural art (fig. 15).

As a painter, Zhao Zhiqian followed in the scholar (*wenren*) tradition of including in one work the "three excellences" of poetry, calligraphy, and painting. His specialty was flower painting, and he developed a style with strong colors and the

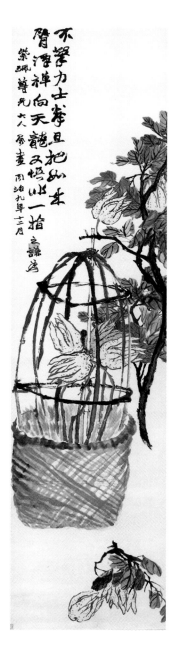
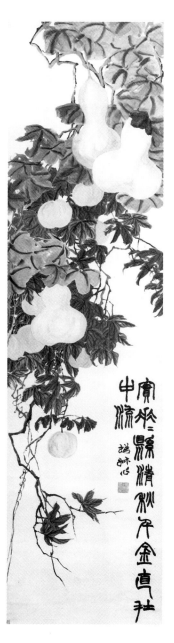
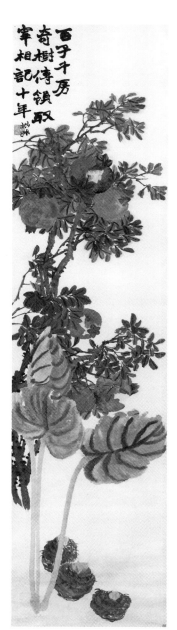
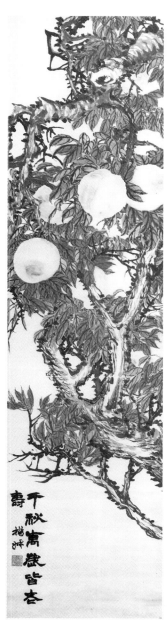

FIGURE 20
Zhao Zhiqian (1829–1884), *Four Auspicious Fruits*, dated 1870. Set of four hanging scrolls, ink and color on paper, each scroll 94½ × 23⅝ in. (240 × 60 cm). Tokyo National Museum, Gift of Mr. Takashima Kikujirō

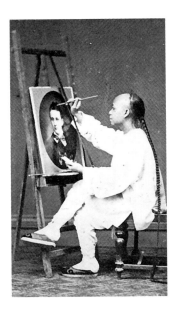
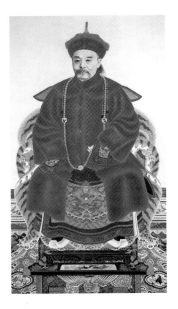

FIGURE 21
Photograph of a Chinese artist
copying a photograph for the
export trade. Hong Kong, 1860s

FIGURE 22
Tang family ancestral portrait,
ca. 1930. Hanging scroll, ink and
color on paper. Private collection

34

forceful brushwork favored by the urban consumer public. One of Zhao's favorite formats was the folding fan. Imported from Japan,[30] the fan became a fashionable personal ornament for men after the late-Ming period and a popular format for painting and calligraphy during the Qing. In *Peony* (pl. 2 and page 23), dated 1862, which represents an image that denotes material prosperity and good fortune, and *Peony and Peach Blossoms* (pl. 3), dating to about the same time, Zhao introduces to flower painting of the folding fan format the aesthetics of seal carving and metal-and-stone calligraphy. The blooming red peony, with its fully open petals, rich pollen-bearing stamens, and gracefully twisting leaves connected by a tracery of yellow stalks, is beautifully arranged against the circular form. It shows a very different sensibility from the same subject (fig. 18) by Li Shan (active ca. 1711–62), one of the Yangzhou Eccentrics, who writes on his painting:

I am accomplished at this coarse style.
[My flower] looks like a cracked watermelon.

While Li Shan employed a rough (*cu*) style, using coarse brushwork and a studied carelessness to show his disdain for the fine (*xi* or *kong*) style of painters who excelled in realistic representation, Zhao's chiseled brushwork lends to his work a new kinesthetic quality. With precisely placed brushstrokes, Zhao renders flower petals and leaves in sharply etched silhouettes and bold patterns of bright color washes that echo and contrast with the sprightly dots of the inscription. And in his interlacing flower stalks and leaves he creates lively, interacting negative and positive spaces in the surface design.

Zhao's *Peony* differs also from the flower paintings of the seventeenth-century orthodox painter Yun Shouping (1633–1690). The comments of Yun's friend and fellow orthodox master Wang Hui (1632–1717) on Yun's "Peonies" (fig. 19) are relevant in connection with the success Zhao enjoyed a century later:

Peonies are difficult to paint because they can easily become common and vulgar. In the hands of a professional artisan painter, who knows only how to smear red and green colors, the thousand flowers and stamens can look the same. . . . Shouping, however, in mastering the boneless method, has captured the infinitely varying forms of the flower, producing a work comparable to that of a Northern Song master.[31]

This statement harks back to the scholar-painting aesthetic of the late Northern Song period in the eleventh century,[32] which held the work of the professional artisan in contempt. It also reflects both the aesthetic concerns and social anxieties of painters of the Ming and Qing periods, who prided themselves on drawing on antique sources and purging their work of the superficial realism and ornate decoration of the vulgar (*su*) artisan painter. In describing Yun's colorful painting as elegant (*ya*) rather than vulgar, Wang Hui was alluding to aesthetic cultivation as a social phenomenon of the early-Qing period. At a time when a consumer economy was beginning to dominate late-imperial Chinese society, good taste became an important social distinction between the cultivated elite and those who were merely rich.[33]

By the late nineteenth century, Shanghai was the center of

FIGURE 23

Xugu (1823–1896), *The Priest Hengfeng*, ca. 1867. Hanging scroll, ink and color on paper. Suzhou Museum

a thriving export trade in hand-painted wallpapers bound for European and American markets.[34] To the sophisticated Chinese consumer public, however, it was Zhao Zhiqian's erudite learning in epigraphy, seal carving, and metal-and-stone-style calligraphy that made his art interesting and marketable. People flocked to buy Zhao's fan paintings as well as his large-scale decorative hangings, such as *Four Auspicious Fruits* (fig. 20), dated 1870, in which he created tapestry-like designs of brilliantly colored patterns and exhilarating calligraphic brushwork.[35] Balanced between brash realism and erudite cultivation, Zhao's work captivated Shanghai collectors and inaugurated a new, modern age in Chinese painting.[36]

REALISM AND ABSTRACTION

Unlike professional scholar-painters, such as Zhao Zhiqian, professional craftsman-painters plied their trade without the benefit of a formal education. A common training ground for many late-nineteenth- and early-twentieth-century craftsman-painters was the portrait studio, where ancestor portraits for funerary and memorial services were churned out and apprentice painters honed their skills by copying from photographs, a new, mechanically produced import from the West.

Photography was introduced to China soon after the opening of treaty ports in the 1840s following the first Opium War.[37] By the 1860s, it was widely used by Chinese portrait painters (fig. 21), who, by laying a grid over the photograph, traced and copied the image, usually only the face, before adding an appropriate costume or robe for a formal portrait (fig. 22). In copying the photographic image,

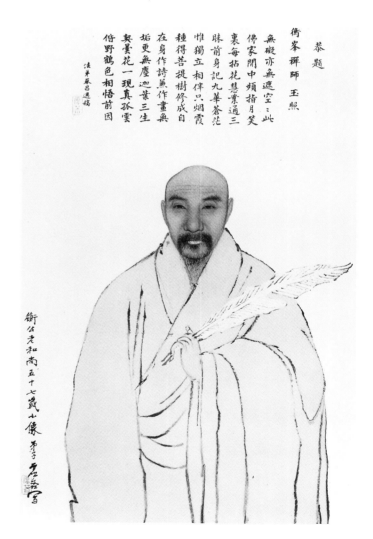

35

the painter used charcoal powder and ink wash for chiaroscuro shading, a method that is the opposite of traditional Chinese figure painting, in which definition is provided by linear brushwork.[38]

36

One of the most inventive professional painters of the period was Xugu (1823–1896), a native of Shexian (Anhui). Xugu grew up as Zhu Huairen in Yangzhou (Jiangsu), where he was trained as a portrait artist. About 1852, during the Taiping uprising, Zhu joined the imperial army. Not long after, he left government service and went to Suzhou (Jiangsu) to become a Buddhist monk. It was during this time that he took the Buddhist name Xugu (Valley of Emptiness) and began to paint.[39] In 1868, he settled in Shanghai and supported himself as a professional painter. He died there in 1896.

In *The Priest Hengfeng* (fig. 23), dating from about 1867, in which the face of the sitter is based on a photograph, Xugu, instead of using the stylized drapery pattern seen in traditional Chinese figure painting, draws the drapery from life. The halting, seemingly unsophisticated dry brushline is an apt expression of the simple, sturdy character of the sitter.

By the second half of the nineteenth century, such Western art forms as prints, watercolors, drawings, and commercial publications became widespread in larger Chinese cities. Western-style lithographs, made by a Suzhou artist Wu Jiayou (also known as Wu Youru), were reproduced in the *Dianshizhai Pictorial*, a magazine published by an Englishman, Frederick Major, in 1884.[40] While it is impossible to determine the extent of Xugu's knowledge of Western art, there is little doubt that by the late nineteenth century, with the dissemination of Western art and its absorption into

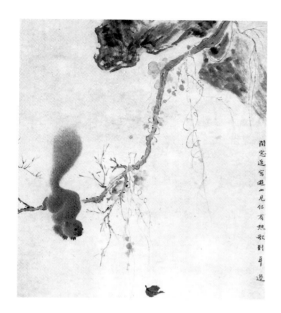

FIGURE 24

Hua Yan (1682–ca. 1765), *Birds and Squirrel on Tree Branches*, detail. Hanging scroll, ink and color on paper, 108¾ × 31½ in. (276 × 79.9 cm). Freer Gallery of Art, Smithsonian Institution, Washington, D.C. (f1958.8)

FIGURE 25

Xugu (1823–1896), *Flowers and Fruits*, ca. 1880. Four-fold screen, ink and color on paper, 35½ × 62½ in. (90 × 158.8 cm). Tokyo National Museum, Gift of Mr. Takashima Kikujirō

FIGURE 26

Chen Hongshou (1598–1652), *Vase of Flowers*. Hanging scroll, ink and color on silk, 63 × 23½ in. (160 × 59.7 cm). The Metropolitan Museum of Art, Gift of Mr. and Mrs. Earl Morse, 1972 (1972.278.2)

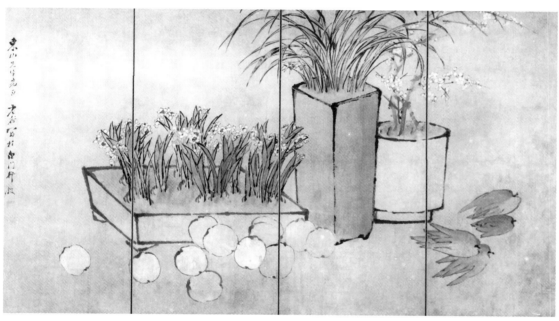
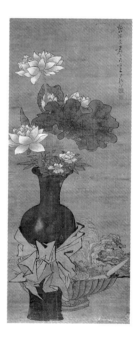

Chinese culture, the visual practice of the Chinese underwent a fundamental change.

In *Squirrel on an Autumn Branch* (pl. 4), a fan painting dating from the 1880s, Xugu displays his technical versatility first in his precise rendering of the furry body and then switching to a broad, abstract brushwork to represent tree branches and leaves. Turning away from form-likeness, he also explores non-likeness by adding two owl-like eyes to make the image both humorous and enigmatic. Xugu was inspired by the realistic bird-and-animal paintings of the eighteenth-century Yangzhou Eccentric Hua Yan (1682–ca. 1765; fig. 24), but he was also drawing from life. Living in the crowded old quarter of a rapidly developing Shanghai, Xugu

depicted subjects that were increasingly scarce in an urban environment.

In *Flowers and Fruits* (fig. 25), dating from about 1880, Xugu presents a group of potted plants with fruits scattered in the foreground, much as in a Western still life. Applying the principle of linear perspective, he uses three variously shaped vases to define a three-dimensional space. In traditional Chinese *xiesheng*, or painting from life, such as Chen Hongshou's *Vase of Flowers* (fig. 26), the artist delineates the flowers in detail and, through calligraphic brushwork, evokes life and vitality. By contrast, Xugu's flowers and fruits, in a defined space, are a stylized linear interpretation of a Western-style still life, with the lines and the shapes of the vases

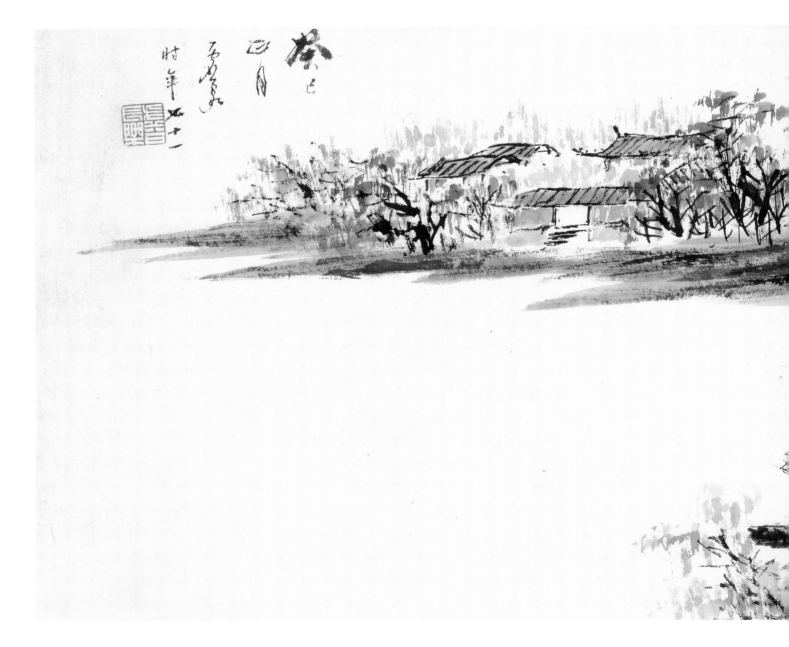

38

PLATE 5
Xugu (1823–1896), *Sailing in Autumn*, dated 1893. Album leaf, ink and color on paper, 14⅛ × 35⅞ in. (35.9 × 91.1 cm). Gift of Robert Hatfield Ellsworth, in memory of La Ferne Hatfield Ellsworth, 1986 (1986.267.53)

40

geometrically balanced within the four borders of the picture frame.

This new approach to painting is also seen in Xugu's landscape *Sailing in Autumn* (pl. 5), dated 1893. Here the artist forgoes the traditional Chinese conventions of formulaic texture methods (*cunfa*) and form types, employing instead a free brushwork and bright colors to record a direct impression of nature. The riverscape, seen from a relatively low vantage point, is framed like an image captured through a camera's viewfinder. Unlike classical Chinese landscape, which is known as "painting of the mountains and waters" (*shanshui hua*) and is inspired by cosmic principles in nature, Xugu's autumnal scene is appropriately called a "scenic painting" (*fengjing hua*, after the Japanese term, *fūkeiga*). Chinese painters of the late nineteenth century equated form-likeness with Western realism and contrasted it to calligraphic non-likeness, which they associated with the scholar painter's concept of *xieyi*, or the "writing of ideas." In the case of Xugu, who began painting in the idiom of photographic realism, the use of a spare, dry brushwork meant a reassertion of scholarly values. To the Chinese, Xugu's dry brushwork not only expressed the quiet, austere nature of the artist himself but also recalled the styles of two seventeenth-century Anhui masters, Hongren (active 1610–64) and Cheng Sui (active ca. 1650–80).[41]

Even more successful than Xugu in the Shanghai art market were the Ren family of painters: Ren Xiong, Ren Xun, and Ren Yu, all of whom worked in a wide range of "fine" and "rough" flower-and-bird and figure painting. Born to a

FIGURE 29
Chen Hongshou (1598–1652),
Bird on a Flowering Branch.
Album leaf, ink and color on silk,
8¾ × 8⅝ in. (22.2 × 21.7 cm).
The Metropolitan Museum of
Art, Gift of Mr. and Mrs. Wan-go
H.C. Weng, 1999 (1999.521c)

PLATE 7
Ren Xun (1835–1893), *Scholar in
the Wind*, ca. 1880. Folding fan
mounted as an album leaf, ink
and color on alum paper, 6½ ×
9⅜ in. (16.7 × 23.8 cm). Gift
of Robert Hatfield Ellsworth,
in memory of La Ferne Hatfield
Ellsworth, 1986 (1986.267.45)

PLATE 8
Ren Bonian (1840–1896), *Scholar
on a Rock*, ca. 1880. Folding fan
mounted as an album leaf, ink
and color on alum paper, 7½ ×
21¼ in. (19.1 × 53.8 cm). Gift
of Robert Hatfield Ellsworth,
in memory of La Ferne Hatfield
Ellsworth, 1986 (1986.267.49)

42

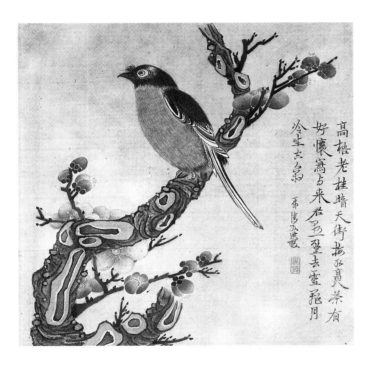

draped over his bare, brawny shoulders. In the inscription
he writes:

Great is the universe, but what do we see?
Let me laugh at my endless burdens,
Why do they cling to me? . . .
Let us continue to sing and dance,
Never giving way to despair.
In my youth despair was unknown.
I merely depicted what happened, from
 ancient times to the present.
Who was foolish or ignorant,
Wise or sagacious?
I have not the slightest idea.
But time has vanished.
Like a vast ocean, there is no shore in sight.[44]

family of modest means in Xiaoshan (Zhejiang), Ren Xiong
(1823–1857), who received his early training as a portrait
artist, was a woodblock printer and figure painter. His most
frequent subjects were drawn from mythology and history.[42]
He gained renown in the 1840s and 1850s, specializing in
figure and flower-and-bird painting in the stylized, deco-
rative manner of Chen Hongshou (fig. 8).[43] Ren died of tuber-
culosis at the age of thirty-four in 1857, in the midst of the
Taiping uprising.

In his most memorable image, a self-portrait (fig. 27)
dating from about 1856, Ren Xiong, who was rather short
and unprepossessing in appearance, portrays himself as a
heroic boxerlike figure standing with a voluminous robe

Ren Xiong's younger brother Ren Xun (1835–1893) stud-
ied painting with Xiong and also specialized in figure and
flower-and-bird painting in the mode of Chen Hongshou.
Bird on a Rock by a Flowering Branch (pl. 6), dated 1879, ren-
dered in a detailed and delicate brushwork, updates the bird-
and-flower genre in the fine-style tradition. The painting may
be compared with *Finches and Bamboo* (fig. 28), a painting
by the early-twelfth-century emperor Huizong (r. 1100–25)
that exemplifies the heightened realism of the academic
painters of the Song dynasty. Huizong's flawlessly executed
representation, described as "magic realism," is regarded as
functionally "real."[45] In Chen Hongshou's *Bird on a Flower-
ing Branch* (fig. 29), fine-style drawing has lost its magical

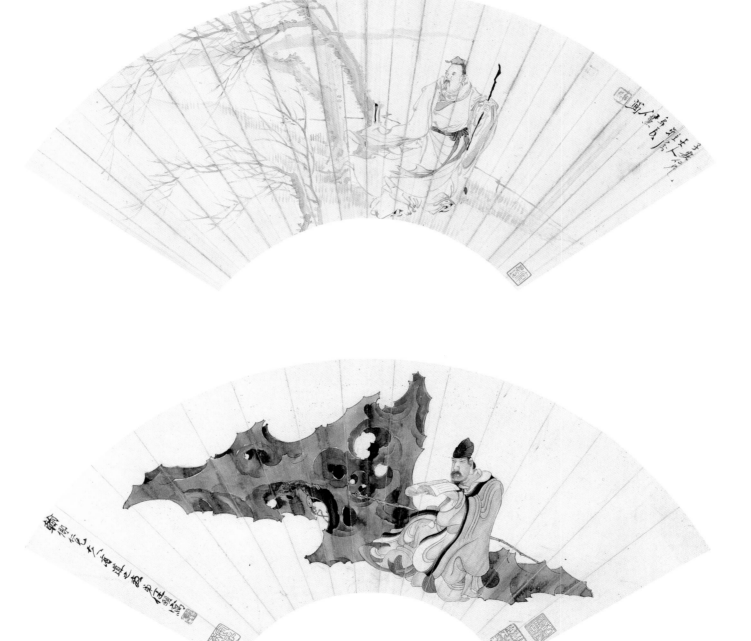

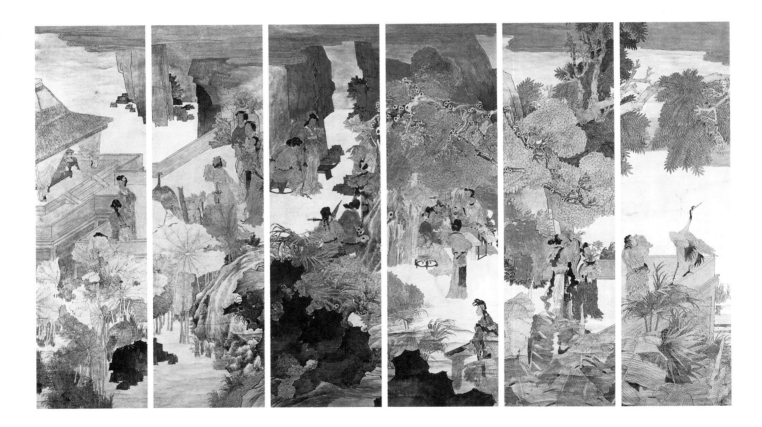

quality. Unlike the realism of the twelfth century, which was believed to possess magical properties that reflect the workings of the cosmos, it is the incisive, archaizing iron-wire brushlines that animate the picture surface and define the mood of the painting. Ren Xun's work takes this development a step further. Rather than employing an archaizing linear style, Ren appeals to a more popular taste. With the plumage of the bird and the details of the flowers meticulously rendered with light and dark shading, the depiction

displays the scientific exactitude of an Audubon print.

Ren Xun's *Scholar in the Wind* (pl. 7), dating from about 1880, portrays an ancient scholar in a capacious robe, the sleeves and hemlines of which are blown about dramatically by the wind. Although the figure suggests a character in a popular historical novel, it appears to be a self-portrait that depicts the artist's journey through a tumultuous life. Drawn with verve and energy, Ren Xun's figure paintings, with posed and dramatically gesticulating protagonists, gained enormous

FIGURE 30

Ren Bonian (1840–1895), *Gods
and Fairies Celebrating the
Birthday of the Queen Mother
of the West*, dated 1878. Screen
of twelve panels, each panel
81⅜ × 23⅜ in. (206.7 × 59.5 cm).
Shanghai Chinese Artists'
Association

45

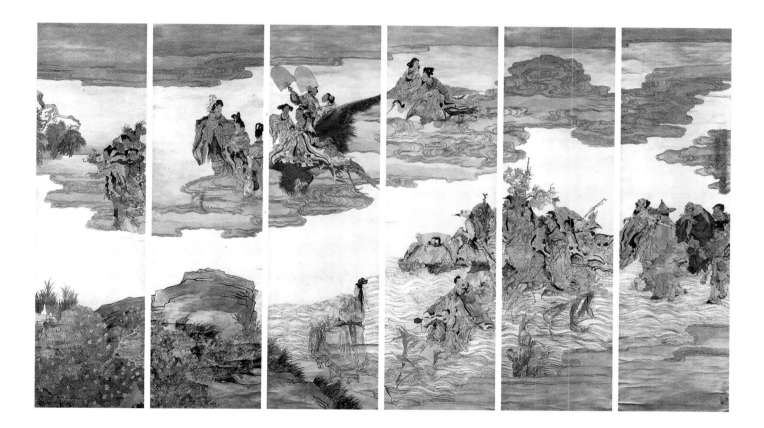

popularity among the Shanghai collectors.[46]

The most famous follower of Ren Xun was Ren Yi, bet-
ter known as Ren Bonian (1840–1895), who was no direct
relation of the older Rens. Brought up by his father as a
portraitist in his native Xiaoshan (Zhejiang), Ren Yi went to
Suzhou in about 1864 and was a pupil of Ren Xun's. Arriv-
ing in Shanghai in late 1868, he became the city's leading
painter.[47] In *Scholar on a Rock* (pl. 8), dating from about 1880,
Ren Bonian draws on Chen Hongshou's archaizing linear

idiom with fine brushlines articulating the features of the
scholar's face, swirling patterns of the drapery, and the out-
lines of the sculptural rocks.

A spectacular set of twelve large hanging scrolls, *Gods
and Fairies Celebrating the Birthday of the Queen Mother of
the West* (fig. 30), dated 1878, is dazzling in its theatricality.[48]
Painted in brilliant mineral colors on gold-colored paper, the
multipaneled work was presented to celebrate the birthday
of a wealthy patron's mother or grandmother. Ren depicts a

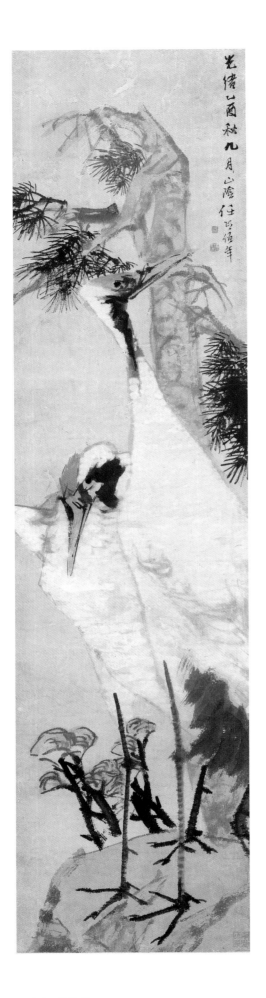

PLATE 9

Ren Bonian (1840–1896), *Cranes, Pine Tree, and Lichen*, dated 1885. Hanging scroll, ink and color on paper, 56½ × 14¾ in. (143.5 × 37.5 cm). Gift of Robert Hatfield Ellsworth, in memory of La Ferne Hatfield Ellsworth, 1988 (1988.324.1)

PLATE 10

Ren Bonian (1840–1896), *Man on a Bridge*, dated 1889. Hanging scroll, ink on bark paper, 36⅞ × 24¼ in. (93.7 × 61.6 cm). Gift of Robert Hatfield Ellsworth, in memory of La Ferne Hatfield Ellsworth, 1986 (1986.267.50)

fabulous array of gods and deities and other participants in the festivities. Arriving by sea from the East (at right), the celebrants are led by the bullet-headed God of Longevity, who is followed by an assortment of Daoist deities gathered around a regal female deity draped in a leaf-woven gown. Holding a staff dangling with flowers and standing on a giant shrimp, this must be the bodhisattva Avalokitesvara. In the rear, riding on a buffalo, is Laozi, founder of Daoism. Overhead on cloud scrolls is a goddess on the back of a magnificent mineral-green phoenix, followed by two more female deities, one riding a crane (symbol of longevity) and the other a giant red bat (symbol of good fortune); the goddess is surrounded by heavenly maidens bearing rare flowers and fruits. To the left, the terraced garden of the queen mother's island palace is filled with gorgeous flowers and plants; greeters who welcome the arriving guests stand with raised hands, while behind them groups of music-making palace maidens are in attendance. At the extreme left, three female guests are introduced to the queen mother who sits, hidden from view, inside a curtained pavilion.

The three symbols of longevity in *Cranes, Pine Tree, and Lichen* (pl. 9), dated 1885, suggest that this painting as well was made as a birthday gift. Ren Bonian easily combines fluent traditional brushwork with modern realism and well-modeled forms that are three-dimensionally organized in a tightly knit composition. The narrow format of the design, with the contours of the cranes cutting diagonally across the picture plane, suggests the influence of Japanese prints.

In his later years, Ren Bonian used increasingly free brushwork to depict everyday subjects that he frequently painted

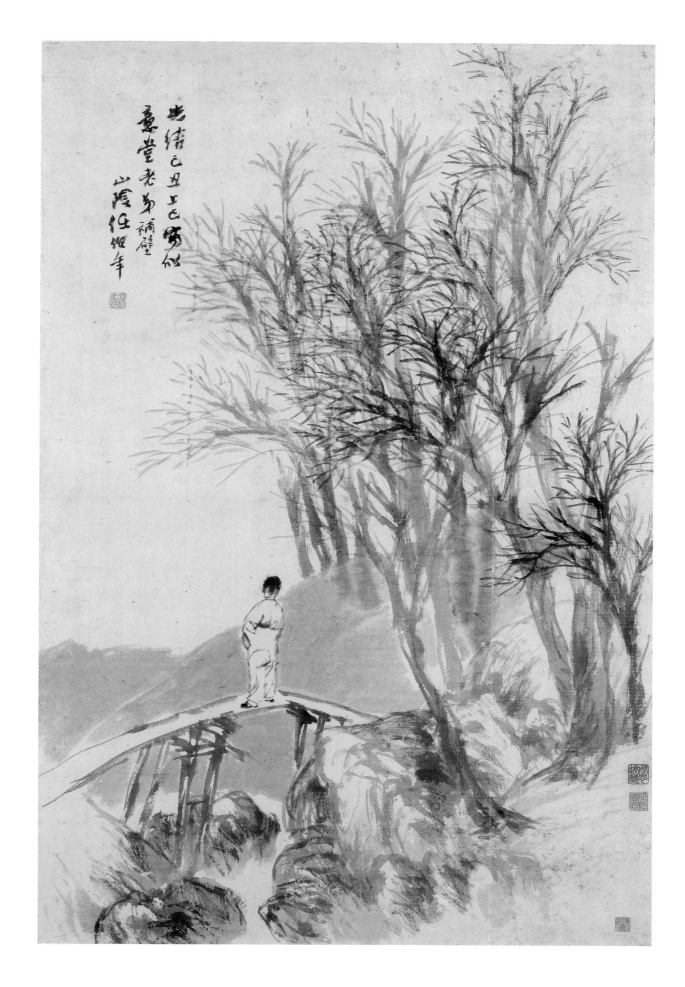

PLATE 11

Ren Bonian (1840–1896),
Herdboy and Water Buffalo, dated
1890. Folding fan mounted as an
album leaf, ink and color on alum
paper,
7½ × 21⅜ in. (19.1 × 54.3 cm).
Gift of Robert Hatfield Ellsworth,
in memory of La Ferne Hatfield
Ellsworth, 1986 (1986.267.48)

48

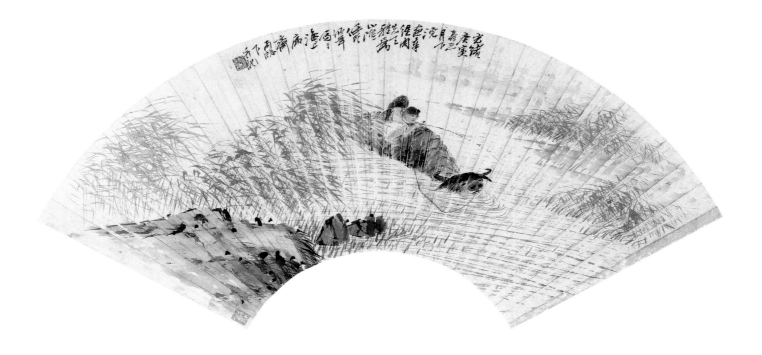

directly from nature. In *Man on a Bridge* (pl. 10), dated 1889, the scene is viewed as in a photograph. Like Xugu's *Sailing in Autumn*, Ren's painting is a scenic view (*fengjing hua*) rather than a traditional mountain-and-water landscape (*shanshui hua*), and thus not based on conventional form types and compositional formulas. Rendering the scene in Western-style realism, Ren models the rock and tree forms with a brushwork that is loose and unstructured rather than one which employs traditional texture patterns. But unlike Western oil painters, who build forms with "erasive" brushmarks,[49] Ren, working with Chinese brush and ink on absorbent paper, constructs forms with clearly defined brushstrokes and without correction. Similarly, in a charming bucolic scene depicted on a fan painting, *Herdboy and Water Buffalo* (pl. 11), dated 1890, Western realism is rendered with masterly, if somewhat facile, brushwork.

The youngest of the Ren family of painters was Ren Yu (1853–1901). A son of Ren Xiong, he was less than four years old when his father died, and he learned to paint from his uncle Ren Xun. Although overshadowed by the older Rens, Ren Yu was not content to be merely a follower. In *Buddha of Longevity* (pl. 12), dating from the early 1890s, which derives from an image of Bodhidharma, the first patriarch of Chan Buddhism, by the eighteenth-century Yangzhou painter Jin Nong (1687–1764),[50] Ren Yu conflates the traditional image of Bodhidharma with that of a popular folk deity, the bullet-headed God of Longevity. Compared with the pleasing effect of Ren Bonian's decorative, archaizing style (pl. 8), Ren Yu's quasi-religious image appears almost grotesque. Seated under a parasol of filigreed tree branches and garbed in robes with angular folds, the deity has a severe yet saintly

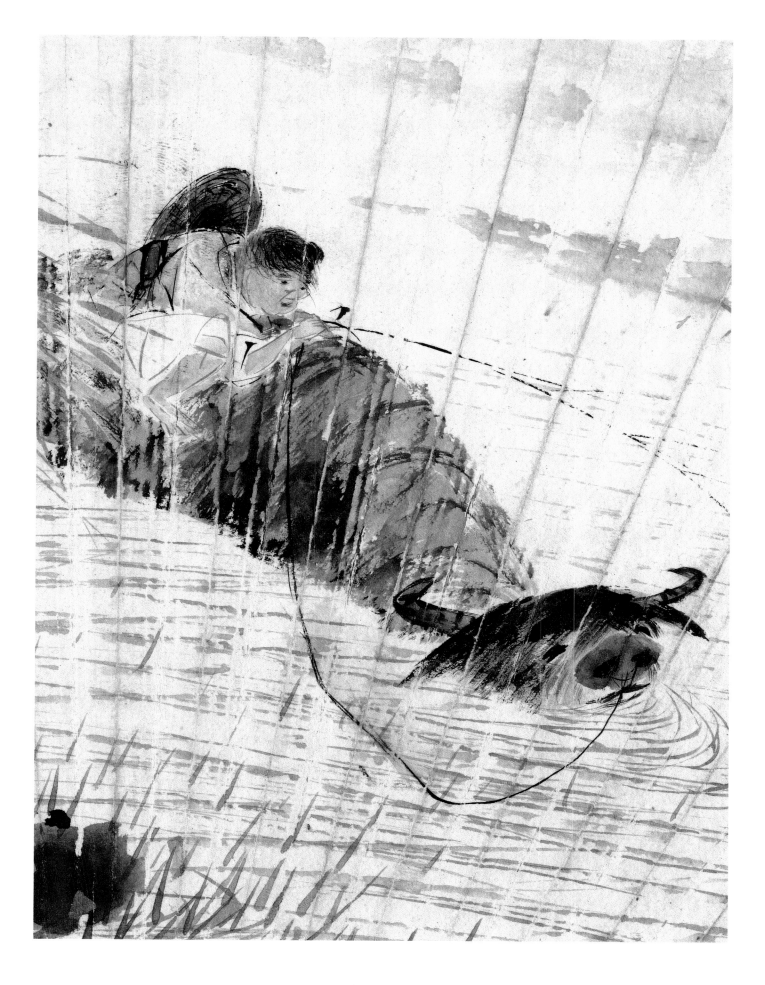

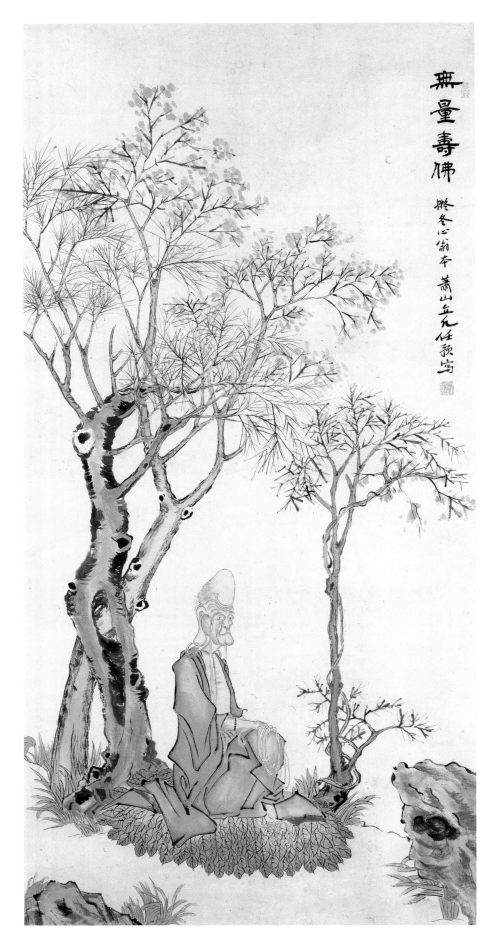

無量壽佛

擬冬心翁本 蕭山
弟子任預寫

PLATE 12

Ren Yu (1853–1901), *Buddha of
Longevity*, early 1890s. Hanging
scroll, ink and color on paper,
53 × 26 in. (134.6 × 66 cm). Gift
of Robert Hatfield Ellsworth,
in memory of La Ferne Hatfield
Ellsworth, 1986 (1986.267.72)

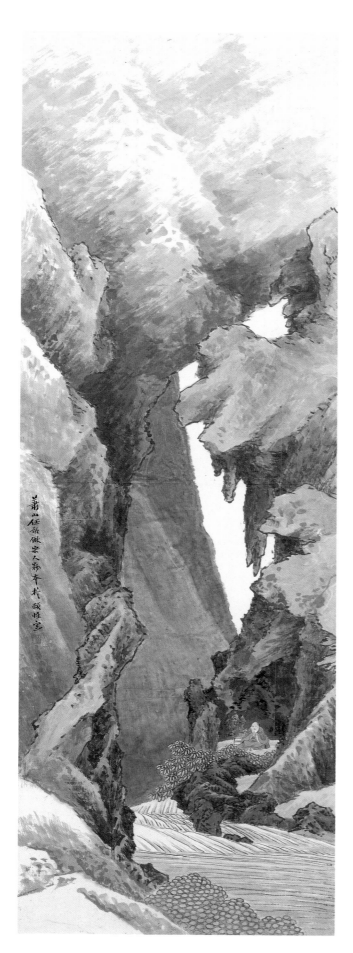

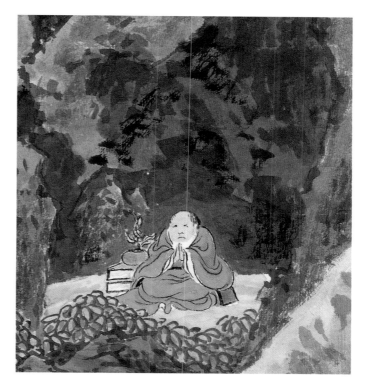

PLATE 13

Ren Yu (1853–1901), *Meditation in a Cave*, ca. 1899. Hanging scroll, ink and color on paper. Gift of Robert Hatfield Ellsworth, in memory of La Ferne Hatfield Ellsworth, 1986 (1986.267.71)

demeanor, hardly the ingratiating expression depicted by a commercial artist.

Meditation in a Cave (pl. 13), dating from about 1899, shows a landscape charged with emotion. A tiny figure in red sits in meditation in a dark cave under jagged, towering boulders that fill the borders of the tall picture format. Around the periphery of the painting, angular brushstrokes in rich black ink are gradually worked toward the calm focus of the composition. Directly above the meditating figure, through an opening in the rocks, a shaft of downward-pointing white radiance signifies the instant of Buddhist enlightenment.

52

FIGURES 31a–d

Li Ruiqing (1867–1920), *Calligraphy in Four Ancient Scripts*, ca. 1915. Set of four hanging scrolls, ink on paper, each scroll 37¼ × 16⅛ in. (94.64 × 40.97 cm). Robert H. Ellsworth Collection, Freer Gallery of Art, Smithsonian Institution, Washington, D.C. (F1998.180.1.4)

d c b a

CLASSICISTS AND MODERNISTS

On January 1, 1912, Sun Yat-sen, head of the Revolutionary Alliance, assumed the office of provisional president of the new republic in Nanjing (Jiangsu). He soon resigned in favor of Yuan Shikai, the power holder in Beijing, who was inaugurated as his successor on March 10 of the same year. Yuan's failed attempt to restore the monarchy by installing himself as emperor in 1915, however, plunged the country into a protracted period of regional warlordism. This fragmented rule ended only with the Nationalist (Guomindang) Northern Expedition (1926–28), when a military campaign under Chiang Kai-shek (1887–1975) unified China under one rule. Chiang established the capital of his Nationalist government in Nanjing in 1927, and his forces occupied Beijing (Northern Capital) in 1928 and renamed it Beiping (Northern Peace).

While Beijing in the late 1910s and early 1920s, during the heady years of the May Fourth and New Culture Movements, was the center of Western-inspired intellectual and artistic reform, the Shanghai artistic community was reinvigorated during that period by the infusion of classically trained scholar-official artists from the fallen Qing court. Li Ruiqing and Zeng Xi, both calligraphers of the metal-and-stone school, were two

of the leading traditionalists. Eventually, they would have a formative influence on Zhang Daqian, who became the most famous Chinese painter of the twentieth century.

A native of Linquan (Jiangxi), Li Ruiqing (1867–1920) passed his *jinshi* degree in 1895 and was a member of the imperial Hanlin Academy before he became minister of education in Nanjing and, concurrently, president of the Liangjiang Normal College (later the National Central University [1928–49] and now known as Nanjing University). Li was credited with the introduction of the modern institution of the art academy in China for having established, in 1906, at Liangjiang Normal College a department of painting and crafts that was modeled after the art department of Tokyo Normal School.[51] After 1911, Li settled in Shanghai, where foreign concessions provided a safe haven for refugees of different political persuasions, and made his living by selling his work.[52] Holding court among his fellow ex-Qing scholar-officials, Li was an exemplar of the revered scholar-artist tradition. His calligraphy, based on erudite classical learning, represented the very antithesis of Ren Bonian's populist realism, which catered to the middle-class public.

In *Calligraphy in Four Ancient Scripts* (figs. 31a–d), dating from about 1915, Li illustrates in a single work the historical development of Chinese calligraphy. He demonstrates, from right to left, four script forms—seal (ca. 13th century B.C.–206 B.C.), clerical (206 B.C.–A.D. 220), draft cursive (a variation of clerical), and standard (4th–6th century)—and adds after each a commentary written in his own cursive clerical. The pictographic origin of ancient Chinese writing is alluded to in the colophon after the first scroll (fig. 31a):

*Like ancient branches twisting and turning, and
 strange boulders one atop the other,
This is my [calligraphic] scenery; nature is my master.*[53]

On the third scroll, in draft cursive (fig. 31c), Li notes that he has borrowed the brush techniques of the Xiacheng stele (dated A.D. 170; fig. 32), to execute the text of the *Model Essay for Draft Cursive*, in a calligraphy traditionally attributed to the third-century master Huang Xiang (active ca. 220–79; fig. 33). Because the *Model Essay* was known only through rubbings in the *tie*, or letter-writing, tradition, which was considered unreliable, Li tried to re-create the calligraphy of Huang Xiang through the Xiacheng stele, dating from the late Han, the period in which Huang Xiang had lived.

In the late fourteenth century, during the late-Yuan dynasty, the calligrapher Song Ke (1327–1387) had done something similar, inventing a new genre that combined four scripts—standard, running, draft cursive, and modern cursive—to represent four expressive modes in one composition.[54] Li Ruiqing's project, however, comprising all calligraphic styles, had a far more ambitious purpose. As a Qing loyalist, Li was a leftover citizen (*yimin*) of the fallen dynasty and, adopting the sobriquet Qing Daoren (the Daoist Qing), he proclaimed himself a defender of China's threatened cultural traditions. His vision was that of a synthesized national tradition that would unite through calligraphic styles an evolving but homogeneous body of artworks that would represent some five thousand years of art history. Li began with the assumption that while the design of a written character evolved over time, the same brush techniques could be applied.[55] In his

53

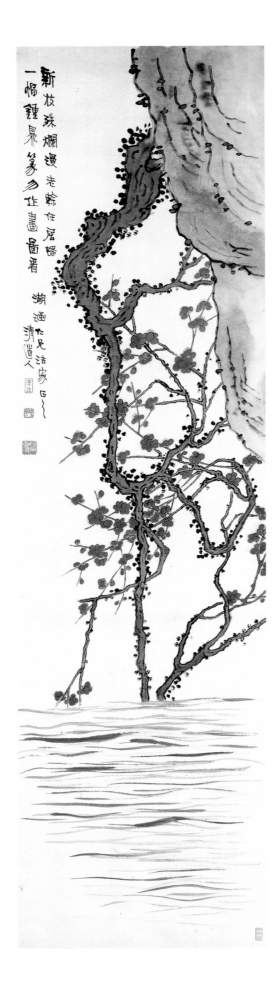

54

PLATE 14

Li Ruiqing (1867–1920), *Blossoming Plum*, ca. 1915. Hanging scroll, ink and color on paper, 70½ × 18⅞ in. (179.1 × 47.9 cm). Gift of Robert Hatfield Ellsworth, in memory of La Ferne Hatfield Ellsworth, 1986 (1986.267.98)

PLATE 15

Li Ruiqing, *Buddha of Longevity*, dated 1917. Hanging scroll, ink and color on paper, 41¼ × 20½ in. (104.8 × 52.1 cm). Gift of Robert Hatfield Ellsworth, in memory of La Ferne Hatfield Ellsworth, 1986 (1986.267.99)

attempt to trace a linear, evolutionary development of Chinese calligraphy, Li combed through thousands of ancient bronze and stele inscriptions, from the Shang and Zhou dynasties through the Northern Wei period, searching for stylistic affinities between them. On the second of the *Four Ancient Scripts* (fig. 31b), which shows the rectilinear clerical style, for example, he writes: "This follows [the style] of the Yu tripod," a reference to a Western Zhou ritual bronze dating to about 1070 B.C., and now in the Historical Museum, Beijing. The fourth scroll (fig. 31d), which shows an elegant Northern Wei style with square, wedge-shaped brushstrokes, he describes as the "sharp, stern," qualities he identified with the early-Tang calligrapher Ouyang Xun (557–645). In this way, he traced the development of the four ancient scripts with two sets of brush techniques, the square and the round, which could, in effect, be applied to all four styles. Both his round and angular (or square) brushstrokes, with a chiseled, or cast iron, look, are rendered with a tremulous, struggling (*dunzuo*) movement, the brush held tightly and wielded like a stylus. Significantly, Li's distinctly personal brush technique led him not to imitate the ancient models but to attempt to recapture the spirit of the traditional forms and through them to revitalize the art of calligraphy.

Because he was primarily a calligrapher, Li Ruiqing only occasionally dabbled in calligraphic paintings, as "ink plays." In *Blossoming Plum* (pl. 14), dating from about 1915, which shows an overhanging plum branch reaching down to a stream, the gnarled and twisted trunk of the old tree recalls Li's description of seal script, "like ancient branches twisting and

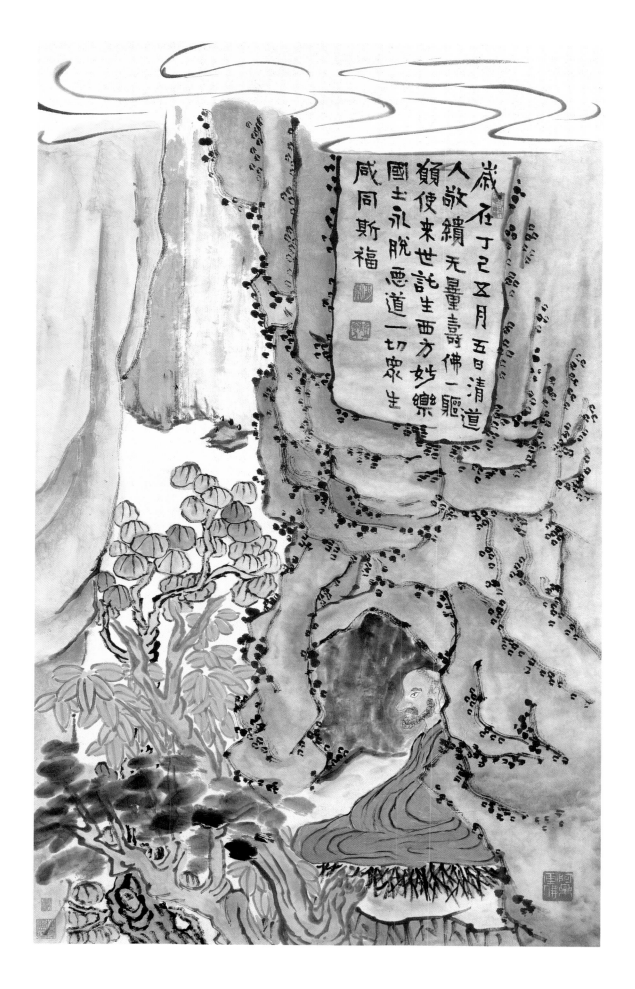

歲在丁巳五月五日清道
人敬續无量壽佛一軀
願使來世託生西方妙樂
國土永脫惡道一切眾生
咸同斯福

PLATE 16
Zeng Xi (1861–1930), *Old Pine Shrouded in Clouds*, dated 1922. Hanging scroll, ink and color on paper, 33 × 25⅞ in. (83.8 × 65.7 cm). Gift of Robert Hatfield Ellsworth, in memory of La Ferne Hatfield Ellsworth, 1986 (1986.267.132)

56 turning" (fig. 31a). On the painting he writes:

Though a new branch is in full bloom,
The old tree remains gnarled and twisted.
This is a scroll of bell-and-tripod seal writing.
Please do not treat it as a painting.[56]

Buddha of Longevity (pl. 15), dated 1917, treats Jin Nong's archaistic Bodhidharma theme with humor and aplomb, using round dots and seal-style brushstrokes and brilliant patches of color to suggest the monumentality and elegance of the epigraphic style.

In 1922, after Li Ruiqing's death two years earlier, his friend Zeng Xi (1861–1930) painted *Old Pine Shrouded in Clouds* (pl. 16), which he dedicated to Ruiqing's nephew Li Jian (1881–1956):

An ancient pine tree, having turned into a dragon, displays shining claws in the cloudy firmament. A branch stemming from the same root and luxuriantly green is auspicious in its burgeoning youth. I painted this as a metaphor for his nephew Li Jian, who has inherited his uncle Ruiqing's [artistic] family legacy. Like the clouds encircling the [pine tree's] roots and branches, the rain and dew will nurture their growth. Jian will pass on what he learned [from Ruiqing] to educate future generations.[57]

In the 1930s and 1940s, Li Jian was the leading master in Shanghai of the metal-and-stone style,[58] and I was fortunate to be among the many students who benefited from his profound learning in Chinese art and history.[59] I grew up in the 1930s and early 1940s in Shanghai, the most cosmopolitan and Westernized city in China, and my encounter with Master Li Jian at an early age had a permanent, transforming effect on my mental and intellectual outlook. It was also the enchantment of working under a master who had a direct lineage to ancient China, the beauty and grandeur of which offered a welcome change from urban life. Such enchantment may, I believe, be experienced by any tourist who visits ancient archaeological sites such as the Buddhist cave temples at Longmen or the Egyptian pyramids. But it was the eye-opening discipline of the metal-and-stone master to look, intently and meaningfully, at the technical and creative process of writing and seal carving that I found awe-inspiring and unforgettable. Most important, I learned that Li Ruiqing's method of synthesizing and harmonizing calligraphic styles was creative—and thus modern rather than conservative—in spirit. It explains why, in modern Chinese painting, the impetus for creativity derives from calligraphy, which was inspired by the study of ancient metal-and-stone monuments.

It was the scholar-artist Wu Changshuo (1844–1927), around the turn of the century, who first combined the erudite metal-and-stone style of calligraphy with Ren Bonian's popular realism. Born to an impoverished scholarly family in a remote village near Anji, in northern Zhejiang near the Anhui border, Wu at age seventeen lost his home and most of his family in the Taiping uprising.[60] Passing his first *xiucai* (cultivated talent) degree in 1865, he took up calligraphy and seal carving while studying the classics with a local scholar. In 1882 he moved to Suzhou, and the following year he met Xugu and Ren Bonian in Shanghai. In a portrait of

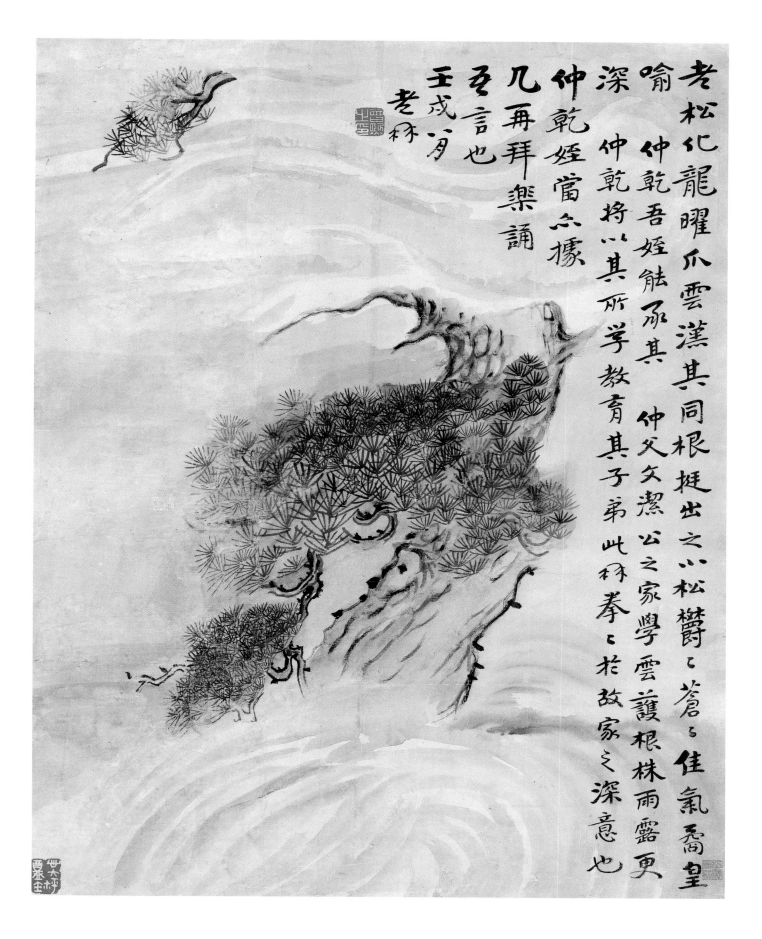

老松化龍曜爪雲漢其同根挺出之小松鬱く蒼ら佳氣喬皇
喻仲乾吾姪骷承其　仲父攵潔公之家學雲護根株雨露更
深仲乾將以其所學教育其子弟此杯拳く於故家之深意也
仲乾姪當念樣
几再拜樂誦
臣言也
壬戌八月
老杯

58

Wu by Ren Bonian, entitled *The Poor Sour Junior Official Wu Changshuo* (fig. 34) and dated 1888, the artist depicts the struggling young scholar-official decked out in his official hat and robe, his hands joined in polite greeting, looking stiff and uncomfortable. Wu wrote a poem on the painting:

Master Ren of Shanying . . .
Why did he paint this?
Because he pities my life as an official.
When I first received my xiucai degree,
I was poor but dared not complain.
Patching my scholar's robe and hat,
I read the classics in my walled study
And worked for a meager salary.[61]

In the late 1880s, Wu developed a close friendship with Ren Bonian and, with Ren's encouragement, learned to paint. In 1899 he was appointed magistrate of Andong (Jiangsu), but left after only one month and spent the rest of his life as a painter.

When Wu Changshuo first went to Shanghai in 1887, he lived in Wusong, in the northern suburb of Shanghai. After the establishment of the Republic in 1912, with the help of Wang Zhen, a successful businessman with strong ties to Japanese shipping and trading interests, he took up residence in the International Settlement in the northern part of the city.[62] A charismatic man with a warm and sympathetic personality, he soon won many friends and admirers. Elected in 1913 chairman of the Xiling Seal Carving Society[63] and head of the Shanghai Calligraphy and Painting Association, Wu became widely known in Japan through his seal carving, calligraphy, and

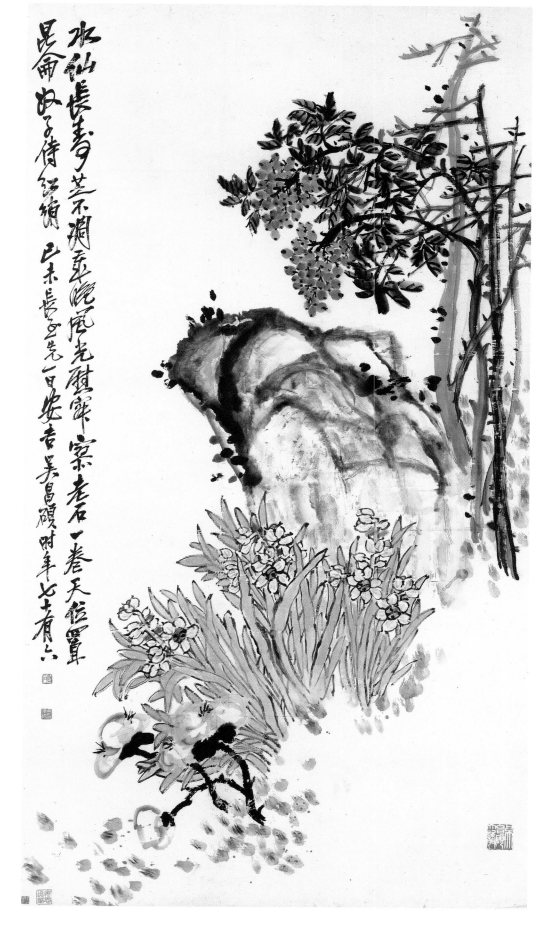

59

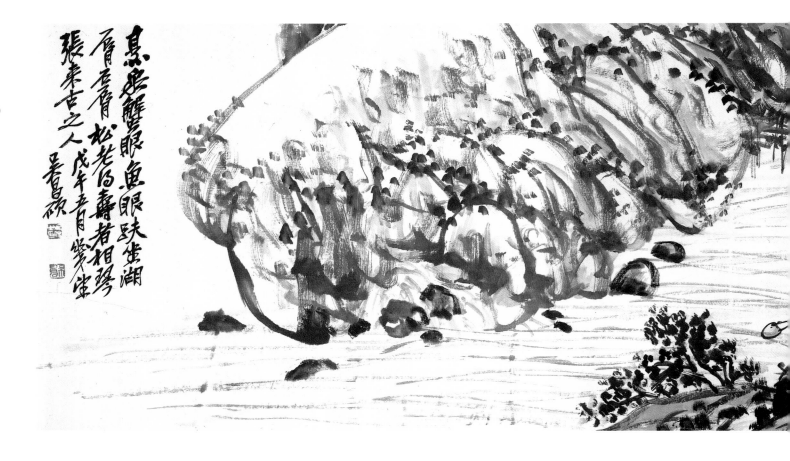

painting. Two major exhibitions of his works were held, in 1921 and 1926, at the Takashimaya department store in Osaka.

In calligraphy (fig. 35), Wu specialized in writing in the style of *Stone Drums*, a set of engraved stone monuments dating from about 422 B.C. (fig. 36). Imitating the ancient inscription, he heightened the dynamic tension of the characters by placing their component parts off balance. Individual brushstrokes, made with a locked wrist and with the arm suspended over the table, display a tautly controlled round brushwork, with a hidden, centered tip.

Wu also applied calligraphic brushstrokes to his paintings.

Like the compositions of Zhao Zhiqian (fig. 20), the majority of Wu's paintings are of flowers and fruits rendered in an animated calligraphic style. In *Spring Offering* (pl. 17), dated 1919, Wu's vigorous brushwork, compact forms, and bold colors combine Li Ruiqing's round seal-style calligraphic technique with Ren Bonian's brash realism and set a new standard for decorative paintings in early-twentieth-century Shanghai. In contrast to Li's individually assertive, round calligraphic brushstrokes, which can be decidedly unpainterly, Wu's swirling dots and strokes are subtly complex and varied, creating a microstructure of movement and shapes in the service of a representational style.

PLATE 18
Wu Changshuo (1844–1927),
Brewing Tea, dated 1918. Ink
on paper, 15½ × 54 in. (39.5 ×
137.2 cm). Gift of Robert Hatfield
Ellsworth, in memory of La
Ferne Hatfield Ellsworth, 1986
(1986.267.124)

61

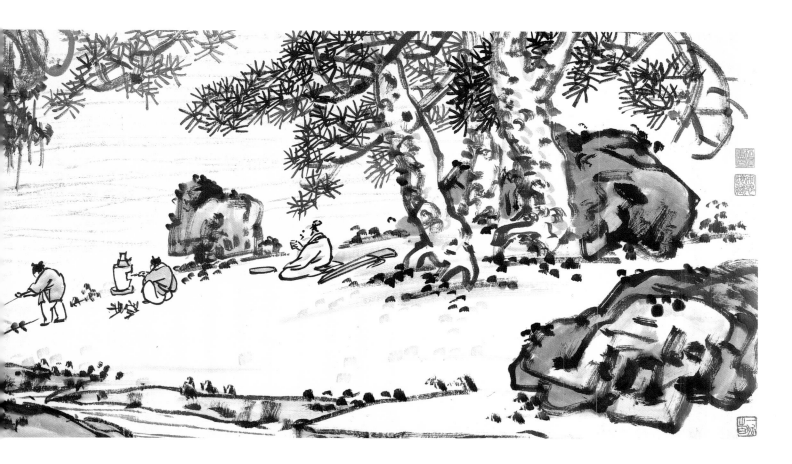

In the wake of the Westernizing New Culture Movement of the late 1910s, Wu's calligraphic style was in the vanguard of the revival of the scholar tradition. A rare landscape painting, *Brewing Tea* (pl. 18), dated 1918, shows a scholar with a qin sitting under pine trees while servants prepare tea from a mountain stream. The inscription reads:

Watching the bubbling spring water,
Sitting by the stony edge of the lake,
Old pines resemble ancient sages,
A qin lies by a man from the past.[64]

Like the works of Li Ruiqing (pl. 15) and Zeng Xi (pl. 16), Wu's landscape, expressed in round, centered seal-style calligraphic brushstrokes, may be viewed as the manifesto of a counter-culture movement. Compared with the work of the seventeenth-century landscape master Shitao (fig. 9), Wu's painting is concerned neither with traditional texture method nor with nature. Instead, the rocks and streams are abstract brush patterns that, in their bold abruptness, lend to the work a striking modernity.

Among the many followers of Wu Changshuo, the most prolific was the Shanghai businessman-artist Wang Zhen

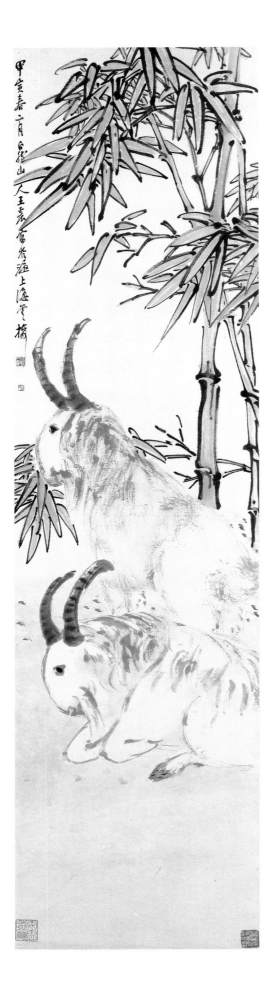

PLATE 19

Wang Zhen (1867–1938), *Two Goats*, dated 1914. Hanging scroll, ink and color on paper, 57½ × 15⅝ in. (146.1 × 39.7 cm). Gift of Robert Hatfield Ellsworth, in memory of La Ferne Hatfield Ellsworth, 1986 (1986.267.154)

(1867–1938), who befriended and looked after Wu in his later years. Born in Pudong, which was then situated just outside Shanghai, Wang was initially an apprentice in a picture-mounting shop, where he studied and copied works by Ren Bonian, then the most famous painter in Shanghai. He later worked in a bank, which helped to launch his business career. In 1902, he became the comprador of the Osaka Shipping Company and, shortly thereafter, a representative of two leading Japanese trading firms, Mitsubishi and Mitsui.[65] He was also a generous supporter of artists and the arts in Shanghai. Having contributed financially to the revolutionary activities in 1911, he became influential in Shanghai politics as well as business in the 1920s and 1930s. When the Sino-Japanese War erupted in 1937, he left for Hong Kong, and died shortly after returning to Shanghai the following year.

As a painter Wang Zhen, who had a natural facility in draftsmanship similar to Ren Bonian's, was able to combine, even more successfully than Wu Changshuo, Ren's realism with strong brushwork. In *Two Goats* (pl. 19), dated 1914, Wang uses the round brushwork of Wu Changshuo to recall a similar composition by Ren Bonian entitled *Three Goats* (fig. 37), dated 1878, though Wang's work is more calligraphically patterned. In *Returning Fisherman* (pl. 20), dated 1917, Wang turns to a bucolic scene of his native countryside in Pudong, on the eastern shore of the Huangpu River. On the painting he writes:

The fisherman exchanges his fish for some wine.
He lives east of willow-covered shores south of the
 [Yangzi] river.

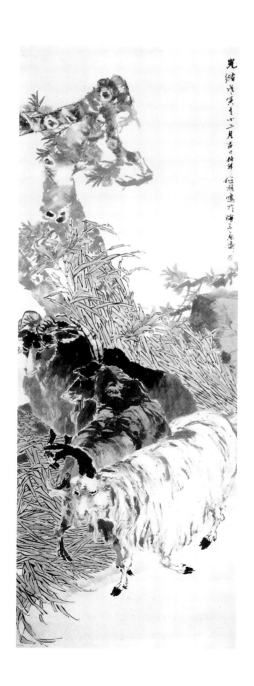

FIGURE 37
Ren Bonian (1840–1895), *Three Goats*, dated 1878. Hanging scroll, ink and colors on paper. Private collection, Hong Kong

FIGURE 38
Tang Di (1287–1355), *Fisherman Returning on a Frosty Bank*, dated 1338. Hanging scroll, ink and colors on silk, 56¾ × 35⅜ in. (144 × 89.7 cm). National Palace Museum, Taipei

PLATE 20
Wang Zhen (1867–1938), *Returning Fisherman*, dated 1917. Hanging scroll, ink and color on paper, 70 × 37 in. (177.8 × 94 cm). Gift of Robert Hatfield Ellsworth, in memory of La Ferne Hatfield Ellsworth, 1986 (1986.267.155)

PLATE 21

Wang Zhen (1867–1938), *Buddhist Sage*, dated 1928. Hanging scroll, ink and color on paper, 78½ × 36⅞ in. (199.4 × 93.7 cm). Gift of Robert Hatfield Ellsworth, in memory of La Ferne Hatfield Ellsworth, 1986 (1986.267.156)

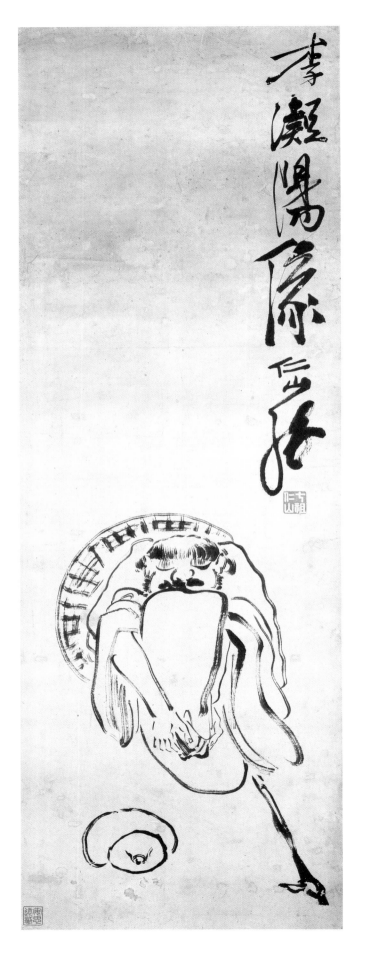

PLATE 22
Su Renshan (1814–1849), *The Immortal Li Tieguai*, late 1840s. Hanging scroll, ink on paper. Gift of Robert Hatfield Ellsworth, in memory of La Ferne Hatfield Ellsworth, 1986 (1986.267.9)

Returning contentedly before dusk in the setting sun,
Laughing and calling to his children, as he gets tipsy
 in the spring breeze.[66]

Compared with a fourteenth-century painting of a similar subject by the Yuan-dynasty painter Tang Di (1287–1355; fig. 38), Wang's painting, which resembles Ren Bonian's *Man on a Bridge* (pl. 10), abandons the form types and compositional formulas of classical Chinese painting in favor of a Western-style realism. No longer are the rocks and trees built up with the tenth- and eleventh-century scrolling-cloud and crab-claw texture patterns, which characterize the paintings of Li Cheng and Guo Xi. And distant elements now recede into the background, creating a three-dimensional space rather than pressing up to the picture plane in a more two-dimensional space. Unlike Ren's rock and human forms, which are rendered with loosely applied brushwork, Wang Zhen's pictorial elements follow the metal-and-stone calligraphic tradition of Wu Changshuo. But Wang now paints directly from nature.

While he was a highly successful businessman, Wang Zhen was also a devout Buddhist. *Buddhist Sage* (pl. 21), dated 1928, portrays the first Chan patriarch, Bodhidharma, attended by his disciple and later the second patriarch, Huike. On the painting Wang writes:

A sage from the West
Preaches the miraculous doctrine of the Upper Vehicle.
Preaching, he sits under a bodhi tree.
Roosting birds listen in silence.

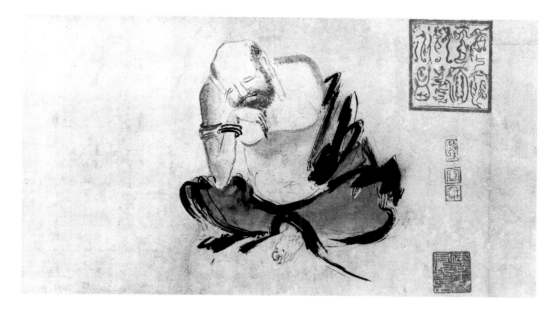

FIGURE 39

The Second Patriarch Huike Harmonizing His Mind, 13th century. Hanging scroll, ink on paper, 13⅞ × 26⅛ in. (35.3 × 64.4 cm). Tokyo National Museum

The Wheel of the Law is as bright as a full moon,
Its precious light illuminating the lamp of transmission.
Ailing worshipers travel from afar
To receive guidance from the monk at the stone cave.[67]

In contrast to Ren Yu's *Meditation in a Cave* (pl. 13), *Buddhist Sage* shows the more activist expression of Chan Buddhism. Wang's Bodhidharma holds forth amid swirling circles of tumultuous black brushstrokes. The depiction is a perfect metaphor for Wang, the businessman-cum-artist, who sought a calm center in the clamorous discord of the commercial world of modern Shanghai. And the brush abstractions, which in their repetition of calligraphic rhythms and shapes create resonances between natural and human forms, signify the apprehension of the universe achieved through the practice of Chan.

A GUANGDONG REBEL AND ECCENTRIC PAINTER

Before the opening of the five treaty ports to Western trade, the southern coastal town of Canton (Guangdong) was China's only seaport open to the world beyond its shores. While the exposure to foreign influences made Guangdong politically sensitive, the province remained culturally conservative. Two of the defining events of late-Qing China, the Opium War and the Taiping uprising, originated in Guangdong and Guangxi, China's two southernmost provinces. Leading political and cultural figures, such as the early reformers Kang Youwei and Liang Qichao and the revolutionary leader Sun Yat-sen, hailed from Guangdong Province, and in the middle decades of the nineteenth century, Guangdong also produced a remarkable painter.

Su Renshan (1814–1849), who came to be recognized only in the twentieth century, was virtually unknown as an artist during his lifetime. He has been described as both a madman and a genius, in the manner of the thirteenth-century Chan painter Liang Kai or the seventeenth-century painter Bada Shanren, and the intensity of his work has been compared with that of Vincent van Gogh.[68] More than any of the sophisticated painters of Shanghai in the late nineteenth century, Su fits David Wang's characterization of late-Qing fiction writers whose art contained too much "waste": excessive tears and laughter, hyperbole, high-strung propaganda, and the like."[69]

A native of Shunde Prefecture in the fertile Pearl River delta, Su Renshan was the eldest son of a minor government official. Although early recognized for his talent in literature and art Su failed, first at age nineteen and again at age twenty-two, to pass his civil service examinations. "At twenty-three, I gave up examinations," he wrote in an inscription dated 1841, "and turned to my passion for painting."[70] In 1842, he was involved in a serious family dispute, as a result of which he left home. In the wake of the outbreak of the Opium War and with increasing signs of peasant unrest, Su spent several years roaming the countryside and visiting scenic sites in Guilin (Guangxi). He returned home in 1848, and died the following year.

A self-taught painter, Su worked in a linear idiom modeled after the popular woodblock-printed painters' manuals, such as the popular *Mustard Seed Garden Painter's Manual,* by Wang Gai (1642–ca. 1710), and the *Late Bloomer's Manual of Painting,* by Shangguan Zhou (1665–ca. 1749).[71]

67

68

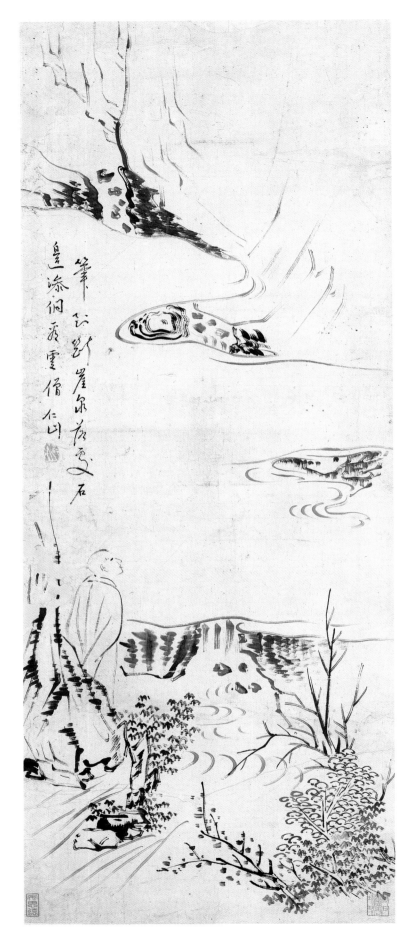

PLATE 23
Su Renshan (1814–1849), *Monk Gazing at Clouds*, late 1840s. Hanging scroll, ink on paper. Gift of Robert Hatfield Ellsworth, in memory of La Ferne Hatfield Ellsworth, 1986 (1986.267.8)

FIGURE 40

Liang Kai (first half of 13th century), *Poet Strolling by a Marshy Bank*. Fan mounted as an album leaf, ink on silk, 9⅝ × 10½ in. (24.5 × 26 cm). The Metropolitan Museum of Art, Bequest of John M. Crawford Jr., 1988 (1989.363.14)

Embittered by life, he wrote long inscriptions ranting about his wasted life. On being a Confucian scholar he wrote:

Confucian scholars are among nature's many sentient beings. . . . But over the years they have been held hostage by Warring States princes, burnt alive by the tyrannical Qin, and ridiculed and mistreated by the Han; having lived precariously through the Tang, they were oppressed by the Song, beaten to death by the first Ming emperor, and finally discarded [in the late Ming]. . . . They have suffered indignities in the extreme. . . . Our civilization of the Six Arts has served only as a tool for massacre.[72]

Su railed against the Manchus and warned of armed rebellion:

[Rapacious officials] are robbing the common people to line their own pockets, doing so in the name of the emperor, by whose order they carry out evil deeds. As people refuse to accept extreme hardship, they will turn to rebellion.[73]

Su was vain, self-righteous, and intolerant. The seals on his paintings boast of a fictive lineage from ancient royalty: "Princely descendant of the Han people," says one, and another claims that he is a "descendant of [the mythical] Emperor Gaoyang."[74] Because these claims, if taken seriously by the xenophobic Manchus, would have placed his family in jeopardy, he was first disowned by his father and eventually committed to prison. His jailers supplied him with paper and ink, and he continued to paint until he died.

During his last years, Su painted many Daoist and Buddhist subjects. *The Immortal Li Tieguai* (pl. 22), dating from the late 1840s, portrays an inebriated Daoist immortal asleep, his walking stick and an empty wine gourd beside him. Compared with an early Chan painting, *The Second Patriarch Huike Harmonizing His Mind* (fig. 39), originally attributed to Shike (ca. 965) but now dated to the thirteenth century, Su's image is a calligraphic statement and an unadulterated caricature. His seal, which reads, "Renshan, the Seventh Patriarch," identifies him as the successor to the sixth Chan patriarch, Huineng (638–713), a fellow citizen of Guangdong. In using seals as explanatory captions, Su may be thought of as a precursor of such modern cartoonists as Feng Zukai (1898–1975).

Monk Gazing at Clouds (pl. 23) dates also from the late 1840s. Here Su paints a monk watching a waterfall in the tradition of Chan ink painting.[75] The inscription reads:

Where my brush reaches the broken cliff with a rushing waterfall,
I add the figure of a monk by a rock, gazing at the clouds.[76]

Compared with a thirteenth-century Chan landscape, *Poet Strolling by a Marshy Bank*, by Liang Kai (fig. 40), which shows the bleak mind-landscape of a true mountain recluse, Su's painting conveys none of the awe that the Song painter felt for the stark power of nature. Instead, Su now caricatures himself as a painter.

Although Su's career as a painter seems eccentric and isolated, his painting style nevertheless reflects the larger movement of Chinese art during the late-Qing and early-Republic period. He lived at a time when the influence of the epigraphic school of calligraphy, led by Deng Shiru (1743–1805),

69

Ruan Yuan (1764–1849), and Bao Shichen (1775–1855), was becoming more widespread. While Su's writing style does not seem to follow the epigraphic manner, his linear drawing style, as seen in *The Immortal Li Tieguai* (pl. 22), displays a predilection for a round, centered brush technique that later became the hallmark of the work of Li Ruiqing (figs. 31a–d).

This brush technique, first made famous by the eleventh-century individualist master Huang Tingjian (1045–1105),[77] is executed by concealing the tip of the brush at the center of each stroke and holding the brush perpendicular to the paper surface, with wrist and elbow suspended. It packs so much energy into the brushwork that it produces a tremulous, struggling rhythm, as the artist follows through on each stroke with his entire arm and body, rather than only with the motion of his fingers and wrist. Thus, in turning figure painting into tensely coiled, agitated brushwork, Su Renshan's image of Li Tieguai inaugurates a modern Chinese expressionist style.

NOTES

1. Mayching Kao, "The Beginning of the Western-Style Painting Movement in Relationship to Reform of Education in Early Twentieth-Century China," *New Asia Academic Bulletin* 4 (1983), pp. 373–400.

2. David Der-wei Wang, *Fin-de-siècle Splendor: Repressed Modernities of Late Qing Fiction, 1849–1911* (Stanford: Stanford University Press, 1997), p. 15.

3. In using the concept of mimicry, Wang (ibid., p. 46) acknowledges his debt to such post-colonial critics as Homi Bhabha, but states: "I see mimicry as one of the ancient forms of Western and Chinese theater; its rich tropical implications need not be conditioned only by theories of colonialism."

4. Ibid., p. 43.

5. Ibid., pp. 45–46.

6. Ibid., pp. 16–17.

7. Hu Shi, introduction, in *An Exhibition of Modern Chinese Paintings*, by Alan Priest (exh. cat., New York: The Metropolitan Museum of Art, 1943).

8. Adapted from Susan Bush, *The Chinese Literati on Painting: Su Shih (1037–1101) to Tung Ch'i-ch'ang (1555–1636)* (Cambridge, Mass.: Harvard University Press, 1971), p. 26.

9. For Loehr's characterization of Ming and Qing painting as "art-historical," see Max Loehr, "Some Fundamental Issues in the History of Chinese Painting," *Journal of Asian Studies* 23, no. 2 (February 1964).

10. Bai Qianshen, "Qingchu jinshixue de fuxing dui Bada Shanren wannian shufeng de yingxiang" (The Impact of the Revival of Metal-and-Stone Studies during the Early Qing on the Late Calligraphic Style of Bada Shanren), *Gugong Xueshu jikan* (Palace Museum Research Quarterly) 12, no. 3 (1995), pp. 89–124; Bai Qianshen, "Fu Shan (1607–1684/85) and the Transformation of Chinese Calligraphy in the Seventeenth Century" (Ph.D. dissertation, Yale University, New Haven, 1996); Wen C. Fong, "Chinese Calligraphy: Theory and History," in *The Embodied Image: Chinese Calligraphy from the John B. Elliott Collection*, by Robert E. Harrist Jr. and Wen C. Fong (exh. cat.,

Princeton: The Art Museum, Princeton University, 1999), pp. 76ff.

11. Susan Naquin and Evelyn S. Rawski, *Chinese Society in the Eighteenth Century* (New Haven: Yale University Press, 1987), pp. 64–67; Frederick W. Mote, *Imperial China: 900–1800* (Cambridge, Mass.: Harvard University Press, 1999), pp. 929–35.

12. Wen C. Fong, *Beyond Representation: Chinese Painting and Calligraphy, 8th–14th Century* (New York: The Metropolitan Museum of Art, 1992), p. 142.

13. Bao Shichen, "Yizhou shuangji" (Two Oars of the Ship of Art), in *Yilin mingzhu congkan* (Collection of Famous Writings on Art) (Shanghai: Shijie Shuju, 1936), pp. 72–117.

14. For Deng Shiru, see Jianghu, "Deng Shiru di shengping" (The Life of Deng Shiru), *Shupu* (Chronicles of Calligraphy), no. 39 (1981, no. 4), pp. 34–61.

15. See Hao Chang, "Intellectual Change and the Reform Movement, 1890–8," in *The Cambridge History of China*, vol. 11, *Late Ch'ing, 1800–1911, Part 2*, edited by John K. Fairbank and Kwang-ching Liu (Cambridge: Cambridge University Press, 1980), pp. 283–91.

16. Kang Youwei, "Guang yizhou shuangji," in *Yilin mingzhu congkan*, pp. 1–66.

17. Ibid., p. 5.

18. Freer to Frederick W. Gookin, October 31, 1910, Gookin file, Charles Lang Freer papers, Freer Gallery of Art, Washington, D.C., quoted in Warren I. Cohen, *East Asian Art and American Culture: A Study in International Relations* (New York: Columbia University Press, 1992), pp. 60, 213 n. 38.

19. Kang Youwei, "Guang yizhou shuangji," pp. 1–4.

20. See Zhu Jianxin, *Jinshixue* (Metal-and-Stone Studies; preface dated 1938), in *Renren wenku* (Everyone's Library), edited by Wang Yunwu (Taipei: Shangwu Yinshuguan, 1966), pp. 53–58.

21. Qian Juntao, "Zhao Zhiqian de yishu chengjiu" (The Artistic Accomplishments of Zhao Zhiqian), *Wenwu* (Cultural Relics), no. 268 (1978, no. 9), pp. 56–67.

22. Ma Guoquan, "Zhao Zhiqian jiqi yishu" (Zhao Zhiqian and His Art), and Zhao Erchang, "Zhao Zhiqian xiansheng nianpu" (Chronology of Zhao Zhiqian), *Shupu*, no. 65 (1984, no. 2), pp. 16–33.

23. Published in *Shupu*, special issue (1984, no. 2), p. 25.

24. It is not certain that the calligraphy of this inscription is by Zhao's own hand, but there is no reason to doubt that the portrait is by someone other than Wang Yun.

25. Ma, "Zhao Zhiqian jiqi yishu," p. 9.

26. "Lun Zhepai" (On the Zhejiang School [of Seal Carvers]), *Shupu*, no. 84 (1988), pp. 17–19.

27. Ma, "Zhao Zhiqian jiqi yishu," pp. 24–25.

28. *Shupu*, no. 39 (1981, no. 4), pp. 34–61.

29. For standard-script calligraphy, see Fong, "Chinese Calligraphy," in *Embodied Image*, pp. 42–46, 53–57.

30. See Deng Chun, *Huaji* (A Continuation of the History of Painting; preface dated 1167), in *Zhongguo hualun leibian* (Classified Compilation of Writings on Chinese Painting Theories), edited by Yu Jianhua (Beijing: Zhongguo Gudian Yishu, 1957), vol. 1, p. 82.

31. See Wen C. Fong, "The Orthodox School of Painting," in *Possessing the Past: Treasures from the National Palace Museum, Taipei*, by Wen C. Fong and James C.Y. Watt (exh. cat., New York: The Metropolitan Museum of Art; Taipei: National Palace Museum, 1996), pp. 489–91.

32. Fong, *Beyond Representation*, pp. 58–61.

33. For a discussion of the "elegant" versus the "vulgar" in late-Ming society, see Craig Clunas, *Superfluous Things: Material Culture and Social Status in Early Modern China* (Urbana-Champaign: University of Illinois Press, 1991), pp. 82–83.

34. Catherine Lynn, "Oriental Wallpapers," chap. 5 of *Wallpaper in America, from the Seventeenth Century to World War I* (New York: W.W. Norton and Company, 1980), pp. 99–106.

35. Claudia Brown and Ju-hsi Chou, eds., *Transcending Turmoil: Painting at the Close of China's Empire, 1796–1911* (exh. cat., Phoenix: Phoenix Art Museum, 1992), pp. 267–69.

36. According to the early-twentieth-century source *Haishang molin* (The Forest of Ink of Shanghai), by Yang Yi (Shanghai: Yuyuan Shuhua, 1928), vol. 3, p. 10, "[Zhao] traveled

to Shanghai, and his calligraphy was extremely popular. Everyone coveted it." See Shan Guolin, "Painting of China's New Metropolis: The Shanghai School, 1850–1900," in *A Century in Crisis: Modernity and Tradition in the Art of Twentieth-Century China*, by Julia F. Andrews and Kuiyi Shen (exh. cat., New York: Guggenheim Museum Soho; Bilbao: Guggenheim Museum, 1998), pp. 31–33.

37. Clark Worswick, "Photography in Imperial China," in *Imperial China: Photographs, 1850–1912* (exh. cat., New York: Asia House Gallery; circulated by American Federation of the Arts; New York: Pennwick, 1978), pp. 134–49.

38. For a discussion of late-nineteenth-century Chinese portrait painting techniques, see Wang Jingxian, "Ren Bonian qiren qiyi" (Ren Yi, the Man and His Art), in Chinese Fine Arts Gallery, *Ren Bonian jingpinji* (Masterpieces of Ren Yi) (Beijing: Renmin Meishu Chubanshe, 1993), pp. 11, 14; see also Lang Shaojun, "Qi Baishi zaoqi huihua, 1878–1909" (On the Early Period of Qi Baishi's Painting), *Meishu shilun* (Studies in Art History), no. 43 (1992, no. 3), pp. 9–11.

39. Gong Chanxing, "Xugu qiren qihua" (Xugu, the Man and His Painting), *Meishu shilun*, no. 31 (1989, no. 3), pp. 56–61, 107; and Ding Xiyuan, "Xugu yanjiu yu jianshang" (A Study and Appreciation of Xugu), *National Palace Museum Monthly of Chinese Art*, no. 165 (1996), pp. 4–37.

40. *Dianshizhai huabao*, 10 vols. (published three times monthly, Shanghai, 1884; reprinted Hong Kong: Guangjiao Jing Chubanshe, 1983).

41. Ding Xiyuan, "Xugu yanjiu yu jianshang," pp. 9–11.

42. For reproductions, see Zhao Guide and Wu Shouming, eds., *Ren Xiong, Ren Xun, Ren Yi, Ren Yu* (Shijiazhuang: Hebei Meishu Chubanshe, 1995).

43. For illustrations of Ren Xiong's works in the style of Chen Hongshou, see Andrews and Shen, *Century in Crisis*, nos. 3, 4.

44. For an interpretation of this self-portrait, see Richard Vinograd, *Boundaries of the Self: Chinese Portraits, 1600–1900* (Cambridge: Cambridge University Press, 1992), pp. 128–30.

45. Fong, *Beyond Representation*, pp. 182–87.

46. For figure paintings by Ren Xun, see reproductions in Zhao and Wu, *Ren Xiong, Ren Xun, Ren Yi, Ren Yu*, pp. 56–79.

47. Wang Jingxian, "Ren Bonian qiren qiyi," and Gong Chanxing, "Ren Bonian nianbiao" (Chronology of Ren Yi), in *Ren Bonian jingpinji*, pp. 1–44.

48. Li Chu-tsing and Wan Qingli, *Zhongguo xiandai huihua shi* (A History of Contemporary Chinese Painting) (Taipei: Shitou Chuban Gufen Youxian Gongsi, 1998), p. 108. For the *Queen Mother of the West*, see Wu Hung, "Han Mingdi, Wei Wendi de lizhi gaige yu Handai huaxuang yishu zhi shengshuai" (The Ritual Reforms of Emperor Ming of the Han and Emperor Wen of the Wei and the Rise

and Fall of Han Pictorial Art), *Jiuzhou xuekan* (Chinese Cultural Quarterly) 3, no. 2 (1989), pp. 31–44. For a comparison of Ren Bonian's *Celebrating the Birthday of the Queen Mother of the West* with Chen Hongshou, see Chen's *Xuan Wenjun Lecturing on the Classics* in the Cleveland Museum of Art, illustrated in Osvald Sirén, *Chinese Painting: Leading Masters and Principles* (New York: Ronald Press, 1956–58), vol. 7, pl. 318.

49. See p. 6, in this publication.

50. Late-Qing painters of the early years of the Republic often refer to a Bodhidharma image by Jin Nong; see, for example, both Li Ruiqing's *Buddha of Longevity* (pl. 15) and Qi Baishi's *Bodhidharma* dated 1913 (pl. 48). I have not been able to find a suitable extant example to illustrate this image, although there are several modern attributions to Jin Nong showing the Bodhidharma theme.

51. Kao, "Reform in Education and Western-Style Painting Movement in China," p. 149.

52. Hou Jingchang, "Qing Daoren qiren qimu" (Li Ruiqing: The Man and His Grave), *Shupu*, no. 72 (1986, no. 5), pp. 64–67.

53. Translation adapted from Robert H. Ellsworth, *Later Chinese Painting and Calligraphy, 1800–1950*, research and translation by Keita Itoh and Lawrence Wu (New York: Random House, 1986), vol. 1, p. 302.

54. Wen C. Fong, "The Literati Artists of the Ming Dynasty," in *Possessing the Past*, p. 369.

55. This observation was first made by Zhao Mengfu in the early fourteenth century; see

Wen C. Fong et al., *Images of the Mind: Selections from the Edward L. Elliott Family and John B. Elliott Collections of Chinese Calligraphy and Painting at The Art Museum, Princeton University* (exh. cat., Princeton: The Art Museum, Princeton University, 1984), p. 98.

56. Adapted from Ellsworth, *Later Chinese Painting and Calligraphy*, vol. 1, p. 113.

57. Ibid., p. 126.

58. Wang Yichang, ed., *China Art Year Book: 1946, 1947* (Shanghai: Committee for Shanghai Municipal Cultural Movement, 1948), frontis., "Biography," p. 28.

59. Ibid., "Biography," p. 3, "Calligraphy," ill. p. 12, "Chinese Painting," p. 120.

60. Ding Xiyuan, preface and "Chronology of Wu Changshuo," in *Wu Changshuo* (Tianjin: Tianjin Renmin Meishu Chubanshe, 1996).

61. Li and Wan, *Zhongguo xiandai huihua shi*, p. 109.

62. Xiao Fengji, "Haishang huajia Wang Zhen shengping shiji" (The Life Story of the Shanghai Painter Wang Zhen), *Duoyun* 49 (1996), pp. 49–51.

63. Established in 1904 in Hangzhou to commemorate the Zhe school of seal carvers.

64. Adapted from Ellsworth, *Later Chinese Painting and Calligraphy*, vol. 1, p. 123.

65. Xiao Fengji, "Haishang huajia Wang Zhen shengping shiji," pp. 47, 53. See also Tsao Hsing-yuan, "A Forgotten Celebrity: Wang Zhen (1867–1938), Businessman, Philanthropist, and Artist," in *Art at the Close of China's Empire*, *Phoebus*, vol. 8 (Tempe: Arizona State University, 1998), pp. 94–109.

66. Adapted from Ellsworth, *Later Chinese Painting and Calligraphy*, vol. 1, p. 135.

67. Ibid.

68. Chu-tsing Li, "Su Jen-shan (1814–1849): The Rediscovery and Reappraisal of a Tragic Cantonese Genius," *Oriental Art* 16, no. 4 (winter 1970), pp. 349–60; Pierre Ryckmans, *The Life and Work of Su Renshan: Rebel, Painter and Madman, 1814–1849?*, translated by Angharad Pimpaneau, 2 vols. (Paris: Université de Paris, 1970); and Mayching Kao, "A Study on the Art of Su Renshan," in *Su Liupeng Su Renshan shu hua / The Art of Su Liupeng and Su Renshan*, edited by Mayching Kao (Hong Kong: Hongkong Zhongwen Daxue Zhongguo Wenhua Yanjiusuo Wenwuguan, 1990), pp. 148–67.

69. Wang, *Fin-de-siècle Splendor*, p. 15.

70. Kao, "A Study on the Art of Su Renshan," p. 153.

71. Ryckmans, *Life and Work of Su Renshan*, pp. 35–36.

72. Tan Dihua, "Su Renshan jieqi sixiang yu yishu" (The Thoughts and Art of Su Renshan), *Meishujia* (The Artist), no. 34 (1983), p. 46.

73. Ibid., p. 43.

74. Kao, "A Study on the Art of Su Renshan," pp. 149, 154, fig. 2.

75. James Cahill, "Continuations of Ch'an Ink Painting into Ming-Ch'ing and the Prevalence of Type Images," *Archives of Asian Art* 50 (1997–98), pp. 17–41.

76. Adapted from Ellsworth, *Later Chinese Painting and Calligraphy*, vol. 1, p. 79.

77. Fong, *Beyond Representation*, pp. 147–50.

Chapter Two

The Westernizers

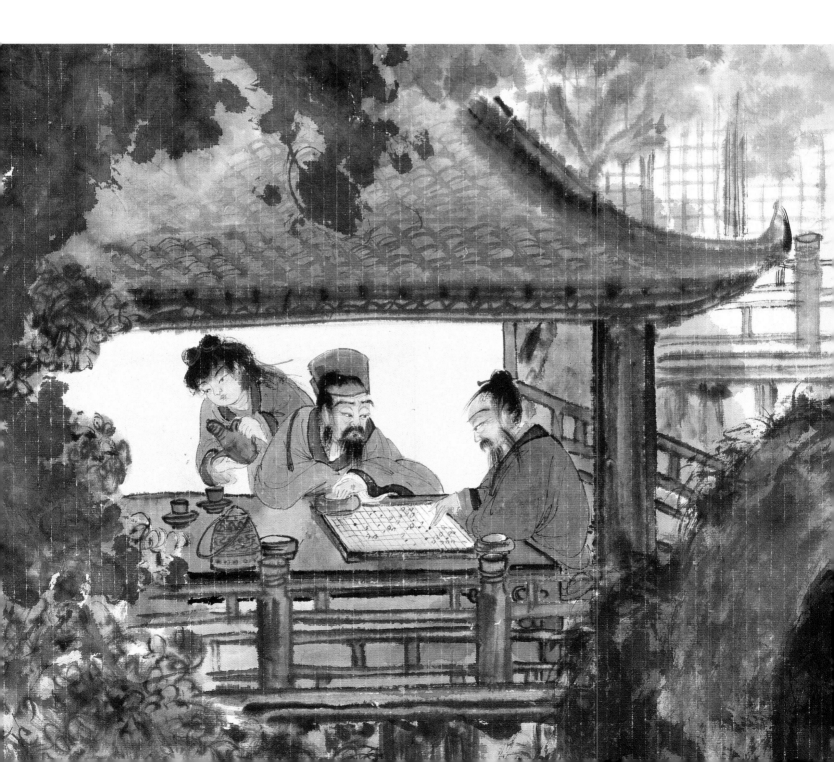

The Qing dynasty, established by the Manchus in 1644, was overthrown by revolution in 1911, and a republic, briefly led by Sun Yat-sen (1866–1925), was established in 1912. Cai Yuanpei (1868–1940), a Confucian scholar and a member of the revolutionary Alliance Society, was named minister of education first under Sun and then under Yuan Shikai. In that position, Cai enumerated five subdivisions of education for rebuilding China as a modern nation-state; one of them was the arts.[1] In 1917, as chancellor of the prestigious National Peking University, Cai launched a program to "replace religion with the fine arts," advancing his belief that culture and art rather than religion must guide the spiritual values of an ideal new society.[2] Cai named Chen Duxiu (1879–1942), a leftist journalist and later a founder of the Chinese Communist Party, as dean of letters at Peking University. Having studied in Japan and France and, as the founder in 1915 of the monthly journal *New Youth*, Chen exhorted China's youth to assume responsibility for building a new nation. At Peking University, seat of intellectual ferment, he encouraged the Westernization of Chinese painting. The traditional approach to painting, which advocated the systematic study of classical idioms, was represented by the seventeenth-century orthodox masters Wang Shimin, Wang Jian, Wang Hui, and Wang Yuanqi, known collectively as the Four Wangs. And it was the Four Wangs who became targets of modern reform. "If you want to reform Chinese painting," Chen wrote, "you must begin by revolutionizing the paintings of the Four Wangs . . . and use the realism of Western art to reform Chinese painting."[3] But as reformists tried to define a new approach to painting, they encountered different Western-style models.

One model was mediated through Chinese students who had gone to Japan; another derived from direct exposure to Western art by painters who had studied in Europe.

JAPAN'S ENCOUNTER WITH THE WEST

To understand Western-style Chinese painting, we must turn first to Japan, which had been transformed into a modern nation under the Meiji emperor (r. 1868–1912). Mutsuhito set in motion a systematic program of education based on the Western model. Indeed, soon after the accession of Mutsuhito, traditional Japanese institutions and values were officially renounced. Western art, perceived as a manifestation of Western technology, was held up as the standard to be emulated.[4] In 1876, the government established the Technical Art School, the first official institution of art education, the express aim of which was to "improve various crafts by promoting the application of modern European techniques to traditional Japanese methods." Three instructors from Italy were hired, under a regulation stipulating that "only Westerners shall be appointed as instructors," and "within the school, both staff and students shall adopt the Western mode in all things relating to clothing, meals, and living quarters."[5]

Within a few years, as the inevitable reaction against such arbitrary Westernization set in, an equally dramatic swing to ultraconservative Japanese traditions followed. In 1878, a young American scholar, Ernest Fenollosa (1853–1908; fig. 12), arrived from Harvard University to assume a position teaching political philosophy at Tokyo University. He was soon a dedicated aficionado of early Japanese art and a champion

FIGURE 41

Yokoyama Taikan (1868–1958), *Qu Yuan*, dated 1898, detail. Ink and color on silk, 52⅝ × 114⅜ in. (132.7 × 289.7 cm). Itsukushima Shrine, Hiroshima

FIGURE 42

Yokoyama Taikan, *Master of Five Willow Trees*, dated 1912. Details from two screens of six panels, colors and gold on paper, 66¾ × 145⅛ in. (169.5 × 368.5 cm). Tokyo National Museum

of what he called "true painting." Fenollosa held seminars and lectures on the traditional Kano and Tosa schools of Japanese painting, to which he drew a large audience of cabinet ministers and members of the ecclesiastic community, as well as Japanese painters. Appointed an imperial commissioner to investigate the practices of schools and museums throughout the world, he made a tour accompanied by his pupil and protégé Okakura Kakuzō (1862–1913; fig. 13). On their return to Japan in 1887, the two worked together to establish a National Office for the Protection of Cultural Properties (now known as the Bunkachō) to ensure the preservation and prevent the loss by theft or sale of ancient art treasures and to encourage the revival of traditional Japanese styles. Meanwhile, rising nationalism in Japan at that time helped to foster the National Essence Movement, which glorified not only the nation's cultural and artistic patrimony but also its spiritual heritage as represented by Shinto, Confucianism, and Buddhism.[6]

Also in 1887, Fenollosa was appointed the head of both the Tokyo Imperial Museum and the newly founded Tokyo School of Fine Arts.[7] In 1889 he declared, "A new art is going to grow in the school; it will dominate Japanese art in the near future, and it will be influential the world over."[8] The new art taught by Fenollosa and Okakura was Nihonga, or Japanese-style painting. Distinct from Western-style painting, or *yōga*, which had been taught at the Technical Art School (closed in 1883), Nihonga was not only a revival of traditional styles but the creation of a new painting style.

In 1882, Fenollosa spoke of "true theories of art and true painting."[9] As a Westerner, he was struck by the influence of

FIGURE 43

Attributed to Kano Kotonobu
(active early 17th century),
Chinese Immortals, ca. 1606.
Detail from a set of four sliding
panels from Ryōanji, Kyoto. Ink,
pigments, and gold leaf on paper.
Each panel 72 × 68 in. (198.2 ×
182.9 cm). The Metropolitan
Museum of Art, Anonymous Gift,
in honor of Ambassador and Mrs.
Michael Mansfield (1989.139.1)

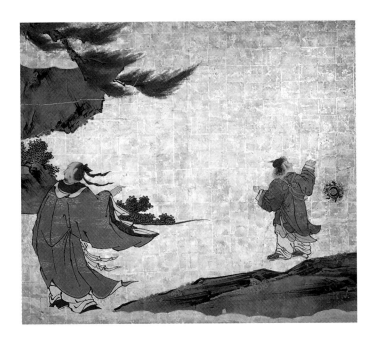

Greco-Roman art on ancient Buddhist art, namely, figural elements that could be traced back to Gandharan art of northern India and Pakistan.[10] Fenollosa was critical of Nanga, or the Southern school, a Japanese ink style based on Chinese scholar painting (*wenrenhua*). He claimed that leading Nanga painters, such as Yosa Buson (1716–1783) and Ikeno Taiga (1723–1776), had little knowledge of anatomy and linear perspective and that their work lacked formal harmony. He identified the Kano school as the true progenitor of Japanese painting, and as Kano Eitan Masanobu, a name given to him by the Japanese, he devoted himself to the revival of that style. Fenollosa left Japan to become curator of Japanese art at the Museum of Fine Arts, Boston, in 1890, after which the direction of the Tokyo School of Fine Arts fell to Okakura

Kakuzō and Okakura's pupils and associates Yokoyama Taikan (1868–1958), Hishida Shunsō (1874–1911), and Shimomura Kanzan (1873–1930).[11] Nihonga to these masters meant a synthesis of Eastern and Western traditions, achieved by the reworking of classical brush techniques and the *yamato-e* (Japanese painting) color patterns of such traditional schools as Kano, Rinpa, Tosa, and Maruyama-Shijo with Western realist principles of chiaroscuro and perspective.

In 1898, after a bitter fight with his critics, Okakura, better known in Japan as Tenshin, was forced to resign the directorship of the School of Fine Arts. With financial assistance from his American benefactor, William Sturgis Bigelow (1850–1926) of Boston, Tenshin established the Japan Art Institute, taking with him his pupils Taikan and Shunsō. At the inaugural exhibition of the institute in 1898, Taikan presented a dramatic ten-foot-wide portrait of Tenshin in the guise of the slandered minister Qu Yuan (343–278 B.C.; fig. 41).[12] This loyal official of the kingdom of Chu, betrayed by his friends and banished from court, wrote the immortal poem "On Encountering Sorrow," before drowning himself in the Mile River.[13] Taikan's *Qu Yuan* was not only a tribute to Tenshin but also a foreshadowing of the latter's subsequent exile in the United States. Holding in his right hand an orchid, symbol of virtue, the brooding, realistically rendered figure embarks on a life in exile, while an aura of uneasy foreboding is created by the gusty wind that sends dark clouds and fallen leaves whirling about his flapping robes.

In 1912, Taikan painted *Master of Five Willow Trees* (fig. 42) for a memorial exhibition held after the death of his colleague Hishida Shunsō in 1911. The figure in the painting refers to

FIGURE 44
Yokoyama Taikan (1868–1958), *Wild Geese Descending to a Sandbar* from *Eight Views of the Xiao and Xiang Rivers*, dated 1912. Hanging scroll, ink and colors on silk, 45 × 23⅞ in. (114.4 × 60.6 cm). Tokyo National Museum

(fig. 44), dated 1912. Here, Taikan evokes one of the Eight Views of the Xiao and Xiang Rivers, a popular theme borrowed from Southern Song Chinese prototypes.[15] Applying fluid ink wash to a silk surface, Taikan creates abstract zigzag patterns across the picture surface to evoke a mood of solitude and loneliness.

After Tenshin immigrated to Boston, he published *Ideals of the East* (1903), in which he spoke of "Asia as one," with India, China, and Japan as parts of a pan-Asian culture.[16] Even more than his American mentor Ernest Fenollosa, Tenshin was a romantic champion of pan-Asian cultural unity. It would be a mistake to think, however, that he wished to identify Japan with modern Asia. Rather, he shared the opinion of such Japanese thinkers as Fukuzawa Yukichi (1835–1901), an adviser to reformers in Korea and the author of "Essay on Dissociating from Asia" (1885),[17] who viewed China and Korea in their political and military resistance to change as a drag on Asia's rise in the modern world. Nevertheless, for Tenshin contemporary India and China were to Japan as classical Greece and Rome were to the West—its spiritual and cultural legacy to be mastered and used for new purposes.

the fifth-century poet Tao Yuanming (365–427), who lived in a period of political instability and left his frustrating low-level government position at the age of forty to live as a farmer. In 405, he wrote the poem "Returning Home."[14] Acclaimed for its celebration of liberation from material concerns, the poem also raises the moral dilemma of having to choose between serving one's ruler at the expense of following one's conscience or withdrawing from political engagement. Taikan's depiction of Tao Yuanming recalls the exuberant style of an early-seventeenth-century Momoyama-period painting, *Chinese Immortals* (fig. 43), from Ryōanji, in Kyoto. Taikan's Nihonga style is an attempt to transform *yamato-e* into a sumptuously decorative modern style. Another representative work by Taikan is *Wild Geese Descending to a Sandbar*

THE NEW CHINESE PAINTING

One of the first Chinese painters to study Western-style painting in Japan was Gao Jianfu (1878–1951), who brought the Nihonga style to China and tried to develop a new painting style. Referred to as *xin guohua* (the new Chinese painting), it was also known as the Lingnan (Cantonese) school.[18] Born in Fanyu (Canton, Guangdong), the fourth of six sons in an

THE TRUE RECORD

FIGURE 45
Gao Qifeng (1889–1933), cover of
the *True Pictorial Record*, 1912.

FIGURE 46
Gao Jianfu, *Burning of the Efang
Palace*, dated 1930, detail. Hanging
scroll, ink and color on silk,
15⅜ × 10⅞ in. (39 × 27.5 cm).
Art Museum, Chinese University
of Hong Kong

80 impoverished family, Gao was apprenticed at age fourteen to the local professional painter Ju Lian (1828–1904),[19] in nearby Lishan. Under Ju's tutelage he learned to paint birds and flowers in a realistic, brightly colored style. In 1903, Gao went to Canton to enroll in the Canton Christian College (later Lingnan University), and in 1906 he went to Tokyo. There he joined the revolutionary Alliance Society, which had been founded by Sun Yat-sen the previous year. After returning to Canton briefly in 1907, he took his brother Qifeng back with him to Tokyo to study art. For a year they studied both Nihonga and Western painting, after which they returned to Canton to take part in the revolution that led to the fall of the Manchu dynasty in 1911.

Following the establishment of the Republic and with the financial backing of the Guangdong revolutionary government, Gao Jianfu and his brother founded a publishing house in Shanghai. This enterprise, which included the publication of the illustrated fortnightly the *True Pictorial Record* (fig. 45), folded in less than a year.[20] In 1918, Gao became the head of the Provincial Art School in Canton, in which capacity he advocated a new Chinese painting that echoed Cai Yuanpei's call for a new approach to the teaching of the fine arts. Referring to the new style as a middle path (after the Japanese, *setchū*) between Eastern and Western art,[21] he argued that art should not be like "a book from heaven," incomprehensible to the masses.[22]

Details of the Gao brothers' artistic training in Japan are not well documented, but it seems clear that during their stay they assimilated the lessons of Nihonga.[23] In *Burning of the Efang Palace* (fig. 46), dated 1930, Gao adapts a well-known

composition of the same subject, dated 1907, by Kimura Buzan (1876–1942; fig. 47).[24] A pupil of Tenshin at the Tokyo School of Fine Arts, Kimura painted in a style he shared with his colleagues Taikan and Shunsō, using graded color washes on silk to represent light, space, and atmosphere. Although this new style was disparaged by conservative critics in Japan as the misty style (*mōrō-tai*), its synthesis of Eastern and Western techniques met with considerable success when Taikan and Shunsō exhibited their work in the United States and Europe during their travels in 1903–5.[25]

FIGURE 47
Kimura Buzan (1876–1942),
Burning of the Efang Palace,
dated 1907. Ink and color on silk.

81

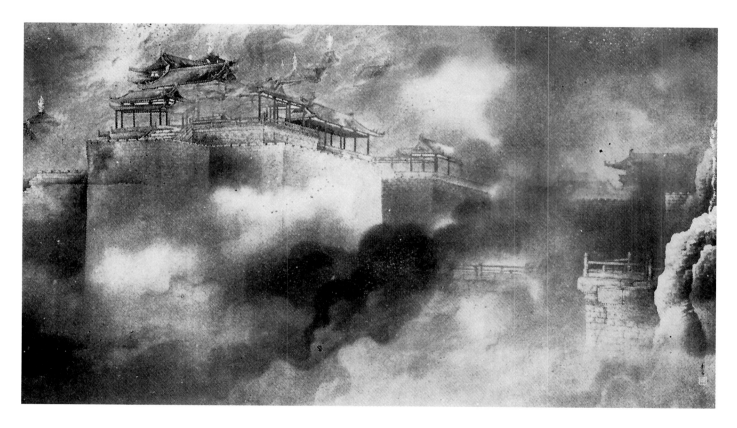

The new Chinese painting envisioned by the Gao brothers also had an "altruistic mission" that went far beyond the establishment of a local or national school:

Students of art must adopt a lofty viewpoint and consider themselves charged with an altruistic mission that requires them to consider the miseries and afflictions of their fellow men as their own. They will then work … [to] bring about an improvement of society in general, thereby presenting the new spirit of the arts in all its glory and grandeur.[26]

In 1936, Gao Jianfu was made a professor at the National Central University in Nanjing, the nation's capital. In his lectures of 1936 and 1937, later published as "My Views of Contemporary Art,"[27] he presented his vision of the scope of the new Chinese painting that would be broad enough to include elements from all cultures:

I believe we should not only take in elements of Western painting. If there are good points in Indian painting, Egyptian painting, Persian painting, or the masterpieces of other countries

82

PLATE 24
Gao Jianfu (1878–1951), *Ancient Warrior*, dated 1931. Hanging scroll, ink and color on alum paper, 38½ × 19 in. (97.8 × 48.3 cm). Gift of Robert Hatfield Ellsworth, in memory of La Ferne Hatfield Ellsworth, 1986 (1986.267.183)

PLATE 25

Gao Jianfu (1878–1951), *Ancient Tree with Golden Gourds*, dated 1935. Hanging scroll, ink and color on paper, 52⅛ × 17¼ in. (13.2 × 43.8 cm). Gift of Robert Hatfield Ellsworth, in memory of La Ferne Hatfield Ellsworth, 1986 (1986.267.187)

ancient or modern, we should absorb and adopt all of them as well, as nourishment for our national painting.... In the twentieth century, with science progressing and communications developing...I hope this new national painting becomes world painting.[28]

Gao was particularly interested in Indian art:

Since the Han dynasty...learned priests from India and China had many cultural exchanges.... Ancient figure paintings of our country were greatly influenced by Indian art. In the ancient arts of India, such as the two-thousand-year-old murals in the grottos and temples at Ajanta, Bagh, and Gandhara, the bone method and colors [of the figures] are just like those in Tang-dynasty paintings. And in Indian painting, there are also the Six Laws known as the Six Limbs. In "Art of India," Abanindranath Tagore, leader of the new-style Indian painting, noted that "in Indian painting, what is known as the Six Limbs represented the ancient Indian artist's Six Great Principles." They are similar to the Six Laws of Xie He of our country. It is possible that the latter was influenced by the former.[29]

The Bengali nationalist painter Abanindranath Tagore (1871–1951), a relative of the mystic poet Rabindranath Tagore (1861–1941), was an active supporter of the pan-Asian cultural movement once espoused by Tenshin.[30] From 1930 to 1931, while attending a pan-Asian conference on education in India, Gao called on Tagore.

In *Ancient Warrior* (pl. 24), dated 1931 and painted in Calcutta,[31] Gao depicts a mustachioed warrior figure with Indian features and complexion. The figure is shown in a schematic profile view with flat geometricizing lines that are made with the aid of a compass or some other mechanical device. A touch of color shades the contours of the shield and the warrior's shoulder. In *Ancient Tree with Golden Gourds* (pl. 25), dated 1935, Gao reverts to a more conventional calligraphic brushwork. Indeed, central to Gao's new Chinese painting was his belief that "the ideas must be new [but] the brushwork must be old." For all his rhetoric against traditional scholar painting, which he regarded as both a symptom and the cause of China's stagnant artistic development, Gao acknowledged that modern Chinese painting was indebted to the scholar tradition for its brushwork and breath-resonance (*qiyun*).[32]

The outbreak of the second Sino-Japanese War occurred in 1937. The war led to the Japanese occupation of Beijing and Shanghai, among other cities, and the occupation in 1938 of the national capital, Nanjing. The Japanese attack on Pearl Harbor in 1941 would merge the Sino-Japanese War with World War II. Gao Jianfu fled Nanjing, taking his family to the Portuguese colony of Macao on the Pearl River estuary south of Canton. The move from the nation's artistic and political center necessarily resulted in his loss of influence. His paintings, which had long been criticized for showing too much Japanese flavor (*dongyang wei*), became more traditional and more introspective. *Junks* (pl. 26) is dated "five days after the Double Ten National Day celebration [October 15] in 1945" and marks Gao's own return to Canton after the surrender of the Japanese. Two seafaring junks sail in the wind toward a rose-colored sky, an optimistic vision that is perhaps a metaphor for his return home. The painting harmoniously

PLATE 26

Gao Jianfu (1878–1951), *Junks*,
dated 1945. Hanging scroll, ink
and color on alum paper, 29 ×
35⅛ in. (73.7 × 89.2 cm). Gift
of Robert Hatfield Ellsworth,
in memory of La Ferne Hatfield
Ellsworth, 1986 (1986.267.186)

86

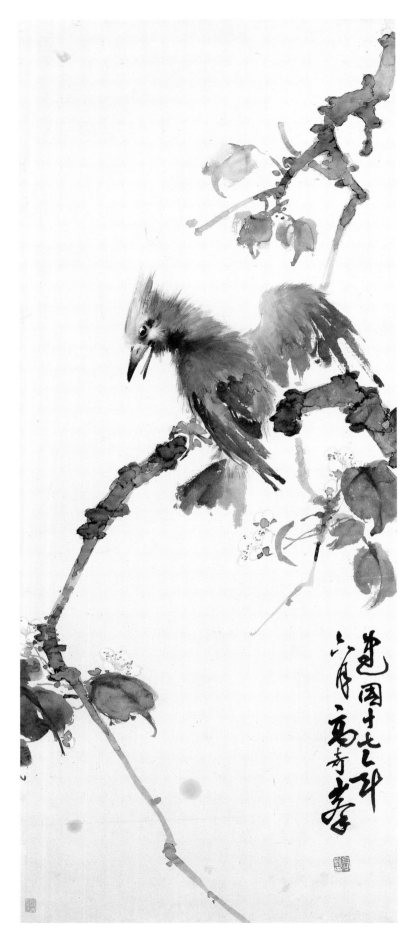

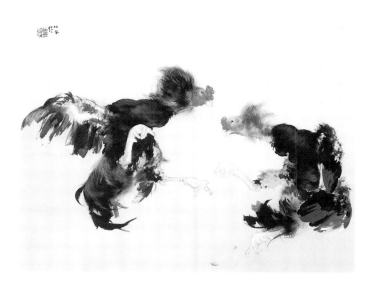

FIGURE 48

Takeuchi Seijō (1864–1942),
Cockfight, 1926. Color on silk,
framed, 48⅜ × 55¾ in. (123 ×
141.5 cm). Private collection

FIGURE 49

Gao Qifeng (1889–1933), *Roaring
Tiger*, dated 1908. Hanging scroll,
ink and color on paper. Private
collection, Hong Kong

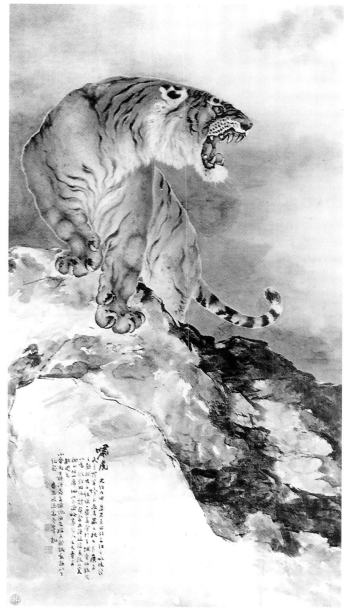

combines Chinese brushwork with Western chiaroscuro, and with seagulls accented in white against the rosy sky, it seems a calm recollection of Gao's early exploration of the Nihonga style.

Jianfu's younger brother Gao Qifeng (1889–1933) worked closely with Jianfu in developing a parallel career. *Woodpecker* (pl. 27), dated 1927, reflects the influence of realistic Nihonga artists such as Takeuchi Seihō (1864–1942),[33] who developed a technique of mixing white pigment in his color to create iridescence in the plumage of his vividly depicted birds (fig. 48). More than traditional bird and flower subjects, however, predatory animals and birds—tigers, lions, and eagles, traditional symbols of militancy and power—were favorite subjects of both Gao brothers (fig. 49). Both had learned to paint tigers in Japan from Kyoto painters such as Kishi Chikudō (1826–1897; fig. 50) and traced their fascination with animals to the eighteenth-century Kyoto artist Maruyama Ōkyo (1733–1798).

FIGURE 50
Kishi Chikudō (1826–1897),
Tiger. Hanging scroll, ink and
color on silk, 63¾ × 28⅛ in.
(161.8 × 71.5 cm). Tokyo National
Museum

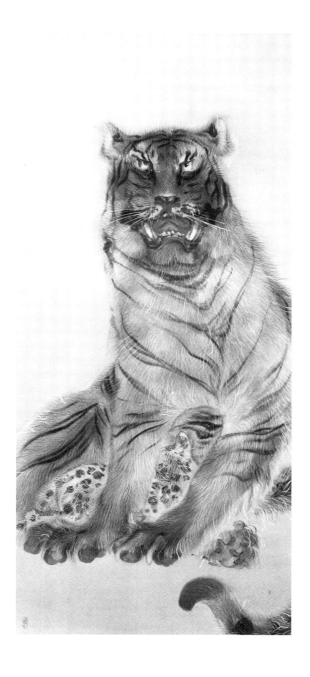

Gao Qifeng's ferociously roaring early tigers from 1908 (fig. 49) and 1912 (fig. 45) show the influence of their Japanese model. A later tiger (pl. 28), however, datable by the style of Gao's signature and the landscape background from the late 1920s, shows the fine, detailed drawing with its schematic pattern of the tiger's coat more in keeping with the traditional Chinese fine-style of animal painting.

THE ÉCOLE DES BEAUX-ARTS

The most important Western-style Chinese painter of the early twentieth century was Xu Beihong (1895–1953). Xu was raised in Yixing (Jiangsu) and went to Shanghai at the age of twenty. Like Gao Jianfu, Xu too studied art in Japan, spending nearly a year there in 1917. In 1918 he returned to China and became an instructor at the newly founded Painting Methods Research Society (later the Art Academy) at Peking University, where he became involved in the New Culture Movement. He next spent eight years in Europe, studying first under François Flameng (1856–1923) at the École des Beaux-Arts in Paris and Arthur Kampf (1864–1950) in Berlin. He then returned to Paris to study with Pascal Dagnan-Bouveret (1852–1929). On his return to China in 1927, Xu taught at the South China Art Academy in Shanghai and again at the Art Academy in Beijing. Moving to Nanjing, he was a professor at the National Central University from 1929 to 1936, a year before the outbreak of the Sino-Japanese War. In 1946, after the war, he became the director of the Beiping Art Academy (from 1950, the National Central Academy of Fine Arts), a post he held until his death in 1953.[34]

PLATE 28

Gao Qifeng (1889–1933), *Tiger*,
late 1920s. Hanging scroll, ink
and color on alum paper, 49½ ×
25 in. (125.7 × 63.5 cm). Gift of
Robert Hatfield Ellsworth, in
memory of La Ferne Hatfield
Ellsworth, 1986 (1986.267.142)

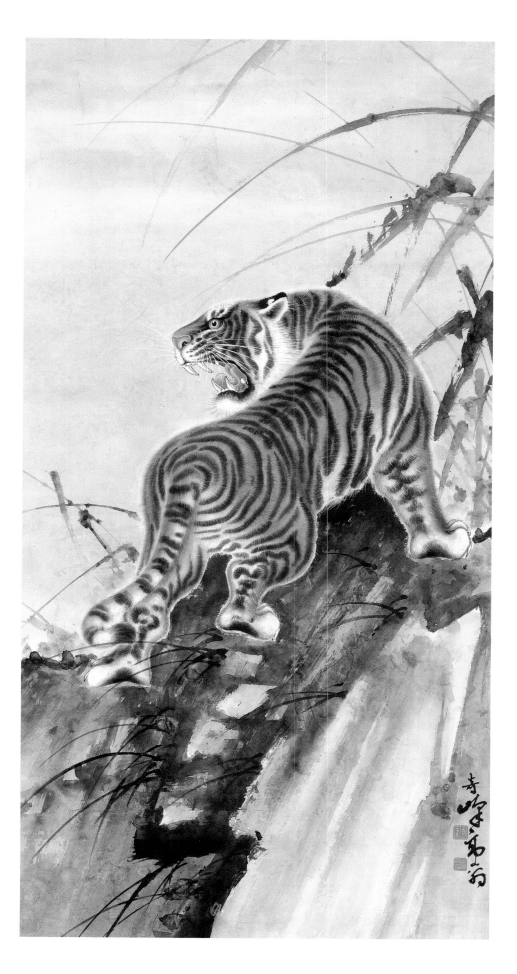

In his study of the leading early-twentieth-century Chinese writer Lu Xun (1881–1936), William A. Lyell, Jr., observes that "by virtue of social position and sentiment...[Lu] was convinced that the burden of responsibility for the state of Chinese society lay squarely on his own shoulders. Intellectually, his mixed Chinese-foreign training made him into a being quite different from the traditional scholar-officials; in terms of spirit, however, he was convinced [as the traditional scholar was] that one's aim in life was self-cultivation carried on for the purpose of improving the human lot."[35] Like Lu, Xu Beihong, with both Chinese and foreign training, remained very much the Confucian scholar-official, committed to highly idealistic pursuits.

Returning to Beijing from Japan in 1918, at the height of the New Culture Movement, Xu adopted Cai Yuanpei's dictum that in the new society religion should be replaced by the fine arts. He gave a lecture entitled "Methods of Reforming Chinese Painting" at Peking University that year:

The decline of Chinese painting has reached its nadir. A civilization should never go backward. But Chinese painting today has gone back fifty paces from twenty years ago, five hundred paces from three hundred years ago...and a thousand from seven hundred years ago![36]

Xu attributed this artistic decline to "traditionalism" and "the loss of the independent and professional status [of the painter]." To transform Chinese painting, he argued, the painter must "keep what is good...change what is bad...and adopt what he can from Western painting." In addition, the Chinese "must forswear the pernicious habit of copying the ancient masters...and instead apply modern technology to a disciplined rendering of 'true' painting."[37]

Xu's mission was to bring Chinese painting into the twentieth century. His conception of modernity as the application of "scientific" methodology to the representational practice of painting was shared by all reformers of Chinese art. "Artists, like scientists," he wrote, "are guided by the search for truth. Just as mathematics is the basis of science, figure drawing provides the foundation for art."[38] Xu inherited— from the late-Qing reformer Kang Youwei, whom he met in Shanghai in 1915—a dislike for the seventeenth-century orthodox masters Dong Qichang and the Four Wangs,[39] and he described traditional Qing landscapes as formalist and artificial (*renzao zilai shanshui*), court-chancellery styles (*guange ti*) responsible for the demise of Chinese art.[40]

Xu interpreted Western art through Chinese theory. Western figural representation, for example, was to be understood in terms of the traditional Chinese dichotomy between form-likeness (*xingsi*) and spirit-resonance (*shenyun*):

It is said that while Chinese art values spirit-resonance, Western art emphasizes form-likeness, not knowing that both form-likeness and spirit-resonance are a matter of technique. While "spirit" represents the essence of form-likeness, "resonance" comes with the transformation of form-likeness. Thus for someone who excels in form-likeness, it is not hard to achieve spirit-resonance. Look at the relief sculptures at the Parthenon, carved some twenty-five hundred years ago in ancient Greece, and see how wonderful they are! It is simply not true that all Western art has no resonance.[41]

Xu's view of Western art was strongly influenced by the conservative academic tastes of his teachers, especially Dagnan-Bouveret. He worshiped classical and Renaissance art, and admired Rodin, Delacroix, Monet, and Degas. He rejected Renoir, Manet, and Cézanne, but he accepted Picasso— while denigrating Matisse. Soon after Xu returned to China in 1927, he engaged in an open debate with the proponents of the Western avant-garde artists and writers who had studied in Europe, most notably the poet Xu Zhimo (1896–1931).[42] When the First National Exhibition of Chinese Art opened in Shanghai in 1929, Xu was critical of the fact that it included, as reference material, reproductions of works by post-Impressionist painters whom he regarded as having pandered to popular taste and succumbed to a desire for commercial success. In an open letter entitled "Puzzlement," addressed to the exhibition organizer Xu Zhimo, he wrote:

For all the mediocrity of Manet, the vulgarity of Renoir, the superficiality of Cézanne, and the inferiority of Matisse, and for all the vileness of their reactionary tendencies through the manipulation by and support of art dealers, their works have become for the public a form of much admired sensationalism. Since the Great War in Europe, with changes in outlook and the decline in the status of the fine arts, the public has turned to what is merely fashionable. It is my hope that our national arts will uphold what is noble and good and that we shall continue to reject fame and financial gain, so that the merchants of this world will not be able to play their wily tricks.[43]

The early 1930s were a time of both high hopes and national crisis. From 1928, when Chiang Kai-shek's Northern Expedition reunified China, to the outbreak of the second Sino-Japanese War in 1937, the Nationalist government in Nanjing succeeded in reducing the number of foreign concessions, restoring tariff autonomy, and regaining control over maritime customs. Oriented toward foreign trade and commerce, China sought Western support in the face of the mounting aggression of Japan. After staging the Mukden Incident in 1931, the Japanese Kwantung Army occupied Manchuria and began moving on northern China. Japan's full-scale aggression in China, beginning in 1937, instigated World War II in Asia. It lasted in China for eight years, until the Japanese surrender in 1945.

For the generation of "returned students" who had studied in the West, life in the 1930s in Westernized coastal cities, especially Shanghai, had the quality of a gilded age. Returning to Shanghai from Europe in 1927, Xu Beihong was first appointed chairman of the South China Art Academy in Shanghai and then invited to join the Beijing Academy of Art as its director. But Beijing, by that time, had lost its luster as an intellectual and artistic center. (Lin Fengmian had just left Beijing to found an academy in Hangzhou.) After settling in at the National Central University in Nanjing in 1929, Xu maintained a high profile in Shanghai, where most important art events took place. It was in Shanghai, in 1929, that his debate with Xu Zhimo, the poet and leader of the modernist literary movement, took place. The two Xus, one thirty-four and the other a year younger, epitomized the Chinese movement in art (*maodun*). Beihong, in particular, sporting a beret and velvet cape and speaking an excellent

FIGURE 51

Jin Nong (1687–1764), *Returning by Boat in a Rainstorm*, dated 1760. Hanging scroll, ink on paper. Xu Beihong Memorial Museum, Beijing

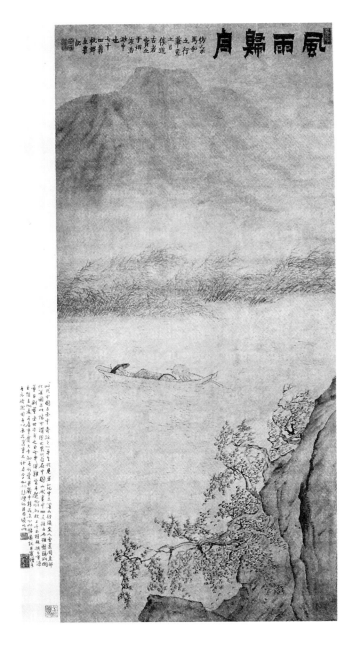

French, cut a dashing figure in the company of chic young women dressed in stylishly adapted Manchu "banner" dresses, French lace, and large picture hats. Both men were involved in romantic affairs in a generation newly liberated from the Confucian strictures of arranged marriages. Zhimo, who died tragically in a plane accident in 1931, was remembered by the public for his unrequited love for the poet and artist Lin Huiyin (1904–1955).[44] And Xu Beihong, in 1930, became involved in an affair with a young woman student, which led to his divorce from his wife.

Xu Beihong's visits, in 1919, to the British Museum and the Musée du Louvre sparked his interest in building a collection of paintings and reproductions to advance the education of the arts in China. Throughout the late 1920s and early 1930s, while he actively exhibited his own paintings in Europe and Singapore, he also campaigned for the establishment of a national art museum.[45] Frustrated by the political atmosphere in Nanjing, he resigned from his post at the National Central University in 1936 and made his way to Guangxi Province in southwestern China. There he served as an adviser to the prowar provincial authorities, whom he also attempted to persuade to establish an art museum in Guilin.[46] His lifelong desire to found a museum was finally realized after his death in 1953, when his family donated his collection to the state and the Xu Beihong Memorial Museum was established in Beijing the following year.[47]

As a collector, Xu's tastes in ancient Chinese paintings were eclectic. By and large, he preferred realism (*xieshi zhuyi*) as exemplified in figural and floral paintings of the Song period. In 1937, on a visit to Hong Kong, he acquired his most

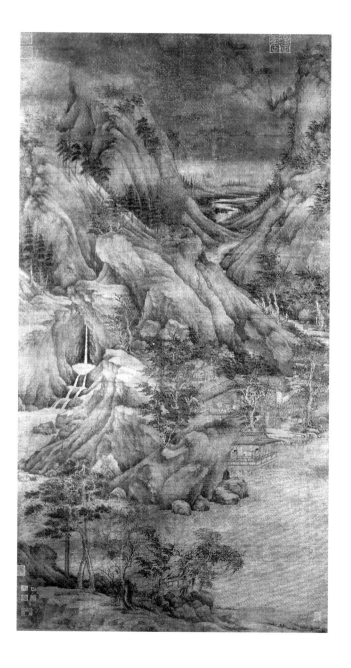

important work, a twelfth-century Song composition entitled
Eighty-seven Immortals, now in the Xu Beihong Memorial
Museum.[48] In general, he was not sympathetic to early Chi-
nese landscapes. For him, they were products of naturalism
(*ziran zhuyi*), which implied decadence and vulgarity and was
responsible for the decline and weakness of later Chinese
art.[49] "There are extant today nearly one hundred Northern
Song landscape paintings, but fewer than one-tenth of these
works can meet our standards," he wrote.[50] One of his favorite
landscapes was *Returning by Boat in a Rainstorm* by Jin Nong
(1687–1764; fig. 51), dated 1760, which conjured up "an atmo-
sphere of change, vast spaces, and spirituality," comparable
to "the landscapes of [J.M.W.] Turner in the Tate Gallery."[51]

In his 1950 colophon on *Returning by Boat*, Xu describes
the work as "[one of] the four great extant Chinese land-
scape paintings":[52]

*Although [scholars] past and present have offered extravagant
praise of [the four ancient landscape masters] Jing Hao, Guan
Tong, Dong Yuan, and Juran, works by Jing and Dong that can
be seen today, as well as those by Juran, are all inferior. None
of these works would be described by me [as excellent].*

He goes on to tell how "in early fall of 1938, [the painter and
connoisseur] Zhang Daqian took from [me] in Guilin a large
hanging scroll by Dong Yuan. Then, in the spring of 1944, when
[I] was living in Chongqing, knowing of [my] special love for
the masterpiece by Jin Nong, he had [a mutual friend,] Zhang
Muhan, bring [*Returning by Boat*] to [me, in exchange for the
Dong Yuan]."

The large hanging scroll was *Riverbank*, an early-Northern Song painting attributed to the tenth-century master Dong Yuan (active ca. 930s–60s; fig. 52) and now in The Metropolitan Museum of Art, which Xu had discovered in 1937 in Yangshou, near Guilin, a remote and impoverished area in southwestern China.[53] Although impressed by the signature and early collectors' seals, Xu neither understood nor especially liked the painting, so he allowed Zhang Daqian to take it with him to Sichuan to "research and authenticate." When Zhang offered in exchange *Returning by Boat in a Rainstorm*, which Xu considered "a miracle among all traditional Chinese landscapes," Xu immediately took him up on his offer.[54] Thus did the landscape by Jin Nong earn its place in the annals of Chinese art history as the work that Zhang Daqian used to win possession of *Riverbank*.[55]

Nature held little appeal for Xu as a painter. In Paris in the 1920s, where he studied life drawing (fig. 53), he was introduced to and greatly admired the work of Rubens, Rembrandt, and Delacroix. By the time he returned to China in 1927, he was painting historical subjects in the style of the late-nineteenth-century Salon painters Ernest Meissonier and Jean Léon Gérôme, and worked both in oil and with Chinese brush and ink. In an essay entitled "The Movement to Revive Chinese Art," published in 1948, Xu stated that his objective was to paint the human figure engaged in activity:

All we see in [Chinese] painting today are the likes of Dong Qichang and Wang Hui . . . artificial man-made landscapes. [In Chinese figure paintings] there is at most a poor beggarlike figure which they call a luohan, or a prettily dressed woman they call a [Bodhisattva] Guanyin. There is not a single composition of more than two figures that is not an embarrassment. . . . In the last three hundred years, except for Ren Bonian and Wu Youru,[56] most Chinese painters are "Suzhou emptyheads" [i.e., devoid of ideas].[57]

Citing the rich heritage of mythological and historical subject matter in the Greco-Roman tradition, Xu enumerated the range of source material from Chinese history and culture:

Although we are relatively wanting in mythological subjects, we have a profusion of historical subjects. There are, for example, descriptions in the ancient text "Liezi" of the imperial palaces of Qingdu, Ziwei, Juntian, and Guang yue, the story of King Yu managing the flood . . . King Pangeng's moving of the capital to Yin, King Wu's overcoming of the tyrant Zhou . . . the affairs of the Spring and Autumn and the Warring States periods . . . the meeting of Xiang Yu and Liu Bang at Hongmen, the conquest of the kingdom of Ferghana by Li Guangli, the pacification of the western regions by Ban Chao, and innumerable others. All such topics require expansive compositions and have seldom been explored by earlier painters. Besides these, there are tales of miraculous cities and unreal places, which give free rein to the imagination, and the folklore of our common people. If we do not exclude superstitious beliefs, the range is truly rich and inexhaustible.[58]

Beginning in the late 1920s, Xu tackled a series of ambitious paintings on historical subjects. *Awaiting the Deliverer* (fig. 54), painted in 1930, portrays a perennial Chinese theme:

FIGURE 53
Xu Beihong (1895–1953), *Figure Studies*, dated 1920. Charcoal on paper.

FIGURE 54
Xu Beihong, *Awaiting the Deliverer*, dated 1930. Oil on canvas, 90½ × 125¼ in. (230 × 318 cm). Xu Beihong Memorial Museum, Beijing

whether it is preferable to rebel against a bad ruler or to wait patiently for a sage deliverer. The composition, in oil, shows a tableau of figures in rags posed dramatically as if on a stage. *The Foolish Old Man Moving the Mountain* (fig. 55), painted in 1940 in Chinese brush and ink and color when Xu was in India, illustrates the story of a man trying to move a mountain that blocks his view, a parable of the heroic but patient Chinese people attempting the impossible. In the painting an old man, a widow, two boys, and a woman oxcart driver appear as Chinese figures; the movers of the mountains are powerfully built Indians. As he explained:

While making this painting in India, I found the perfect model for the strong Lu Zhishen type [Lu Zhishen is a character in the popular Chinese novel "On the Water Margin"] of figures. Not only was this man magnificent in physique but he was straight-forward in character and serious and sincere in demeanor. I liked him so much that I carefully preserved his likeness in my painting.[59]

In departing from objective reality by using non-Chinese figures, Xu invited severe criticism from socialist writers. One of the most outspoken was Tian Han:

In the representation of reality and in the expression of a close relationship between the painter and his social milieu, such [artistic license] is unacceptable. Although [Xu] Beihong professes faith in "realism," in fact he creates an idealized vision

FIGURE 55

Xu Beihong (1895–1953), *The Foolish Old Man Moving the Mountain*, detail, 1940. Handscroll, ink and color on paper, 56¾ × 166¼ in. (144 × 421 cm). Xu Beihong Memorial Museum, Beijing

FIGURE 56

Xu Beihong, Study for *The Foolish Old Man Moving the Mountain*, 1940. Charcoal and white chalk on paper, 17⅞ × 12⅝ in. (45.5 × 32 cm). Xu Beihong Memorial Museum, Beijing

of the world. Because he is intoxicated by seductive capitalist aspirations, the suffering of the Chinese people does not exist in his paintings. And although he represents them, they appear merely as products of his imagination.[60]

Xu had difficulty representing historical subjects in the mode of the French Salon. For although he was a competent draftsman of individual figures, he failed in his attempt to depict many figures in one composition. The paintings are static and awkward, as he was unable to integrate the figures spatially or to make them interact expressively with one another. His attempt to master the technique of Western realism with Chinese brush and ink appears to have been precluded by what Norman Bryson characterizes as the fundamental bifurcation of the two traditions of representational

painting.[61] Xu's dilemma is painfully evident when we compare his far more successful charcoal and white chalk drawing of the Indian model (fig. 56) with the same figure in the finished Chinese brush-and-ink painting. The assertive brush outlines and flat ink wash of the latter fail completely to recapture the effective chiaroscuro modeling in the earlier charcoal study that it replaced.

Xu's struggle to create a technical synthesis of Chinese and Western methods began in 1931, when he painted a large multifigured composition, *Jiu Fanggao, the Astute Judge of Horses*, in the traditional medium of Chinese brush, with ink and color on paper.[62] The subject is the woodcutter Jiu Fanggao, who lived during the Warring States period. Jiu possessed an uncanny ability to judge horses, a metaphor for the selection of China's talented young scholars to serve the coun-

FIGURE 57

Xu Beihong (1895–1953), *Man with Horse*, ca. 1924. Charcoal on paper, 24¾ × 18⅞ in. (63 × 48 cm). Xu Beihong Memorial Museum, Beijing

try. Creating a work with brush and ink on absorbent paper does not allow for the correction, or repainting, of the image once it has been committed to paper. Xu therefore made several versions of the composition before he arrived at one that was acceptable. The final image was his seventh attempt. Xu wrote of this process in painting *Jiu Fanggao*:

In this painting…although I expended much effort, I found that

some of the horses' hooves were still not quite correct. Chinese painting is different from [Western] oil painting, which can be scraped off and repainted. Thus my method was to repeat the composition many times.*[63]*

Long fascinated with paintings of animals, Xu made horses—the traditional symbol of high spirit and courage—his specialty. In the charcoal study *Man with Horse* (fig. 57), made about 1924, he shows his mastery of the animal form in the academic manner of Dagnan-Bouveret. As a reformer, he believed that only a solid foundation in the techniques of Western art could rescue Chinese painting from its decline. He describes his own immersion in such techniques:

In painting horses I have made thousands of quick sketches. Having studied the horse's anatomy, I am thoroughly versed in its bone structure and musculature, and in carefully observing its movement and spirit I have developed a special insight into this subject.[64]

Xu painted *Grazing Horse* (pl. 29), dated 1932, for the son of the traditional-style painter Qi Baishi (1863–1957). In it he combines a realistic, or "scientific," rendering of the form with a spontaneous Chinese brush technique. A classical Chinese horse painting, exemplified by *Night-Shining White* (fig. 4), by comparison delineates the horse by strictly linear means and with a minimum of shading.

In the late 1930s and early 1940s, Xu's famous galloping-horse paintings (fig. 58), churned out with Chinese brush and ink in a realistic style, became a popular wartime symbol of

97

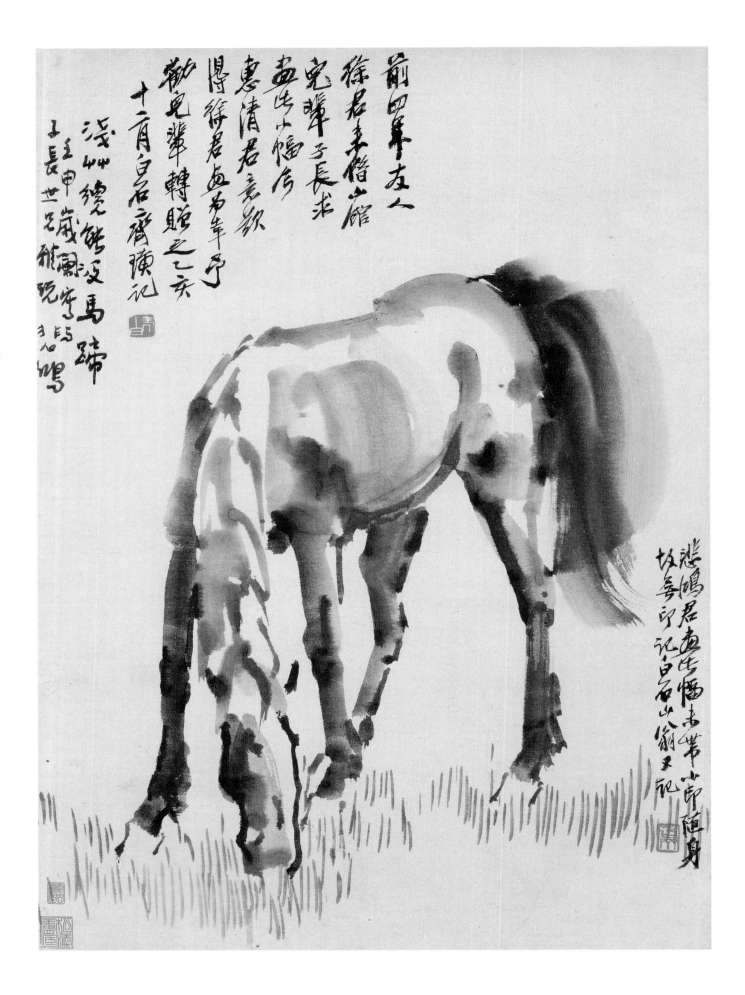

PLATE 29

Xu Beihong (1895–1953), *Grazing Horse*, dated 1932. Hanging scroll, ink on paper, 20½ × 14¾ in. (52.1 × 37.5 cm). Gift of Robert Hatfield Ellsworth, in memory of La Ferne Hatfield Ellsworth, 1986 (1986.267.192)

FIGURE 58

Xu Beihong, *Galloping Horse*, dated 1943, detail. Hanging scroll, ink on paper. Xu Beihong Memorial Museum, Beijing

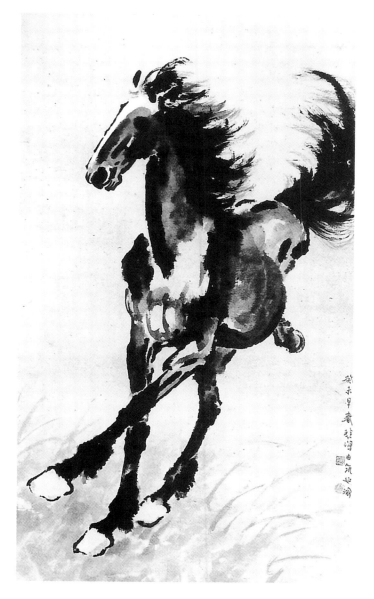

China's spirit and nobility. Michael Sullivan has described how they were produced, "by a kind of assembly-line method, with a dozen sheets of paper laid out on which he painted first the necks, then heads, then manes."[65] Lothar Ledderose has described the paintings as modular works: "In a group of [Xu's] horses, [the viewer] finds similar legs, manes, tails, and equivalent sets of brushstrokes for heads, necks, and chests. A comparative analysis of a large number of [Xu's] paintings reveals how [he] created the bravado of his horses from set parts."[66]

In combining Chinese and Western techniques, Xu was very much aware of the expressive dimension of pictorial representation as exemplified in the concepts of breath-resonance (*qiyun*), and spirit-resonance (*shenyun*): "While 'spirit' represents the essence of form-likeness, 'resonance' comes with the transformation of form-likeness."[67] Although Xu saw the future course for Chinese painting in realistic description (*xieshi*), he also tried to make his brushwork expressive. In *Cypress Tree* (pl. 30), dated 1935, for example, the tree trunk looks less like a living plant than a preserved specimen in an artist's studio. The somewhat heavy-handed brushwork appears more Western-inspired than intrinsically Chinese.

Xu turns, in *A Spotted Cat* (pl. 31), dated 1938, to another favorite subject. Here, the artist's abbreviated brushwork creates animation by focusing on the glowing eyes and upswept tail. He wrote:

In painting a cat, the most important thing is the expression of the eyes, and next its physical movements. This cat has the so-called gold-and-silver eyes considered the mark of a rare breed. I have painted one eye lemon yellow, the other light blue. The

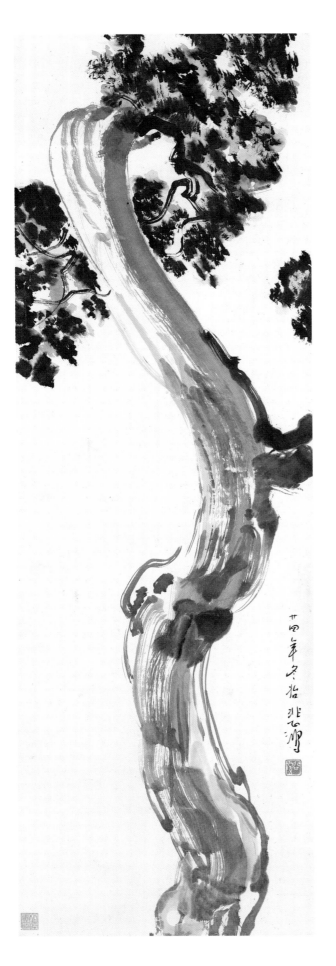

PLATE 30
Xu Beihong (1895–1953), *Cypress Tree*, dated 1935. Hanging scroll, ink and light color on paper, 38⅞ × 12½ in. (98.7 × 31.8 cm). Gift of Robert Hatfield Ellsworth, in memory of La Ferne Hatfield Ellsworth, 1986 (1986.267.193)

cat should be shown in three movements, those of the head, the body, and the tail. One should make the cat's body turn while it looks up and is ready to move forward.[68]

After the establishment of the People's Republic in 1949, Xu was made titular head of the prestigious Beijing National Academy of Art (after 1950, the Central Academy of Fine Arts). Under the strict supervision of the Ministry of Culture, Xu's Sino-Western style was banned in favor of Soviet-style Social Realism. Ironically, it was Xu's legacy of teaching drawing from plaster-cast models at the academy that made the outpouring of Social Realist art possible.

Xu Beihong's lifelong rival was Liu Haisu (1896–1994). A founder and director of the Shanghai Academy of Art and a standard-bearer of the modern art movement in southern China, Liu was highly critical of Xu's academicism. Born to a well-to-do family in Changzhou (Jiangsu), Liu at the age of thirteen attended the Studio for Painting Scenic Backgrounds in Shanghai. There he learned to paint backgrounds for portrait photographers. He also discovered Velázquez and Goya in foreign-language bookstores.[69] In 1912, dissatisfied with the curriculum at the studio, Liu and two fellow painters started their own art school, which later became the Shanghai Academy of Art, a center for Western-style art education in pre-World War II China.

In 1919, Liu attended the opening of the First Exhibition of the Imperial Academy of Fine Arts in Tokyo.[70] He made a second visit to Japan in 1927 and, with the support of the former chancellor of Peking University, Cai Yuanpei, he was sent to Europe on a two-year study trip, visiting France, Italy, Belgium,

PLATE 31

Xu Beihong (1895–1953), *A Spotted Cat*, dated 1938. Folding fan mounted as an album leaf, ink and color on gold-flecked paper, 7½ × 20 in. (19.1 × 50.8 cm). Gift of Robert Hatfield Ellsworth, in memory of La Ferne Hatfield Ellsworth, 1986 (1986.267.194)

101

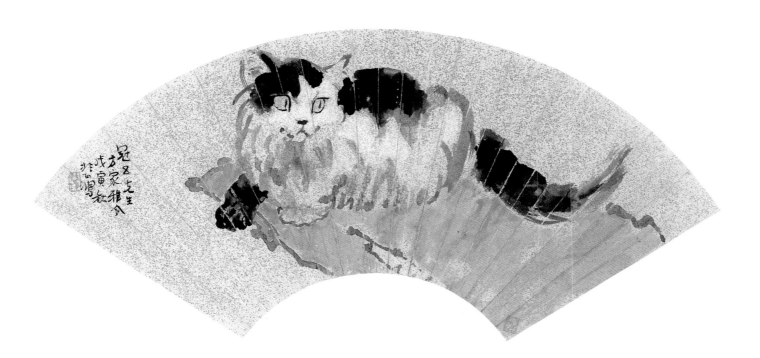

and Germany. During this time he exhibited at the Salon in Paris, was given an award in Brussels, and lectured in Frankfurt on the Six Principles of Xie He. On a second visit to Europe, in 1933–35, he helped to organize an exhibition of contemporary Chinese paintings in traditional-style brush and ink, which opened in Berlin and traveled to other cities in Germany and to Holland, Switzerland, England, and Czechoslovakia.[71]

In the early 1930s, both during and after his European travels, Liu wrote with admiration about Cézanne, van Gogh, Matisse, Picasso, and other avant-garde European painters, and he attacked the academic style represented by Xu Beihong. In 1935 he wrote:

Like the Cubists…[the Fauves] were drawn to something that lies beyond nature.… The Fauves were opposed to those who neglected personal expression in favor of nature's surface appearance.… In applying to their work the lessons of Cézanne, Seurat, and Renoir, they initiated a surge of creativity that transformed Impressionist techniques into a new art which enabled them to build on the foundations of Impressionism and reach for something that is far richer than the traditionally based new academicism.[72]

The following year, Liu wrote pointedly about his conflict with Xu's dogmatic conservatism by defending the artist's right to choose his or her own style:

Because I love the works of Cézanne, Matisse, and others, those who condemn them have attacked me relentlessly, resorting to sarcasm and scorn without end.… In [our] modern painting, except for our objection to the academic school, we have neither

102

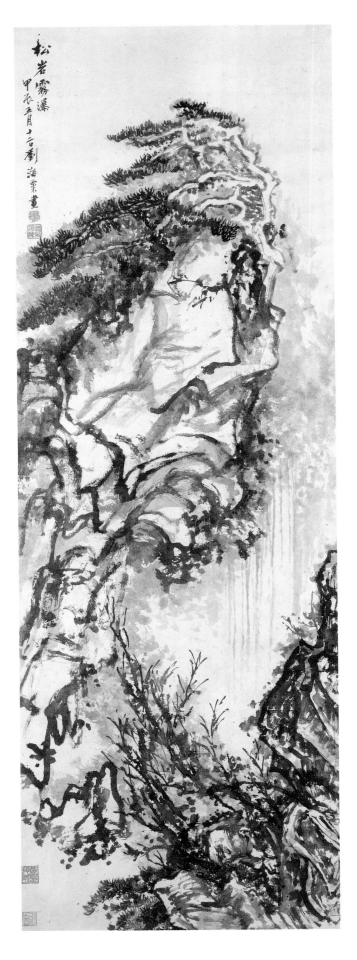

PLATE 32
Liu Haisu (1896–1994), *Pine Cliff and Waterfall*, dated 1964. Hanging scroll, ink on bark paper, 75 × 26 in. (190.5 × 66 cm). Gift of Robert Hatfield Ellsworth, in memory of La Ferne Hatfield Ellsworth, 1986 (1986.267.366)

FIGURE 59

Shitao (1642–1707), *Sixteen Lohans*, dated 1667, detail. Handscroll, ink on paper, 18¼ in. × 20 ft. ½ in. (46.4 × 597.7 cm). The Metropolitan Museum of Art, Gift of Douglas Dillon, 1985 (1985.227.1)

FIGURE 60

Woodblock-printed illustration of "The Lotus Peak," from the *Gazetteer of Yellow Mountain*

rebelled against nor departed from our own tradition. For as long as painting is not bound by academicism, the painter shall be at liberty [to choose his own path,] and each may develop his own special technique and style. The complexity of modern painting is a reflection of this diversity.[73]

Liu, although immersed in the study of new European art during his travels, increasingly reflected on his own artistic heritage. In 1935, he published a history of Chinese painting from the Eastern Jin (317–420) up to the modern era.[74] As early as 1923, he had written an essay comparing the seventeenth-century individualist master Shitao (fig. 9) with post-Impressionist painters.[75] And in 1932, he wrote:

About 1914, I discovered two great artists: Cézanne of France and Shitao of China. I was nineteen at the time.... Shitao's

paintings "express" rather than "represent." What is expression? It is the subjective manifestation of a personality that comes from one's heart; when expressed in an objective manner, it radiates outward from inside. What is representation? It is taken from nature. It is not created, but is a reflection of the outside world; it is not artistic expression, it is a [literal] recording of what is found in nature.... In the history of Chinese art from Wang Wei to the present, over a span of 1,168 years, there has been no shortage of fine art, but no one can equal the greatness of Bada Shanren and Shitao.[76]

Thus, two competing directions came to mark Liu's career. On the one hand, he was a self-taught Western-style oil painter who used strong colors to enrich his compositions. As head of the Shanghai Academy of Art he contended with conservatives who objected to his introduction of drawing

104

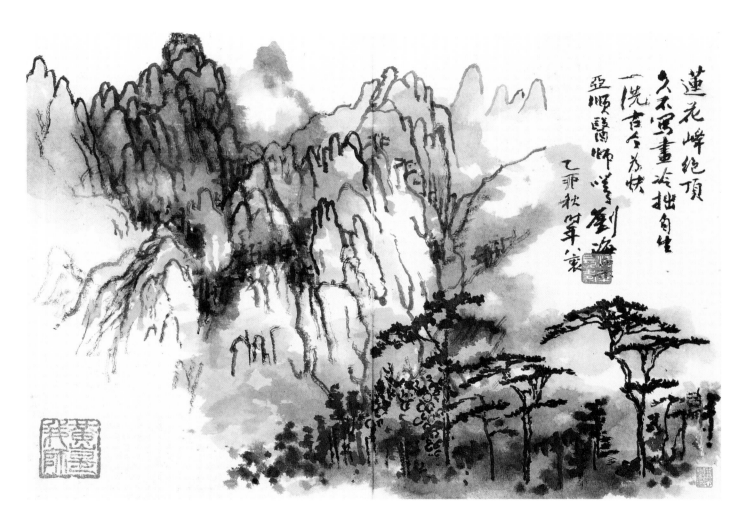

from the nude, which was unprecedented and therefore shocking for the Chinese public. And on the other, he returned in the late 1930s and 1940s to painting with brush and ink on paper. After the academy had been absorbed by the East China College of Art in the 1950s, he continued to paint both in brush and ink and in oil.

Two paintings from his late period show Liu's efforts to incorporate these often conflicting idioms. In *Pine Cliff and Waterfall* (pl. 32), dated 1964, he paints the scenery at Yellow Mountain in Anhui Province in a manner reminiscent of Shitao; indeed, in the lower left corner, Liu's seal quotes Shitao's "Yellow Mountain is my teacher." Compared with

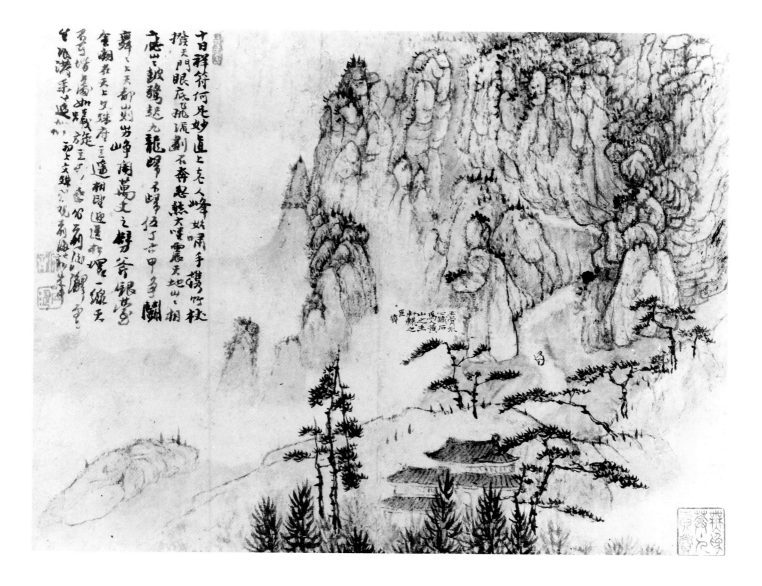

FIGURE 61
Shitao (1642–1707), *Eight Views
of Yellow Mountain*, late 1690s.
Album leaf, ink and color on
paper. Kanichi Sumitomo
Collection, Oiso

Shitao's "On the Mountain Peak" (fig. 9), however, Liu's painting reflects his encounter with Impressionism. The forms in *Pine Cliff and Waterfall* are built largely in terms of light and space; Shitao's landscape art is based on traditional Chinese texture methods (*cunfa*). In his "Recorded Sayings," Shitao enumerates thirteen kinds of texture methods: curling cloud (*juanyun cun*), hemp fiber (*pima cun*), unraveled rope (*jiesuo cun*), and so forth.[77] *Sixteen Lohans* (fig. 59), dated 1667, employs the unraveled-rope texture to describe the concentric striation patterns of the boulders. Energy and movement are generated by the texture patterns and fluid calligraphic brushwork.

Liu paints another favorite subject of Shitao's, *Lotus Peak* (pl. 33), dated 1975, one of the sites of Yellow Mountain (fig. 60). Rising some 5,800 feet over a sea of clouds, the second tallest peak of Yellow Mountain resembles a magic lotus blossom soaring skyward from the water. Shitao's *Eight Views of Yellow Mountain* (fig. 61), dating from the late 1690s, is drawn from an image that the artist had seen thirty years earlier.[78] In his "Recorded Sayings," he explains the transformation of nature into art:

Real mountains are distinct, one from another. . . . Only when a mountain is rendered into texture patterns does it grow . . . [and] only by texture patterns is a mountain in nature transformed. A mountain can reveal itself only when it is expressed through texture patterns.[79]

By contrast, Liu's *Lotus Peak* is based on a sketch from nature, a practice he taught at the modern art school, using linear perspective and atmospheric ink wash. Thus Liu, despite his admiration for Shitao, whose artistic achievement he compared with that of Cézanne, joined the quest for the reinvention of landscape painting by combining a Chinese with a Western aesthetic.

FU BAOSHI'S NATIONALISTIC ART MOVEMENT

In the 1920s, at the height of political ferment, the National People's Party, or Guomindang, under the leadership of Sun Yat-sen, instigated a revolution to reunite China. Supported by the Comintern, the Third International of the Communist Party, established by Vladimir Lenin in 1919, the Guomindang formed an alliance with the nascent Chinese Communist Party (founded in 1921), but the alliance soon failed. After the death of Sun Yat-sen in 1925, the military and political leadership of the Guomindang passed to Chiang Kai-shek. Chiang staged a coup against the Communists in Shanghai in 1927, and the remnants of the Communist forces were driven underground. Thus began a long civil war between the Guomindang and the Communists. Chiang's anti-Communist "extermination campaigns" resulted in the Communist Long March in 1934, a retreat to the northwest under the leadership of Mao Zedong, who established a new territorial base in Yan'an (Shaanxi).

Japan, taking advantage of China's political and military weakness, invaded Manchuria in 1931. Nevertheless, Chiang followed a strategy of "unification [against the Communists] before resistance [against Japan]." He was kidnapped, in late 1936, by anti-Japanese troops and forced to accept a second

united front with the Communists in the fight against Japan. In 1937 the Nationalist government, retreating from the Japanese invaders, withdrew westward, to Sichuan Province. Full-scale conflict between the Nationalists and the Communists resumed in 1946, leading to the removal of Chiang's government to Taiwan in 1948 and the establishment of the People's Republic of China in 1949.

Although he was never formally associated with the Gao brothers, who worked mostly in the 1930s and early 1940s, Fu Baoshi (1904–1965) was heir to Gao Jianfu's new Chinese painting movement.[80] Born in the city of Nanchang (Jiangxi), to a family of farmers who had left their rural life to work in an umbrella shop, Fu was apprenticed at age thirteen to a ceramic shop where he studied seal carving, calligraphy, and painting in his spare time.[81] He graduated in 1926 from the First Normal College in Nanchang and

became an art teacher. In 1931 he met Xu Beihong, then a professor at the National Central University in Nanjing, when Xu was visiting Nanchang. With Xu's help, Fu obtained financial assistance from the provincial governor in 1932 to study art and industrial craft in Japan. In early 1934, he enrolled in the Imperial Academy of Fine Arts (now Musashino Fine Arts University) in Tokyo.[82] After returning from Japan in 1935, he was invited by Xu to teach at the National Central University. In 1937, he joined the resistance against the Japanese and participated in a campaign in Jiangxi of anti-Japanese propaganda under Guo Moruo (1892–1978), who was later a vice premier and chairman of the National Committee on Culture and Education under the People's Republic. In 1940, Fu rejoined the National Central University in the wartime capital of Chongqing (Sichuan). After the establishment of the People's Republic,

108

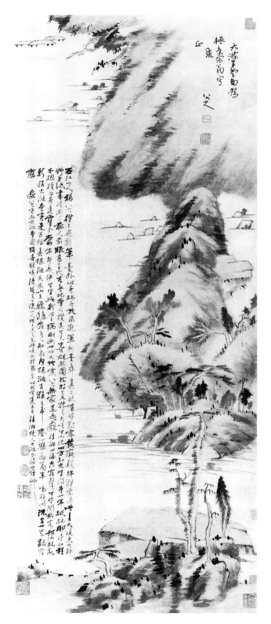

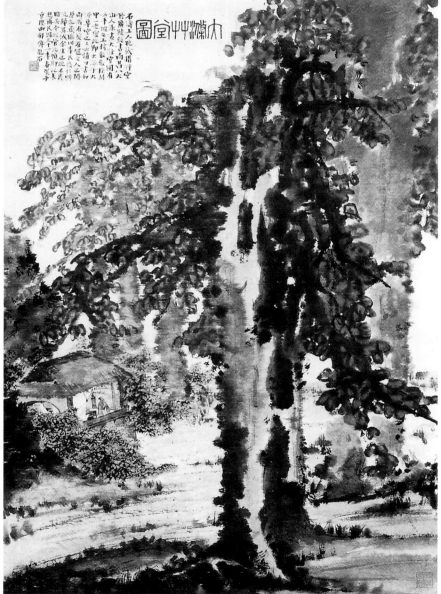

FIGURE 64

Zhang Daqian (1899–1983), forgery of *Thatched Hut of Great Cleanliness*, signed as Bada Shanren, ca. 1925. Hanging scroll, ink and color on paper, 72½ × 28⅜ in. (184 × 72 cm). Nagahara Oriharu Collection, Japan

FIGURE 65

Fu Baoshi (1904–1965), *Thatched Hut of Great Cleanliness*, dated 1940. Hanging scroll, ink and color on paper, 33½ × 22⅞ in. (85 × 58.1 cm). Fu Baoshi Family Collection, Nanjing

he resumed teaching at the Central University, now back in Nanjing, and became a much honored artist of the new regime. He died in 1965.

Fu's study of Chinese art history began in Japan under Kanehara Shōgo, whose book *Painting of the Tang and Song Periods* Fu translated into Chinese in 1935.[83] He also compiled a book entitled *Biographies of Nationalistic Artists of the Late Ming Period* (1939). Based on research by the Japanese scholar and collector Yamamoto Teijirō (1870–1937), it included a preface by Guo Moruo.[84] In the book, Fu highlights the lives of Bada Shanren and Shitao, two seventeenth-century *yimin* (leftover citizens) who were described by Fu as nationalistic (*minzu*) because of their anti-Manchu sentiments.

Between 1933 and 1941, Fu Baoshi published six studies on the life of Shitao.[85] These led to the final publication, in 1948, of his major scholarly work, *A Chronology of the Eminent Priest Shitao.*[86] As *yimin*, Bada and Shitao had lived under assumed names to conceal their identities. The only direct reference to the ages of the two artists appears in a document known as *Shitao's Letter to Bada Shanren* (fig. 62), dating from late 1698.[87] In 1926, the Nanga painter and scholar Hashimoto Kansetsu (1883–1945) quoted from a Japanese transcription (with two critical passages marked "illegible"; see pages 183–84) of that letter in his *Sekito* (Shitao), the first major Japanese study of that master. Two years after Hashimoto's publication appeared, in 1928, another version of the letter, attributed to Shitao (fig. 63), was published by its owner, Nagahara Oriharu (1893–after 1961), a Japanese doctor and collector of Chinese paintings living in Dalian, Liaoning Province (then

Manchuria). Nagahara also happened to be the owner of a large landscape painting purportedly by Bada entitled *Thatched Hut of Great Cleanliness* (fig. 64).[88] The Nagahara letter, which was exhibited with *Thatched Hut of Great Cleanliness* at the art gallery Kyukyo-dō in Ginza, Tokyo, in 1935, was generally accepted by Japanese scholars as evidence of Shitao's birth date, which, according to the Nagahara letter, was 1630 or 1631. Fu Baoshi in 1948, relying on Japanese scholarship, settled on 1630 as the year in which Shitao was born.[89]

But the Nagahara letter and *Thatched Hut* were, in fact, forgeries made by the brilliant painter Zhang Daqian (1899–1983), who fabricated the letter and altered the ages mentioned in the letter in order to "document" and sell the bogus painting.[90] (Zhang Daqian's activities as a connoisseur, collector, and forger of classical Chinese paintings are discussed in chapter 3.) The lifelong interest in Shitao and Bada Shanren of both Fu Baoshi and Zhang Daqian began partly as a Chinese response to the Japanese fascination with these two masters. Unlike Fu, whose work as a scholar and painter were quite distinct, however, Zhang the painter was inseparable from Zhang the collector and forger. In the tradition of classical Chinese connoisseur-artists such as Mi Fu (1052–1107), Zhao Mengfu (1254–1322), and Dong Qichang (1555–1636), Zhang studied painting as both a collector and a painter, and painted with the eye of a connoisseur.

By contrast Fu Baoshi, an academic who had little experience with original works of art, learned about Shitao primarily through secondary sources and reproductions. The colophon on his own painting, *Thatched Hut of Great Cleanliness* (fig. 65),

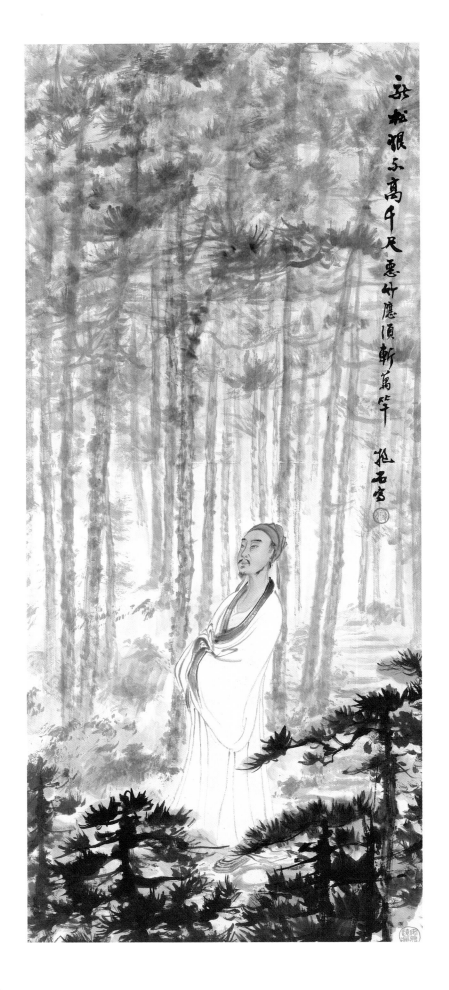

PLATE 34

Fu Baoshi (1904–1965), *Man in a Forest*, early 1940s. Hanging scroll, ink and color on paper, 41½ × 18 in. (105.4 × 45.7 cm). Gift of Robert Hatfield Ellsworth, in memory of La Ferne Hatfield Ellsworth, 1986 (1986.267.276)

FIGURE 66

Photograph of Fu Baoshi, ca. 1959.

dated 1940, indicates that he re-created Shitao's studio based on the Nagahara letter: "On a flat slope, a few old houses surrounded by ancient trees; an upper room with nothing in it is the Hall of Great Cleanliness." Stylistically, Fu's painting has of course nothing to do with either Shitao or Bada, but the colophon, written by Fu's friend and mentor Xu Beihong, claims that although "Bada Shanren's *Thatched Hut of Great Cleanliness* is no longer extant, I know it cannot be better than this work."[91]

Preoccupied in the 1930s with art-historical research, Fu did not devote himself seriously to painting until after he settled, after 1939, in the wartime capital of Chongqing. *Man in a Forest* (pl. 34), a self-portrait dating from the early 1940s

(compare the photograph of Fu dating from about 1959 in fig. 66), shows the artist lost in a thick grove of trees and brambles.[92] Fu's colophon on the painting quotes two lines from the poet Du Fu (712–770):

Pity that the young pine trees cannot grow a thousand feet tall,
So let the thicket of bamboo be cut down by the tens of thousands![93]

These lines evoke a familiar refrain in ancient literature that rails against how good is often overwhelmed by evil. Thus the *Chuci* (Songs of the South) laments:

Now fragrant and foul are mixed together.
Who, though he labored all night, could distinguish between them?
Why have the sweet flowers died so soon?
A light frost descended and mowed them down.[94]

Fu painted several portraits of himself in the guise of historical figures, comparing himself with disillusioned patriots, such as the poet Qu Yuan and the recluse Tao Yuanming, who were earlier portrayed by Yokoyama Taikan (figs. 41, 42). In 1953 he portrayed himself as Qu Yuan, with bushy eyebrows and sad eyes (fig. 67). In this and other works, Fu combines Chinese brushwork with Western-style chiaroscuro modeling, in what Gao Jianfu had called the middle path between Eastern and Western art. In *Portrait of Tao Yuanming* (pl. 35), dated 1947, Fu is shown with an attendant

112

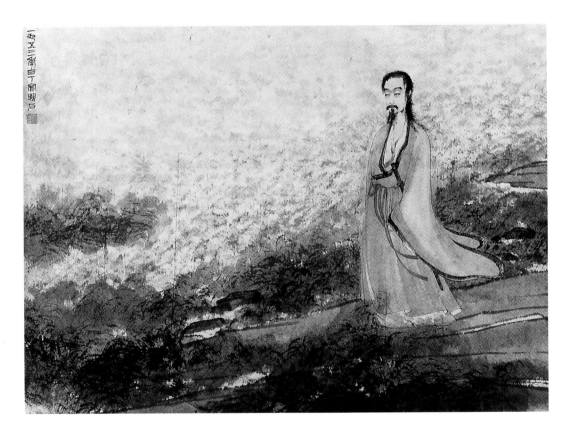

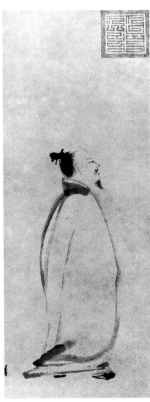

figure possibly modeled after one of his sons.[95] For a similar subject of a standing figure (fig. 41), Yokoyama Taikan had shown the carefully crafted Nihonga technique of applying smooth ink lines and flat color washes on a nonabsorbent surface. Fu used this technique on absorbent paper, executing his figures rapidly with simplified brushstrokes. One might compare Fu's figure with *The Strolling Poet Li Bo,* by Liang Kai (fig. 68), a work that Fu greatly admired.[96] While Liang Kai's spontaneous brushwork in capturing the image

becomes transparent and virtually disappears, Fu's image now combines a realistic rendering of the form with a spontaneous Chinese brush technique.

Developing the theme of Qu Yuan and topics related to the poet, Fu frequently made images of the Goddess of the River Xiang.[97] In one such painting (pl. 36),[98] dated 1947, Fu quotes a line from the "Nine Songs": "Gazing into the distance, how sad she looks"—a description of the classical Chinese beauty yearning for her lover.[99] Fu is believed to have used

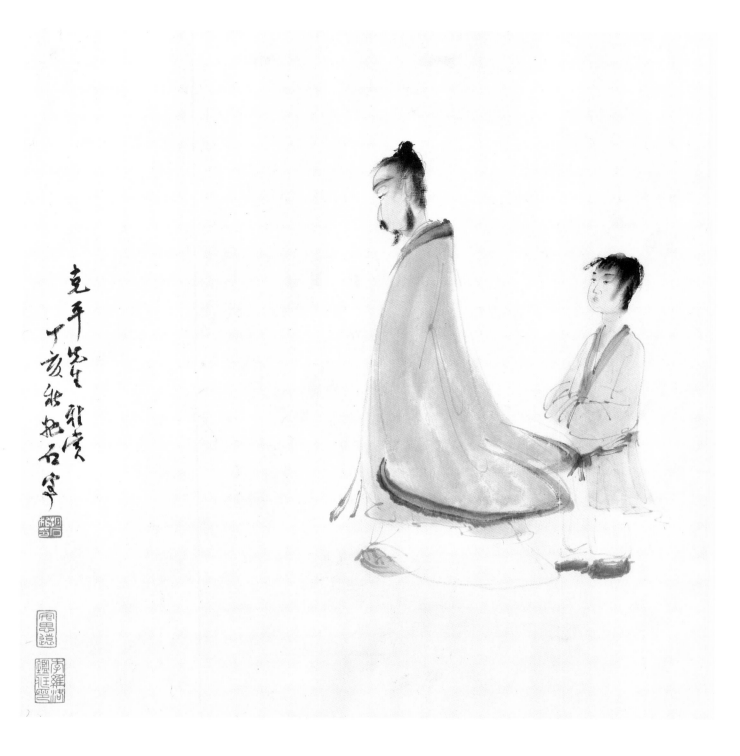

his wife, Luo Shihui, as his model.[100] While Fu's image of feminine beauty continues in the classical mode of the fourth-century painter Gu Kaizhi's *Admonitions of the Instructress to the Court Ladies* (fig. 2), the modeling of the three-dimensional, volumetric figure now reflects Taikan's Western-influenced realistic style.

In *Playing the Qin and Watching Geese in Flight* (pl. 37), dated 1948, Fu places the poet in a familiar classical composition, that of Wild Geese Descending to a Sandbar, one

of the Eight Views of the Xiao and Xiang Rivers.[101] The flat zigzag patterns rendered in flat ink washes are borrowed from Taikan's *Wild Geese Descending to a Sandbar* (fig. 44), but the bleakness of Fu's scene would appear to reflect the artist's own unhappiness.[102]

A large painting dating from about 1945, *Playing Weiqi at the Water Pavilion* (pl. 38), exemplifies the finest of Fu Baoshi's figure paintings. One of the Four Elegant Accomplishments of Chinese literati culture (together with playing the *qin*,

PLATE 36

Fu Baoshi (1904–1965), *Goddess of the River Xiang*, dated 1947. Album leaf, ink and color on paper, 10½ × 12⅞ in. (26.7 × 32.7 cm). Gift of Robert Hatfield Ellsworth, in memory of La Ferne Hatfield Ellsworth, 1986 (1986.267.277)

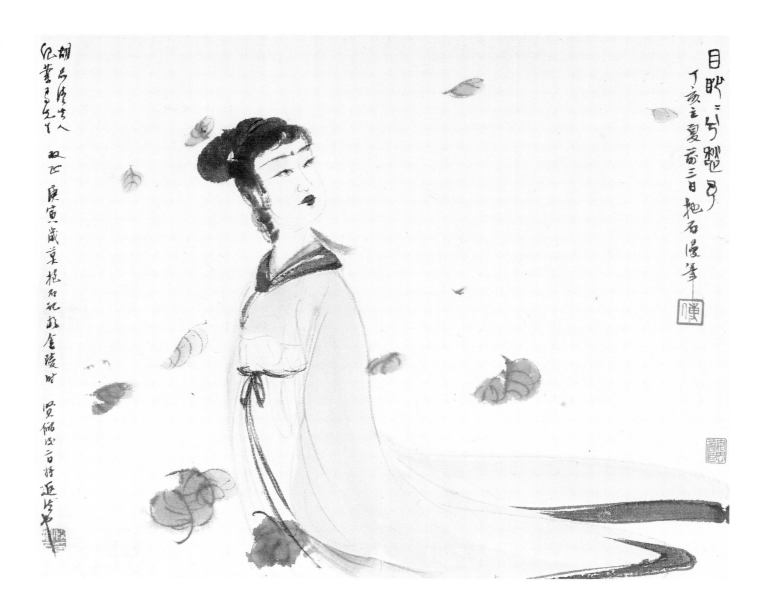

PLATE 37

Fu Baoshi (1904–1965), *Playing the Qin and Watching Geese in Flight*, dated 1948. Hanging scroll, ink and color on bark paper, 14¼ × 23¾ in. (36.2 × 60.3 cm). Gift of Robert Hatfield Ellsworth, in memory of La Ferne Hatfield Ellsworth, 1986 (1986.267.278)

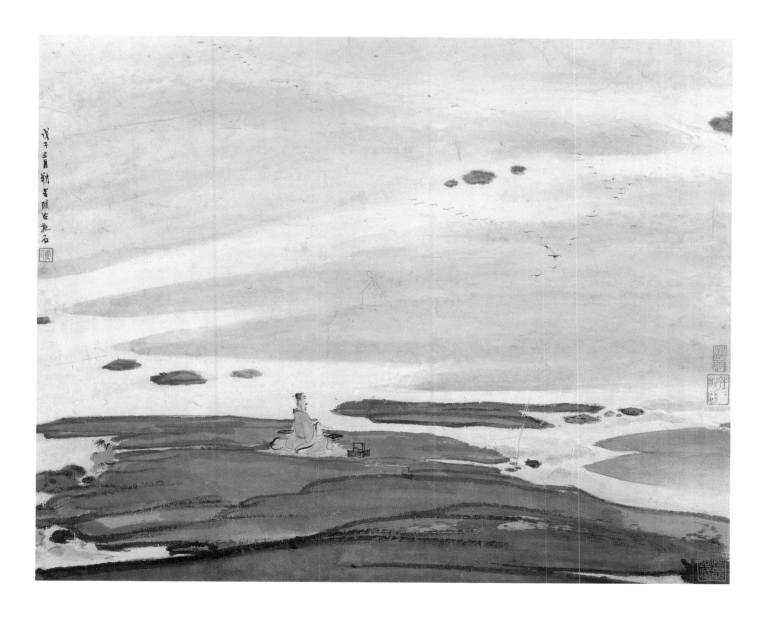

THE WESTERNIZERS

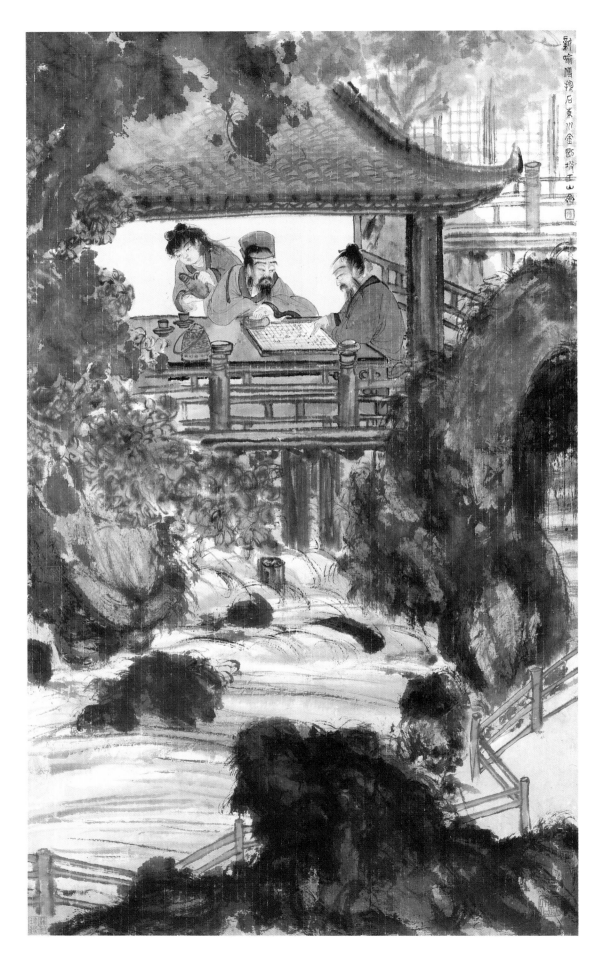

Fu Baoshi (1904–1965), *Playing Weiqi at the Water Pavilion*, ca. 1945. Hanging scroll, ink and color on Korean paper, 49¾ × 29½ in. (126.4 × 74.9 cm). Gift of Robert Hatfield Ellsworth, in memory of La Ferne Hatfield Ellsworth, 1988 (1988.324.3)

Kano Takanobu (early 17th century), *Chinese Figures in a Landscape: Playing Go*, ca. 1609, detail. From the Ryōanji. Ink and gouache on gold paper. Seattle Art Museum, Gift of Carmen M. Christensen (92.33.1)

writing calligraphy, and painting), playing *weiqi* (in Japanese, *go*) was a favorite subject in Momoyama-period Japanese paintings (fig. 69). Again, the influence of Taikan's *Qu Yuan* is paramount in Fu's well-modeled and dark-complexioned figures (page 75), as well as in the overall darkly dramatic tonality of the painting. Fu's skillful handling of the play of light and the contrast of the black rocks with the uninked paper of the water reflects his mastery of Western watercolor techniques. He also infuses Taikan's smoothly finished chiaroscuro technique with the Chinese concept of the writing of ideas and feelings (*xieyi*), rapidly executing calligraphic brushwork and splattered ink wash.

But in spite of his indebtedness to Japanese artistic models, Fu's beliefs were strongly nationalistic. While studying in Tokyo in the mid-1930s, he began to formulate his thinking on the purpose of art education for strengthening and modernizing China. The following quote is taken from his war-time essay "From the Viewpoint of Chinese Artistic Spirit, Our War of Resistance Shall Prevail" (1938–39):

In the vanguard of our time, we are core members of our Nationalistic Cultural Movement [Minzu Wenhua Yundong], and we can lead the masses...to appreciate our national arts.... Once we recognize the true meaning of our Nationalistic Cultural Movement,...we must unite under the single objective of developing the creative spirit of our great Chinese people. By absorbing to the fullest the new ideas and technologies of the modern world, as we once assimilated the civilizations of Central Asia and India during the Han and Tang periods, we shall build a brilliant future for the national arts of China.[103]

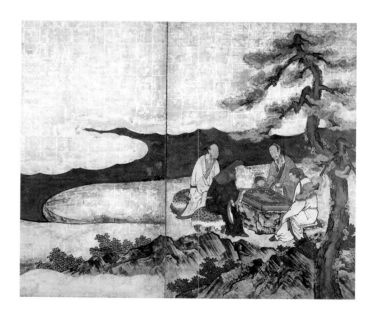

Although Fu admired all the great classical masters, especially Shitao,[104] he departed considerably from their styles. In his exploration of how Chinese painting had evolved from realistic description to the writing of ideas and feelings, and from using colors to using primarily ink wash, Fu concluded, in an essay published in 1940, that "the future course [of Chinese painting] lies in the development of landscape painting, the writing of ideas, and the use of ink wash."[105] He believed that "the beauty of a painting will affect the viewer if it first affects the painter,"[106] and that a successful painting employs calligraphic brushwork which emerges from physicality and emotion. "When my brush courses over the silk, with water and ink running freely," he wrote, "I can hardly distinguish what is brushwork from what is paper." Recollecting stories of artists painting as if possessed, he added, "This is not

PLATE 39

Fu Baoshi (1904–1965), *Fisherman,*
dated 1947. Hanging scroll, ink
and color on paper, 21 × 17⅜ in.
(53.4 × 44.2 cm). Robert H.
Ellsworth Collection

118 mythology, just as Zhuangzi's story of the Song painter stripping off his clothing while painting is not a legend!"[107]

Thus, in the tradition of "inspired" painters who worked under the influence of spirits, Fu often painted while inebriated. *Fisherman* (pl. 39), dated 1947, shows a desolate mountain view. Other than a fishing boat and fisherman, the painting comprises only two contrasting patterns of swirling brushwork and ink wash, one that is dark in the foreground and one that is light in the background. The artist's colophon reads: "What a sight of waste and desolation!"

According to family and friends who witnessed the artist at work, Fu often began a painting by first marking out large patterns in bold brushwork and ink wash, and then hanging it up for several days to study before completing it by adding details.[108] During this process, Fu would "discover" images in the abstractions of his forms. He related this approach to that of the Eccentric eighth-century painter Wang Mo, who painted with splashed ink, and to the eleventh-century master Guo Xi (fig. 5), who created landscapes by splattering plaster on a wall and making visual associations to the images produced.[109] In *Visiting the Mountain* (pl. 40), dating from about 1945, abstract patterns of brush and ink are given landscape form by the presence of a lone traveler, a path trailing behind him in the foreground. And in *Yangzi Gorge* (pl. 41), also dated 1947, two towering cliffs in dark colors flanking a shining expanse of water frame a luminous view of the natural spectacle, with tiny sailboats swept perilously down the rapids. By tilting the foreshortened river into the picture plane, Fu combines the traditional Chinese principle used in monumental landscape painting, that of

vertical superimposition to suggest depth, with linear perspective, used in European painting.

After the establishment of the People's Republic, Fu began to make paintings of revolutionary subjects and paintings that illustrated the poetry of Mao Zedong. In 1957, he was appointed committee chairman in charge of the planning of the new Jiangsu Provincial National Painting Academy in Nanjing, and was named its first director in 1960. Also in 1957 he led an official delegation of Chinese artists to Romania and Czechoslovakia. He wrote an article in 1961 in *The People's Daily* entitled, "When Ideology Changes, Style Must Also Change!"[110] In 1959, he was given the most prestigious commission by the government, the decoration of the Great Hall of the People in Beijing. For this Fu painted, with the collaboration of the Cantonese painter Guan Shanyue (1912–2000), a landscape nearly thirty feet wide illustrating a line of poetry by Mao, "How beautiful are our rivers and mountains" (fig. 70), in which a red sun in the eastern sky symbolizes the Red Army slogan "East is Red."[111] To achieve a vision of monumental grandeur, Fu turned to a formal descriptive style with a highly finished chiaroscuro that recalls the lessons of the Nihonga school, which he had studied early in his career in Japan. The grand but lifeless painting echoes in its composition a work by Taikan entitled *The Great Shining Japanese Nation of Eight Islands* (fig. 71), dated 1941. The painting, which depicts the imperial Japanese nation, was presented to the emperor of Japan just before the Japanese attack on Pearl Harbor on December 7 of the same year. It is not known whether Fu Baoshi's painting is a copy of Taikan's 1941 composition or of a similar, earlier work by Taikan.[112] Fu's painting set the tone for government-sponsored monumental

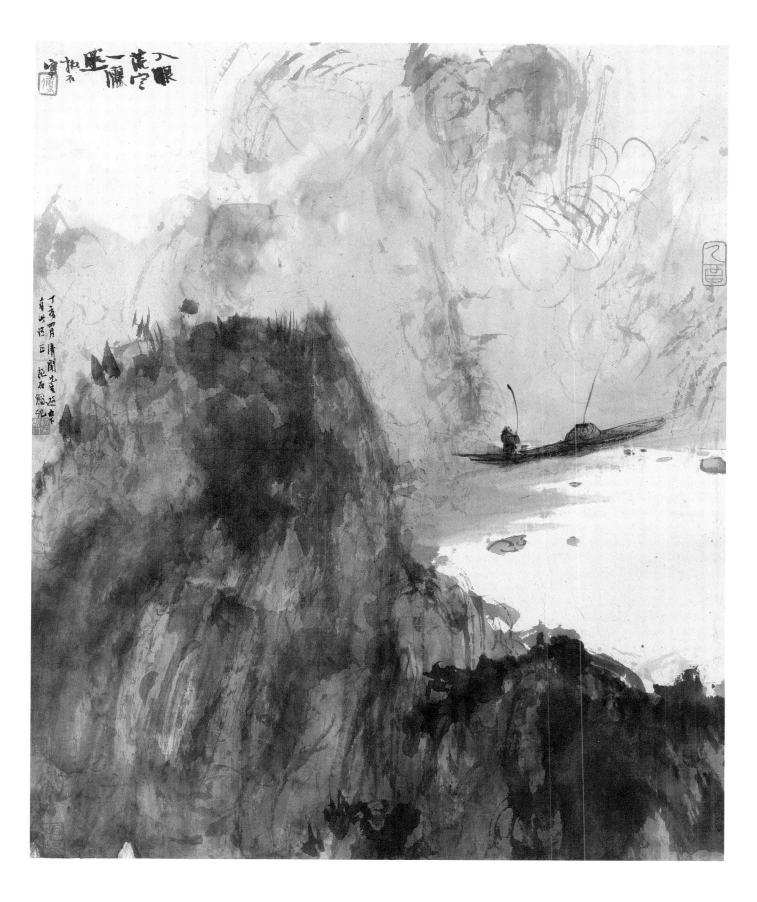

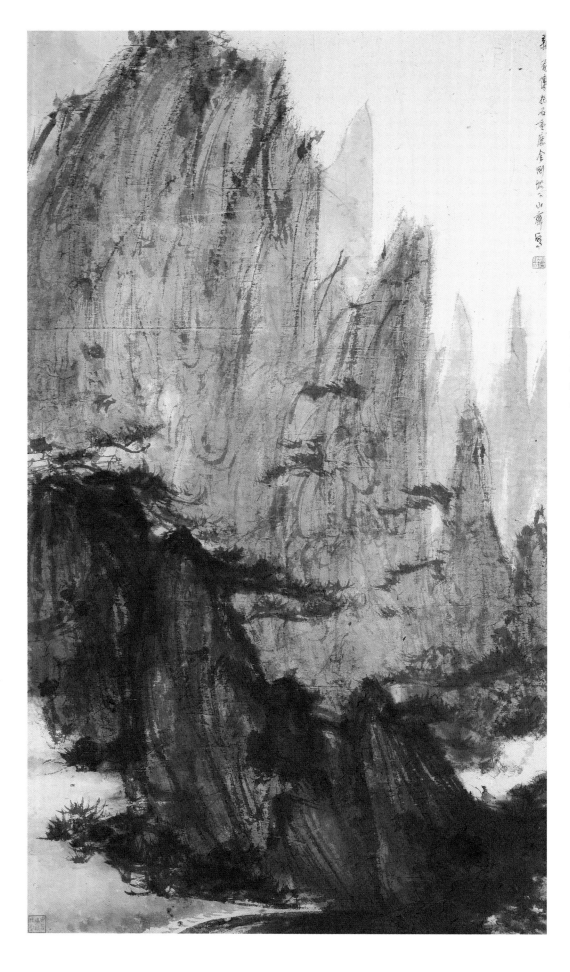

120

PLATE 40
Fu Baoshi (1904–1965), *Visiting the Mountain,* ca. 1945. Hanging scroll, ink and color on paper, 42½ × 23⅝ in. (108 × 60 cm). Robert H. Ellsworth Collection

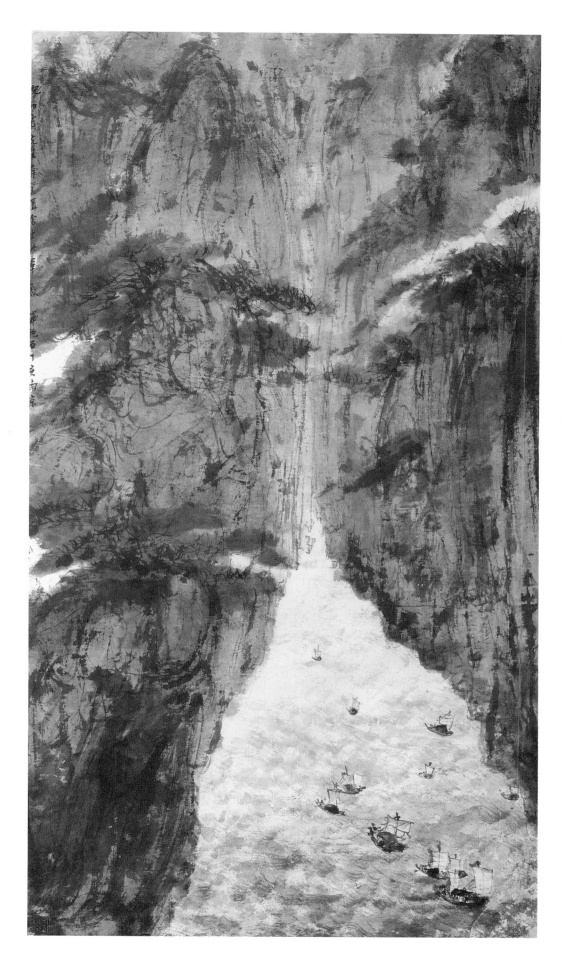

PLATE 41

121

Fu Baoshi (1904–1965), *Yangzi
Gorge*, dated 1947. Hanging
scroll, ink and color on paper,
40½ × 20¼ in. (102.9 × 56.5 cm).
Robert H. Ellsworth Collection

FIGURE 70

Fu Baoshi (1904–1965), *How Beautiful Are Our Rivers and Mountains*, dated 1959. 22 ft. 4 in. × 29 ft. 6 in. (6.5 × 9 m). Great Hall of the People, Beijing

FIGURE 71

Yokoyama Taikan, *The Great Shining Japanese Nation of Eight Islands*, dated 1941, detail. Handscroll, ink and color on paper, 18½ in. × 95.2 ft. (47 cm × 29.03 m). Imperial Household Museum, Tokyo

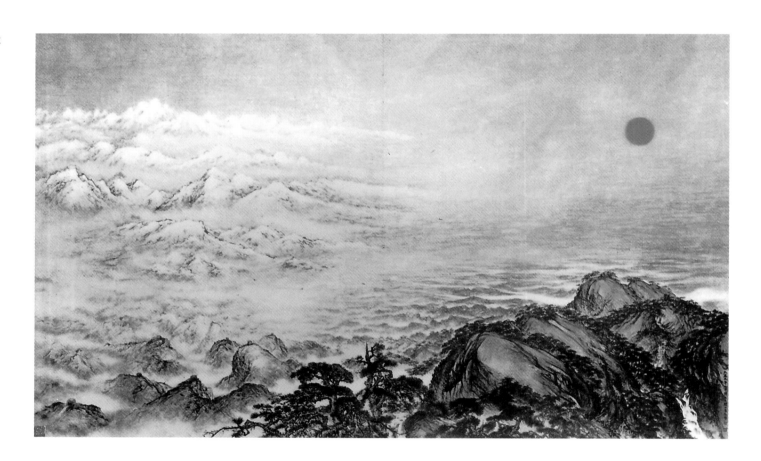

murals in the service of the Socialist state that covered the walls of public buildings, hotels, and airports when China reopened its doors to the West in the late 1970s.

FENG ZIKAI'S MANHUA STYLE

Feng Zikai (1898–1975), an essayist and graphic artist, created a new kind of popular art that, for Michael Sullivan, "defies classification."[113] Born in Shimenwan, north of Hang-

zhou (Zhejiang), Feng at age eighteen began his study of Western painting and music at Zhejiang First Normal College, in Hangzhou, under the tutelage of Li Shutong (1880–1942), a pioneer of the Western style.[114] Li had studied oil painting at the Tokyo School of Fine Arts, where he was a pupil of Kuroda Seiki (1866–1924). After returning to China in 1910, he taught drawing from nature, developed woodcut as an art form, introduced graphics to Chinese newspapers,

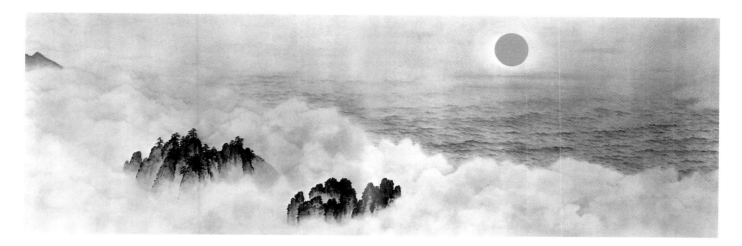

and encouraged advertising and commercial art.[115] Discouraged by the corruption and generally chaotic state which prevailed at that time, Li quit teaching in 1917 and became a Buddhist priest. It was through Li's influence that Feng Zikai also became interested in Buddhist philosophy, although he remained resolutely secular.[116]

In 1921, Feng was in Japan at the Kawabata Painting School in Tokyo. There he discovered the Japanese *manga* (a kind of cartoon) tradition of the *ukiyo-e* artist Hokusai (1760–1849)[117] and the Nihonga painter Takehisa Yumeji (1884–1934). After his return to China, Feng started to practice what he called the *manhua* (Chinese for *manga*) style, producing woodcut illustrations with mordant social commentaries for newspapers and journals.[118] Feng's work attracted the attention of Zheng Zhenduo (1898–1958), a scholar of classical woodblock-printed illustrations and the editor of the *Literary Weekly* in Shanghai. Zheng published "Zikai Manhua" (The Manhua of Feng Zikai) in that journal in 1925,[119] and the *Complete Collection of Zikai's Manhua* in 1941.[120] The term *manhua* has ever since been identified with Feng's style.

Although the tradition of Chinese woodblock-printed book illustrations harks back to at least the Tang dynasty, the woodcut movement of the late 1920s and early 1930s was inspired by Western literature and graphic arts. The movement was led by Lu Xun (1881–1936), China's literary giant whom Mao Zedong celebrated as "the chief commander of China's cultural revolution."[121] Lu Xun admired Francisco de Goya's *Disasters of War* (1810–20), but it was in the Expressionist work of the German graphic artist Käthe Kollwitz (1867–1945) that he saw the potential for social propaganda and

change; in 1936, he published a book of her prints.[122] In 1928, Lu founded the Morning Flower Society, which published five volumes of foreign woodcuts, the last devoted to Soviet graphic art.[123] Kollwitz's works, along with those by the German painter George Grosz (1893–1959) and the British artist David Low (1891–1963), inspired a generation of Chinese woodcut artists both before and during World War II.[124]

Feng Zikai's *manhua* style is at once Chinese and anti-traditional. In his writings he discusses Japanese *manga*, European caricature by Honoré Daumier (1808–1879), the British magazine *Punch*, and poster art of the Soviet Union, and pointedly criticizes Western-influenced Chinese paintings as those "modeled after Western styles with little that is Chinese in taste or in character."[125] Feng defines *manhua* as "a painting style that employs a simplified brushwork to express meaning," and he links the term to the literary genre of *manbi*, "a short piece with a distilled content."[126] He then defines three kinds of *manhua*: imaginary (*ganxiang*), satirical (*fengci*), and propagandistic (*xuanchuan*). His own preference was for the imaginary, as the most "artistic": "It originates in one's feelings and derives from nature. It is unlike satirical *manhua*, which makes a critical judgment, and it differs also from propagandistic *manhua*, which calculates the effect of its message."[127]

In *Drunken Old Farmer* (pl. 42), painted about 1947 and based on a print dated 1940 (fig. 72), Feng illustrates two lines of a poem:

An drunken old farmer staggers as if dancing,
Supported by two children who help him back to the boat.

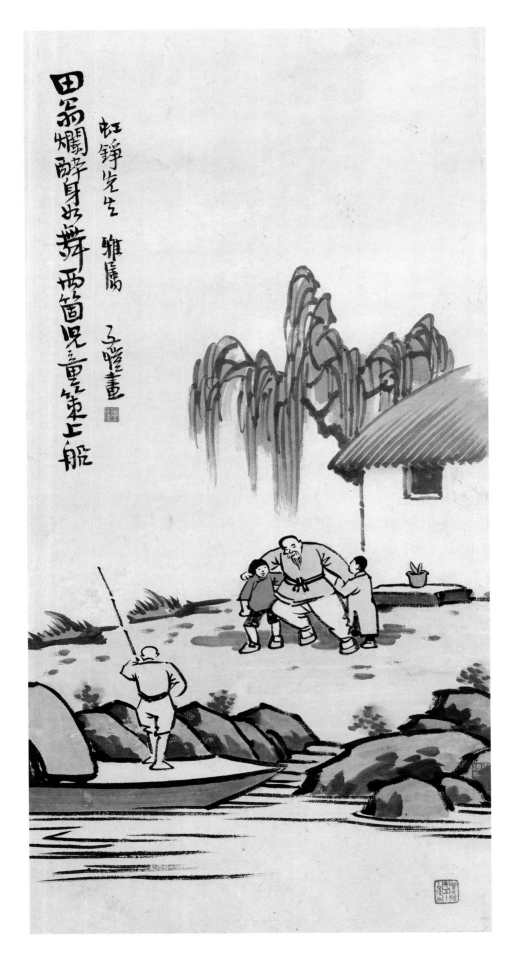

田翁爛醉身如舞
兩箇兒童策上船

虹錚先生
雅屬
子愷畫

PLATE 42

Feng Zikai (1898–1975), *Drunken Old Farmer*, ca. 1947. Hanging scroll, ink and color on paper, 25⅞ × 12⅞ in. (65.7 × 32.7 cm). Gift of Robert Hatfield Ellsworth, in memory of La Ferne Hatfield Ellsworth, 1986 (1986.267.324)

FIGURE 72

Feng Zikai (1898–1975), *Old Drunken Farmer*, dated 1940. Woodcut print.

FIGURE 73

Academy painting, *Waking Under a Thatched Awning*, with inscription by Emperor Xiaozong (r. 1162–89). Album leaf, ink and color on silk, 9¾ × 29⅝ in. (24.8 × 52.3 cm). National Palace Museum, Taipei

125

In his study of Feng, Christoph Harbsmeier writes:

The uniqueness of Feng Zikai, to my mind, lies in his combination of a light-hearted relaxed artistic form with philosophical and almost religious semantic depth and seriousness.... But he never achieved Daumier's precision of individual characterization or anything like Daumier's versatile virtuosity as a draftsman.... His comments tend to be—often defiantly—down to earth. They are never abstract.... [Although] he does not really know the working people's life from the inside,... he describes why he finds the current [political] posters socially irrelevant and theater generally of low quality.... If art is to become popular, the artistic and aesthetic elements can be no more than seasoning, he concludes.[128]

Compared with a twelfth-century Southern Song ink painting, *Waking Under a Thatched Awning* (fig. 73), which illustrates

a poem written by Emperor Xiaozong (r. 1162–89),[129] Feng's painting, done in unmodulated brush outlines, appears crude and simplistic. But it is this simple linear technique, easily translated into woodcut, that transformed the traditional poetry-and-painting genre into a populist idiom.

Reading by the Window (pl. 43), dating from the war years, about 1940, when Feng was living in the remote province of Guizhou, bears the following inscription:

Clouds are my only companions;
Please forgive the mountain recluse for not greeting his guests.

Feng's seemingly naïve style was perhaps so popular at this time because it offered both comic relief and distance from the war.

In 1942 Feng's mentor, Li Shutong, now known as the priest Hongyi, died. As a memorial, Feng painted his portrait,

PLATE 43

Feng Zikai (1898–1975), *Reading by the Window,* ca. 1940. Hanging scroll, ink and color on paper, 19 × 13 in. (48.3 × 33 cm). Robert H. Ellsworth Collection

PLATE 44

Feng Zikai, *Portrait of the Priest Hongyi,* dated 1943. Hanging scroll, ink on paper, 23¼ × 14¼ in. (59.1 × 36.2 cm). Gift of Robert Hatfield Ellsworth, in memory of La Ferne Hatfield Ellsworth, 1986 (1986.267.327)

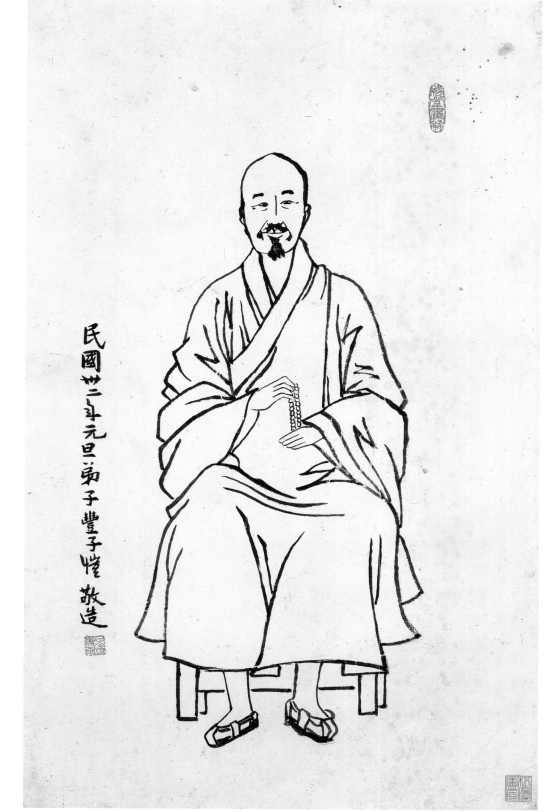

民國卅二年元旦弟子豐子愷敬造

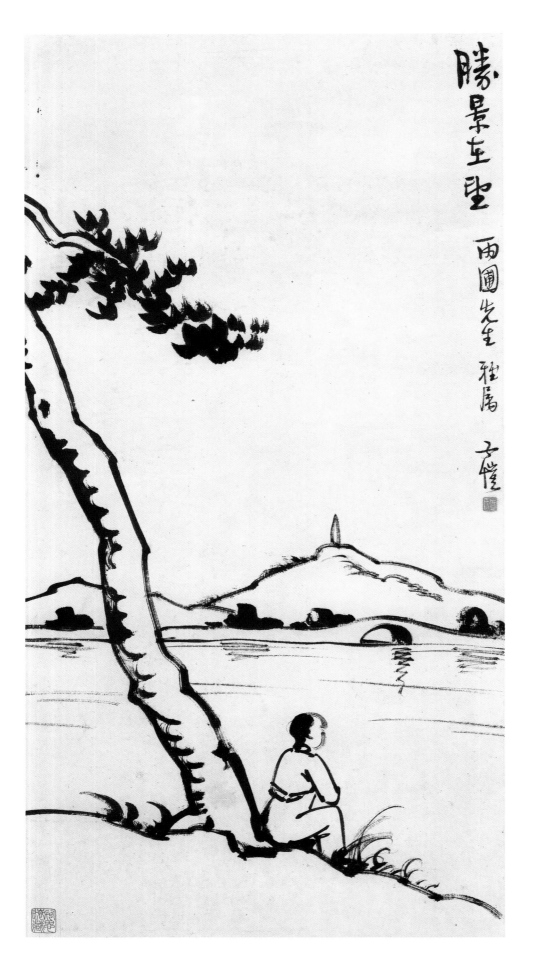

PLATE 45
Feng Zikai (1898–1975), *Victory in Sight*, 1945. Hanging scroll, ink on paper, 30⅜ × 15⅝ in. (77.2 × 39.7 cm). Gift of Robert Hatfield Ellsworth, in memory of La Ferne Hatfield Ellsworth, 1986 (1986.267.326)

which he also published in an edition of one hundred wood-cut prints.[130] The *Portrait of the Priest Hongyi* (pl. 44), dating from the Chinese New Year of 1943, is a rare surviving print. Compared with the *Portrait of the Priest Hengfeng* (fig. 23), by the nineteenth-century painter Xugu, the portrait by Feng Zikai appears even simpler and less adorned. *Victory in Sight* (pl. 45), dating from 1945, the year of the Armistice, shows the artist sitting by West Lake in his native Hangzhou, with the Bai Causeway and the Baoshu Pagoda in view. The figure in the painting resembles a child. Chang-tai Hung has written of Feng's romantic view of children: "[Feng] believed that…only children…[could] comprehend the fundamental Buddhist [teaching] that life should be filled with love and hope."[131] The childlike simplicity that animates Feng's work echoes the belief of the late-Ming Buddhist thinker Li Zhi (1527–1602), who advocated in art and letters a return to the truth of the child's mind and to a state of nature unspoiled by learning.[132]

Among the legions of popular *manhua* paintings produced both during and after World War II, the simplicity and lack of drama in Feng's drawings remain unique. Feng's plain, undemonstrative brushwork is the opposite of the emotional, neurotically charged brush style of the late-Qing expressionist Su Renshan (see pages 67–70). The simple abstractness of Feng's figure drawings echoes that of modern Western cartoons such as "Peanuts," by Charles Schulz, except that for wartime Chinese viewers, such detached brush style affords an added, almost spiritual, dimension.

NOTES

1. Mayching Kao, "Reforms in Education and the Beginning of the Western-Style Painting Movement in China," in *A Century in Crisis: Modernity and Tradition in the Art of Twentieth-Century China*, edited by Julia F. Andrews and Kuiyi Shen (exh. cat., New York: Guggenheim Museum Soho; Bilbao: Guggenheim Museum, 1998), p. 154; Mayching Kao, "The Beginning of the Western-Style Painting Movement in Relationship to Reform of Education in Early Twentieth-Century China," *New Asia Academic Bulletin* 4 (1983), pp. 373–400; Wan Qingli, "Cai Yuanpei yu jindai Zhongguo meishu jiaoyu" (Cai Yuanpei and Modern Chinese Art Education), in *Ershi shiji Zhongguo meishu jiaoyu* (Twentieth-Century Chinese Art Education) (Shanghai: Shanghai Shuhua Chubanshe, 1999), pp. 1–7.

2. Cai Yuanpei, "Yi meishu dai zongjiao shuo" (Replacing Religion with Aesthetic Education), *Xin qingnian* (New Youth) 3, no. 6 (1917), pp. 509–13; translated by Julia F. Andrews, in *Modern Chinese Literary Thought: Writings on Literature, 1893–1945*, edited by Kirk A. Denton (Stanford: Stanford University Press, 1996), pp. 182–89. See also William J. Duiker, *Ts'ai Yuan-p'ei: Educator of Modern China* (University Park: Penn State University Press, 1977), pp. 15–52.

3. Chen Duxiu, letter to Lu Cheng, in *Xin qingnian* 6, no. 1 (1919), p. 86.

4. Shūji Takashina, "Eastern and Western Dynamics in the Development of Western-Style Oil Painting during the Meiji Era," in *Paris in Japan: The Japanese Encounter with European Painting* (exh. cat., Tokyo: Japan Foundation; Saint Louis: Washington University, 1987), pp. 21–31. See also Michael Sullivan, *The Meeting of Eastern and Western Art*, 2d ed. (Berkeley and Los Angeles: University of California Press, 1989), pp. 119–29.

5. Takashina, "Eastern and Western Dynamics," pp. 22–23.

6. Delmer M. Brown, *Nationalism in Japan: An Introductory Historical Analysis* (Berkeley and Los Angeles: University of California Press, 1955); also, Aida Yuen Yuen, "Inventing Eastern Art in Japan and China, ca. 1890s to 1930s" (Ph.D. dissertation, Columbia University, New York, 1999), pp. 8–9.

7. See p. 15, in this publication.

8. Sullivan, *Meeting of Eastern and Western Art*, p. 129.

9. "True Theories of Art" was the title of Fenollosa's famous lecture in 1882 at the Dragon Lake Society (Ryūchikai). See Ernest Fenollosa, "Bijutsu shinsetsu," in *Bijutsu* (Art), edited by Aoki Shigeru and Sakai Tadayasu, Nihon kindai shisō taikei (Modern Japanese Thought Series), vol. 17 (Tokyo: Iwanami Shoten, 1989), pp. 35–65.

10. Ernest Fenollosa, "Greco-Buddhist Art in Japan," in *Epochs of Chinese and Japanese Art: An Outline History of East Asiatic Design*, 2 vols. (London: William Heinemann, 1912), vol. 1, pp. 90–115.

11. Ellen P. Conant, "The Tokyo School of Fine Arts and the Development of Nihonga, 1889–1906," in *Nihonga, Transcending the Past: Japanese-Style Painting, 1868–1968*, by Ellen P. Conant, with Steven D. Owyoung and J. Thomas Rimer (exh. cat., Saint Louis: Saint Louis Art Museum; Tokyo: Japan Foundation, 1995), pp. 25–35.

12. Ibid., p. 28.

13. Stephen Owen, ed. and trans., *An Anthology of Chinese Literature: Beginnings to 1911* (New York and London: W.W. Norton, 1996), pp. 162–75.

14. Translated as "The Return" in *The Poetry of Tao Ch'ien*, translated by James R. Hightower (Oxford: Clarendon Press, 1970), pp. 268–70.

15. Alfreda Murck, "*Eight Views of the Hsiao and Hsiang Rivers*, by Wang Hung," in *Images of the Mind: Selections from the Edward L. Elliott Family and John B. Elliott Collections of Chinese Calligraphy and Painting at The Art Museum, Princeton University*, by Wen C. Fong et al. (Princeton: The Art Museum, Princeton University, 1984), pp. 214–35.

16. Okakura Kakuzō, *The Ideals of the East, with Special Reference to the Art of Japan* (New York: E.P. Dutton, 1903).

17. Fukuzawa Yukichi, "Datsu-A Ron" (Essay on Dissociating from Asia), in *Fukuzawa Yukichi zenshū* (The Complete Works of Fukuzawa Yukichi) (Tokyo: Iwanami Shoten, 1960), vol. 10, pp. 238–40.

18. Ralph Croizier, *Art and Revolution in Modern China: The Lingnan (Cantonese) School of Painting, 1906–1951* (Berkeley and Los Angeles: University of California Press, 1988); Chen Xiangpu, *Gao Jianfu de huihua yishu* (Gao Jianfu: His Life and His Paintings) (Taipei: Taipei Fine Arts Museum, 1991). See also Huang Dufeng, "Tan Lingnan Huapai: Lingnan huapai zhi youlai" (On the Lingnan School of Painting: The Origin of the Lingnan School of Painting), *Zhongguo hua yanjiu* (Study of Chinese Painting), no. 3 (1983), pp. 182–91; and Huang Dade, "Guanyu Lingnan pai de diaocha cailiao" (Research Materials on the Lingnan School of Painting), *Meishu shilun* (Studies in Art History) 53 (1995), pp. 15–28.

19. For Ju Lian, see Robert H. Ellsworth, *Later Chinese Painting and Calligraphy, 1800–1950*, research and translation by Keita Itoh and Lawrence Wu (New York: Random House, 1986), vol. 1, p. 104, vol. 2, pp. 66–67, no. P042.

20. Croizier, *Art and Revolution in Modern China*, pp. 64–70; Chen Xiangpu, *Gao Jianfu de huihua yishu*, pp. 34–36.

21. Yuen ("Inventing Eastern Art in Japan and China," p. 36) traces the expression *zhezhong* to the Japanese term *setchū*, citing the article, "Nihon seiyō ryō gafū no setchū" (The Middle Path between Eastern and Western Art), *Taiyō* (The Sun) 2, no. 14 (July 20, 1896), pp. 109–10.

22. Gao Jianfu, "Wo de xiandai huihua guan" (My Views on Contemporary Painting), in *Lingnan huapai yanjiu* (Study of the Lingnan School of Painting), edited by Yu Feng (Guangdong: Lingnan Meishu Chubanshe, 1987), vol. 1, p. 19; cited in Christina Chu, "The Lingnan School and Its Followers: Radical Innovation in Southern China," in *Century in Crisis*, p. 68.

23. Croizier, *Art and Revolution in Modern China*, pp. 26–32.

24. Kimura's painting had won a prize at the Ministry of Education Art Exhibition (known as the *Bunten*) in 1919. Yuen ("Inventing Eastern Art in Japan and China," p. 39) also cites and illustrates a page from an article by Deng Yaoping and Liu Tianshu, "Er Gao yu yinjin" (The Two Gaos and Their Derivations), *Zhongguo shuhua bao* (Newspaper of Chinese Calligraphy and Painting), no. 343–45 (1993), which discusses the similarities between Gao's painting and its model of the same subject by Kimura Buzan.

25. Conant, *Nihonga*, pp. 148, 149, 333.

26. *Gao Qifeng xiansheng yi hua ji* (Collected Works of the Late Gao Qifeng) (Shanghai: Huaqiao Tushu Yinshua Gongsi, 1935), unpaginated; Hong Kong Museum of Art, *Gao Qifeng de yishu / The Art of Gao Qifeng* (exh. cat., Hong Kong: Urban Council, 1981), p. 9.

27. Croizier, *Art and Revolution in Modern China*, pp. 110–14.

28. Gao Jianfu, "Wo de xiandai huihua guan," pp. 11, 20.

29. Ibid., pp. 3–4. For Xie Ho's Six Laws and the *Sadanga*, see William R.B. Acker, trans. and ann., *Some T'ang and Pre-T'ang Texts on Chinese Painting* (Leiden: E.J. Brill, 1954), pp. xliii–xlv.

30. Tapati Guha-Thakurta, *The Making of a New "Indian" Art: Artists, Aesthetics, and Nationalism in Bengal, c. 1850–1920* (Cambridge: Cambridge University Press, 1992); see also David Kopf, *British Orientalism and the Bengal Renaissance: The Dynamics of Indian Modernization, 1773–1835* (Berkeley and Los Angeles: University of California Press, 1969).

31. A composition he repeated as *An Egyptian Warrior*, dated 1933, now in the Art Gallery, Chinese University of Hong Kong; see Croizier, *Art and Revolution in Modern China*, fig. 51.

32. Gao Jianfu, "Wo de xiandai huihua guan," p. 12; see also Croizier, *Art and Revolution in Modern China*, pp. 111–12.

33. Conant, *Nihonga*, pp. 322–23.

34. Xu Boyang and Jin Shan, eds., *Xu Beihong nianpu* (Chronology of Xu Beihong) (Taipei: Yishujia Chubanshe, 1991).

35. William A. Lyell Jr., *Lu Hsun's Vision of Reality* (Berkeley and Los Angeles: University of California Press, 1976), pp. 304–5.

36. The lecture was reprinted as "Zhongguo hua gailiang lun" (Essay on Reforming Chinese Painting), in *Huihua zazhi* (Painting Magazine; Beijing University), June 1920. See Wang Zhen and Xu Boyang, *Xu Beihong yishu wenji* (Collection of Writings on Art by Xu Beihong) (Yinchuan: Ningxia Renmin Chubanshe, 1994), p. 11.

37. Wang Zhen and Xu Boyang, *Xu Beihong yishu wenji*, p. 12.

38. From Xu Beihong, "Dangqian Zhongguo zhi yishu wenti" (Problems Facing Today's Chinese Art), in *Xu Beihong danchen jiushi zhounian jinianji* (Collection Commemorating Xu Beihong's Ninetieth Birthday) (Beijing: Xu Beihong Memorial Museum, 1983), p. 217; see also Zhuo Shengge, *Xu Beihong yanjiu* (A Study of Xu Beihong) (Taipei: Taipei Municipal Art Gallery, 1989), p. 78.

39. Zhuo Shengge, *Xu Beihong yanjiu*, pp. 43–44.

40. Ibid., pp. 67, 68.

41. From Xu Beihong, "Dangqian Zhongguo zhi yishu wenti," pp. 217–18. Xu used the terms *qiyun*, "breath-resonance," and *shenyun*, "spirit-resonance," interchangeably; see Zhuo Shengge, *Xu Beihong yanjiu*, pp. 75–79.

42. For Xu Zhimo, see Leo Ou-tan Lee, *The Romantic Generation of Modern Chinese Writers* (Cambridge, Mass.: Harvard University Press, 1973); and Jiang Fucong and Liang Shiqiu, eds., *Xu Zhimo quanji* (Collected Works of Xu Zhimo), 6 vols. (Taipei: Zhuanji Wenxue Chubanshe, 1969).

43. Wang Zhen and Xu Boyang, *Xu Beihong yishu wenji*, pp. 93–94.

44. Pang-mei Natasha Chang, *Bound Feet*

132

and Western Dress / *Xiaojiao yu xifu*, Chinese translation by Dan Jiayu ([Taipei]: Triumph Publishing Co., 1996); Liang Congjie, ed., *Lin Huiyin wenji* (Collected Works of Lin Huiyin) (Taipei: Yuanjian Chuban Gufen Youxian Gongsi, 2000). A twenty-hour video series on the life and times of Xu Zhimo has been aired recently on Taipei Television.

45. In 1925 Xu Beihong discussed his ideas with a wealthy overseas Chinese businessman in Singapore; see Xu Boyang and Jin Shan, *Xu Beihong nianpu*, p. 33. In 1927 he wrote the Sino-Franco Boxer Indemnity Committee proposing his ideas (ibid., pp. 41–42); text in Wang Zhen and Xu Boyang, *Xu Beihong yishu wenji*, pp. 67–71. See also Xu Boyang and Jin Shan, *Xu Beihong nianpu*, pp. 107, 117.

46. Xu Boyang and Jin Shan, *Xu Beihong nianpu*, pp. 127, 131. See also Xu Boyang, "Xu Beihong yu huajia: Jinian fuqin shishi ershiqi zhounian erzhou" (Xu Beihong and the Painter: Commemorating the 27th Anniversary of My Father's Death), *Xiongshi meishu* Monthly, no. 130 (1970), p. 85; and Zhuo Shengge, *Xu Beihong yanjiu*, p. 82.

47. *Xu Beihong canghua xuanji / Selections from Xu Beihong's Collection of Paintings*, 2 vols. (Beijing: Xu Beihong Memorial Museum, 1991–92).

48. Xu Boyang and Jin Shan, *Xu Beihong nianpu*, p. 138.

49. For a discussion of Xu's statement that "Chinese art, no doubt, was almost entirely based on Naturalism," see letter from Yang Zhumin, "Zhongguo shanshui hua di fazhan he Chengjiu" (The Development and Achievements of Chinese Landscape Painting), in Wang Zhen and Xu Boyang, *Xu Beihong yishu wenji*, pp. 605–13.

50. Xu's letter, "Da Yang Zhumin xiansheng" (A Reply to Mr. Yang Zhumin), dated 1951, in Wang Zhen and Xu Boyang, *Xu Beihong yishu wenji*, pp. 602–4; Zhuo Shengge, *Xu Beihong yanjiu*, p. 78.

51. Wang Zhen and Xu Boyang, *Xu Beihong yishu wenji*, p. 603.

52. The other three, according to Xu, are *Travelers amid Streams and Mountains* by the early Northern Song master Fan Kuan, now in the National Palace Museum, Taipei; an unsigned work by the Song painter Guo Xi, which he saw as a student in Japan; and *North Sea* by the Ming painter Zhou Chen, now in the Nelson-Atkins Museum of Art, Kansas City. See Xu Boyang and Jin Shan, *Xu Beihong nianpu*, p. 112.

53. Maxwell K. Hearn and Wen C. Fong, *Along the Riverbank: Chinese Paintings from the C.C. Wang Family Collection* (exh. cat., New York: The Metropolitan Museum of Art, 1999), p. 46.

54. Liao Jingwen, introduction, in *Xu Beihong canghua xuanji*.

55. Wen C. Fong, "A Reply to James Cahill's Queries about the Authenticity of *Riverbank*," *Orientations* 31, no. 3 (March 2000), pp. 114–28.

56. Wu Youru (see p. 36, in this publication) drew Western-style lithographs for the magazine *Dianshizhai Pictorial*, published by Frederick Major in 1884; see also Zhuo Shengge, *Xu Beihong yanjiu*, p. 99.

57. Wang Zhen and Xu Boyang, *Xu Beihong yishu wenji*, p. 524.

58. Ibid., pp. 523, 522.

59. Ibid., p. 107.

60. Ibid., p. 104.

61. See p. 6 and n. 6, in this publication.

62. Zhuo Shengge, *Xu Beihong yanjiu*, pls. 9, 29.

63. Ibid., pp. 108–9.

64. Ibid., pl. 54.

65. Michael Sullivan, *Art and Artists of Twentieth-Century China* (Berkeley and Los Angeles: University of California Press, 1996), pp. 70–71.

66. Lothar Ledderose, *Ten Thousand Things: Module and Mass Production in Chinese Art* (Princeton: Princeton University Press, 2000), p. 206.

67. See p. 90 and n. 41, in this publication.

68. Zhuo Shengge, *Xu Beihong yanjiu*, p. 128.

69. Zhu Jinlou and Yuan Zhihuang, eds., *Liu Haisu yishu wenxian* (Collected Writings on Art by Liu Haisu) (Shanghai: Renmin Meishu Chubanshe, 1987), p. 534.

70. Popularly referred to as "Teiten"; see J. Thomas Rimer, "'Teiten' and After, 1919–1935," in *Nihonga*, pp. 45–56.

71. Liu Haisu, "Ouzhou Zhongguo huazhan shimo" (An Account of the Exhibition of

Chinese Paintings in Europe), in Zhu Jinlou and Yuan Zhihuang, *Liu Haisu yishu wenxian*, pp. 153–62.

72. Zhu Jinlou and Yuan Zhihuang, *Liu Haisu yishu wenxian*, pp. 131–32.

73. Ibid., pp. 427–28.

74. Ibid., pp. 262–304.

75. Ibid., pp. 69–73.

76. Ibid., pp. 143–45.

77. Fong, *Images of the Mind*, p. 206.

78. Kohara Hironobu, *Sekitō to Ōzan hasshō gasatsu* (Shitao's "Eight Views of Yellow Mountain") (Tokyo: Chikuma Shobō, 1970), p. 10.

79. Adapted from Fong, *Images of the Mind*, p. 206.

80. Zhang Guoying, *Fu Baoshi yanjiu* (The Study of Fu Baoshi) (Taipei: Taipei Municipal Art Museum, 1991); Hu Zhiliang, *Fu Baoshi zhuan* (Biography of Fu Baoshi) (Nanchang: Baihua Zhou Wenyi Chubanshe, 1994); and Ye Zonggao, ed., *Fu Baoshi meishu wenji* (Fu Baoshi's Writings on Art) ([Nanjing]: Jiangsu Wenyi Chubanshe, 1986).

81. Huang Miaozi, *Huatan shiyou lu* (Teachers and Colleagues in Painting) (Taipei: Dongda Tushu Gongsi, 1998), pp. 153–55.

82. Tsuruta Takeyoshi, "Ryūnichi bijutsu gakusei: Kin hyakunen rai Chūgoku kaigashi kenkyū" (Chinese Art Students in Japan: Research on the History of Chinese Painting of the Past 100 Years), part 5, *Bijutsu kenkyū*, no. 367 (1997), pp. 127–39; and *Fu Hōseki: Nijusseiki Chūgoku gadan no kyoshō. Nicchū bijutsu kōryū no kakehashi* (Fu Baoshi: A Great Master of Twentieth-Century Chinese Painting. A Bridge of Japan-China Artistic Exchange) (exh. cat., Tokyo: Shibuya Kuritsu Shōtō Bijutsukan, 1999).

83. Kinbara Seigo and Fu Baoshi, *Tang Song zhi huihua* (Shanghai: Shangwu Yinshuguan, 1935).

84. Yamamoto Teijiro, Norishige Koichi, and Fu Baoshi, *Mingmo minzu yiren zhuan*; preface dated 1938 (1939; reprint, Hong Kong: Liwen Chubanshe, 1971).

85. Zhang Guoying, *Fu Baoshi yanjiu*, pp. 36–37.

86. Fu Baoshi, *Shitao shangren nianpu* (A Chronology of the Eminent Priest Shitao) (Nanjing: Jinwu Zhoukan She, 1948).

87. Wen C. Fong, "A Letter from Shih-t'ao to Pa-ta-shan-jên and the Problem of Shih-t'ao's Chronology," *Archives of the Chinese Art Society of America* 13 (1959), pp. 22–53.

88. Nagahara Oriharu, "Hachidai Sanjin ni ataeta Sekitō shokan ni tsuite" (On Shitao's letter to Bada Shanren), *Bijutsu* (Art [Magazine], Tokyo) 10, no. 12 (1928), pp. 56–57.

89. In settling on 1630 as Shitao's birth year, Fu also uses the evidence of a painting entitled *Wu Ruitu*, which is also a forgery (Fu Baoshi, *Shitao shangren nianpu*, p. 88); see Fong, "Letter from Shih-t'ao," p. 31, fig. 3.

90. Alexander C. Soper, "The Letter from Shih-t'ao to Pa-ta-shan-jen," *Artibus Asiae* 29, no. 2–3 (1967), pp. 267–69; and Wen C. Fong, "Reply to Professor Soper's Comments on Tao-chi's Letter to Chu Ta," *Artibus Asiae* 29, no. 4 (1967), pp. 351–57.

91. Zhang Guoying, *Fu Baoshi yanjiu*, pp. 120–21, fig. 3/8.

92. Fu later adapted this image to paint a portrait of the poet Du Fu (712–770); see Fu Baoshi, *Portrait of Du Fu*, dated 1959, in the Nanjing Museum, illustrated in Yu Huali and Ji Lin, *Fu Baoshi* (Tianjin: Tianjin Renmin Meishu Chubanshe, 1996), pl. 94.

93. Han Chengwu and Zhang Zhimin, eds., *Du Fu shi quanji* (Explications of Du Fu's Poetry) (Shijiazhuang: Hebei Renmin Chubanshe, 1997), p. 589.

94. David Hawkes, *Ch'u Tz'u: The Songs of the South* (Oxford: Clarendon Press, 1959), p. 76.

95. In a colophon dated 1945, Fu notes that it is his daughter who is depicted in the painting. See Zhang Guoying, *Fu Baoshi yanjiu*, p. 39.

96. Ibid., pp. 57–58.

97. Ibid., pp. 164, 176, 185, 203.

98. Made in 1947, the painting was presented to "Madame Hu Pinde and Mr. Ji Yema." According to Mr. Ellsworth's research, these are the Chinese names for the French ambassador to China and his wife; see Ellsworth, *Later Chinese Painting and Calligraphy*, vol. 1, p. 181.

99. For an illustration of the Mistress of Xiang and the accompanying text from the "Nine Songs," see After Zhao Mengfu, *Nine Songs*, dated 1305, in Wen C. Fong, with

134

Marilyn Fu, *Sung and Yuan Paintings* (New York: The Metropolitan Museum of Art, 1973), p. 103.

100. In a hanging scroll dated 1945, *Beauty under a Willow Tree*, dedicated to his wife in honor of her thirty-fifth birthday, Fu writes a colophon describing the hardships his family suffered and expressing his gratitude for the support of his wife; illustrated in Zhang Guoying, *Fu Baoshi yanjiu*, pp. 65, 111, ill. p. 96.

101. Murck, "*Eight Views of the Hsiao and Hsiang Rivers*," in *Images of the Mind*, pp. 214–35.

102. Another version of the composition by Fu, dated 1955, is found in the Fu Family Collection; see Zhang Guoying, *Fu Baoshi yanjiu*, p. 101.

103. Ye Zonggao, *Fu Baoshi meishu wenji*, p. 103; Zhang Guoying, *Fu Baoshi yanjiu*, p. 54.

104. Fu Baoshi, "Preface to Exhibition of [His] Paintings in Chongqing in 1942," in Ye Zonggao, *Fu Baoshi meishu wenji*, pp. 455–73.

105. Fu Baoshi, "An Inquiry into the History of 'Landscape Painting,' 'Writing of Ideas,' and 'Ink Wash' in Chinese Painting," in *Fu Baoshi meishu wenji*, p. 253; see Zhang Guoying, *Fu Baoshi yanjiu*, p. 56.

106. Fu Baoshi, preface, in Ye Zonggao, *Fu Baoshi meishu wenji*, p. 465; Zhang Guoying, *Fu Baoshi yanjiu*, p. 58.

107. Ye Zonggao, *Fu Baoshi meishu wenji*, p. 472.

108. Zhang Guoying, *Fu Baoshi yanjiu*, pp. 60–61.

109. For found art in random images, see E.H. Gombrich, *Art and Illusion: A Study in the Psychology of Pictorial Representation*, 2d ed. (New York: Bollingen Foundation, 1961), pp. 188–91. For Wang Mo, see Zhu Jingxuan, *Tangchao minghua lu* (Record of Famous Painters of the Tang Dynasty, ca. 840), in *Meishu congkan* (Collected Reprints on Fine Arts), compiled by Yu Junzhi (Taipei: Zhonghua Congshu Weiyuan Hui, 1956), vol. 1; and for the story of Guo Xi, see Ogawa Hiromitsu, "Tō Sō sansuiga shi ni okeru imajinēshon—hatsuboku kara *Sōshunzu*, *Shoshō gayū zukan* made" (Imagination in the History of Tang and Song Landscape Painting—from *Pomo* to *Early Spring* and *Dream Journey on the Xiao and Xiang Rivers*), *Kokka*, no. 1034 (June 1980), pp. 5–17, no. 1036 (July 1980), pp. 25–36.

110. Ye Zonggao, *Fu Baoshi meishu wenji*.

111. Ellen Laing, *The Winking Owl: Art in the People's Republic of China* (Berkeley and Los Angeles: University of California Press, 1988), p. 36.

112. For other works by Taikan with a rising sun, dating from 1907 to 1939, see Hosono Masanobu, ed., *Yokoyama Taikan*, Gendai Nihon bijutsu zenshū (Compilation of Modern Japanese Fine Art), vol. 2 (Tokyo: Shueisha, 1972), pls. 12, 42, 44.

113. Sullivan, *Art and Artists of Twentieth-Century China*, p. 125.

114. Feng Yiyin et al., eds., *Feng Zikai zhuan* (Biography of Feng Zikai) (Hangzhou: Zhejiang Renmin Chubanshe, 1983), p. 181. See also Christoph Harbsmeier, *The Cartoonist Feng Zikai: Social Realism with a Buddhist Face* (Oslo: Universitetsforlaget, 1984); and Chang-tai Hung, "War and Peace in Feng Zikai's Wartime Cartoons," *Modern China* 16, no. 1 (January 1990), pp. 39–83, with a list of Feng Zikai's publications, pp. 80–81.

115. Sullivan, *Art and Artists of Twentieth-Century China*, p. 29; and Bi Keguan, "Jindai meishu de xianqu zhe Li Shutong" (A Forerunner of Modern Art: Li Shutong), *Meishu yanjiu* (Fine Art Studies), no. 4 (1984), p. 69.

116. Feng Zikai, "Hongyi fashi" (The Buddhist Priest Hongyi), in *Feng Zikai zizhuan* (Autobiography of Feng Zikai), edited by Feng Chenbao and Yang Ziyun (Nanking: Jiangsu Wenyi Chubanshe, 1996), pp. 68–82.

117. James A. Michener, ed., *The Hokusai Sketchbooks: Selections from the Manga* (Rutland, Vt.: Charles E. Tuttle, 1958).

118. Feng Yiyin et al., *Feng Zikai zhuan*, p. 184.

119. Zheng Zhenduo's preface to Feng Zikai, *Feng Zikai manhua* (Feng Zikai's Cartoons), 4 vols. (Shanghai: Kaiming Shudian, 1931–39), vol. 1, pp. 3–5.

120. Feng's works are shown in six sections: "New Illustrations of Ancient Poems" (84 images); "World of the Children" (84 images); "World of Students" (64 images);

"World of the Common People" (64 images); and "World of the City" (64 images). See *Zikai manhua quanji* (A Complete Collection of Feng Zikai's Cartoons), 6 vols. (1941; reprint, Shanghai: Kaiming Shudian, 1946).

121. Lyell, *Lu Hsun's Vision of Reality*, p. vii; and Sullivan, *Art and Artists of Twentieth-Century China*, pp. 8−87. See also Shirley Hsiao-ling Sun, "Lu Hsün and the Chinese Woodcut Movement, 1929−1936" (Ph.D. dissertation, Stanford University, 1974).

122. Agnes Smedley, *Battle Hymn of China* (New York: Alfred A. Knopf, 1943), p. 81.

123. Li Hua, Li Shusheng, and Ma Ke, eds., *Zhongguo xinxing banhua yundong wushinian, 1931−81* (Fifty Years' Development of the Chinese Woodcut Movement, 1931−81) (Shenyang: Liaoning Meishu Chubanshe, 1982), pp. 144−46.

124. Chang-tai Hung, *War and Popular Culture: Resistance in Modern China, 1937−1945* (Berkeley and Los Angeles: University of California Press, 1994), pp. 35−38.

125. Feng Zikai, *Manhua de miaofa* (Cartooning Methods) (1943; reprint, Shanghai: Kaiming Shudian, 1947), pp. 6−19.

126. Ibid., pp. 3−5.

127. Ibid., pp. 21−22.

128. Harbsmeier, *Cartoonist Feng Zikai*, pp. 20, 33−34.

129. Wen C. Fong, *Beyond Representation: Chinese Painting and Calligraphy, 8th−14th Century* (New York: The Metropolitan Museum of Art, 1992), p. 229.

130. Feng Yiyin et al., *Feng Zikai zhuan*, p. 199.

131. Hung, *War and Popular Culture*, pp. 45−50.

132. W. Theodore de Bary, "Individualism and Humanitarianism in Late Ming Thought," in *Self and Society in Ming Thought*, by W. Theodore de Bary et al. (New York: Columbia University Press, 1970), pp. 188−225.

OPPOSITE

Huang Binhong (1865–1955),
Dwelling in the Xixia Mountains,
dated 1954. Detail of plate 68

Chapter Three

Three Great Traditionalists

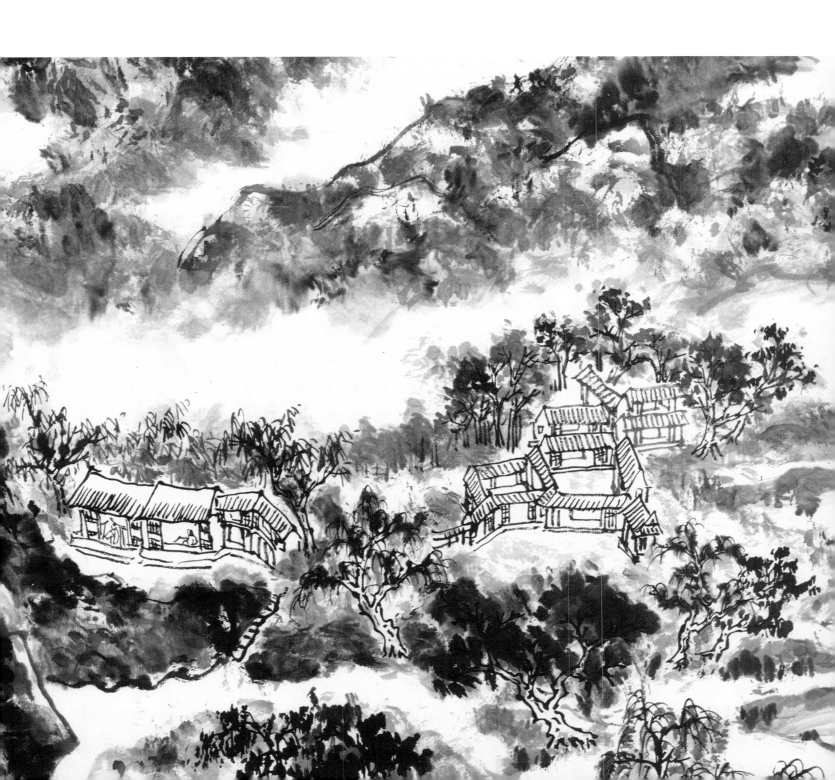

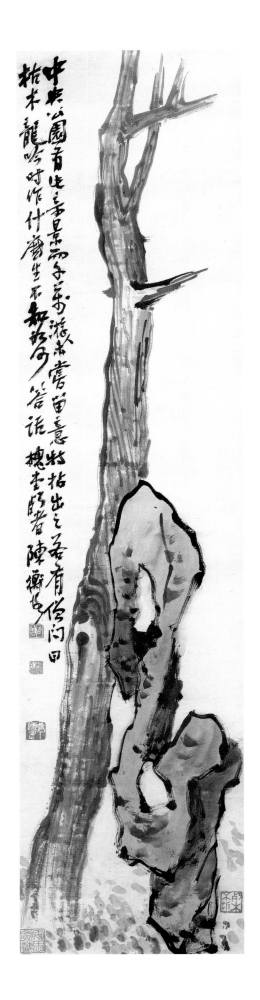

138 During the 1910s and 1920s, when traditional scholar-artists such as Li Ruiqing (pl. 14) and Wu Changshuo (pl. 17) were successfully pursuing the metal-and-stone aesthetic in Shanghai, the leading scholar-painter and theorist in Beijing was Chen Hengke (Chen Shizeng; 1876–1923). The son of a poet in Yining (Nanchang, Jiangxi), Chen, after receiving his degree from the South China Technical School in Nanjing, went in 1902 to Japan, where he lived for seven years. When Cai Yuanpei established the Painting Methods Research Society at Beijing University in 1918, Chen became a teacher of traditional Chinese painting. In 1919, he organized the Society for Research in Chinese Painting, which was devoted to the study of the Song and Yuan masters. And in 1922, he published "A Study of Chinese Scholar Painting," in which he translated an essay entitled "The Revival of Scholar Painting," by the Japanese scholar Ōmura Seigai. In the essay, Chen contrasts Western realism with the Chinese scholar's disdain for form-likeness, arguing that Cubism, Futurism, and Expressionism "only show that form-likeness alone can never exhaust what art can do; one must always seek alternative paths."[1]

In a narrow hanging scroll, *Strange Rock and Tree Trunk* (pl. 46), dating from about 1920, Chen paints a garden rock and a dead tree trunk, and adds the following colophon:

There is this strange sight in the Central Park [in Beijing], but tens of thousands of tourists have passed it by, unnoticed. So I decided to paint it. A Buddhist monk friend of mine asks, "What does it mean when a dead tree looks like a chanting dragon?" I have no answer.[2]

PLATE 47

Chen Hengke (1876–1923), "Studio by the Water," dated 1921. Album leaf, ink and color on paper, 13¼ × 18¾ in. (33.7 × 47.6 cm). Gift of Robert Hatfield Ellsworth, in memory of La Ferne Hatfield Ellsworth, 1986 (1986.267.104)

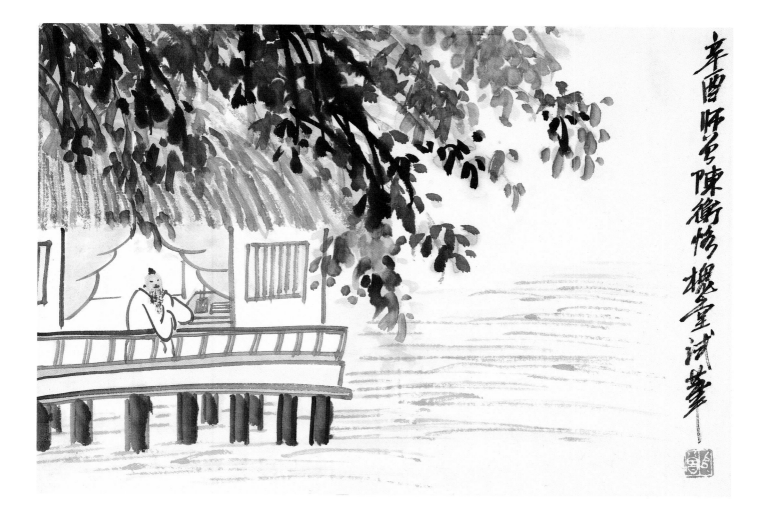

FIGURE 74

Water Buffalo and Sheep, wood-block illustration from the *Mustard Seed Garden Painter's Manual*, ca. 1689.

140

The painting illustrates what Chen considered the "essence" of scholar painting. Rather than representing a real tree and rock, he paints a tree of his imagination, a dead tree that "looks like a chanting dragon." As he wrote in his essay "A Study of Chinese Scholar Painting": "What defines art is the artist's ability to affect his viewer and to elicit a sympathetic response by means of his own spirit.... Only when the artist himself experiences a response to an object can he move his viewer to respond to what he feels."[3]

An album leaf, "Studio by the Water" (pl. 47), dated 1921, shows Chen painting with a simple, unmodulated brushwork in a style that echoes the work of the Japanese painters Tomioka Tessai (1837–1924) and Maeda Seison (1885–1977) in the Nanga and Nihonga styles.[4] Indeed, Chen's simplified brush style would later be a source for the *manhua* manner of Feng Zikai (pl. 43),[5] and it would have a transforming effect on Qi Baishi, whose career Chen Hengke did much to encourage and advance.

THE GRAPHIC REALISM OF QI BAISHI

Qi Baishi (1864–1957) is the most highly respected traditional-style painter of China in the twentieth century. Born to a peasant family in Xiangtan (Hunan), he apprenticed first in a carpentry and then in a wood-carving shop.[6] When he was eighteen, he came across a seventeenth-century copybook, the woodblock-printed *Mustard Seed Garden Painter's Manual* (fig. 74), from which he made tracing copies to use as models for his own wood-carving work. In 1889 he studied portraiture, and over the next ten years, calligraphy, poetry,

PLATE 48

Qi Baishi (1864–1957), *Bodhi-dharma*, dated 1913. Hanging scroll, ink and color on paper, 32⅝ × 17⅞ in. (82.9 × 45.4 cm). Gift of Robert Hatfield Ellsworth, in memory of La Ferne Hatfield Ellsworth, 1986 (1986.267.208)

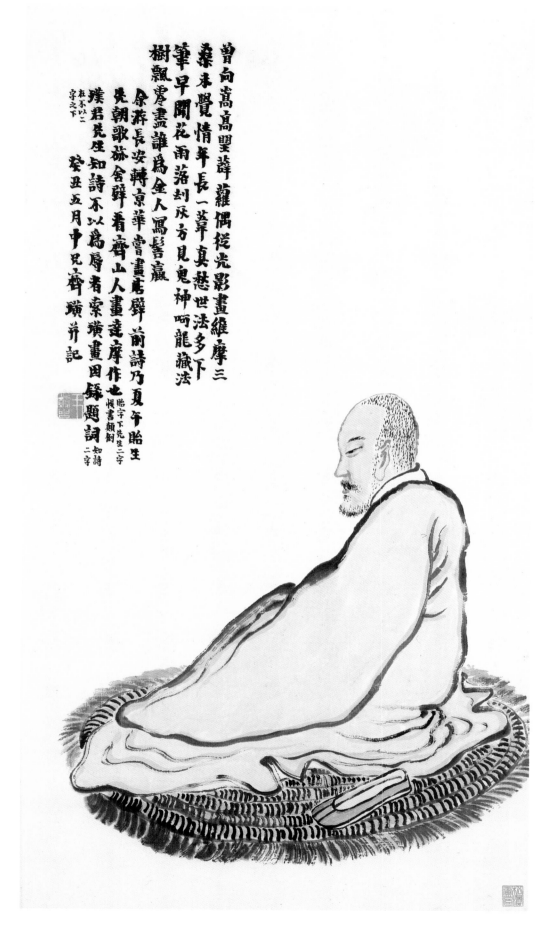

142

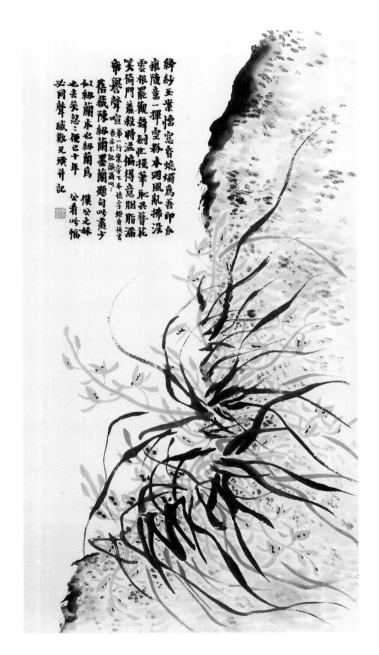

painting, and seal carving.[7] From 1902 to 1909, when he was in his early forties, he made six extended trips crisscrossing China,[8] visiting scenic sites in the north, south, and southwest. Finally, in 1919, he settled in Beijing, where he made the acquaintance of Chen Hengke. Under Chen's influence, Qi began to paint in a simpler, more expressive style. In 1927, he joined the faculty of the Beijing Art Academy, where he taught traditional painting. He remained in Beijing during the Sino-Japanese War, from 1937 to 1945. After the establishment of the People's Republic in 1949, Qi was received by Mao Zedong and honored, in 1953, with an award as the Chinese People's Distinguished Artist. He died in 1957, when he was ninety-three years old.[9]

The rise of Qi Baishi from a simple craftsman to the nation's most renowned painter, in a career that spanned nearly a century—from the late Qing through the Republic and the People's Republic—marks the democratization of the ancient Chinese painting tradition. Initially, he honed his skills from two commonly available sources, one indigenous and one foreign: the *Mustard Seed Garden Painter's Manual* and the photographic image. Qi learned realistic portrait painting by copying from photographs with charcoal and ink wash, in a manner similar to Xugu's *The Priest Hengfeng* (fig. 23).[10] As he rose in artistic and social standing he perfected a third skill, that of the metal-and-stone calligraphic technique, which professional scholar-painters, led by Zhao Zhiqian and Wu Changshuo, had made widely popular in the south. Qi fused three distinct skills: woodblock design, realistic representation, and calligraphic brushwork, creating a new style that revolutionized traditional painting. One reason for the

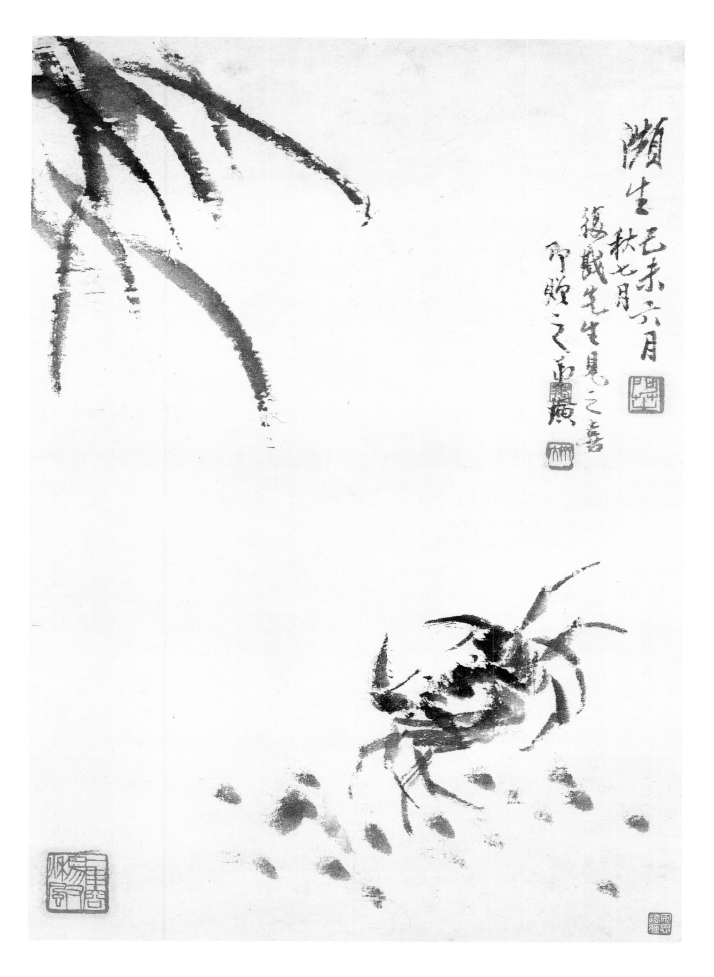

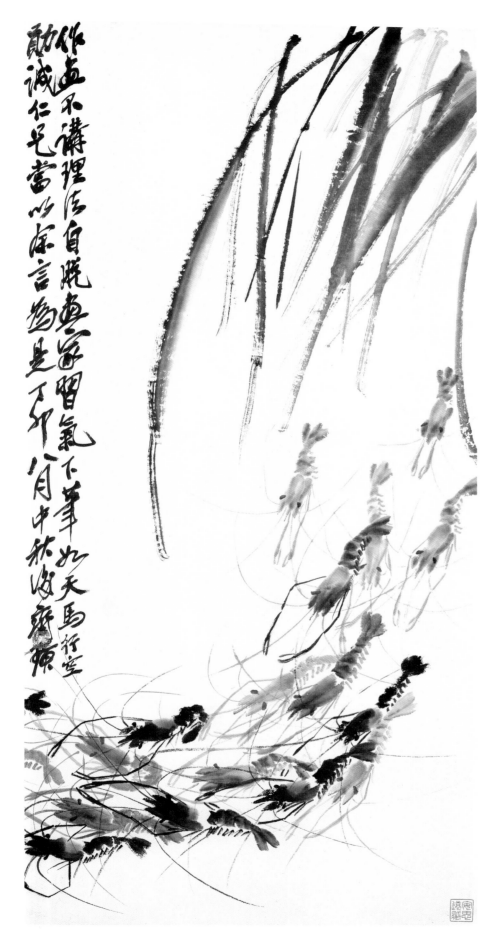

144

PLATE 50

Qi Baishi (1864–1957), *Shrimp*, dated 1927. Hanging scroll, ink on paper, 38⅜ × 18¾ in. (97.5 × 47.6 cm). Gift of Robert Hatfield Ellsworth, in memory of La Ferne Hatfield Ellsworth, 1986 (1986.267.212)

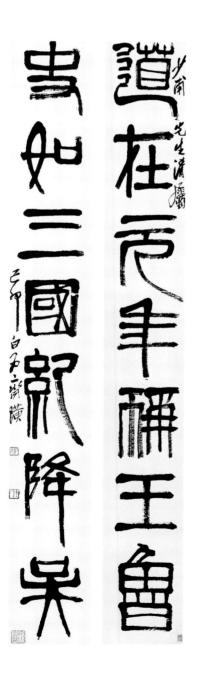

FIGURE 76

Qi Baishi (1864–1957), *Couplet in Seal-script Calligraphy*, dated 1937. Paired hanging scrolls, ink on paper, each scroll 65½ × 8¾ in. (166.4 × 22.2 cm). Robert H. Ellsworth Collection, Freer Gallery of Art, Smithsonian Institution, Washington, D.C. (F1998.250.1–.2)

145

commercial success of his work was its accessibility to the average viewer. Furthermore, his simple brushwork and vibrant colors were easily made into woodblock prints. Reproductions of his paintings made by the Rongbaozhai studio in Beijing made his work widely available at an affordable price and catapulted Qi into the public domain.

By the early 1910s, Qi was painting in a wide range of popular seventeenth- and eighteenth-century styles, among them those of Zhu Da, Huang Shen, and Jin Nong. In *Bodhidharma* (pl. 48), dated 1913, he draws the meditating monk in profile seated on a straw prayer mat and writes a long colophon in Jin Nong's awkward, archaistic style. The face of the seated figure is realistic, with his half-closed eye and high cheekbone shaded and highlighted in color wash and the stubble of his unshaven head and beard stippled in brush dots, while the outlines and drapery folds of his body are done in a round, seemingly awkward brushline, not unlike Xugu's. In another work from the period, *Orchid and Rock* (fig. 75), dating from about 1911,[11] Qi again paints with a deliberately awkward brushwork and writes an inscription, again in the archaizing style of Jin Nong. In both, he makes errors in transcribing the texts, an indication that he was not yet comfortable with writing long poetic inscriptions.

In *Scuttling Crab* (pl. 49), made three months after he had moved to Beijing, Qi discovers a live form in nature that would later become a favorite subject. A spirited crustacean, its two claws and eight jointed legs raised high, scurries across a sandy bank toward a dangling reed. Qi writes in the colophon: "Fukan saw this painting and liked it so much that I present it to him as a gift." The descriptive brushwork is both sensitive

PLATE 51

Qi Baishi (1864–1957), "Viewing Antiquities at the Studio of Humility," dated 1930. Album leaf, ink and color on paper, 11 × 13¼ in. (28.1 × 33.7 cm). Gift of Robert Hatfield Ellsworth, in memory of La Ferne Hatfield Ellsworth, 1986 (1986.267.214)

PLATE 52

Qi Baishi, *Lamp-lit Pavilion on a Rainy Night*, dated 1933. Hanging scroll, ink and color on paper, 21⅞ × 18⅜ in. (55.6 × 46.7 cm). Gift of Robert Hatfield Ellsworth, in memory of La Ferne Hatfield Ellsworth, 1986 (1986.267.215)

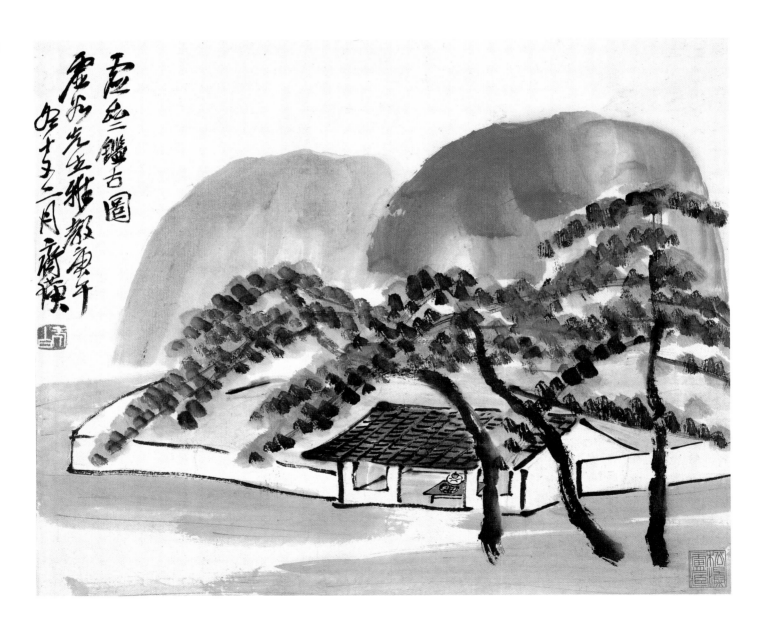

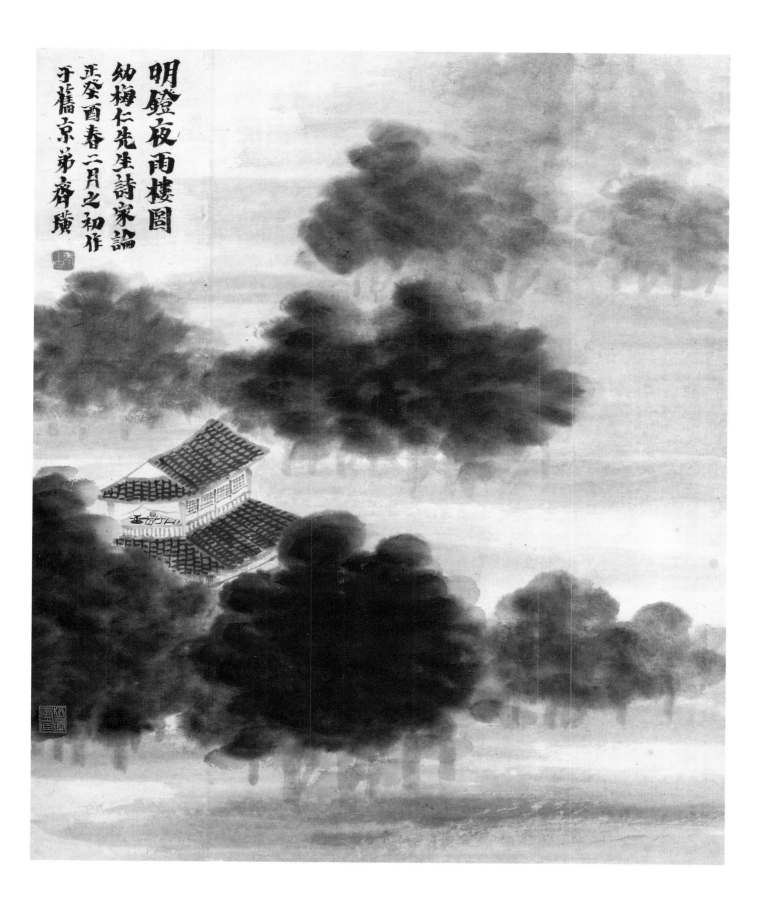

PLATE 53

Qi Baishi (1864–1957), *Catfish*,
dated 1937. Hanging scroll, ink
on wrapping paper, 21⅛ × 17⅛ in.
(53.7 × 43.5 cm). Gift of Robert
Hatfield Ellsworth, in memory of
La Ferne Hatfield Ellsworth, 1986
(1986.267.222)

FIGURE 77

Bada Shanren (1626–1705),
"Catfish," from the album *Flowers,
Catfish, and Other Subjects* dated
1689. Album leaf, ink on paper.
Palace Museum, Beijing

and lively, with free-form strokes that capture the essential character of the crab and deftly convey a sense of movement.

In 1919, when Qi was fifty-six, there was a shift in the direction of his work. In Beijing, under the influence of Chen Hengke, his paintings underwent a radical change, focusing on seal-script calligraphy (fig. 76). In *Shrimp* (pl. 50), dated 1927, realism and calligraphy are combined to make Qi Baishi's signature style. Here the shrimp is formed by the repetition of brushstroke motifs. Variety and movement are achieved by varying the direction of the head and the curve of the body, while the manipulation of the running ink tones creates the impression of the shrimp in water.

Turning to landscape, Qi in *Viewing Antiquities at the Studio of Humility* (pl. 51), dated 1930, shows the influence of Chen Hengke's simplified brushwork (pl. 47). Using blunt, seal-style strokes and bright patches of color, he creates abstract patterns with an archaic flavor, the simplicity of which makes the design easily transferred to woodblock reproductions. In *Lamp-lit Pavilion on a Rainy Night* (pl. 52), dated 1933, Qi tries his hand at the cloudy ink-dot (*yundian*) idiom first used by Mi Fu (1052–1107). Developing the tenth-century master Dong Yuan's early experiments in light and reflection in landscape painting, Mi's technique is best suited to painting on silk, when mountain forms are enveloped in mist by means of a graded ink wash that fades into the silk surface. Here Qi experiments with this idiom on paper, suffusing the painting surface with a wet, ink-filled brush.

Pursuing his calligraphic style in the 1930s, Qi also followed in the tradition of the seventeenth-century individualist master Bada Shanren (1626–1705; fig. 77). By his own account,

PLATE 54
Qi Baishi (1864–1957),
"Persimmon," early 1940s.
Album leaf, ink on paper,
11⅞ × 12¼ in. (30.2 × 31.1 cm).
Robert H. Ellsworth Collection

FIGURE 78
Bada Shanren (1626–1705),
"Sheshi," from the album *Birds
and Flowers,* 1692. Album leaf,
ink on paper, 8⅝ × 11⅜ in. (21.9 ×
28.8 cm). Freer Gallery of Art,
Wang Fangyu and Sum Wai
Collection, Washington, D.C.
(F1998.56.1)

he first saw an original work by Bada in 1904.[12] "Catfish"
(pl. 53), dated 1937, is inscribed with the following:

*I once saw Zhu Xuege's [Bada's] painting of a small fish less
than three inches long and enlivened with natural vitality. To-
day, I took a piece of old wrapping paper and painted on it this
[fish], which measures more than ten inches in length. But mine
is not as skilled and sturdy as Xuege's. I feel ashamed.*[13]

Bada's paintings of fish (fig. 77), small animals, and birds,
which appear vulnerable and terrified, are vivid examples of
how art can invest nature with human emotions.

In a picture of a persimmon, symbol of good fortune at
the New Year (pl. 54), dating also from the late 1930s or early
1940s, Qi again emulates Bada (fig. 78). Bada's characters
sheshi, meaning "immersion in the practice [of painting and
calligraphy]," are written on the title page of an album of six-
teen leaves entitled *Birds and Flowers,* dated 1692, in which
newborn chicks, flowers, fruits, bamboo, and rocks are ren-
dered in an abstract, seal-style calligraphic brushwork.[14] Bada
gives us a clue to the meaning of the work in his cryptic in-
scription, "Nature's heart [brings] seagulls," which refers to a
Daoist fable: A boy of the sea loved seagulls, and he and the
gulls would frolic on the shore. One day his father asks, Why
not capture one and bring it home? When the boy returns,
the gulls merely circle in the sky and never come near him
again. The meaning of the story appears to be that the at-
tempt to apprehend reality—the seagulls—leads only to its
slipping out of reach; so does art come to the artist only
by selfless acceptance. Following Bada, Qi returns to a state

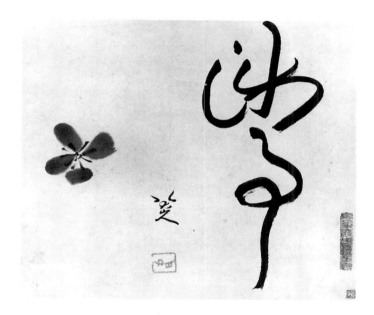

151

of acceptance by cultivating a simple, straightforward style.
His inscription, a greeting for the New Year, reads, in Han
clerical script: "Great good fortune."

Eagle on a Pine Tree (pl. 55), dating from about 1940, emu-
lates a painting by Bada (fig. 79), dated 1702. Richard Barnhart
has linked Bada's eagle paintings to the Manchu emperor
Kangxi, and interprets Bada's heroic images of eagles as reflect-
ing the artist's spirit of defiance.[15] Qi's eagle, painted when
the artist lived in Japanese-occupied Beijing, may express his
own unbending spirit. The inscription on his painting,
borrowing lines from the eighth-century poet Du Fu, has a
more conciliatory tone:

*Why attack ordinary birds,
Spraying blood and scattering feathers on the ground?*

152

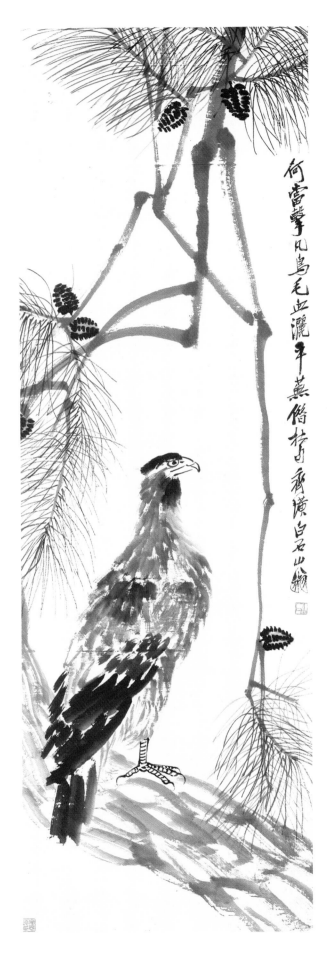

PLATE 55

Qi Baishi (1864–1957), *Eagle on a Pine Tree*, ca. 1940. Hanging scroll, ink on paper, 68⅛ × 21½ in. (173 × 54.6 cm). Gift of Robert Hatfield Ellsworth, in memory of La Ferne Hatfield Ellsworth, 1986 (1986.267.216)

FIGURE 79

Bada Shanren (1626–1705),
Two Eagles, dated 1702. Hanging
scroll, ink on paper, 73 × 35½ in.
(185.5 × 90 cm). The Metropolitan
Museum of Art, Ex coll.: C.C.
Wang Family, Lent by Oscar L.
Tang, 1997 (l.1997.30)

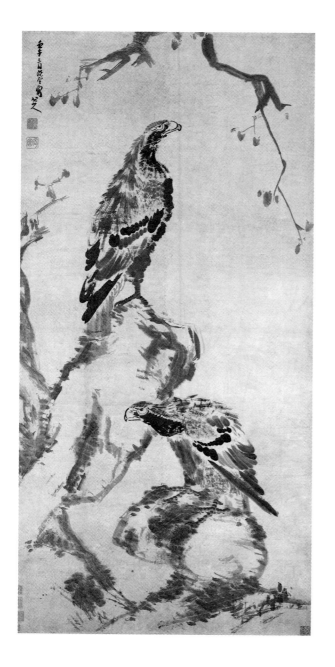

In 1950, Qi presented a similar painting of an eagle, dated 1941, to Mao Zedong.[16]

About the same time, Qi painted *The Immortal Li Tieguai* (pl. 56), on which he writes:

I once wrote a poem about Iron-Crutch Li [Tieguai], which says: "Without his gourd and crutch, who can recognize him as an immortal?" On this painting, I added a cinnabar stove. Now he looks even more like a starving refugee.[17]

In popular mythology, the Daoist immortal Li Tieguai often appeared in the guise of a beggarly figure (pl. 22). In wartime Beijing, Qi perhaps used Li Tieguai as a symbol of the refugees who populated the city.

During the late 1930s and early 1940s, Qi continued to simplify his brushwork. He focused in particular on the narrow vertical format. In *Weeping Willow*, dating from about 1937 (pl. 57), soon after the Japanese took Beijing, Qi draws fluttering willow branches in a decorative calligraphic pattern to comment on life under foreign occupation:

Do not criticize Tao [Yuanming's] family for being weak, for lacking courage. There are times that willow branches must learn to bend [with the wind].[18]

Water Buffalo Under a Willow Tree (pl. 58), dating from about the same time,[19] shows the rear view of a buffalo in cartoonlike shorthand, with a lively tracery of draping willow branches in the space above. And on the painting *Five Water Buffalo* (pl. 59), he writes:

153

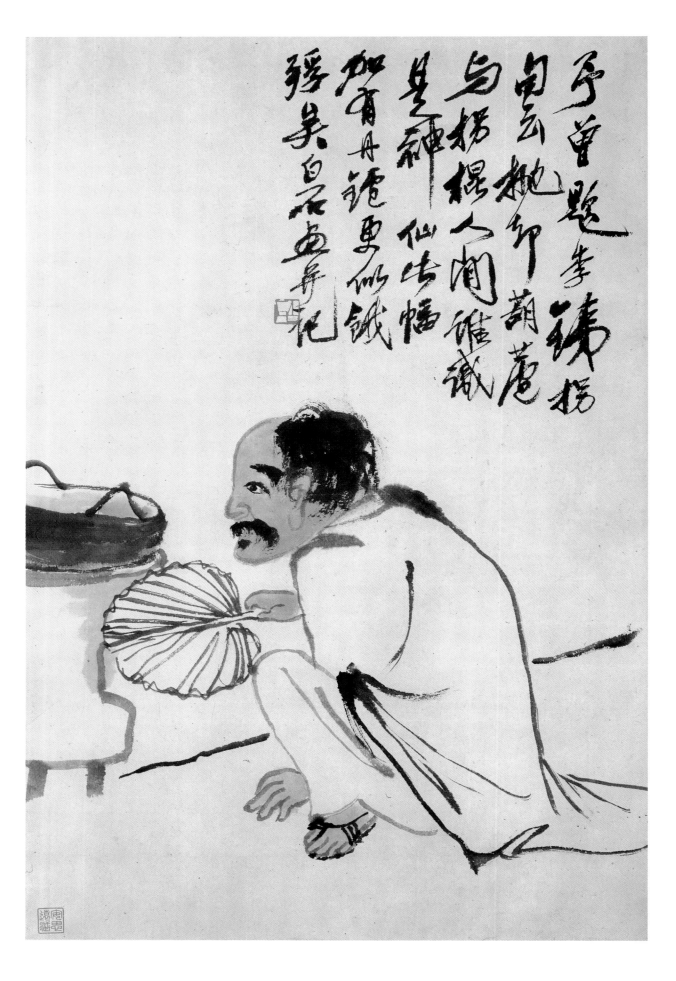

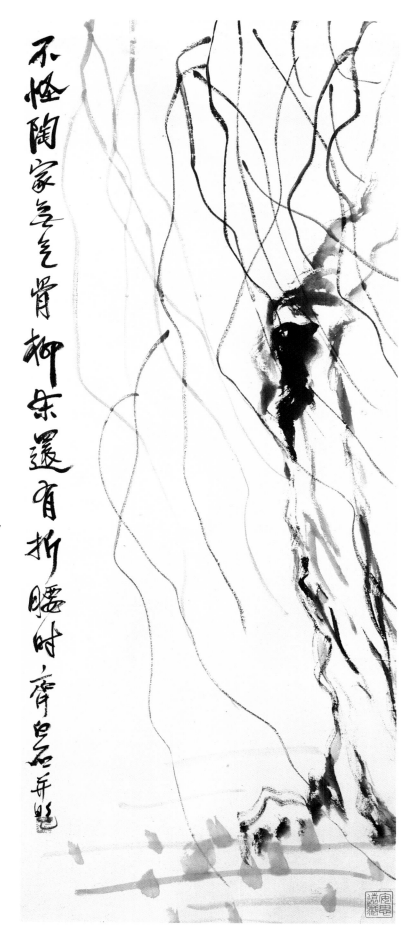

PLATE 56

Qi Baishi (1864–1957), *The Immortal Li Tieguai,* early 1940s. Hanging scroll, ink and color on paper, 33¾ × 22½ in. (85.8 × 57.2 cm). Robert H. Ellsworth Collection

PLATE 57

Qi Baishi, *Weeping Willow,* ca. 1937. Hanging scroll, ink on paper, 31⅞ × 13 in. (81 × 33 cm). Gift of Robert Hatfield Ellsworth, in memory of La Ferne Hatfield Ellsworth, 1986 (1986.267.221)

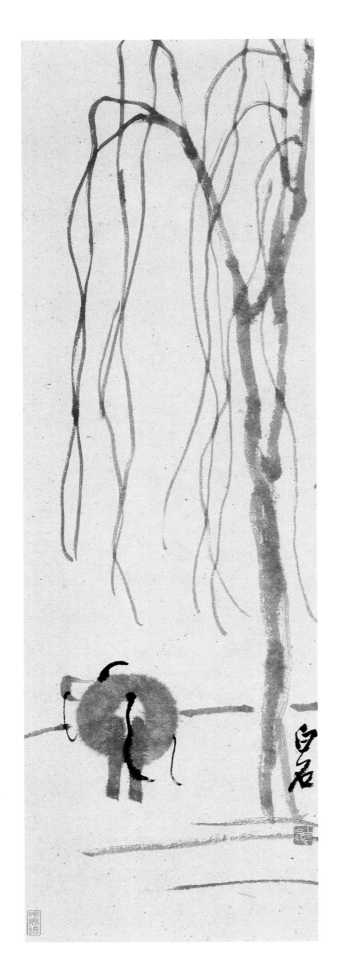

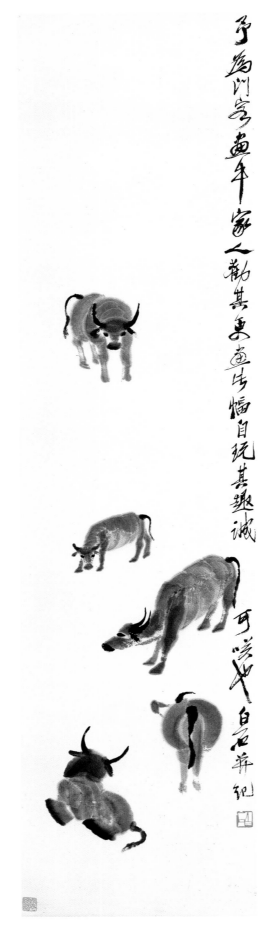

PLATE 58

Qi Baishi (1864–1957), *Water Buffalo Under a Willow Tree*, ca. 1937. Hanging scroll, ink on wrapping paper, 34⅜ × 11 in. (87.2 × 27.9 cm). Gift of Robert Hatfield Ellsworth, in memory of La Ferne Hatfield Ellsworth, 1986 (1986.267.223)

PLATE 59

Qi Baishi, *Five Water Buffalo*, ca. 1937. Hanging scroll, ink on paper, 53¼ × 13¼ in. (135.3 × 33.7 cm). Gift of Robert Hatfield Ellsworth, in memory of La Ferne Hatfield Ellsworth, 1986 (1986.267.219)

FIGURE 80

Attributed to Han Huang (723–787), *Five Water Buffalo*, detail. Handscroll, ink and color on paper, 8⅛ × 55 in. (20.8 × 139.8 cm). Palace Museum, Beijing

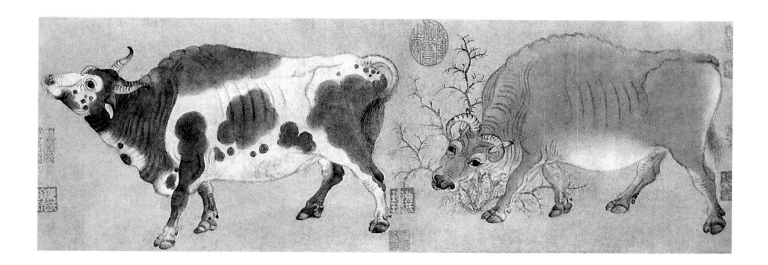

I painted this for a family friend. My family persuaded me to repeat the composition and keep the copy for ourselves, since it is rather amusing.[20]

Silhouetted against the blank space of the narrow hanging scroll format, five realistically rendered buffalo, posed in various frontal, rear, and side views, are no doubt an homage to the classical composition attributed to the eighth-century Tang buffalo painter Han Huang (723–787; fig. 80).

The quintessential Qi Baishi is seen in *Water Life* (pls. 60a–d), a set of small hanging scrolls dated 1940, which represents in four narrow vertical spaces two frogs, two crabs, three fish, and two shrimp. By this time, Qi has achieved his full power in both visual acuity and calligraphic brushwork. Compared with the earlier *Shrimp* (pl. 50), Qi's crustaceans of 1940 (pl. 60d) show graphic formulas that exemplify

traditional painting from life (*xiesheng*), now updated. The painting of the shrimp shows two oblong strokes representing the carapace of the head (see page 3); the body, in five sections, forming an arc, is done with five curved dots in diminishing size; a sixth, more elongated dot represents the tail section, which ends with two side strokes. Qi's shrimp is an exacting depiction of a shrimp coursing through the water, propelling itself forward by curving its back into a humped position, its feelers pushed back by the resistance of the water.

In the crabs (pl. 60b), Qi turns his earlier, free-form descriptive brushwork (pl. 49) into a series of well-defined strokes, with controlled, running ink dots that suggest the texture of the claws. By placing the cropped forms diagonally across the narrow picture plane, he turns the empty whiteness of the paper into significant negative spaces that help to define the forms. The formulaic approach of Qi's painting

PLATES 60a–d

Qi Baishi (1864–1957), *Water Life*, dated 1940. Set of four hanging scrolls, ink on paper, 25½ × 6 in. (64.9 × 15.2 cm). Gift of Robert Hatfield Ellsworth, in memory of La Ferne Hatfield Ellsworth, 1986 (1986.267.234a–d)

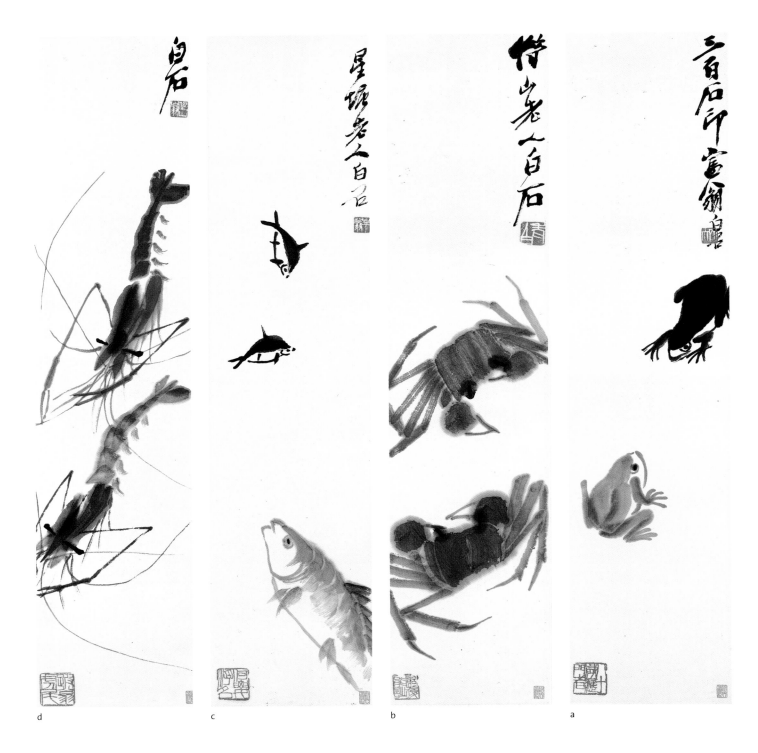

d c b a

PLATE 61

Qi Baishi (1864–1957), *Two Hens*, dated 1942. Folding fan, ink and color on alum paper, 7½ × 20¼ in. (18.9 × 51.4 cm). Gift of Robert Hatfield Ellsworth, in memory of La Ferne Hatfield Ellsworth, 1986 (1986.267.230ab)

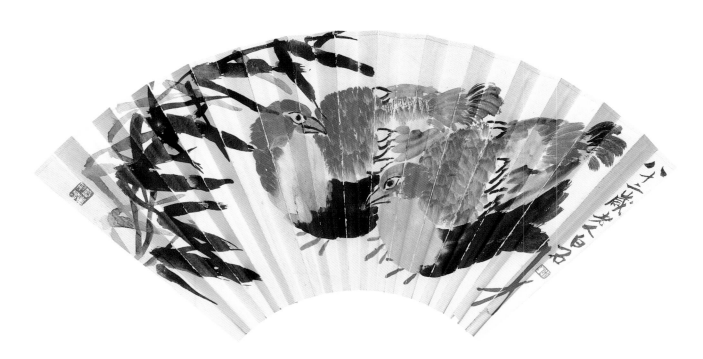

was followed by many painters, who not only painted in his style but also wrote detailed technical manuals on how to execute his various subjects.[21] In the end, however, Qi cannot be imitated. As he repeatedly warned his students, "Those who learn from me live, those who copy me die."[22]

By the early 1940s, now in his early eighties and more prolific than ever, Qi could hardly contain his energy. In *Two Hens* (pl. 61), dated 1942, he fills the fan surface with plump, contented chickens with the confidence of an unsurpassed master. *Insects and Plants* (pls. 62a–e), dated 1943, is an album of twelve leaves that represent Qi's favorite subjects. Matching and contrasting realistic depictions of insects with calligraphic representations of household utensils, flowers, and vegetables, Qi demonstrates his mastery of different skills: fine and detailed, versus a more cursory, abbreviated style. As a young portrait artist, he had perfected the drawing of small, lively ornaments (*xiaohuo*) in his depictions of female subjects with richly embroidered garments and household furnishings.[23] Here, in his mature works, he freely represents bountiful nature with everyday flower-and-insect subjects in both a fine and an abbreviated style, with popular associations of the moth with the oil lamp, the dragonfly with the lotus flower (pl. 62c), and the locust grasshopper with the rice plant (pl. 62d).

PLATES 62a–e
Qi Baishi (1864–1957), *Insects and Plants*, dated 1943. Album of twelve leaves, ink on paper, 10⅛ × 13½ in. (25.7 × 34.3 cm). Gift of Robert Hatfield Ellsworth, in memory of La Ferne Hatfield Ellsworth, 1986 (1986.267.237a–l)

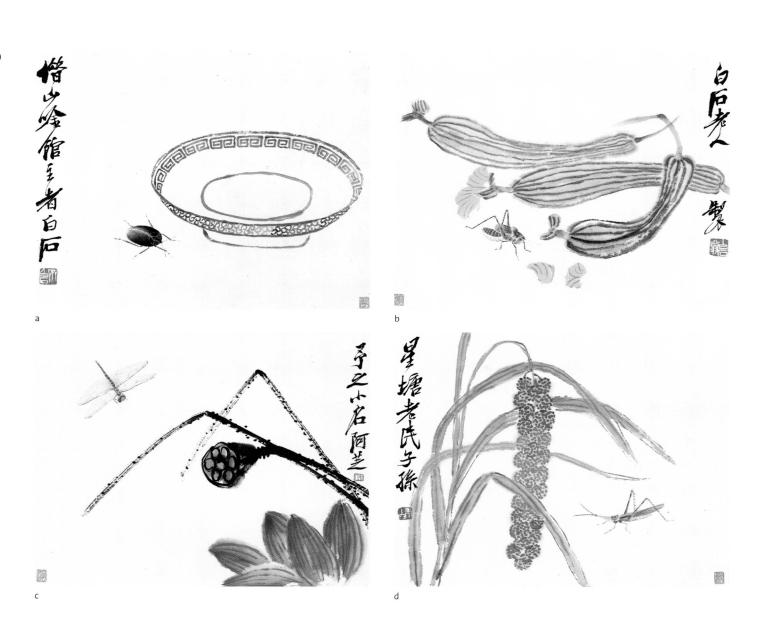

a

b

c

d

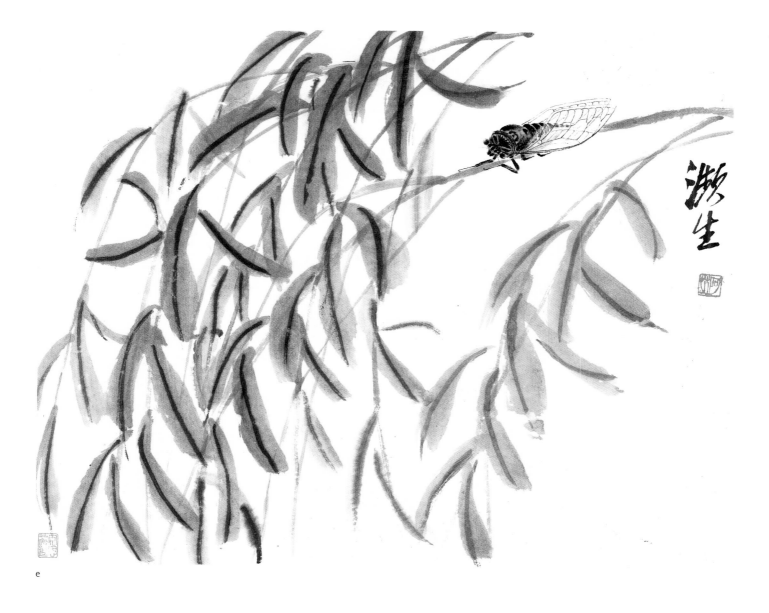

e

PLATE 63

Qi Baishi (1864–1957), *Peaches and Buddha Hands*, dated 1955. Folding fan mounted as an album leaf, ink and color on alum paper, 7¼ × 20½ in. (18.4 × 52.2 cm). Gift of Robert Hatfield Ellsworth, in memory of La Ferne Hatfield Ellsworth, 1986 (1986.267.236)

Peaches and Buddha Hands (pl. 63), dated 1955, painted in the artist's ninety-first year, displays Qi's technical control undiminished. Two auspicious symbols, a pair of succulent red peaches and two citrons, called Buddha hands, are painted in an abbreviated, almost abstract style. Forever the populist artist, he adds a good-luck greeting, "Great Fortune, Great Longevity."

THE LANDSCAPE AND FLOWER PAINTING OF HUANG BINHONG

The life of Huang Binhong (1865–1955) spanned the years from the end of the Taiping uprising through the early years of Communist rule, a century of turmoil and change.[24] Unlike Qi Baishi, who was raised in poverty and trained as a craftsman, Huang was born to a prosperous family in Jinhua (Zhejiang) and educated in the traditional mold of a young scholar preparing for an official career. Huang worked in his family's ink-stick manufacturing business from 1889 to 1891, and in the early 1900s was actively engaged in building dams to develop farmlands. Beginning in 1904, when he was thirty-nine, he embarked on his long career as a teacher, editor, author, and painter.[25]

In his *Autobiography*, published in 1943 on the occasion of an exhibition of his paintings celebrating his eightieth *sui* birthday (his birthday by Chinese count), Huang recollects his long career:

When I was thirteen, I returned to Shexian [Anhui] to take part in the civil examination. In the wake of the Taiping uprising,

when the older families still owned many antique objects, I had opportunities to see many original paintings by ancient masters, a number of them of exceptionally high quality. Among them were paintings by Dong Qichang and Zha Shibiao, which attracted my special attention.... At the beginning of the gengzi troubles [the Boxer Rebellion of 1900], I retired [from business] to farm in rural Jiangnan. Over a period of nearly ten years, I cultivated several thousand acres of rice crops. During this time, I spent all my spare income collecting works of metal and stone, as well as calligraphy and painting, devoting myself to research.[26]

In 1905, Huang joined the Anhui Public School, a hotbed of revolutionary activity, where his fellow teachers included radical young thinkers, among them Chen Duxiu, later a founder of the Chinese Communist Party.[27] Arriving in Shanghai in 1908, Huang became chief editor of the *Anthology of Fine Arts*, a compilation of 160 volumes of writings on Chinese art, published in 1911, 1913, and 1928.[28] In 1909, at the invitation of Li Ruiqing, then minister of education in Nanjing, Huang served as director of the Preparatory School for Overseas Study in the United States, located in Shanghai.[29] In the wake of the Japanese invasion of Manchuria, in 1931, the Chinese government prepared for the evacuation of the finest objects in the National Palace Museum in Beijing. In 1936, Huang was elected to the Committee for the Authentication of Ancient Artifacts in the National Palace Museum, whose responsibility was to authenticate the paintings then being stored in Shanghai.[30] Early in 1937, he moved with his family to Beijing to continue his work. Huang remained in Beijing through the Japanese occupation, until 1948. That year he

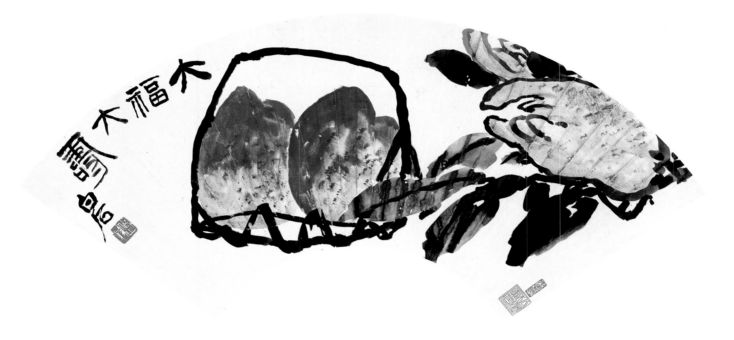

became a professor at the Hangzhou Academy of Art, where he taught until his death in 1955.

As an editor and a painter, Huang was involved primarily in the study of traditional-style painting and theories of art. He disagreed with Chen Hengke in his essay "A Study of Chinese Scholar Painting" (1922), which placed high value only on the works of early Qing masters, such as Shitao, Bada Shanren, and the Eight Eccentrics of Yangzhou, to the exclusion of later Qing artists. Instead, he held the works of many nineteenth-century calligraphers and painters, such as Bao Shichen, Wu Xizai, Weng Tonghe, and Zhao Zhiqian (pls. 2, 3), in high regard.[31] Huang criticized the work of the Yangzhou Eccentrics as coarse and lazy, but he believed that the metal-

and-stone school of calligraphy and the painting of the Dao-Xian era (that of the rulers Daoguang and Xianfeng, 1821–61), inspired by Neolithic pottery, oracle bones, ritual bronzes, and stone engravings, represented a revival of Chinese art.[32]

During the late 1920s and early 1930s, Huang painted many landscapes in the classical styles of Juran (active ca. 960–95), Huang Gongwang (1269–1354), and Wang Meng (ca. 1308–1385), using a hemp-fiber (*pima*) texture method with wavy, parallel brushstrokes.[33] In *Ten Thousand Valleys in Deep Shade* (pl. 64), dated 1933, Huang recalls the monumental landscapes of stacked peaks and valleys that hark back to the tenth-century masters Dong Yuan (active 930s–60s) and Juran. In *Rocky Crags* (fig. 81), dating from before 1938, he

萬壑深陰卉木稠鬱螺黛濃影澄澹流丹黃
幾點蕭蕭葉白帝城高易得秋
菊游雜詠
吹萬先生哂正
筆首　黃賓虹并畫

PLATE 64

Huang Binhong (1865–1955), *Ten Thousand Valleys in Deep Shade*, dated 1933. Hanging scroll, ink and color on paper, 67½ × 18 in. (171.5 × 45.7 cm). Gift of Robert Hatfield Ellsworth, in memory of La Ferne Hatfield Ellsworth, 1986 (1986.267.200)

signs his work "Yuxiang" (I emulate Xiang), a sobriquet he adopted in admiration of the late-Ming painter Yun Xiang (1586–1655). In his *Autobiography*, he explains:

The reason for my sobriquet Yuxiang is that, in my view, the works of the late-Ming painter Yun Xiang, in capturing the lush and resplendent [huaci], full and round [hunhou] qualities of Dong Yuan and Juran, best exemplify the characteristics of a great painter, unmatched even by Dong Qichang, Wang Shimin, Wang Hui, and other masters. Because of my devotion to Yun Xiang, I have studied him more than any other painter. Since I also love to travel in the mountains, I have directed my study of the ancient masters toward understanding nature. Thus, in emulating Xiang, I have adopted the sobriquet [Yuxiang].[34]

Yun Xiang (fig. 82), who influenced the early-Qing Nanjing individualist master Gong Xian,[35] followed the manner Dong Qichang. Huang Binhong's characterization of Yun's style as "lush and resplendent, full and round" derives from Zhang Yu's (1283–1350) description of the style of the Yuan master Huang Gongwang, in which "the mountain peaks are full and round, and grass and trees lush and resplendent," a description that, through its repeated mention by Dong Qichang, became critically important for seventeenth-century landscape painting.[36] Wang Hui's *Landscape in the Style of Juran* (fig. 83), dated 1664, for example, bears the inscription, "Mountains and streams full and round, grass and trees lush and resplendent."[37] For Wang, who painted during the reign of the Qing Kangxi emperor (r. 1662–1722), when peace and prosperity had been newly restored to southern China, the

FIGURE 81
Huang Binhong (1865–1955), *Rocky Crags*, before 1938. Hanging scroll, ink and color on paper, 34 × 13¼ in. (86.4 × 33.7 cm). Arthur M. Sackler Gallery, Smithsonian Institution, Washington, D.C. (s87.0230)

FIGURE 82
Yun Xiang (1586–1655), *Interpretations of Ancient Masters*, 1626 or 1638. One leaf from an album of ten leaves, ink and color on paper, each leaf 10¼ × 6 in. (26 × 15.2 cm). The Metropolitan Museum of Art, Purchase, Douglas Dillon Gift (1977.171a–j)

FIGURE 83
Wang Hui (1632–1717), *Land-scape in the Style of Juran*, dated 1664. Hanging scroll, ink on paper, 51⅝ × 25¾ in. (131 × 65.5 cm). The Art Museum, Princeton University, Gift of Mr. and Mrs. Earl Morse (y1979-1)

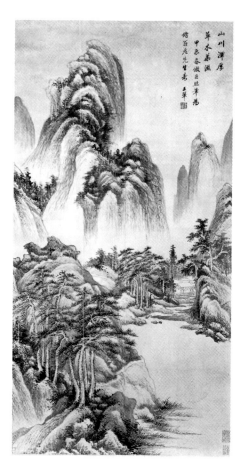

phrase not only described a luxuriant painting style but spoke also for the artist's pride and satisfaction to his native land of Jiangnan. Huang Binhong now adopted the phrase "lush and resplendent, full and round" as his guiding principle in bringing life and energy to modern landscape painting.

After living in Shanghai for more than twenty years, Huang, in 1932–33, made an extended trip to mountain sites in Sichuan in southwest China and again, in 1935, to Guilin in south China. Now nearly seventy years old, he climbed mountain after mountain to study the landscape firsthand, making hundreds of rapid pencil sketches of spectacular mountain views.[38] *Sketches of Twelve Strange Mountain Peaks* (pls. 65a, b), dating from about 1935, are transcriptions of some of the sketches into brush-and-ink drawings. Compared with

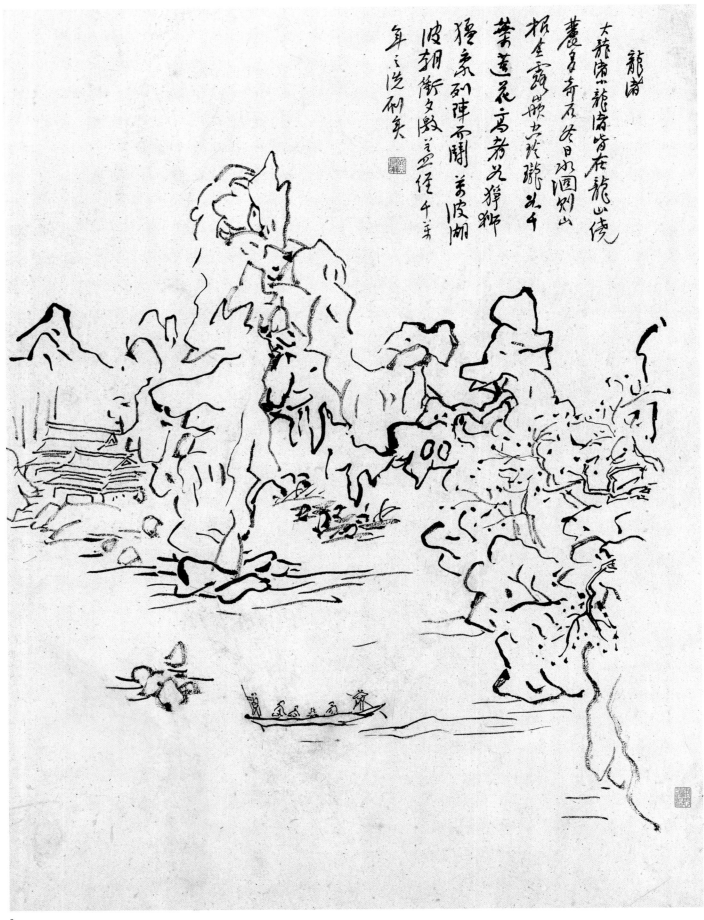

龍渚

太龍渚小龍渚皆在龍山磯
叢多奇石終日映迥別山
根金露纍纍出坡瀧水千
荸遊花高芳光獐獅
猿象列陣而鬪菁波湖
波朝衡夕敗之正侄千年
年之浣卻矣

a

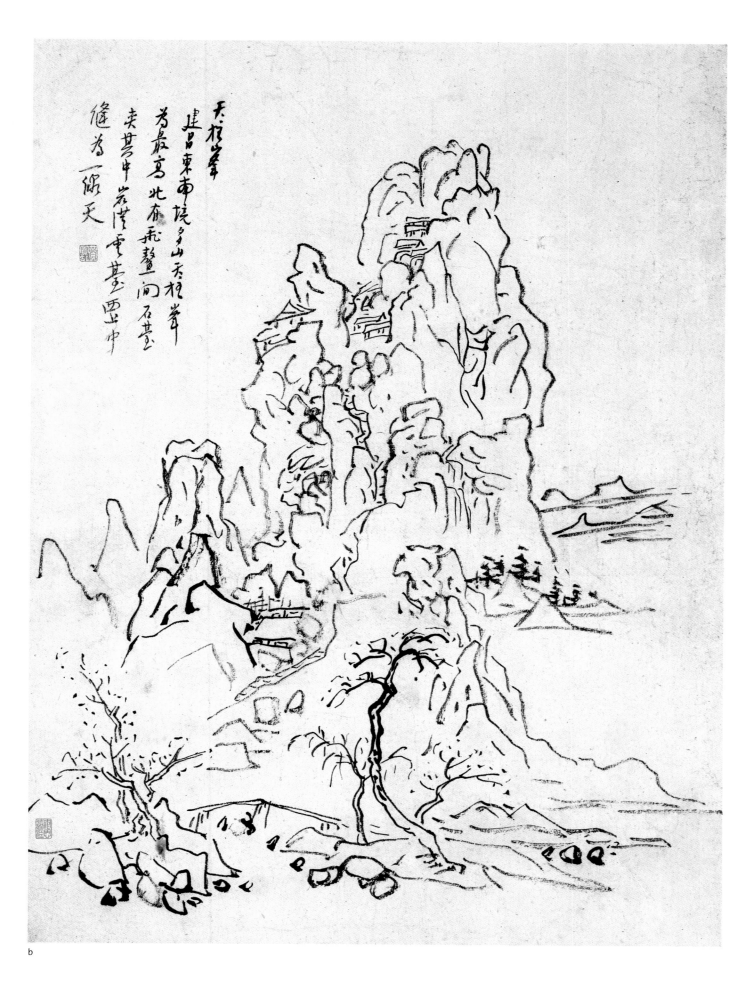

THREE GREAT TRADITIONALISTS

PLATES 65a,b (overleaf)
Huang Binhong (1865–1955),
*Sketches of Twelve Strange
Mountain Peaks*, ca. 1935. Album
of twelve leaves, ink on paper,
22 × 16½ in. (55.9 × 41.9 cm).
Gift of Robert Hatfield Ellsworth,
in memory of La Ferne Hatfield
Ellsworth, 1986 (1986.267.203a–l)

PLATE 66
Huang Binhong, *Black Landscape*,
late 1940s. Album leaf mounted
as a hanging scroll, ink and color
on paper, 10¼ × 9½ in. (26 ×
24.2 cm). Robert H. Ellsworth
Collection

168

the woodblock-printed illustrations of the Lotus Peak of Yellow Mountain from the traditional *Gazetteer of Yellow Mountain* (fig. 60), which build with conventionalized mountain forms, Huang's are life sketches from visual impressions. Huang, however, continues in the gazetteer tradition of describing specific sites in minute detail, often in poetically evocative terms. On "Dragon Islet" (pl. 65a) his inscription reads:

Both the Great Dragon Islet and the Small Dragon Islet are found at Dragon Mountain. Around the base of the mountain are many strange rocks. In winter, when the water recedes, the base is exposed. Intricately hollowed out, it is like a thousand lotus flowers. The large rocks are like ferocious lions and fierce elephants lined up in battle to confront the ten thousand waves of the lake. They have been eroded by the water day and night for thousands and thousands of years.[39]

Huang also turns to the subject of form-likeness, or mimetic realism:

There are three kinds of painting. First, there is painting that reproduces form-likeness [which can be a way] to dupe people and to gain a good reputation. Next, there is painting that displays unlikeness as the writing of ideas and feelings [xieyi], [which can also be a way] to dupe people. Finally, there is that which is realistic without exactly reproducing form-likeness. This is true painting![40]

Huang's study of nature appears to have led him to a deeper appreciation of the ancient masters:

There are those who study the ancient masters without studying nature. But no one can learn about nature without also learning about the ancients.[41]

But Huang objected to paintings that were enslaved by nature (*nuhua*) as much as to those who were slaves to the ancient masters (*huanu*). To avoid stereotypical imitation of both nature and style, Huang, like Dong Qichang before him, believed that landscape painting should be approached through calligraphy. As a youth, Huang practiced metal-and-stone calligraphy and seal carving.[42] Now he turned the texture method into purely calligraphic brushstrokes. Comparing landscape painting to landscape in nature, he recalled Dong Qichang's injunction, "If one considers the wondrous variety of nature, then a landscape painting is not the equal of real landscape. But if one considers the wonders of brush and ink, then real landscape can never match painting."[43] In a similar vein, Huang wrote:

While the interaction of yin and yang,...heaven and earth, creates ten thousand things [in nature], there are inevitable shortcomings, which await man's efforts to bring to perfection.[44]

It remained for the painter to fill in "what heaven leaves out," he argued. "If painters do not show creativity, why do we need painting?"[45]

During the 1940s, when Huang was in his late seventies, his style underwent a transformation. He described the style as "black, dense, thick, and heavy."[46] *Black Landscape* (pl. 66), dating from the late 1940s, shows a mountain village set

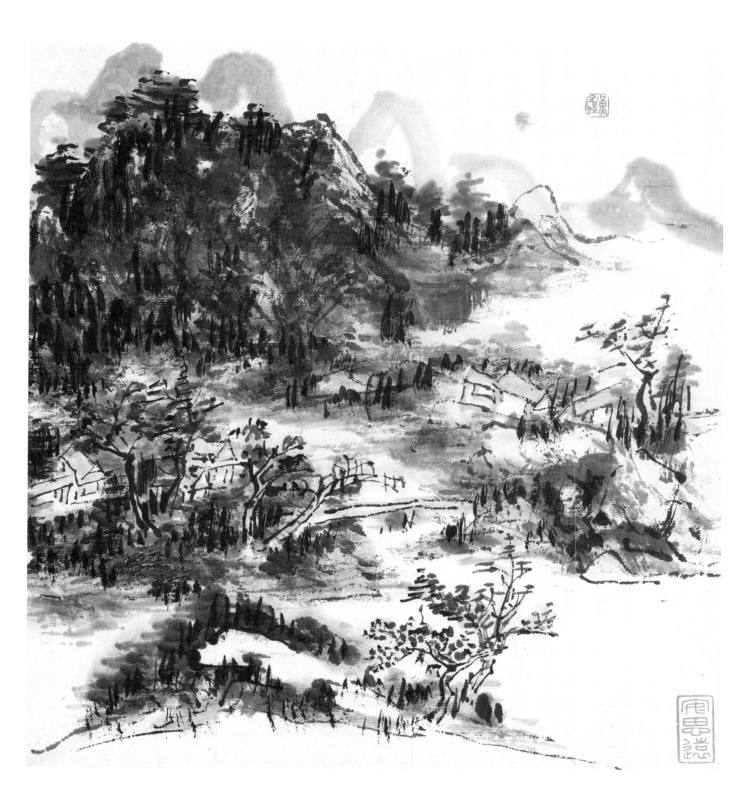

PLATE 67

Huang Binhong (1865–1955), *Landscape in the Style of Dong Qichang*, late 1940s. Album leaf mounted as a hanging scroll, ink and color on paper, 10¼ × 9½ in. (26 × 24.1 cm). Gift of Robert Hatfield Ellsworth, in memory of La Ferne Hatfield Ellsworth, 1988 (1988.324.4)

against dense forest and with a running brook described by patterns of solid and void, black and white, and subtle changes in brush movement and texture. Essentially, it is an exercise in brush and ink. Using a round, blunt brush technique, which he described as evoking cast iron (*ru zhutie*) and derives from archaic seal-style calligraphy, he develops his composition first with contour lines and parallel modeling strokes, after which he overlays them with tree motifs made of crisscrossing vertical and horizontal strokes. Finally, he builds density and depth with layers of ink dots and ink washes. He wrote of his brushwork in 1942:

To achieve weight and solidity [in brushwork], I follow five methods: the level, the round, the reserved, the heavy, and the changing. A level stroke is one that appears to have been drawn in the sand, so that it will not be thin and superficial. When it is round it resembles a bent bracelet, without sharp corners and with flexibility. When it is reserved, it is like a stain slowly seeping from a leaky roof; it does not appear coarse and wild and without restraint. When a stroke is heavy, it is like a rock falling from a high mountain and resembles falling leaves drifting in the wind, aimless and disorganized. When it is changing, it is beautiful from all eight sides and expresses the calligrapher's Eight Principles. Without change, a horizontal painting looks like an abacus, and a vertical one resembles a chessboard.[47]

And he also wrote about seven kinds of ink brushwork: the thick, the light, the splashed, the broken, the accumulated, the burnt, and the leftover.[48] Thick ink is used to break into light ink, and light into thick, and, for added effect, different methods of applying splashed or broken-ink washes are used in combination, with a variety of ink colors described as accumulated, burnt, or leftover.[49]

Huang perceived the physical act of painting with brush and ink in cosmogonic terms. He quoted from Shitao's theory of the Painting of Oneness (*yihua*):

When the brush unites with ink, cosmic atmosphere [yinyun] is created. If the atmosphere remains undifferentiated, chaos results. How can order be created from chaos? Through the painting of oneness. . . . When a painter, in using brush with ink, learns to give form cosmic atmosphere and to create order from chaos, he will be a master through the ages.[50]

In *Landscape in the Style of Dong Qichang* (pl. 67), dating also from the late 1940s, Huang describes the relationship between brushwork and ink wash. The colophon reads:

Dong Qichang's landscape painting, in both its texture strokes and ink wash, follows the quality of "lush and resplendent." But the works of his followers Zhao Zuo and Shen Shichong are cold, misty, and trivial, typical of the style of the Yunjian school. The reason is that their brushwork lacks strength and is easily overwhelmed by ink wash.[51]

In his own painting and using cast-iron brushwork, Huang follows the five principles, applying level, round, reserved, heavy, and changing brushstrokes.

Dwelling in the Xixia Mountains (pl. 68), dated 1954, bears the inscription:

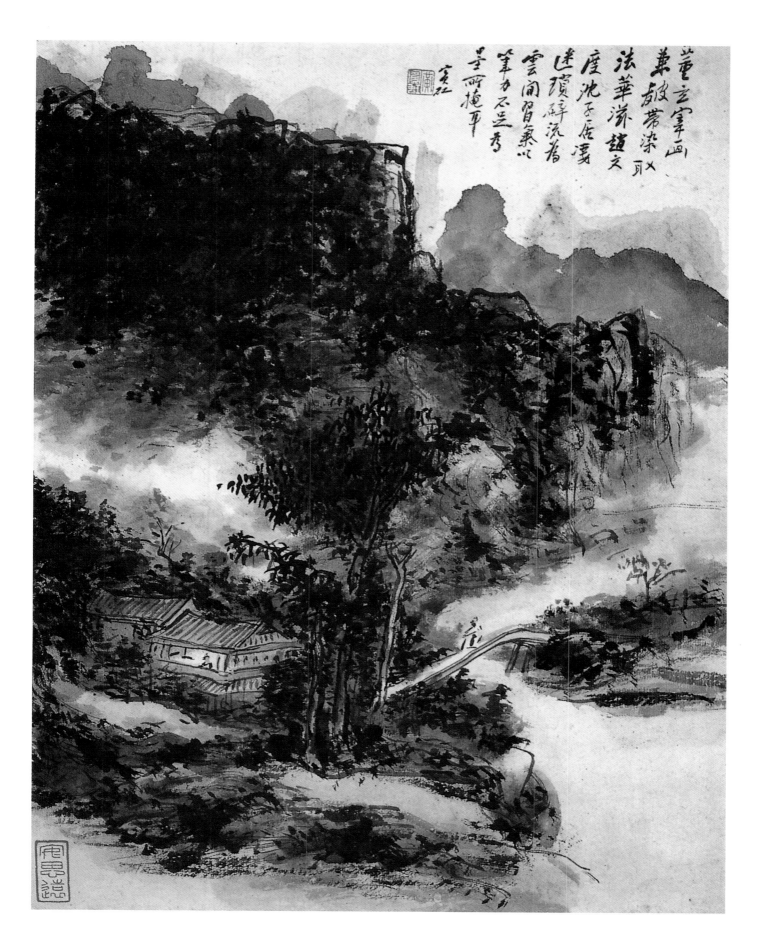

FIGURE 84

After Wang Wei (ca. 699–ca. 761), *Wangchuan Villa*, detail. Hand-scroll, rubbing from a stone en-graving, dated 1617. Ink rubbing on paper, 12 in. × 16 ft. 4 in. (30.4 cm × 4.9 m).

Living in the Xixia Mountains and viewing the peaks to the north and south at dawn, I gaze at the verdant hills and russet forests that nearly cover the village by the lakeshore. I painted this in the styles of Wang Wei [ca. 699–ca. 761] and Zhao Ling-rang [active ca. 1070–after 1100].[52]

Painted less than a year before he died in 1955, at the age of ninety, Huang presents a mountain panorama in a traditional compositional schemata of overlapping, two-dimensional triangular forms, neatly staggered in echelon. His view of

the mountain village recalls Wang Wei's *Wangchuan Villa* (fig. 84), a painting also said to have influenced Zhao Lingrang.[53]

By the 1950s, Cézanne and van Gogh were long known in China, and Jackson Pollock would die in 1956, a year after Huang. Steeped in ancient tradition, Huang nevertheless found common ground in Chinese and Western representa-tional painting. In 1922, Chen Hengke had written that Cubism, Futurism, and Expressionism "only show that form-likeness alone can never exhaust what art can do; one must always

FIGURE 85

Paul Cézanne (1839–1906), *Mont Sainte-Victoire with Large Pine*, 1886–87. Oil on canvas, 23½ × 28½ in. (59.6 × 72.3 cm). The Phillips Collection, Washington, D.C.

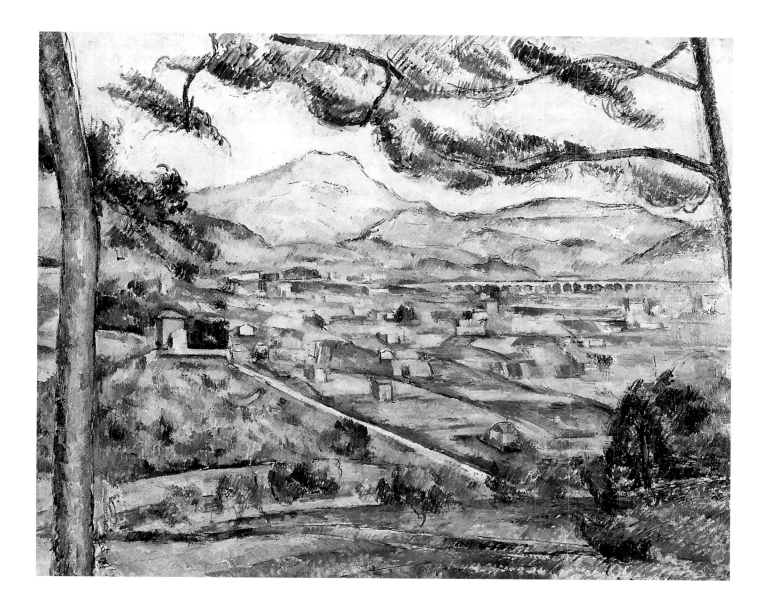

174

PLATE 68

Huang Binhong (1865–1955),
Dwelling in the Xixia Mountains,
dated 1954. Hanging scroll,
ink on paper, 47⅜ × 23½ in.
(120.3 × 59.7 cm). Gift of Robert
Hatfield Ellsworth, in memory of
La Ferne Hatfield Ellsworth, 1986
(1986.267.201)

PLATES 69a,b (overleaf)
Huang Binhong (1865–1955),
Flowers, early 1940s. Album of
eight leaves, ink and color on
paper, 10⅝ × 10⅛ in. (27 ×
25.7 cm). Gift of Robert Hatfield
Ellsworth, in memory of La
Ferne Hatfield Ellsworth, 1986
(1986.267.202a–h)

seek alternative paths."[54] Now, in a letter dated April 16, 1948, Huang Binhong wrote:

In painting one need not be troubled by the differences between the Chinese and Western traditions. With brushwork and ink wash, one simply follows the principles of nature. The evolution from form-likeness [xingsi] to expressive likeness [shensi] has also been followed by the development in the West from Impressionism to abstraction. The Wild Beasts [Fauves] are like [the Zhe school painters of the Ming dynasty] Wu Wei, Zhang Lu, Guo Xu, and Jiang Song, among others, who, basing their work on that of [the Southern Song academic painters] Ma Yuan and Xia Gui but leaning toward the unorthodox, created what is known as the Wild Fox Chan style.[55]

Huang Binhong's exploration of patterns in brush and ink (page 137) is inspired by Dong Qichang's dictum, "If one considers the wonders of brush and ink, then real landscape can never match painting." Dong's statement seems to converge with a remark made by Maurice Denis, which could be applied, for example, to Cézanne (fig. 85): "It must be remembered that any painting—before being a war horse or a nude woman, or some anecdote—is essentially a flat surface covered with colors arranged in a certain order."[56] But the parallel is a superficial one, for whereas Cézanne's proto-Cubist technique experiments with a constructed reality, Huang's concerns are with calligraphic brushwork, which bears the artist's personal "trace," his physical imprint.

In the end, however, it was not theory that motivated Huang Binhong but his love of landscape. In 1951, he wrote:

Landscape painting, as it expresses the human heart, should also express the essence of the natural world. Because nature gives so much to man, we . . . must make its representation beautiful.[57]

Because he built his compositions with layers of inkstrokes and colors, Huang was criticized as being influenced by Western techniques. The painter Pan Tianshou (1897–1971; see pages 214–18), however, defended him, saying: "Huang Binhong is creating a new painting style that has evolved from traditional foundations and does not imitate a Western technique."[58]

Huang turned increasingly to flower painting in his later years. Like his "black, dense, thick, and heavy" landscapes, his late flower paintings are exercises in pure brushwork that resembles cast iron, with black ink and bright color dots. He wrote, "if flower-and-bird painting shows form-likeness without expressiveness, it will look merely like a paper flower."[59] In the album *Flowers* (pls. 69a, b), dating from the early 1940s, Huang paints eight different kinds of flowers with inscriptions. On one leaf, he explains his approach to brushwork: "Abbreviated brushwork does not mean loose [brushwork]; it should look like cast iron."[60] And on another, he comments on historical styles: "The double outline technique of Song flower painting was perfected only by the Yuan masters, who expressed themselves primarily through their brushwork."

He also invokes the names of several Ming and Qing flower painters as sources of his own inspiration. On "Peony" (pl. 69a) he writes: "The ink style of Xu Wei [1521–1593] is

176

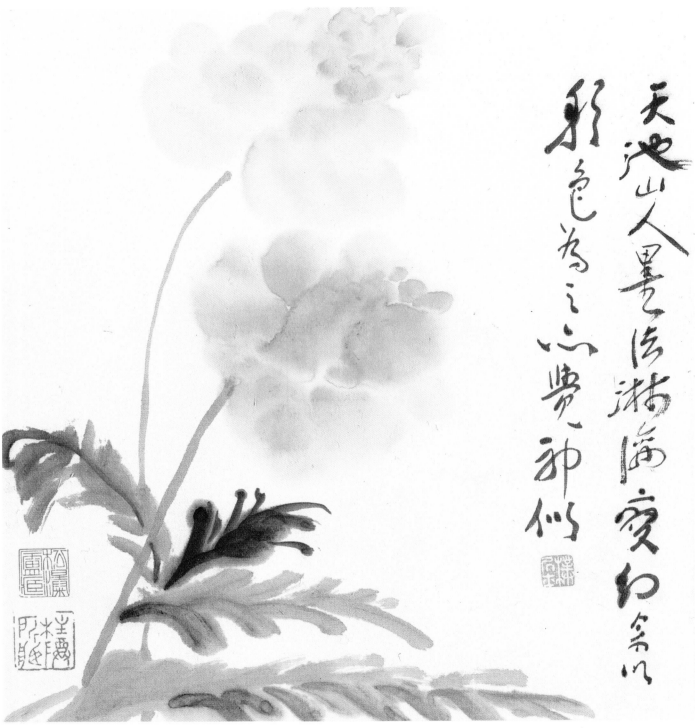

天池山人墨花淋漓愛此丰色為之亦覺神似

69a

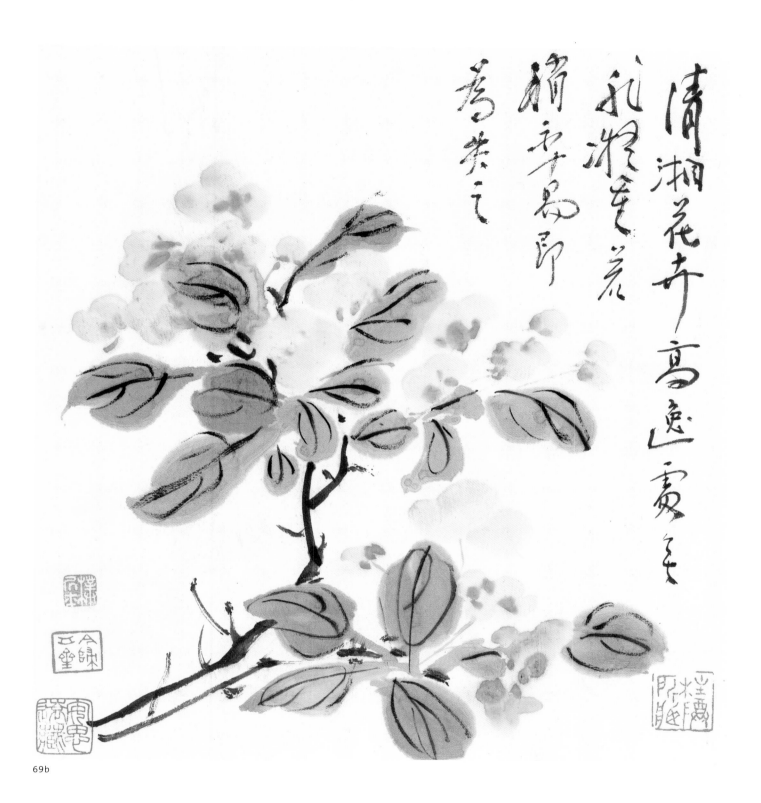

清湘花卉高逸霞多
秋瀑色美
稍平易即
高类之

69b

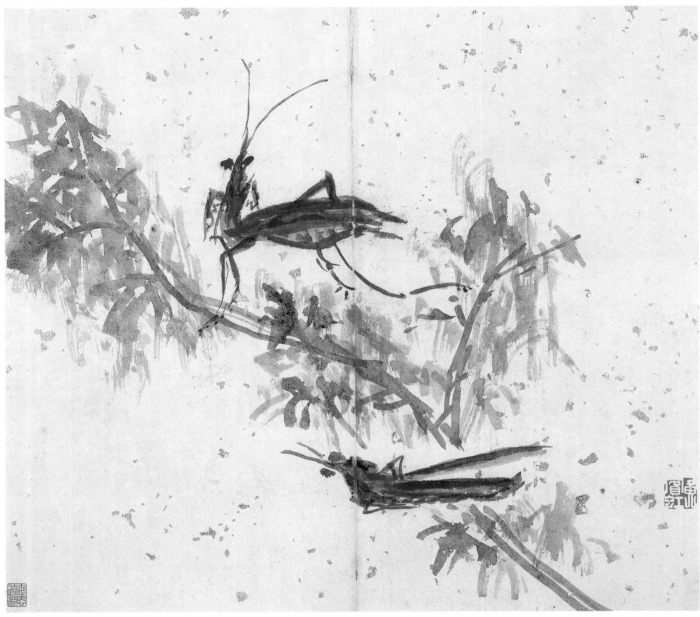

70a

often wet and metamorphic. Here I paint in his style but with color, and feel a certain bond with him." And on "Crab Apple" (pl. 69b) he adds: "The flower paintings of Shitao are eloquent and stately because of his sure and concentrated [brushwork]. Even the slightest carelessness will result in the loss of this quality."

In the album *Insects and Flowers* (pls. 70a,b), the last leaf of which is dated 1948, Huang paints with a blunt, abstract brushwork, disregarding form-likeness. On the last page (pl. 70b), the inscription reads: "The ancients often remarked that in painting it is better to be clumsy [*zhuo*] than clever

[*qiao*]. Some may even say that great cleverness can also be clumsiness, because to understand that cleverness can lead to stupidity is to be close to the ways of Heaven."

ZHANG DAQIAN'S COMPREHENSIVE STUDY OF THE PAST

Perhaps the most famous modern Chinese painter is Zhang Daqian (Chang Dai-chien; 1899–1983), well known not only as a brilliant painter but also as a clever forger of ancient Chinese paintings.[61] As a child in Neijiang (Sichuan), Zhang, whose given name was Zhang Zhengchuan, learned to paint

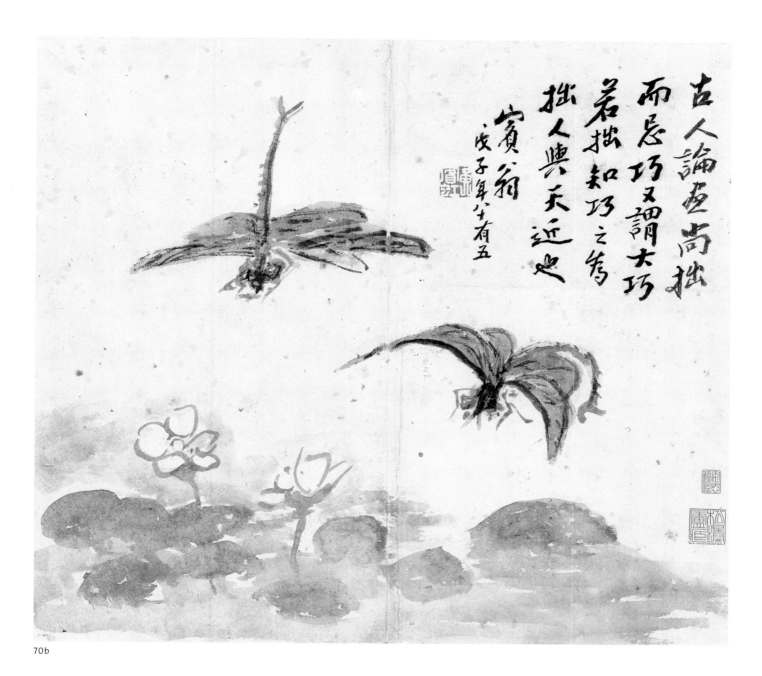

70b

from his mother, brother, and sister. In 1916, he followed his elder brother Zhang Shanzi (1883–1940) to Japan, where he studied textile dyeing and weaving in Kyoto. On returning to Shanghai in 1919, however, he switched to the study of calligraphy under Zeng Xi and Li Ruiqing (see pages 52–56). The latter, a former Qing-dynasty minister of education in Nanjing credited with laying the foundation of modern art education in China and the leading calligrapher of the metal-and-stone school, was at the center of the artistic and social elite of Shanghai. Although Li died in 1920, just a year after Zhang had met him, his influence on Zhang was both profound and enduring.

The colorful early life of Zhang Daqian, although exaggerated by the artist's own later recounting, nevertheless reveals much about the beginnings of what was certainly one of the most fascinating artistic careers of the early twentieth century. Zhang was the eighth son in a family of eleven children, five of whom died in infancy. His father was a salt merchant. When his father's business failed, his mother, an accomplished painter of flowers and animals, supported the family by selling her work. Because she was Catholic, Zhang began his formal education in a Catholic school, later transferring to a boarding school in Chongqing. There, in 1916,

PLATE 70 (overleaf)
Huang Binhong (1865–1955),
Insects and Flowers, dated 1948.
Album of ten leaves, ink and
color on gold-flecked paper,
12½ × 14 in. (31.8 × 35.6 cm). Gift
of Robert Hatfield Ellsworth, in
memory of La Ferne Hatfield
Ellsworth, 1986 (1986.267.204a–j)

he was "kidnapped for one hundred days" by bandits and, because of his fine calligraphic skills, was put to work as secretary to the leader. After becoming acquainted with his mentors Zeng Xi and Li Ruiqing in Shanghai in 1919, he was given a new name by Zeng Xi, who called him Zhang Yuan—Zhang the Gibbon, the gibbon being an animal from Sichuan Province associated with history and mythology. Probably about 1920, Zhang's family proposed an arranged marriage, and he fled to a Buddhist monastery where, again for "one hundred days," he served as an acolyte. It was at the monastery that he received his Buddhist name, Daqian, from the phrase *sanqian daqian* (three thousand times infinity), which refers to the boundless world of the Buddha spirit.[62]

Pine, Plum, and Fungus of Immortality (fig. 86), dated 1923 and based on Li Ruiqing's *Blossoming Plum* (pl. 14), shows Zhang at age twenty-three a quick study. But his inscription, a close imitation of Li's archaizing running-clerical script, when compared with Li's "cast-iron" brushwork, is flamboyant and flat. Zhang's unwillingness to sustain a round, self-contained brushwork in the tradition of the metal-and-stone school is clearly evident in the painting, where he dashes off the foreground rocks and grass with quick, angular brush-strokes. A natural painter rather than a calligrapher, Zhang, unlike virtually all the modern traditionalist painters, from Zhao Zhiqian and Wu Changshuo to Qi Baishi and Huang Binhong, did not submit to the traditional dictates of the calligraphic discipline in his painting but instead explored a much broader horizon.

Possessing unparalleled skills as an imitator of the old masters, Zhang during the 1920s and 1930s perfected a wide range of styles after those of Xu Wei, Bada Shanren, Shitao, Meiqing, Hongren, and Kuncan,[63] landscape and flower painters of the Ming and Qing dynasties. In figure painting, he emulated both Chen Hongshou and Ren Bonian,[64] but as he noted:

Figure painting from Wu Daozi [active 710–60] and Li Gonglin [ca. 1041–1106] was exhausted after Li. Qiu Ying's [ca. 1495–1552] work was too charming, and Chen Hongshou's was too eccentric. Indeed, during the three hundred years of the Qing dynasty there was no [good figure painting] at all.[65]

From 1941 to 1943, during the Sino-Japanese War, Zhang journeyed to the Buddhist Mogao Caves at Dunhuang, in northwestern Gansu Province. There he studied the colorful Sui and Tang monumental wall paintings, which represented early figural painting before it was superseded by the landscape paintings of the Song period. In 1950, he went to India to study the mural paintings at the Buddhist cave temples in Ajanta. And in 1953, he visited the United States for the first time en route to Brazil, where he moved with his family in 1954. In 1956 he made his first trip to Europe, going to Rome, Paris, and Switzerland. In subsequent years, his work was widely exhibited in Japan, Taiwan, Hong Kong, Singapore, Paris, Athens, Madrid, Geneva, London, São Paulo, and several cities in the United States. After moving in 1971 to Pebble Beach, California, he finally settled in 1976 in Taiwan, where he lived, surrounded by popular acclaim, before he died in 1983.

To understand Zhang Daqian and his artistic achievement, we must first follow his early career and see how he

FIGURE 86

Zhang Daqian (1899–1983), *Pine, Plum, and Fungus of Immortality*, dated 1923. Hanging scroll, ink and color on paper, 30⅜ × 13 in. (77 × 33.1 cm). Arthur M. Sackler Gallery, Smithsonian Institution, Washington, D.C. (s1988.48)

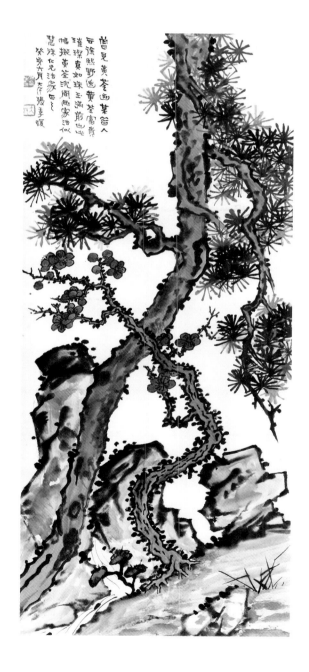

perceived himself. In 1919, when he first "entered the door" (*rumen*) of Li Ruiqing and began his meteoric rise in the Shanghai art world, Chen Duxiu and Hu Shi were leading the New Culture Movement at Beijing University and students were rioting in the May Fourth Movement. Refusing to be labeled either a reformer or a traditionalist, Zhang had no doubt that his talent alone entitled him to claim the mantle of the "Great Tradition."[66]

A romantic rather than an idealist like Xu Beihong, Zhang nevertheless shared Xu's belief that Chinese painting was in decline.[67] In the tradition of such great artist-connoisseurs as Mi Fu, Zhao Mengfu, and Dong Qichang, who studied the ancient masters as both collectors and painters, Zhang collected classical paintings at a time when there was great flux in the ownership of artwork because of political and social unrest. Years later, Zhang wrote about his passion for collecting:

Whenever I come across a treasure, I feel I must absolutely possess it in my own collection. In fact, I feel as if my life depends on making the acquisition and I would dream about it day and night. I am willing to go into debt if need be, and it is hard to change this habit. My addiction for collecting is like Mi Fu's.[68]

The story of the thriving art market in the early twentieth century, especially the rediscovery of two leading late-Ming *yimin* (leftover citizens) artists, Bada Shanren and Shitao (whose work had been neglected in the Manchu imperial collections), has yet to be fully told.[69] It involved in Shanghai such figures as Li Ruiqing, Zeng Xi, Huang Binhong, and the real estate tycoon Cheng Linsheng,[70] and in Japan the Qing expatriate

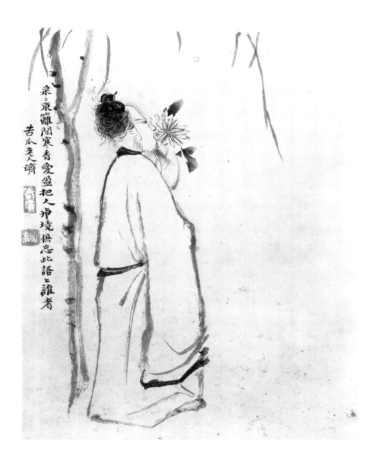

Luo Zhenyu, among others. There was at the time a general reawakening of interest in classical Chinese painting, thanks to the efforts of art editors like Huang Binhong and collectors like Di Baoxian (Bingzi), the latter the owner of the Yuzheng Book Company, which initiated the publication of ancient Chinese paintings in collotype. The availability of these reproductions to the general public encouraged an appreciation of fine paintings. It also facilitated the practice of forgery.

Soon after entering the circle of Li Ruiqing in 1919, Zhang came to know Li's younger brother Li Ruiqi (ca. 1870–ca. 1940), a skilled copyist of the work of Shitao. In *Flowers and Figures* (fig. 87), an album of eight leaves dating from about 1920, Li made an exact copy of an album by Shitao (fig. 88), dating from about 1695.[71] He carefully chose the same paper, ink, and colors, and meticulously fabricated all of Shitao's seals and seal paste, reproducing every twist and turn and every

FIGURE 89

Zhang Daqian (1899–1983), forgery of *Seen Through the Eyes of Jing Hao and Guan Tong*, signed as Shitao, ca. 1923. Hanging scroll, ink and color on paper, 13 × 13 in. (33.3 × 33.3 cm). The Metropolitan Museum of Art, Bequest of John M. Crawford Jr., 1988 (1989.363.189)

subtle nuance of Shitao's brilliant brushwork. It is not known whether Li Ruiqi had intended his painting as a forgery or merely enjoyed the exercise of copying as a gentleman-artist's pastime. Zhang Daqian owned both the original album and the copy by Li Ruiqi. They remained in his collection until the late 1960s, when he sold all his Shitaos. We can well imagine Zhang's glee, as a master forger, in having the paintings over the years side by side.

Soon his own Zhang began to produce paintings in the style of Shitao, paintings that fooled some of the best-known connoisseurs of the time. *Seen Through the Eyes of Jing Hao and Guan Tong* (fig. 89), signed as Shitao, was painted by Zhang about 1923. Unlike Li, Zhang did not copy an existing work but an inscription.[72] He created a "Shitao" using the earlier painter's simplified mountain forms to suggest the archaic style of the tenth-century masters Jing Hao and Guan Tong. Huang Binhong, taken in by the forgery, offered to Zhang an original work by Shitao in exchange for Zhang's forgery.[73] Years later, Zhang recounted the incident:

I was fortunate because I wanted to exchange my painting for another painting and not for money but. . . . Huang Binhong was known for his keen connoisseurship, and he sought my work of his own will, so who is to blame?[74]

Shitao's *Letter to Bada Shanren* (fig. 62), dating from late 1698, provides key evidence for establishing Shitao's date of birth, which would be significant to the study of the chronology of his work.[75] Known as one of the Three Treasures of

Linquan, the letter, since at least the late eighteenth century, had been a treasured heirloom in Li Ruiqing's family in Linquan (Jiangxi).[76] Although Shitao and Bada Shanren were related as distant cousins from two different branches of the fallen Ming, they did not communicate until 1689, when Shitao wrote to Bada asking him to make a painting that would show him in his studio, the Thatched Hut of Great Cleanliness. In that letter, Shitao named Li Songan of Nanchang, a fellow townsman of Bada, to take the letter to Bada, who was a resident of Nanchang.

After Li Ruiqing died in 1920, Shitao's *Letter to Bada Shanren* came into the possession of Zhang Daqian. Zhang made a forgery of the letter (fig. 63), altering certain passages

FIGURE 90

Shitao (1642–1707), colophon on Bada Shanren's *Thatched Hut of Great Cleanliness*, dated 1689. Zhang Daqian Collection

FIGURE 91

Zhang Daqian (1899–1983), detail of figure 64, Zhang Daqian's copy of Shitao's colophon on Zhang's forgery of *Thatched Hut of Great Cleanliness*, signed as Bada Shanren, ca. 1925. Nagahara Collection

184

that he then used to authenticate a painting entitled *Thatched Hut of Great Cleanliness* (fig. 64). The painting was signed as Bada Shanren. It was made by Zhang Daqian. Both forgeries were acquired by the Japanese collector Nagahara Oriharu, a medical doctor and collector of Shitao, who lived in Manchuria. When the Nagahara collection was published in 1961, it showed, besides these two well-publicized works, many other dashingly executed works variously attributed to Shitao, Bada Shanren, and other late-Ming and early-Qing painters, all by the same ebullient—and distinctive—hand of Zhang Daqian.[77]

As in his earlier "Shitao," *Seen Through the Eyes of Jing Hao and Guan Tong*, Zhang's creative forgery of "Bada Shanren's" *Thatched Hut of Great Cleanliness* seeks not only to re-create but also to improve on the original. Bada's *Thatched Hut of Great Cleanliness* had been lost or destroyed, but Zhang owned a poetic colophon, dated "summer 1689," which Shitao had written on the painting (fig. 90).[78] In the colophon, Shitao relates how he had unexpectedly received "a large hanging scroll" (*ju fu*) from Bada as a present for his newly finished studio, but as his *Letter to Bada Shanren* explained later, the painting that Bada sent was "too large for my small house," so he asked if Bada would paint another one, "a small scroll [*xiao fu*] measuring one *chi* in height [14 inches] and three *chi* wide."[79] Because Shitao's colophon, dated 1698, and Shitao's letter, dating from later the same year, were both in Zhang's collection, he decided, about 1925, to re-create the lost large landscape painted by Bada Shanren in 1698. By deleting the passages in Shitao's letter asking for "a small scroll," which was written after Shitao had received the large

scroll, Zhang linked his bogus Shitao letter to his forgery of the large scroll, a connection that proved irresistible to the prospective buyer of these two works. In his re-creation of Bada's *Thatched Hut of Great Cleanliness* (fig. 64), Zhang left space on the left side of the composition for a full transcription of Shitao's colophon, on which he copied Shitao's calligraphy with gusto.[80]

Zhang's passion for art and his pride in his own versatility as a painter thus conflicted with his activities as a collector and dealer, in which the business of art as commerce raised thorny questions of ethical conduct. Disdainful of powerful but tasteless collectors and dealers, he recalled how Mi Fu had railed against ignorant dilettantes and boasted of outwitting them with his forgeries and copies. Zhang had reveled in the Daoist philosophy of viewing life as playfulness (*youxi renjian*), and he regarded questions of authenticity as merely a matter of opinion. He also took great pleasure in touching up damaged paintings, "improving" the old masters to lure the unwary.

Zhang's romanticism may be defined by traditional social mores as described in such classic novels as *The Romance of the Three Kingdoms*, *The Water Margin*, *Golden Lotus*, and *The Story of the Stone*.[81] He lived in what came to be known as the World of Daqian, a Buddhist world "three thousand times infinity," in which he himself was the protagonist.[82] Gregarious, and with a large and generous spirit, Zhang devoted himself to good living, often giving and spending freely so as to surround himself with friends and admirers and delighted in his ability to dazzle and to please. One can imagine him regaling his guests with stories and gossip of the art world and

江山人稱六大任之遊戲筆墨外心奇逸奔放浪觀筆歌墨舞運三昧有時對客塵凝顛徉狂索酒呼青天讀更大醉州千紙書清畫法前人前

取兩百代古無比儕人讚美公示喜胡然圖搆少又挕之方唉日小伎四方知交空門予廿年蹤跡郎得知程子抱犢向手道運个當年即是伊公留與

以同日病剛幽世時天地震八大無家還是家清湘四海空霜鬢賓公時開我客邢江臨谿新撺大滌堂寄來巨幀鳳堪淤炎蒸六月飛秋霜是人知無念

何堪游言稽在年慶沙歷一念萬年鳴指間洗空世界聽霹靂

戊寅夏日題　清湘遺人若極

FIGURE 92

Zhang Daqian (1899–1983), copy
of Dunhuang wall painting, Cave
249, ca. 1941–43.

FIGURE 93

Zhang Daqian, *Diagram of Hand
Mudras from the pre-Tang through
the Early Song Period*, ca. 1941.
Ink on paper.

painting for them during long, convivial evenings. The moral code of Zhang's world, while it disdained bourgeois conventions, placed a high premium on camaraderie and personal loyalty. In his pursuit of old master paintings, Zhang had an astute intuition. He amassed three great collections, one of masterpieces from the Song through the Qing, one of paintings by Shitao, and a third of works by Bada Shanren, which now reside, respectively, in the permanent collections of The Metropolitan Museum of Art, The Art Museum of Princeton University, and the Freer-Sackler Gallery in Washington, D.C. It is worth noting that while Zhang no doubt acquired his collections with great cunning, he was

FIGURE 94
Zhang Daqian (1899–1983), Forgery of Tang dynasty (618–907) *Standing Bodhisattva*, detail, ca. 1943. Private collection, Japan

FIGURE 95
Unidentified artist, *Standing Bodhisattva*, detail. Wall painting, Cave 197, Dunhuang. Tang dynasty (618–907), Mogao Caves, Dunhuang

generous in sharing them with like-minded friends. One of the three collections he gave to a friend, who was so captivated by the works that he devoted his life to studying them.

To the Chinese public, the traditional Ming and Qing genres of the scholar-painters were inadequate to express a modern idiom. Realistic representation failed, in particular, in figure painting. As a result many modern Chinese painters, such as Xu Beihong, turned to Western painting as a model. Zhang, however, resolved to succeed in figure

painting by calling on the resources of his own cultural and artistic traditions.

From his teacher Li Ruiqing, Zhang had learned a comprehensive approach to the study of calligraphy. Li's approach, in presenting the history of calligraphy as a tradition that united the ancient styles of square and round brush techniques in a homogeneous idiom, was an attempt to reform and revitalize the calligraphic art. Zhang now devised his own approach to a comprehensive study of the past. Like Li,

PLATE 71

Zhang Daqian (1899–1983), *Buddha's Manifestation of Joyfulness*, dated 1946. Hanging scroll, ink and color on bark paper, 59½ × 28 in. (151.1 × 71.2 cm). Gift of Robert Hatfield Ellsworth, in memory of La Ferne Hatfield Ellsworth, 1986 (1986.267.360)

188 Zhang, as both a painter and a forger, wanted not to reproduce but to surpass the old masters.

In his essay "On the Art of Painting," published in 1961, Zhang summarizes his approach to painting by enumerating twelve basic principles.[83] He begins with the premise that a painter must first copy ancient models and study nature. He cites the importance of elegance (*qiuya*) and an open mind (*xinxian*). He advocates transformation without plagiarism. He draws on the work of Gu Kaizhi, Xie He, and Jing Hao. Under the heading of themes he lists figure painting, narrative, landscape, and flower painting as his principal genres. And for figural art, he calls for the expression of emotion in narrative and the creation of grand compositions—two qualities that are absent in Ming and Qing figure painting.

Zhang's sojourn in 1941–43, in Dunhuang (Gansu), where for more than two years he practically lived in the Buddhist cave temples to study and to copy the Sui- and Tang-dynasty monumental wall paintings (fig. 92), reflected his determination to learn how to express emotion and to create a "grand composition" in figure painting. With a desire for historical accuracy, he carefully recorded the different styles of drawing a hand in paintings dating from the pre-Tang through the Five Dynasties and early Song (fig. 93).[84] He observed, for example, that in the pre-Tang (6th century), finger joints and fingernails are not depicted (fig. 93a); in the early Tang (7th century), finger joints are delineated and fingernails extend beyond the fingertips (fig. 93b); in the High Tang (8th century), fingers and palms are plump and soft and fingernails are no longer extended beyond the fingertips (fig. 93c); in the Five Dynasties and

early Song (10th century), hands are distinguished by an extra line at the base of the fingernails (fig. d), and so forth. Such distinctions have continued to this day to serve as telltale marks that enable collectors to date and authenticate Tang paintings.[85]

Returning to Sichuan in 1943, Zhang held exhibitions and published catalogues of his copies and studies.[86] He also brought back with him his own forgeries. One forgery, a scroll that shows a striking Bodhisattva in a three-quarter view (fig. 94), caused a sensation in Japan in the 1950s. After laboratory examination and an analysis of the silk and pigments, experts pronounced it authentic, and it was widely published as a fine, newly discovered eighth-century Tang painting.[87] In his forgeries, Zhang was meticulous in his preparation of painting materials, a skill he learned in Japan from his early training in textile dyeing and weaving. Compared with the wall painting in Cave 197 at Dunhuang (fig. 95) on which the forgery is based, however, Zhang's figure shows none of the sculpturelike quality typical of eighth-century paintings. Instead, he relies on flat and elegant but slick brushlines to fashion his own conception of Tang figure painting.

In the late 1940s and early 1950s, in the wake of the Communist revolution, Zhang and his family fled China to live abroad, and as interest in ancient Chinese painting was rising in the postwar years, he sold his forgeries of Tang and Song masterworks on the international art market. Among the best-known hoaxes he perpetrated are those of *Horse and Groom*, attributed to Han Gan (active ca. 742–56) and now in Musée Cernuschi, Paris;[88] *Dense Forests and Layered Peaks*, attributed

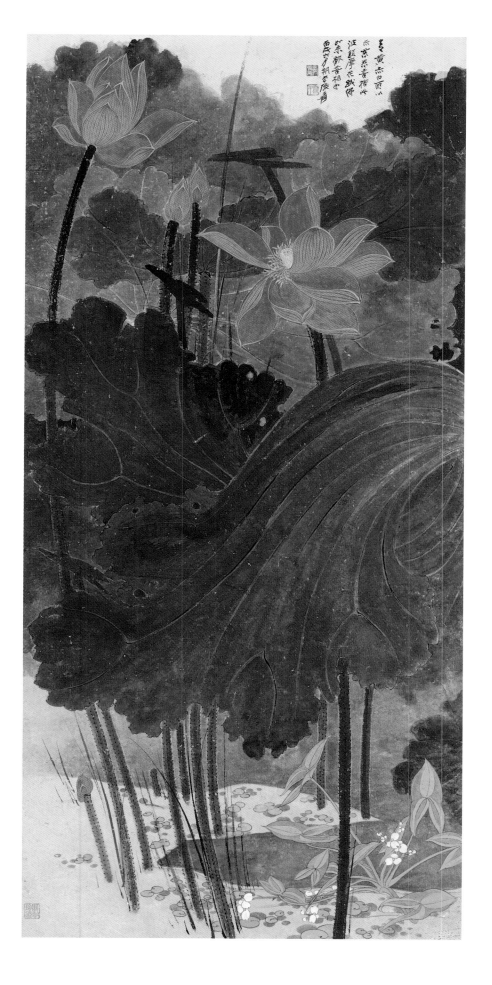

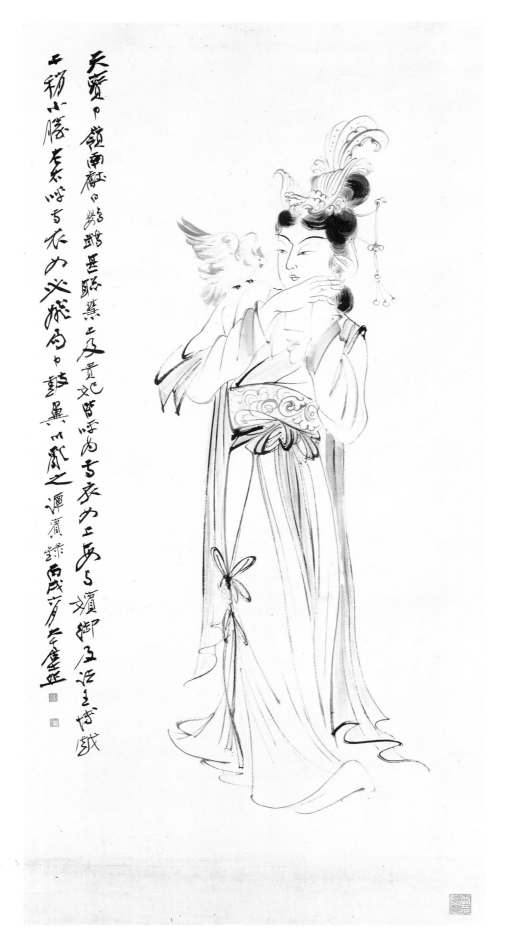

天寶。嶺南獻。⋯鸚甚馴慧。上及貴妃皆呼為雪衣娘。上令授以詩篇。及諷御及諸王博戲。上稍不勝。輒為之語。貴妃以手握之衣袖乃必然為鳥。丙戌秋七千大千

PLATE 72

Zhang Daqian (1899–1983), *Yang Guifei with a Parrot*, dated 1946. Hanging scroll, ink on old paper, 64½ × 32½ in. (163.8 × 82.6 cm). Gift of Robert Hatfield Ellsworth, in memory of La Ferne Hatfield Ellsworth, 1986 (1986.267.359)

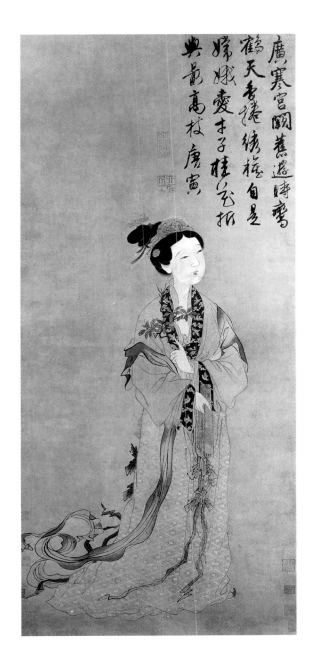

FIGURE 96

Tang Yin (1470–1524), *Moon Goddess Chang E with a Branch of Cassia*. Hanging scroll, ink and color on paper, 53¼ × 23 in. (135.3 × 58.4 cm). The Metropolitan Museum of Art, Gift of Douglas Dillon, 1981 (1981.4.2)

to Juran (active ca. 960–80), in the British Museum;[89] and *Drinking and Singing at the Foot of a Precipitous Mountain*, attributed to Guan Tong (active ca. 907–23), in the Museum of Fine Arts, Boston.[90] On Zhang's Guan Tong forgery, the art historian Shen Fu writes, "The forgery is extremely close to [his] honest copy of *Clear Morning* [attributed to Liu Daoshi] from 1951.... The dividing line between [Zhang's] candid copies of ancient paintings and his forgeries is slight."[91] Zhang's brushwork and methods of articulation in his suavely executed forgeries are the same as the best of his own signed works. His forgeries, in other words, are quintessentially Zhang Daqians.[92]

Zhang learned from the study of wall paintings at Dunhuang the use of bright mineral colors. In *Buddha's Manifestation of Joyfulness* (pl. 71), he applies the boneless (*mogu*) method—a Northern Song technique of painting without ink outlines—to the painting of a lotus, a flower closely associated with Buddhist teachings. Using brilliant patches of vermilion blossoms outlined in gold, supple onyx leaves laced with etched veins, and delicate aquamarine duckweeds and water lilies set against buff-colored bark paper, he creates water plants that seem to shimmer magically in a sunlit pool. For such paintings, Zhang is said to have used "imperial Qianlong-period vermilion 'ink,' Buddha-head blue from Afghanistan, and malachite green from Ajanta, India."[93] On the painting he writes:

Blue, yellow, red, and white express [Buddha's] infinite benevolence.
I offer these lotuses as Buddha's manifestation of joyfulness.[94]

FIGURE 97

Zhang Daqian (1899–1983),
Afternoon Rest, dated 1951.
Mounted for framing, ink and
color on paper, 18⅛ × 11⅜ in.
(46 × 29 cm). Collection of Paul
Chang, Pebble Beach, California

FIGURE 98

Zhang Daqian, *Indian Actress*,
dated 1950.

FIGURE 99

Zhang Daqian, *Self-Portrait*,
dated 1960. Ink and color on
paper.

FIGURE 100

Zhang Daqian, *Self-Portrait with a
Saint Bernard*, dated 1970. Hang-
ing scroll, ink and color on paper,
68 × 36¾ in. (172.7 × 93.4 cm).
Collection of Mr. and Mrs. C.Y.
Lee, São Paulo

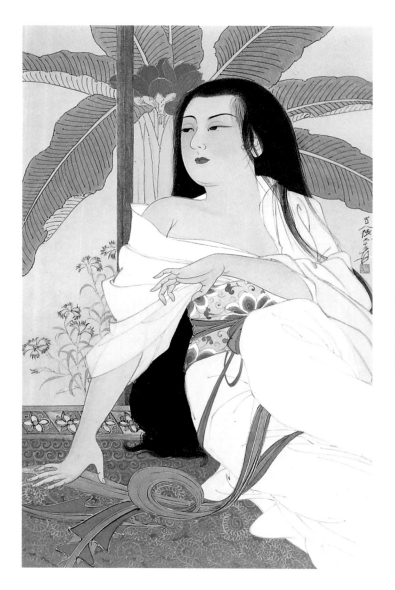

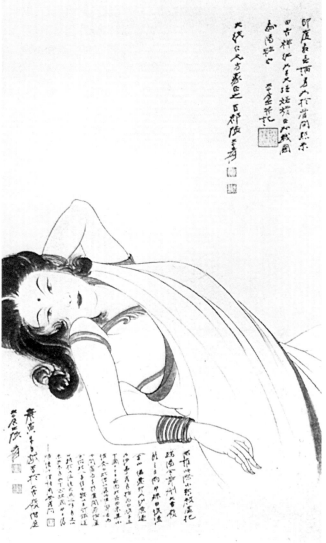

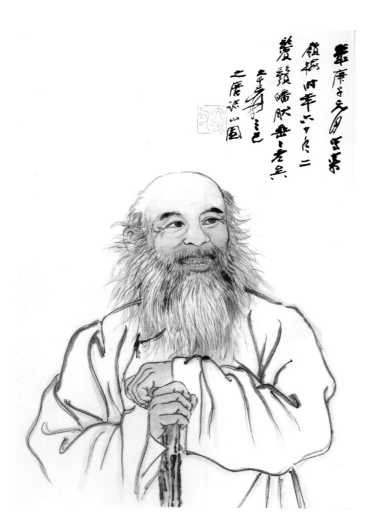

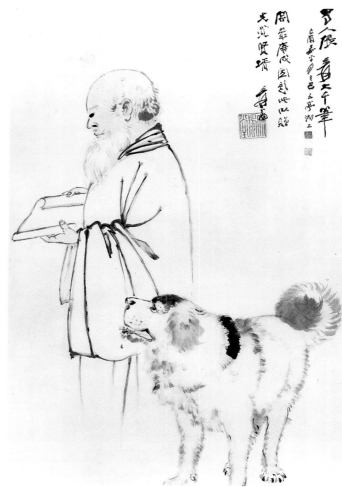

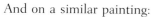

And on a similar painting:

I recall once when I was twenty-three sui [twenty-two years by Western count] going to the three peaks of Mount Emei on the road to Rongxian. In front of a village inn, there was a pond bordered by vermilion flowers in full bloom, and the bright light of morning spread with such gleaming radiance they seemed a crimson wall of rosy clouds.[95]

In his later years Zhang painted many crimson lotuses, but seldom with such power and intensity as in *Buddha's Manifestation of Joyfulness*. This recollection of a memory that seems never to have lost its sense of wonder is Zhang Daqian at his best.

In *Yang Guifei with a Parrot* (pl. 72),[96] dated 1946, Zhang shows his facility in painting female beauties. He quotes from a popular Tang-dynasty story:

During the Tianbao era [742–55], the provincial governor of Lingnan presented the emperor with a white parrot of exceptional intelligence, which [Xuanzong] and [his consort] Yang

Guifei named Girl in a Dress of Snow. The emperor often played dice with his concubines and princes. When the emperor was winning, everyone would cheer and the parrot would fly into the middle of the game to break it up.[97]

Zhang's portrait of Yang Guifei is not based on an original Tang painting. Instead, his model seems to be *Moon-Goddess Chang E with a Branch of Cassia*, by Tang Yin (1470–1524; fig. 96), a painting once in his collection. With flawless, fluid brushlines, he fashions his vision of female beauty with a sensuous appeal, very much in the mode of a contemporary diva, her elaborate coiffure and phoenix-shaped hair ornament played against the parrot on her shoulder.

A more successful portrayal of sensual beauty is Zhang's *Afternoon Rest* (fig. 97), dated 1951. Zhang's sumptuous design of a bare-shouldered, kimono-clad woman is formed by flat, decorative shapes filled with opulent colors and defined by smooth, sleek brushlines. She is shown lounging against a floral carpet and a screen with a large banana tree. The hands, with delicately rendered fingers, resemble those of Zhang's

PLATE 73
Zhang Daqian (1899–1983),
Listening to a Waterfall, dated
1949. Hanging scroll, ink and
color on paper, 12 × 19⅝ in. (30.5 ×
49.9 cm). Robert H. Ellsworth
Collection

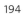

194

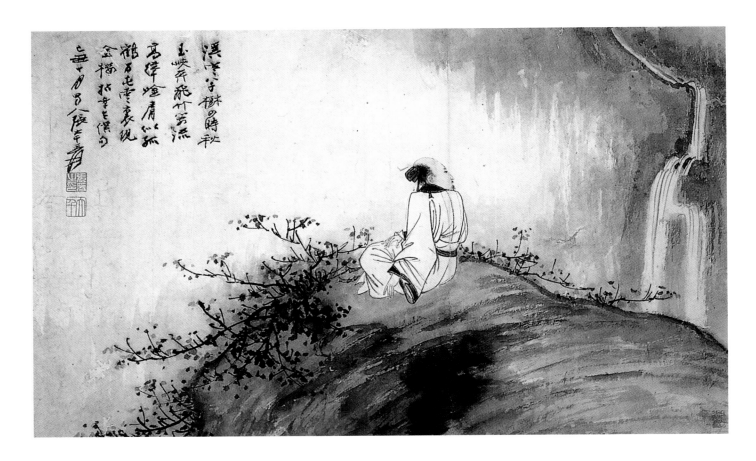

FIGURE 101

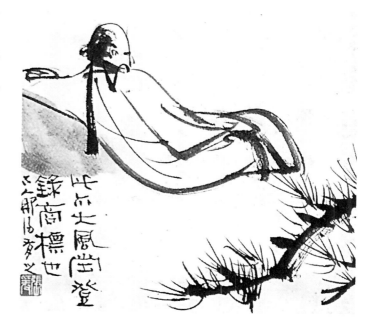

195

Bodhisattva (fig. 94), and while the painting suggests the influence of Japanese *ukiyo-e* painting, Zhang no doubt would have preferred that it recall the palace beauties of the Tang painter Zhou Fang (active ca. 780–ca. 810).[98] But in fact the melonlike face and loosely wrapped kimono, with its obi of silk tapestry, clearly links the painting to Japanese geisha culture. Here, Zhang turns away from classical landscape to pursue contemporary imagery, which made his work accessible and appealing to the general public. Drawn to exotic images of Indian temple dancers and Chinese opera stars,[99] Zhang was inspired, with perhaps dubious taste, even by contemporary Indian movie posters (fig. 98).

But Zhang's favorite subject was himself. His self-portraits show him in many guises—as a companion to his pet gibbon, a lover of nature, a philosopher, a wanderer holding an alms bowl, or the demon-queller Zhong Gui.[100] His *Self-Portrait* of 1960 (fig. 99) is a striking image painted with the pizzazz of a celebrity portraitist. By that time Zhang was seen by the public, both at home and abroad, as a popular cultural icon. In *Self-Portrait with a Saint Bernard* (fig. 100), dated 1970, he appears as a well-to-do suburbanite surrounded by the comforts of modern life.

Listening to a Waterfall (pl. 73), dated 1949, shows Zhang in the traditional theme of the philosopher-poet sitting by a stream composing a poem.[101] The figure in the landscape is the same one as in the self-portrait *My Registered Trademark* (fig. 101) of about 1950. Quickly executed with much panache but little effort, *Listening to a Waterfall* belongs in the category of work done for fulfilling social obligations (*yingchou*).[102] Zhang's habit of demonstrating his skills for friends in public

produced many paintings that are trivial and repetitious, much to the detriment of his ability to focus on more difficult projects. He frequently turned out half a dozen or more well-honed compositions as one evening's entertainment.

By the 1960s, beset by failing eyesight, Zhang turned away from detailed figure drawing to bold, splashed-ink landscapes. In *Splashed-Color Landscape* (pl. 74), dated 1965, the black stillness of an open mountain view illuminated only by a streak of iridescence in the sky is rendered in the splattered-ink (*pomo*) technique inspired by Song Chan Buddhist landscapes such as *Mountain Village in Clearing Mist* (fig. 102), by Yujian (active mid-13th century). In the early 1950s, the paintings of the Tang-dynasty eccentric painter Wang Mo, or Ink Wang as he was known, were compared by the Chinese

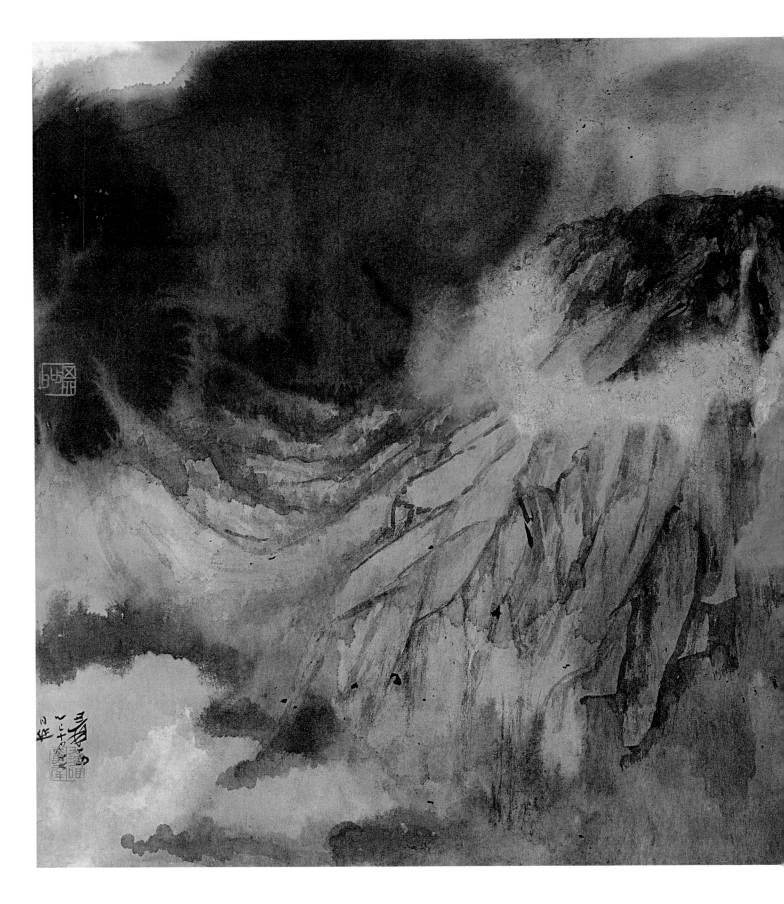

196

PLATE 74
Zhang Daqian (1899–1983),
Splashed-Color Landscape, dated
1965. Hanging scroll, ink and
color on paper, 23¾ × 37¾ in.
(60.3 × 95.9 cm). Gift of Robert
Hatfield Ellsworth, in memory of
La Ferne Hatfield Ellsworth, 1986
(1986.267.361)

FIGURE 102
Yujian (active mid-13th century).
*Mountain Village in Clearing
Mist*. Ink on paper. Idemitzu
Museum of Arts, Tokyo

198

with the work of Jackson Pollock. Wang would paint in an inebriated state, "spattering ink on the painting surface, stamping on it with his feet [and] sweeping it with the brush."[103] Chinese painters have been intrigued by the idea of developing a modern abstract style predicated on the Chinese tradition. In *Aafchen See* (fig. 103), inspired by his visit to the Swiss Alps and dated 1968, the intense malachite-green landscape, symbol of the mythical Chinese land of the Peach-Blossom Spring,[104] now becomes Zhang's vision of paradise, in which representational details have been all but swallowed up by the patterns of black ink and color, leaving only the artist's own psychic presence and physical energy to create "order from chaos," as Shitao had expressed it many centuries earlier.

In his final years, Zhang Daqian concentrated on achieving his artistic goal of creating grand compositions. In *Ten Thousand Li of the Yangzi River*, painted in 1968 for his patron and fellow Sichuan Zhang Qun, a former premier of the Republic in Taiwan, Zhang produced a virtuoso landscape more than sixty feet in length, depicting the winding, twisting gorges and wide open expanses of the great Yangzi, with fine details and lyrical passages of sweeping splashed ink and color.[105] And in 1981 he began another ambitious project, *Panorama of Mount Lu*, a work more than thirty-two feet long, which was exhibited at the National Museum of History in Taipei in 1983, just before he died.[106] These two splashed-ink-and-color paintings are, without a doubt, the most spectacular Chinese landscapes ever created.

NOTES

1. Chen Hengke, *Zhongguo wenrenhua zhi yanjiu* (A Study of Chinese Scholar Painting) (reprint, Tianjin: Tianjin Guji Shudian, 1992), p. 7; see also p. 17, in this publication.
2. Translation adapted from Robert H. Ellsworth, *Later Chinese Painting and Calligraphy, 1800–1950*, research and translation by Keita Itoh and Lawrence Wu (New York: Random House, 1986), vol. 1, p. 117.
3. Chen Hengke, *Zhongguo wenrenhua zhi yanjiu*, pp. 3, 7.
4. Ellen P. Conant, with Steven D. Owyoung and J. Thomas Rimer, *Nihonga, Transcending the Past: Japanese-Style Painting, 1868–1968* (exh. cat., Saint Louis: Saint Louis Art Museum; Tokyo: Japan Foundation, 1995), pls. 56, 145.
5. Feng Zikai credits Chen Hengke as the one who started the *manhua* style of painting. See Feng Yiyin et al., eds., *Feng Zikai zhuan* (Biography of Feng Zikai) (Hangzhou: Zhejiang Renmin Chubanshe, 1983), p. 69.
6. Although many publications give 1863 as Qi's birth date, Qi was actually born on January 1, 1864, which was the twenty-second day of the eleventh lunar month of the second year of the Dongzhi era. In 1937, on the advice of a soothsayer, he added two years to his age "to fool Heaven," or avoid bad luck. He counted his age in 1937 as seventy-seven *sui*, when he was seventy-three by Western count; as a result, when he died in 1957 at what he reckoned as ninety-seven *sui*, he was only ninety-three years old. I have followed Wang Yanchao, "Chronology of Qi Baishi," in *Qi Baishi huihua jingcui* (The Essence of Qi Baishi), edited by Wang Chunfu and Wang Yanchao (Changchun:

200 Jilin Meishu Chubanshe; Shanghai: Xinhua Bookstore, 1994). For Qi's early work as a wood-carver, see Huang Miaozi, "From Carpenter to Painter: Recalling Qi Baishi," *Orientations* 20, no. 4 (April 1989), pp. 85–87.

7. For Qi Baishi's early career, see Lang Shaojun, "Qi Baishi zhaoqi huihua, 1878–1909" (On Qi Baishi's Early Period of Painting), *Meishu shilun* (Studies in Art History) 43 (1992, no. 3), pp. 8–19.

8. Qi himself customarily spoke of five trips (*wuchu wugui*), but he actually made six. See ibid., p. 15.

9. See note 6 above.

10. Lang Shaojun, "Qi Baishi zhaoqi huihua," pp. 9–11.

11. Qi's seal on the painting reads "The Seal of Servitor Huang," which dates it to before the official establishment of the Republic in early 1912.

12. Lang Shaojun, "Qi Baishi zhaoqi huihua," p. 17. See also Meng Yan and Jin Shan, "Qi Baishi huihua yishu daolu chuyi" (Preliminary Discussion of Qi Baishi's Artistic Direction), in *Qi Baishi huihua jingpin xuan* (Selected Masterworks by Qi Baishi), edited by Dong Yulong (Beijing: Renmin Meishu Chubanshe, 1991), p. 14 (left ill.).

13. Adapted from Ellsworth, *Later Chinese Painting and Calligraphy*, vol. 1, p. 160.

14. Wen C. Fong, "Stages in the Life and Art of Chu Ta (1626–1705)," *Archives of Asian Art* 40 (1987), pp. 15–18; Richard M. Barnhart, "Reading the Paintings and Calligraphy of Bada Shanren," in *Master of the Lotus Garden: The Life and Art of Bada Shanren, 1626–1705*, edited by Wang Fangyu, Richard M. Barnhart, and Judith Smith (exh. cat., New Haven: Yale University Art Gallery, 1990), pp. 131–35.

15. Barnhart, "Reading Bada Shanren," p. 199.

16. Wang Yanchao, "Chronology of Qi Baishi."

17. Adapted from Ellsworth, *Later Chinese Painting and Calligraphy*, vol. 1, p. 162.

18. Ibid., p. 159.

19. A similar composition dated 1937 is found in Wang Chunfu and Wang Yanchao, *Qi Baishi huihua jingcui*, pl. 75.

20. Adapted from Ellsworth, *Later Chinese Painting and Calligraphy*, vol. 1, p. 159.

21. Lou Shibai, "Qi Baishi huihua jifa" (Qi Baishi's Painting Techniques), *Zhongguo shuhua bao* (Journal of Chinese Painting and Calligraphy), nos. 66–103 (869–906) (1999), p. 2.

22. Meng Yan and Jin Shan, "Qi Baishi huihua yishu daolu chuyi," p. 18.

23. Lang Shaojun, "Qi Baishi zhaoqi huihua, 1878–1909," p. 11.

24. Huang was born on New Year's day of the lunar year of *yichou*, or January 27, 1865. Because it was still in the winter month of the previous *jiazi* year, he counted himself as second *sui* in 1865. See Wang Bomin, *Huang Binhong* (Shanghai: Renmin Meishu Chubanshe, 1979); Qiu Zhuchang, *Huang Binhong zhuanji nianpu hebian* (Huang Binhong's Biography and Chronology) (Beijing: Renmin Meishu Chubanshe, 1985). See also Shen C.Y. Fu, "Huang Binhong's Shanghai Period Landscape Paintings and His Late Floral Works in the Arthur M. Sackler Gallery," *Orientations* 18, no. 9 (September 1987), pp. 66–78; and Jason C. Kuo, *Innovation within Tradition: The Painting of Huang Pin-hung* (exh. cat., Hong Kong: Hanart Gallery; Williamstown, Mass.: Williams College Museum of Art, 1989).

25. Qiu Zhuchang, *Huang Binhong zhuanji nianpu hebian*, p. 117.

26. Ibid., pp. 81–82.

27. Ibid., p. 120.

28. Ibid., pp. 130, 137, 163. For Huang's editorship, see Robert van Gulik, *Chinese Pictorial Art as Viewed by the Connoisseur: Notes on the Means and Methods of Traditional Chinese Connoisseurship of Pictorial Art, Based upon a Study of the Art of Mounting Scrolls in China and Japan* (Rome: Istituto Italiano per il Medio ed Estremo Oriente, 1958).

29. Zhao Zhijun, "Huang Binhong nianbiao" (Chronology of Huang Binhong), in *Huang Binhong jingpinji* (Selected Masterworks by Huang Binhong), edited by Dong Yulong (Beijing: Renmin Meishu Chubanshe, 1991), p. 268.

30. For criticism of Huang's connoisseurship, see Michael Sullivan, *Art and Artists of Twentieth-Century China* (Berkeley and Los Angeles: University of California Press, 1996), p. 17.

31. Qiu Zhuchang, *Huang Binhong zhuanji nianpu hebian*, p. 46.

32. Wang Bomin, *Huang Binhong*, p. 41.

33. Fu Shen, "Huang Binhong's Shanghai Period Landscape Paintings."

34. Qiu Zhuchang, *Huang Binhong zhuanji nianpu hebian*, pp. 81–82.

35. James Cahill, "The Early Style of Kung Hsien (Gong Xian)," *Oriental Art* 16, no. 1 (spring 1970), pp. 51–71.

36. See Dong Qichang's colophons on the album, *Xiaozhong xianda* (Within Small See Large), leaves 8, 12; Wen C. Fong et al., *Images of the Mind: Selections from the Edward L. Elliott Family and John B. Elliott Collections of Chinese Calligraphy and Painting at The Art Museum, Princeton University* (Princeton: The Art Museum, Princeton University, 1984), p. 183.

37. For Wang Hui's "Great Synthesis" of the Juran-Huang Gongwang-Wang Meng stylistic tradition, see Fong, *Images of the Mind*, pp. 179–92.

38. See, for example, Jianzhai, "Huang Binhong bixiade Xianggang shanshui" (Under Huang Binhong's Brush: The Landscape of Hong Kong), *Meishujia* (The Artist), no. 51 (1986), pp. 50–55.

39. Adapted from Ellsworth, *Later Chinese Painting and Calligraphy*, vol. 1, p. 152.

40. Wang Bomin, ed., *Huang Binhong huayulu* (The Paintings and Recorded Sayings of Huang Binhong) (Shanghai: Shanghai Renmin Meishu Chubanshe, 1961), p. 1.

41. Ibid., pp. 5–6.

42. Wang Bomin, *Huang Binhong*, pp. 39–40.

43. Dong Qichang, *Huayan* (The Eye of Painting), in *Yishu congbian* (Collected Works on Chinese Art), compiled by Yang Jialuo, ser. 1, vol. 12 (reprint, Taipei: Shijian Shuju, 1967), p. 25.

44. Wang Bomin, *Huang Binhong huayulu*, p. 1.

45. Wang Bomin, *Huang Binhong*, p. 42.

46. Wang Bomin, "The Paintings of Huang Binhong," in *Cheng huai gudao/Homage to Tradition/Huang Binhong* (exh. cat., Hong Kong: Hong Kong Museum of Art, 1995), pp. 34, 43.

47. Qiu Zhuchang, *Huang Binhong zhuanji nianpu hebian*, pp. 190–91.

48. Ibid., p. 192; also Wang Bomin, *Huang Binhong huayulu*, p. 32.

49. Wang Bomin, *Huang Binhong huayulu*, p. 60.

50. Ibid., p. 32. For a discussion of Shitao's "Painting of Oneness," see Fong, *Images of the Mind*, pp. 204–6.

51. Adapted from Ellsworth, *Later Chinese Painting and Calligraphy*, vol. 1, p. 149.

52. Ibid., p. 150.

53. Wen C. Fong, *Beyond Representation: Chinese Painting and Calligraphy, 8th–14th Century* (New York: The Metropolitan Museum of Art, 1992), p. 161.

54. See above, p. 138 and n. 1.

55. Dong Yuping, "Zhongguo shanshuihua dajia Huang Binhong " (The Great Chinese Landscape Master Huang Binhong), in *Huang Binhong jingpinji*, p. 261. For Wu Wei et al. and the "Wild Fox Chan" style, see Richard M. Barnhart, "The 'Wild and Heterodox School' of Ming painting," in *Theories of the Arts in China*, edited by Susan Bush and Christian F. Murck (Princeton: Princeton University Press, 1983), pp. 365–96.

56. Maurice Denis, *Théories, 1890–1910* (Paris, 1912), p. 1, as translated by John Rewald, *Post-Impressionism, from Van Gogh to Gauguin*, 2d ed. (New York: Museum of Modern Art, 1962), p. 518.

57. Wang Bomin, *Huang Binhong huayulu*, p. 2.

58. Wang Bomin, *Cheng huai gudao / Homage to Tradition*, pp. 33, 42.

59. Huang Zhufu, "Huang Binhong huaniao hua chutan" (A Preliminary Study of Huang Binhong's Bird-and-Flower Painting), *Meishu shilun* (Studies in Art History), no. 29 (1989, no. 1), pp. 65–68.

60. For this and the following inscriptions on Huang's album, see Ellsworth, *Later Chinese Painting and Calligraphy*, vol. 1, pp. 151, 155.

61. See Shen C.Y. Fu and Jan Stuart, *Challenging the Past: The Paintings of Chang Dai-chien* (exh. cat., Washington, D.C.: Arthur M. Sackler Gallery, Smithsonian Institution, 1991).

62. Ibid., pp. 18–21.

63. Ibid., pp. 100, 108, 120, 126, 131.

64. Ibid., pp. 91–93.

65. Adapted from ibid., p. 51.

202

66. Xu Beihong is said to have remarked, "there is only one Zhang Daqian every five hundred years." See Su Yinghui, "Chang Dai-chien and Tun-huang," in *Zhang Daqian, Pu Xinyu shi shuhua xue shutao lunhui / The International Conference on the Poetry, Calligraphy, and Painting of Chang Dai-chien and P'u Hsin-yu: Proceedings* (Taipei: National Palace Museum, 1994), p. 57.

67. See pp. 90, 94, in this publication.

68. Adapted from Fu and Stuart, *Challenging the Past*, p. 39, quoting from the introduction to Zhang Daqian, ed., *Dafeng Tang mingji* (Masterpieces of Chinese Painting from the Great Wind Hall Collection), vol. 1 (Kyoto: Benrido, 1955), n.p.

69. See Marilyn Fu and Shen C.Y. Fu, *Studies in Connoisseurship: Chinese Painting from the Arthur M. Sackler Collection in New York and Princeton* (Princeton: The Art Museum, Princeton University, 1973), pp. 186–203, 314–17; and Fu and Stuart, *Challenging the Past*, pp. 84–87.

70. Cheng Linsheng, ed., *Shitao tihualu* (Colophons on Shitao's Paintings), 2 vols. ([Shanghai]: N.p., 1925).

71. Wen C. Fong, "A Chinese Album and Its Copy," *Record of The Art Museum, Princeton University* 27, no. 2 (1969), pp. 74–78; Fu and Fu, *Studies in Connoisseurship*, pp. 186–203.

72. Fu Shen (*Challenging the Past*, p. 87) has identified the source of Zhang's inscription.

73. Fu and Fu, *Studies in Connoisseurship*, pp. 84–87.

74. Adapted from Fu and Stuart, *Challenging the Past*, p. 86.

75. Wen C. Fong, "A Letter from Shih-t'ao to Pa-ta-shan-jên and the Problem of Shih-t'ao's Chronology," *Archives of the Chinese Art Society of America* 13 (1959), pp. 22–53.

76. On the right border of the first leaf of the letter are two seals of Li Conghan (1769–1831), a collector and poet from Linchuan (Jiangxi) and an ancestor of Li Ruiqing and Li Jian.

77. Nagahara Oriharu, *Sekitō Hachidai Sanjin / Shitao and Bada Shanren* (Tokyo: Keibunkan, 1961); Wen C. Fong, "Reply to Professor Soper's Comments on Tao-chi's Letter to Chu Ta," *Artibus Asiae* 29, no. 4 (1967), pp. 351–57. Marilyn and Shen Fu have described Zhang Daqian's style well: "[Zhang's] brushwork is sharp, dynamic, and aggressive, moving in angular rhythms which tend to skid across the surface of the paper rather than sinking deep into its fibers.... He almost never cultivates the flavor of the primitive or clumsy (*cho*) but prefers the sleek and striking. As a result his works occasionally suffer from a thinness, an over-brilliance, and an excessive sharpness and brittleness of line. Subtlety and restraint in artistic terms are not [Zhang's] forte: he favors the dramatic and flamboyant" (Fu and Fu, *Studies in Connoisseurship*, p. 315).

78. Wang Fangyu provided the photograph.

79. For Hashimoto's translation of Shitao's letter, see Fong, "Letter from Shih-t'ao to Pa-ta-shan-jên," p. 28.

80. Hashimoto Kansetsu's *Sekito* was published in 1926. It contained a transcription of the original Shitao letter with critical deletions. The transcript was supplied by Zhang Daqian, who made the deletions because he was already planning for the Bada Shanren forgery.

81. For a general introduction, see Andrew Plaks, *The Four Masterworks of the Ming Novel: Ssu ta ch'i-shu* (Princeton: Princeton University Press, 1987).

82. Xie Jiaxiao, *Zhang Daqian di shijie* (The World of Zhang Daqian) (Taipei: Zhengxin Xinwenbao, 1968); Feng Youheng, *Xingxiang zhi wai: Zhang Daqian de shenghuo yu yishu* (Beyond Form and Representation: The Life and Art of Zhang Daqian) (Taipei: Jiuge Chubanshe, 1983).

83. Zhang sums up the art of painting in twelve steps: (1) The copying of ancient models; (2) The studying of nature; (3) The establishment of themes; (4) The creation of imaginary scenery; (5) The cultivation of elegance; (6) "Bone-breath" (or "bone method"); (7) "Breath-resonance"; (8) "Spirit" beyond form; (9) The practice of "mind ease"; (10) The transformation of the model without copying; (11) The expression of emotion in a narrative; (12) The creation of a grand composition. See Gao Lingmei, ed., *Chinese Painting; with the Original Paintings and Discourses on Chinese Art by Professor Chang Dai-chien* (Hong Kong: East Art Company, 1961), p. 7.

84. Li Lincan, *Zhongguo huashi yanjiu lunji* (Essays on Chinese Art History) (Taipei: Taiwan Commercial Press, 1970), pp. 16–17, pls. 14–17. For a discussion of Li's analysis, see Wen C. Fong, "Toward a Structural Analysis of Chinese Landscape Painting," in *National Palace Museum Quarterly*, special issue, no. 1, *Symposium in Honor of Dr. Chiang Fu-tsung on His Seventieth Birthday* (Taipei: National Palace Museum, 1969), pp. 1–3.

85. Su Yinghui, "Chang Dai-chien and Tun-huang," in *International Conference on Chang Dai-chien and P'u Hsin-yu*, pp. 58–59.

86. Shen Fu, "Chronology of Chang Dai-chien," in *Challenging the Past*, p. 81.

87. Wen C. Fong, "The Problem of Forgeries in Chinese Painting," *Artibus Asiae* 25, nos. 2–3. (1962), pp. 95–140.

88. Fu and Stuart, *Challenging the Past*, p. 308.

89. Ibid., pp. 189–92.

90. Ibid., pp. 193–95.

91. Ibid., p. 193.

92. For discussions of Zhang Daqian's forgery of *Dense Forests and Layered Peaks*, attributed to Juran, see Wen C. Fong, "*Riverbank*," in *Along the Riverbank: Chinese Paintings from the C.C. Wang Family Collection*, by Maxwell J. Hearn and Wen C. Fong (exh. cat., New York: The Metropolitan Museum of Art, 1999), pp. 46–52; and Wen C. Fong, "A Reply to James Cahill's Queries about the Authenticity of *Riverbank*," *Orientations* 31, no. 3 (March 2000), pp. 114–28.

93. Fu and Stuart, *Challenging the Past*, p. 296.

94. Ellsworth, *Later Chinese Painting and Calligraphy*, vol. 1, p. 210.

95. Adapted from Fu and Stuart, *Challenging the Past*, p. 296.

96. A similar composition, dated 1945, is reproduced in Gao Lingmei, *Chinese Painting by Professor Chang Dai-chien*, p. 101.

97. Ellsworth, *Later Chinese Painting and Calligraphy*, vol. 1, p. 210.

98. Fu and Stuart, *Challenging the Past*, p. 196.

99. Gao Lingmei, *Chinese Painting by Professor Chang Dai-chien*, pp. 107, 109.

100. Ibid., pp. 51–54.

101. Fong, *Beyond Representation*, p. 272.

102. Fu and Stuart, *Challenging the Past*, pp. 74–76.

103. For Zhang's splashed-ink technique and the story of Wang Mo, see ibid., pp. 71–74.

104. For the origin of "blue-and-green" landscape painting, see Fong, *Beyond Representation*, pp. 102–7.

105. Now on deposit at the National Palace Museum, Taipei.

106. Also on deposit at the National Palace Museum, Taipei; for a reproduction see Fu and Stuart, *Challenging the Past*, pp. 298–99.

Chapter Four

Mainland Chinese Painting, 1950s–1980s

FIGURE 104

Henri Matisse (1869–1954), *Woman in Blue*, dated 1937. Oil on canvas, 36½ × 29 in. (92.7 × 73.6 cm). Philadelphia Museum of Art

PLATE 75

Lin Fengmian (1900–1991), *Seated Woman*, early 1960s. Hanging scroll, ink and color on paper, 27 × 25¾ in. (68.6 × 65.4 cm). Gift of Robert Hatfield Ellsworth, in memory of La Ferne Hatfield Ellsworth, 1986 (1986.267.374)

206

After the establishment of the People's Republic in 1949, the Chinese Communist party, based on the Leninist doctrine of party dictatorship, began a period of consolidation, a restructuring of the economy, and the building of a new socialist state in emulation of the Soviet model. In less than a decade Mao Zedong, from 1949 chairman of the People's Republic, had begun to search for the "Chinese road" to socialism.[1] In his attempt to gain the cooperation and support of the intellectuals who had become disaffected under the rigid control that held sway in the early 1950s, Mao made the pronouncement, "Let a Hundred Flowers Bloom." The resulting dissension led to a sharp reversal of his approach in dealing with the intelligentsia and to the Anti-Rightist Campaign of 1957. By 1958, abruptly changing course from the first five-year economic plan, initiated in 1953, Mao launched the Great Leap Forward, the mass collectivization of peasants into people's communes and the forced development of rural industrial production. The failure of the Great Leap Forward and the resulting economic catastrophe and widespread famine that swept through China in the early and mid-1960s left Mao increasingly isolated from the center of political decision-making. In 1966, he unleashed the Cultural Revolution, a disastrous campaign to heighten the revolutionary goals of the Communist party. He died in 1976, and a new era finally dawned on China as it prepared for the normalization of relationships with the United States and the outside world in the late 1970s and early 1980s.

Under the People's Republic, formal art education is organized by national art academies, the most prestigious of which are in Beijing, Nanjing, Shanghai, and Hangzhou, along

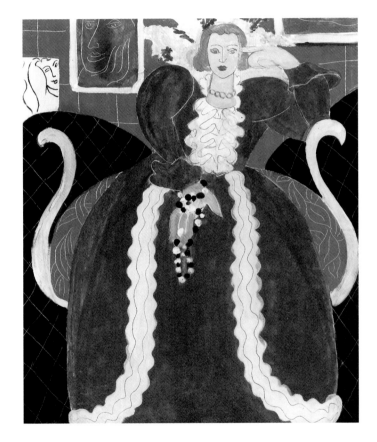

the east coast of China. After settling in Yan'an in northwest China in the 1930s, the Communist party had put into effect a radical program of reform under the strict control of party commissars, who decided what kind of art should be made and which artists would be permitted to work. In the early 1950s, the styles derived from traditional Chinese painting and from the École des Beaux-Arts were declared elitist and corrupt and would be replaced by Socialist Realism, which endorsed the Soviet state. A brief period of liberalization

PLATE 76

Lin Fengmian (1900–1991), *Gladioli*, 1960s. Hanging scroll, ink and color on paper, 24 × 27¼ in. (61 × 69.2 cm). Gift of Robert Hatfield Ellsworth, in memory of La Ferne Hatfield Ellsworth, 1986 (1986.267.375)

during the Hundred Flowers Movement in 1956 was followed by a brutal crackdown under the Anti-Rightist Campaign and the Great Leap Forward. By late 1963 Jiang Qing, the third wife of Mao Zedong, had begun to rise in power and to exert control over the arts. Artists and writers were sent into the countryside to prisons known as "cow pens" and "dung baskets." After Mao died, Jiang Qing and the Gang of Four were defeated in a Politburo power struggle and arrested later that year.

Although the Communist Party tried to broaden the social base for art by encouraging commune and factory art clubs, especially in the production of woodcut art, comic strips, New Year's pictures, and papercuts,[2] the national art academies served as official centers for the professional artists who, having endured the harrowing experiences inflicted on them during the Cultural Revolution, nevertheless remained resolutely determined in their pursuit of artistic reform. As educators focusing on pedagogical methods and theories, the academy painters, in typically Chinese fashion, formed allegiances to their own teachers and schools. In the early 1950s, the principal academies were nominally headed by such well-known figures as Xu Beihong in Beijing and Liu Haisu first in Shanghai and then in Nanjing, while traditionalist painters such as Qi Baishi in Beijing and Huang Binhong in Hangzhou were retained as professors of traditional-style painting. By the 1960s a second generation of artists, who had been trained in the traditionalist and Western styles began their search for a new synthesis of Chinese and Western methods.

Lin Fengmian (1900–1991), from Meixian (Guangdong), was, like Xu Beihong, among the earliest Chinese artists to study in Europe. Arriving in France in 1919, the same year as Xu, Lin entered the studio of the conservative figure painter Fernand Cormon (1854–1924) at the École des Beaux-Arts.[3] Unlike Xu, Lin fell under the spell of the Fauve painters Henri Matisse and Maurice de Vlaminck, whose work was suffused wih dazzling colors and whose compositions were formed with a new approach to space. Returning to China in 1926 after spending six years in France, Lin was appointed president of the National Academy of Art in Beijing, but left the following year to establish a new academy in Hangzhou.[4] During his ten years as director of the National Hangzhou Arts Academy, he attracted a large following and produced some of the most distinguished painters of the new generation, among them Li Keran (1907–1989), Wu Guanzhong (b. 1919), and Zao Wouki (b. 1921), perhaps the best-known Chinese painter in Paris after 1948. Following the establishment of the People's Republic in 1949, Lin moved with his French wife to Shanghai and continued to paint in virtual isolation. Incarcerated during the Cultural Revolution, in 1977 he was granted a leave to visit Hong Kong. He remained there until he died, in 1991.

Early in his career, Lin abandoned oil for Chinese brush and gouache on paper, which he viewed as a medium better suited to capturing the impression of spontaneity. *Seated Woman* (pl. 75), dating from the early 1960s, is Lin's interpretation of an odalisque in the style of Matisse.[5] A robed young woman seated cross-legged in front of a floral hanging is executed in bold, sweeping brushstrokes. Compared with Matisse's *Woman in Blue*, of 1937 (fig. 104), Lin's figure is both flat and formless. Matisse, who, like Lin, had first

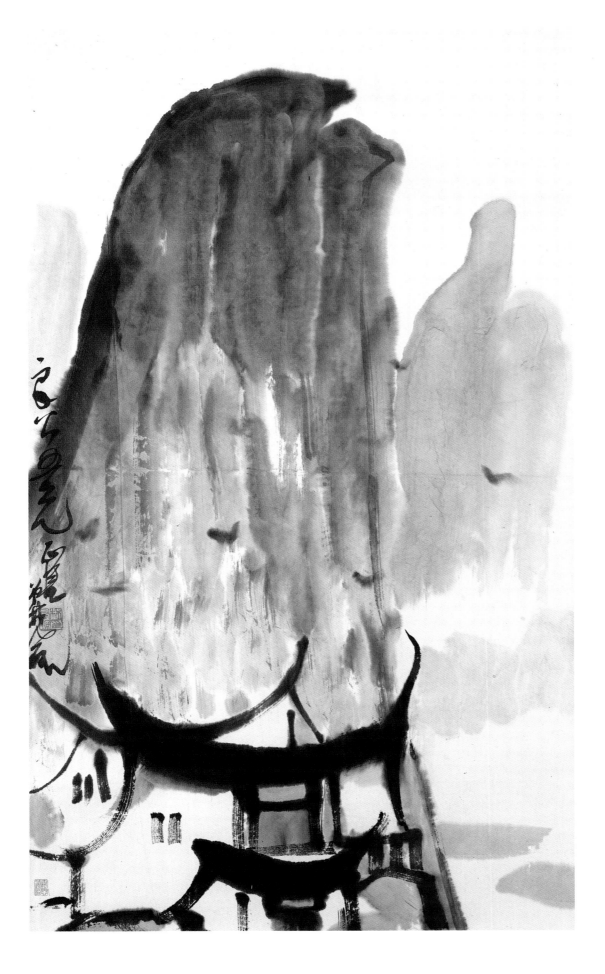

PLATE 77

Lin Fengmian (1900–1991),
Mountain Village, early 1960s.
Hanging scroll, ink and color on
paper, 27 × 15¾ in. (68.6 × 40 cm).
Robert H. Ellsworth Collection

FIGURE 105

Henri Matisse (1869–1954), *Shaft
of Sunlight, the Woods of Trivaux,*
dated 1917. Oil on canvas, 36 ×
29⅛ in. (91 × 74 cm). Private
collection

worked under Cormon, was trained in the classical tradition.[6]
Matisse begins with a portrait from life and develops the com-
position into a decorative, less naturalistic state. There are,
for example, more than twenty preliminary sketches for the
Large Reclining Nude of 1935, and four known successive doc-
umented states for *Woman in Blue.*[7] Clearly Matisse and Lin
had different approaches to their work. Matisse, painting in
oil, builds form by image construction in successive stages,
which conceals his working process, as sketch improves on
sketch and stroke conceals stroke. Lin, on the other hand,
using brush and ink, captures the image at once, with every
stroke clearly marked on the paper surface, reflecting the Chi-
nese belief that the rhythmic quality of the brushwork alone
expresses the artist's intent and state of emotion.[8] The modern
scholar Lang Shaojun has described Lin Fengmian's figure
paintings as done "in a classicizing, elegant color scheme . . .
[that] captures an elusive, visible but intangible, kind of
beauty."[9] Furthermore, although Western in stylistic influence,
Lin's female figures remain distinctly Chinese in feeling.

Lang Shaojun has analyzed Lin Fengmian's paintings in
three categories: the discipline of the two-dimensional world,
the poetry of colors, and the expressive form of the spirit.[10]
Gladioli (pl. 76), dating from the 1960s, shows freely exe-
cuted sprays of leaves and densely clustered flower petals in
bright colors.[11] A design in the flat two-dimensional plane,
without perspective or light, Lin's explosive combinations of
red and yellow, violet and pink, and green and black suggest
discord rather than harmony. Lang describes the style of such
works as Expressionist Realism, which he attributes to the
influence of Matisse.[12]

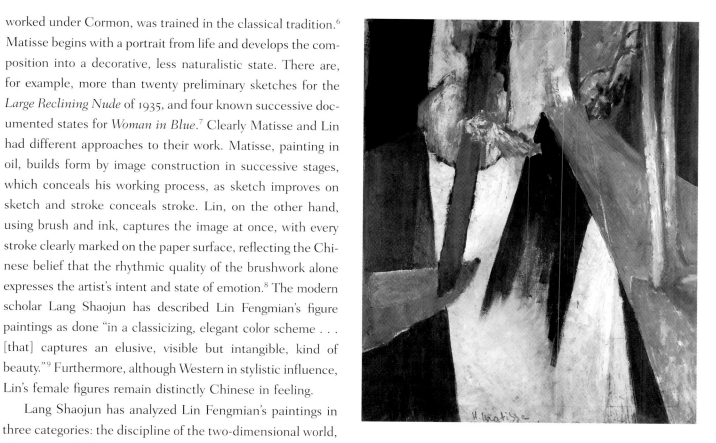

Mountain Village (pl. 77), dating also from the early 1960s,
is a scenic view in a Western-style rectangular format rather
than the traditional hanging or handscroll format. Bringing
the elements to the foreground and cropping them with the
borders of the picture frame, Lin treats the elements of
the picture much as they would appear in a still life. Com-
pared with Matisse's *Shaft of Sunlight, the Woods of Trivaux*
(fig. 105), of 1917, Lin characteristically focuses on brush-
work rather than on the play of light and color.

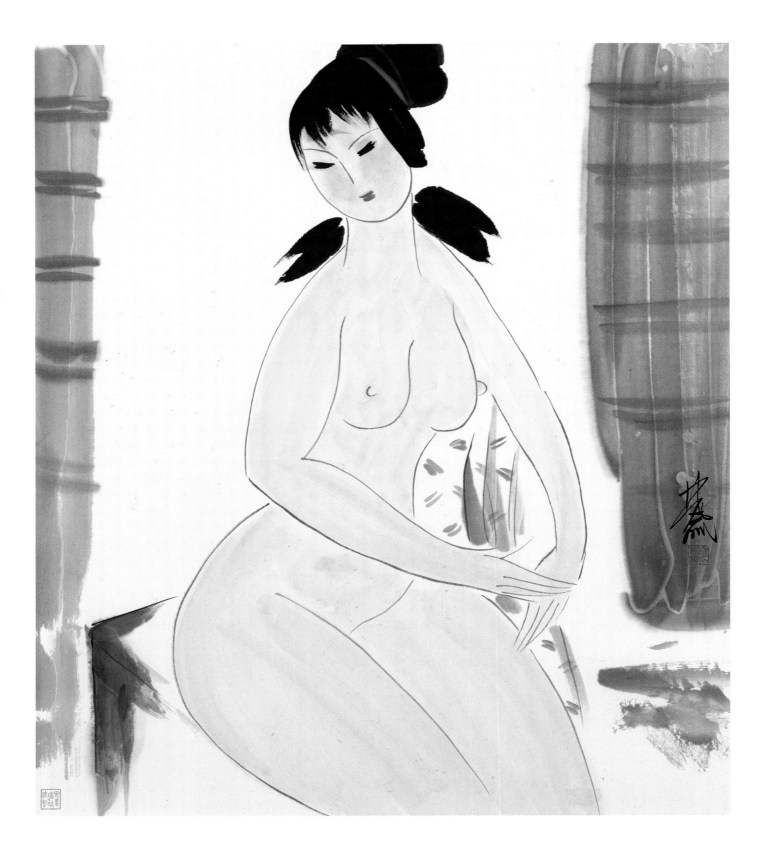

PLATE 78

Lin Fengmian (1900–1991), *Nude*,
late 1970s. Hanging scroll, ink
and color on paper, 28 × 32 in.
(71.1 × 81.3 cm). Gift of Robert
Hatfield Ellsworth, in memory of
La Ferne Hatfield Ellsworth, 1986
(1986.267.372)

FIGURE 106

Pan Tianshou (1897–1971), *Pine
Tree on a Rock* and Pan Gongkai's
diagram of painting. Pan Tianshou
Memorial Gallery, Hangzhou

Nude (pl. 78), dating from the late 1970s, is a development from the figure studies that Lin had made prior to the 1950s.[13] Wu Guanzhong, who studied with Lin, describes how Lin would practice his composition many dozens of times before choosing one or two.[14] Wu writes:

In the early twentieth century many Western painters, increasingly dissatisfied with oil techniques that resulted in heavy, solid images, . . . turned to the study of Japanese and Persian painting. The work of Matisse, Dufy, and Utrillo . . . was freer and more spontaneous, a repudiation of studying from plaster casts and an expression more allied with music than with stone. Lin Fengmian's paintings of female figuress. . . reflect this contemporary Western search for musicality and Oriental feeling. . . . The poetry in his paintings is expressed through formal properties.[15]

When we recall how Liu Haisu had shocked his public by introducing drawing from the nude in the 1910s (see pages 103–4), we can appreciate the courage it took Lin Fengmian to continue to make female nudes under the puritanical

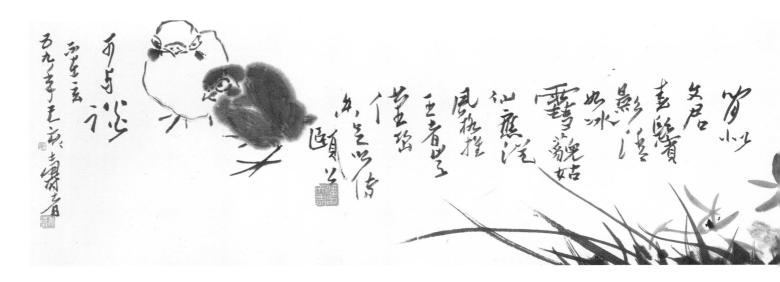

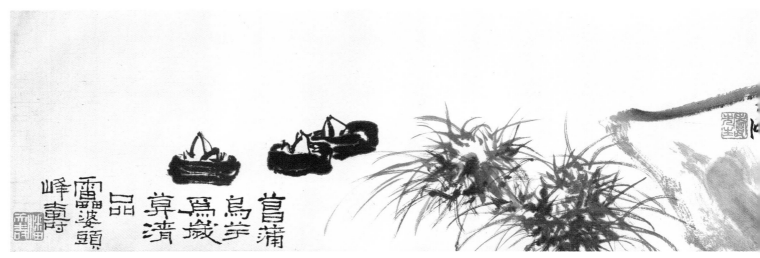

Communist rule. There is, however, a distinct "Oriental feeling" of discomfort in the paintings, which leads his viewers to look in his expressive linear drawing for musicality, poetry, and, in Lang Shaojun's words, "an elusive . . . kind of beauty."

In 1928, Lin Fengmian appointed Pan Tianshou (1897–1971) to the faculty of the newly founded National Hangzhou Arts Academy as professor of traditional-style painting. Pan taught at the academy, renamed the Zhejiang Academy of Fine Arts in the late 1950s, and was appointed director in 1959. As an intellectual, he was persecuted during the Cultural Revolution. Viciously attacked by the Red Guards, he died in 1971. Born to a peasant family in Ninghai (Zhejiang), Pan learned to paint without formal training but by studying

the *Mustard Seed Garden Manual*. Enrolled in 1915 in the First Normal College in Zhejiang, Pan received instruction from Li Shutong (1880–1942), the pioneer Western-style teacher who was also mentor to Feng Zikai (see pages 122, 129, and pl. 44). In Shanghai, where he went in 1925, Pan studied seal-and clerical-style calligraphy under the influence of Wu Changshuo (1844–1927).

In the late 1950s and early 1960s, Pan made many large paintings more than six feet in height, some of which are now in the collection of the Zhejiang Academy of Fine Arts. His son Pan Gongkai published a series of sketches and diagrams that show how his father instructed his students in the principles of mass, space, movement, and balance.[16] Pan

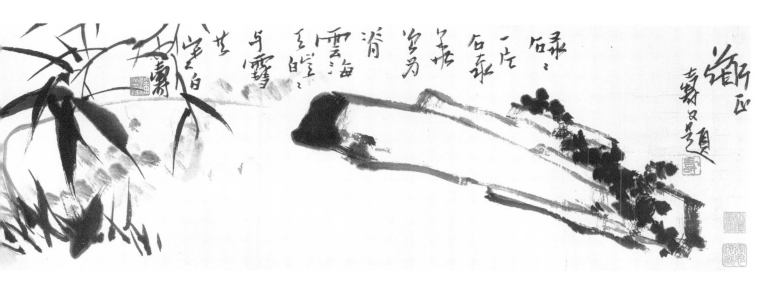

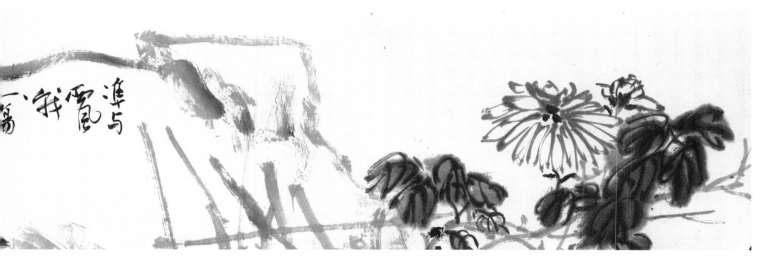

uses straight diagonal lines across the picture plane to inter-sect and interact with the four borders of the painting. Gong-kai's diagram of Pan Tianshou's *Pine Tree on a Rock* (fig. 106), for example, shows how the leftward thrust of the rock at the bottom half of the painting, in abutting the right border, creates a countermovement of the pine tree at the top. Pan Gongkai explains how a painter must seek a formal language to express his emotional content:

Although flowers and grasses are in nature gentle and yielding, in the paintings of Bada Shanren they are isolated and alone, while in those of Wu Changshuo they are tough and resistant. In using a subject to express himself, an artist must also find formal means to describe feelings. The difficulty of self-expression thus lies in finding the right language. In the work of Pan Tianshou, chrysanthemums are upright and lotus leaves sturdy and durable. The structure of his compositions always rests on a firm, stable framework. This is what is meant by finding one's own language.[17]

Pan Tianshou believed that art is the expression of the artist's ethical values. This view is consistent with scholar painting as described by Chen Hengke who, as mentioned earlier (pages 14–15), defined the elements of Chinese paint-ing as moral character, learning, talent and feeling, and idea-lism. Pan described his approach to painting in 1966:

PLATE 79 (overleaf)
Pan Tianshou (1897–1971), *Various Subjects*, dated 1959. Handscroll, ink on paper, 8¾ × 108⅛ in. (22.2 × 274.6 cm). Gift of Robert Hatfield Ellsworth, in memory of La Ferne Hatfield Ellsworth, 1986 (1986.267.315)

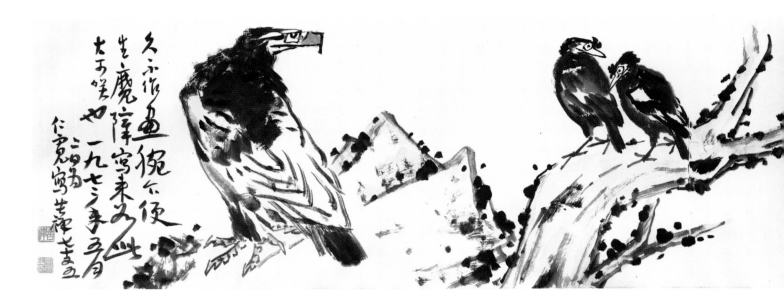

Chinese painting comprises spirit and feeling [shenqing], the idea state [yijing], and style and tone [gediao]. Painting must express high-minded moral principles.... Without cultivating a spiritual state, brush and ink alone can never achieve a noble style.[18]

Various Subjects (pl. 79), dated 1959, shows how, by mid-century, the traditional-style painter had achieved a new synthesis of Chinese and Western methods. This is reflected in the way the date of the painting is recorded; in the middle of the scroll, "fifty-nine year" (for 1959) is followed by the Chinese cyclical date *jihai*. The handscroll begins with a diagonally placed rock, which combines Wu Changshuo's metal-and-stone brush technique with elements of Western spatial usage. Without a graphic context—shading, background, or a baseline to indicate the ground—the rock, composed of angular lines and clusters of dots, is an abstract form that is thrust into a two-dimensional space. Pan's obstinate diagonal rock is accompanied by a poem written in the artist's jagged handwriting, which expresses his own defiant spirit:

This is just an ordinary rock.
It used to lie at the ridge of Mount Tai or Mount Hua.
There a sea of white clouds
Keeps company with snowy cold and purity.[19]

Pan's handscroll, which follows the traditional theme of the

PLATE 80

Li Kuchan (1898–1983), *Various Subjects*, dated 1972. Handscroll, ink and color on Japanese paper, 15⅜ × 14 ft. 3 in. (39.1 × 426.2 cm). Gift of Robert Hatfield Ellsworth, in memory of La Ferne Hatfield Ellsworth, 1986 (1986.267.355)

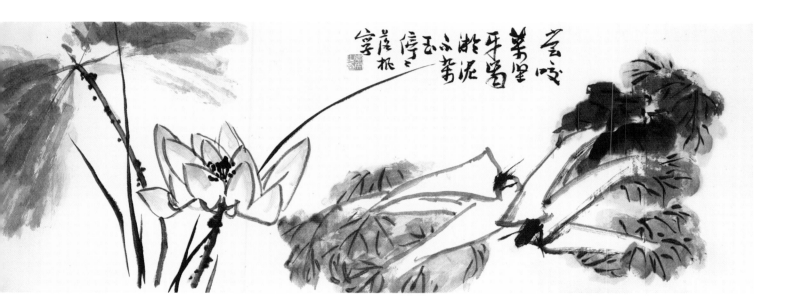

Four Seasons, recalls the Ming-Qing scholar-painting styles of Xu Wei, Bada Shanren, and Zheng Xie. The composition continues, after the rock, with images of bamboo and orchids, symbols of gentlemanly virtue:

Fine as the wisps of hair on Lady Wen's temples,
With the purity of icy snow, [the orchid] surpasses even
 the fairy lady.
Its eloquence may be compared to that of a sage-king;
It is not only its gentle fragrance that will endure.

To the left of the orchids are two chicks, painted in the style of Bada Shanren. The inscription reads:

You can talk to them;
No need to be cryptic.

The autumn scene that follows is represented by a chrysanthemum next to a rock. The stark image of the rock suggests man's resolute spirit:

[The chrysanthemum] stands ready to confront the
 west wind.

The scroll ends with two clumps of sweet flag and three water chestnuts, again in the style of Bada Shanren. The inscription is in clerical script:

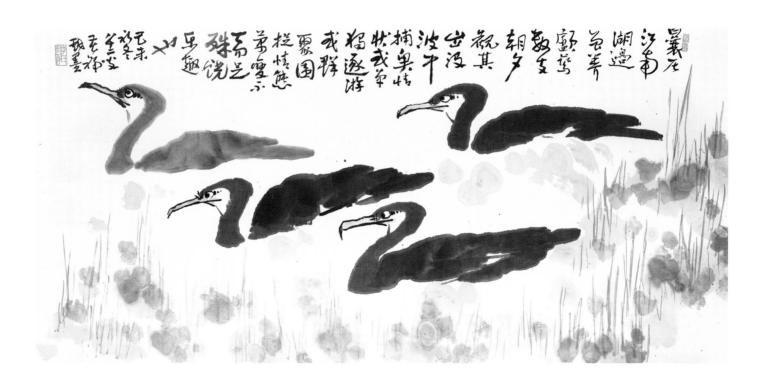

The calamus grass and water chestnuts are pure and fresh at year's end.[20]

Li Kuchan (1898–1983) was another leading painter of Pan's generation. Born to a poor family in Gaotang (Shandong), Li went at the age of twenty-one to Beijing, where he met Xu Beihong. Xu inspired in him the idea of creating a new Chinese painting. Between 1923 and 1925, Li studied Western-style painting at the National Academy of Art in Beijing, where he was a pupil of Qi Baishi. From 1930 to 1934, he taught Chinese painting at the National Hangzhou Arts

Academy as a colleague of Pan Tianshou, and for the rest of his career he was at the Central Academy of Fine Arts in Beijing. He made mostly bird-and-flower paintings influenced by Xu Wei and Bada Shanren. His calligraphy followed in the style of Six Dynasties stone monuments.

Qi Baishi once wrote, "Of my nearly one hundred pupils, most of them have studied merely what my hand does. Only Li Kuchan has studied what my heart speaks. What Li does actually surpasses me." Li's *Various Subjects* (pl. 80),[21] painted in 1972 at the height of the Cultural Revolution during which he was severely persecuted, transforms Qi's

PLATE 81

Li Kuchan (1898–1983), *Cormo-
rants*, dated 1979. Horizontal
scroll, ink and color on paper,
26 × 51¾ in. (66 × 131.4 cm).
Gift of Robert Hatfield Ellsworth,
in memory of La Ferne Hatfield
Ellsworth, 1986 (1986.267.354)

graphic realism into emotion-packed, expressionistic abstract designs. Above two awkwardly shaped, angular stalks of Chinese cabbage above and adjacent to a lotus blossom, the artist writes:

I often chew this vegetable to toughen my teeth.
That which comes out of the mud without stain shall stand tall
* and be at peace.*

And next to the eagle, perhaps a symbolic depiction of himself, he adds:

Not having painted for a long time, my wrist now
* gives me trouble,*
Which makes my painting almost laughable.[22]

Compared with Qi Baishi's elegant *Eagle on a Pine Tree* (pl. 55), the body of Li's eagle has virtually dissolved in a mass of disheveled, bristling brushstrokes. An opera buff, Li compared the quality and movement of brushwork to the timbre of the voice and spoke of the ability of both to communicate feeling.[23] Li's righteous defiance in the face of persecution is here reflected in the agitated gesticulation of his brushwork.

A gentler expression is seen in *Cormorants* (pl. 81), dated 1979, on which the inscription reads:

When I lived in Jiangnan, I kept several cormorants and I would watch them from morning till night chasing about the waves to catch fish in endlessly variable and indescribable ways. It was most enjoyable.

To suggest the movement of the cormorants gliding through water, Li accents their dark silhouettes against the glittering surface of the water reeds and foliage—a moment of peaceful pleasure.

Wu Zuoren (1908–1997) was director of the Central Academy of Fine Arts, Beijing, from the 1950s until 1979.[24] Born in Suzhou (Jiangsu), Wu began his study of Western art techniques with Xu Beihong at the South China Art Academy in Shanghai in 1928. He went to Europe in 1929 to study at the École des Beaux-Arts in Paris and the Académie Royale de Belgique in Brussels. Returning to China in 1935, he taught under Xu Beihong at the Central University in Nanjing, which moved to Chongqing in interior China during the war years. In Chongqing, he joined the war effort, producing anti-Japanese propaganda pictures. Living in Qinghai Province and on the Tibetan plateau in the early 1940s, he developed a romantic fascination with the lives of the peoples and animals of China's western regions and painted them in his works. After 1949, Wu served as Xu Beihong's assistant when Xu was the nominal head of the Beijing Central Academy. He was named president of the academy in 1958. During the Cultural Revolution, Wu and his wife were sent, separately, to the countryside, where he was forced to tend pigs. Restored to his academy position after 1977, he retired as honorary president in 1979.

A talented draftsman who worked both in drawing from life and in oil painting, Wu after 1949 painted mostly in ink and color. Like Xu Beihong and Lin Fengmian before him, he learned to draw realistically with spontaneous brushwork. In his article "On Sketching and Painting," published in 1979,

220

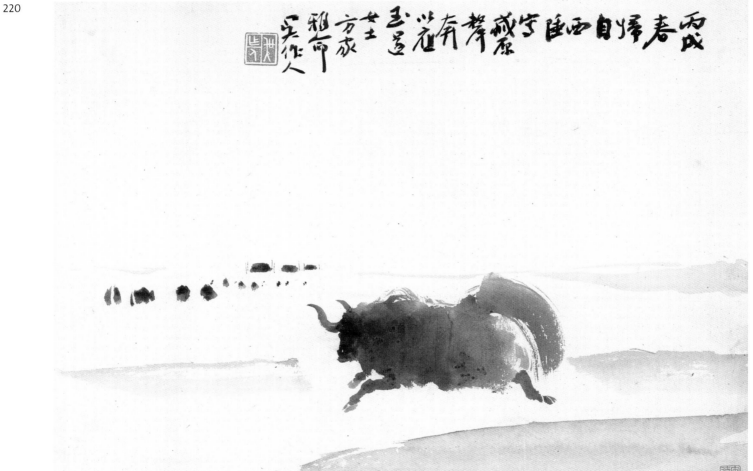

FIGURE 107

Wu Zuoren (1908–1997), *Herd of Yaks*, dated 1943. Charcoal sketch, 8⅞ × 7⅞ in. (22.5 × 20 cm). Wu Zuoren Art Gallery, Suzhou

imperial majesty, aloft a huge boulder high above distant mountains. Wu, a member of the National People's Congress and chairman of the Association of Chinese Artists, in the 1980s produced a series of similar images with such titles as *Vigilance*, *Born to Rule the Sky*, *Clouds and Mountains for a Thousand Miles*, and *A Lofty and Far-Sighted Vision*. The last (fig. 108) is dated 1983 and dedicated to Marshal Ye Jianying, chairman of the Standing Committee for the National People's Congress, wishing him "Good Health and Longevity."[26] The image of the eagle (fig. 109) follows the process described below:

I often jot down what appears first in my mind. These fleeting, unformulated impressions, though only in embryonic, ill-formed shapes, are the seeds of artistic imagination. More careful reflection and exploration may take longer, but the first thoughts serve as an incubator and are an indispensable part of the process.[27]

This process called for a reversal of Wu's usual method of first composing a realistic description and then proceeding to a more spontaneous brush simplification. Starting with his first impression of the eagle, he draws the bird's angular beak and white feathers of the neck, then employs his own technique of using the water seepage from each inkstroke to define the feather patterns of the body. He also manipulates the brush and ink to simulate the tremulous, broad outline of the boulder. The imposing figure presiding over the land is an apt symbol of state rule and party dictatorship.

After its reorganization in 1950, another major presence at the Beijing Central Academy was Li Keran (1907–1989).

he advocated sketching from life to train students in careful observation.[25] *Charging Yak* (pl. 82), dated 1946, belies Wu's thorough grounding in the Western study of anatomy in his seemingly spontaneous brushwork. This is seen also in one of his charcoal sketches, dated 1943 (fig. 107). *Camels* (pl. 83), dating from the late 1940s or early 1950s, shows Wu's indebtedness to Qi Baishi's *Five Water Buffalo* (pl. 59), from the mid-1930s. Qi had been Wu's colleague at the Beijing Central Academy of Fine Arts in the early 1950s. After the opening of mainland China to the West in the late 1970s, Wu's favorite subjects included doves, black swans, goldfish, and pandas, China's most famous export animal.

Ten Thousand Green Mountains (pl. 84), dated 1982, shows the heroic image of an eagle, symbol of Confucian loyalty and

Born in Xuzhou (Jiangsu), Li, like Wu Zuoren, was among the first generation of painters to learn both Chinese and Western techniques. Entering the Shanghai Academy of Art in 1923, he first studied under Liu Haisu (1896–1994), after which he enrolled in the Hangzhou Academy, where he studied oil painting with the French artist André Claudot (1892–1982).[28] In 1930, he joined the Eighteen Art Society of West Lake, which espoused Marxist philosophy, and attended study sessions on art and literature led by Lu Xun in Shanghai. In the immediate prewar years, he joined Guo Moruo's Union of Artists and Writers in Wuhan, turning out propaganda paintings before settling in Chongqing. There he became friends with Xu Beihong and Fu Baoshi, and gave up oil painting for the medium of ink on paper. In 1946, he became an associate professor at the National Academy of Art in Beijing, while he also studied with Qi Baishi and Huang Binhong. After 1960, Li's career flourished at the Beijing Central Academy of Art, where he specialized in landscape painting.[29]

It was in 1935, when he visited the Palace Museum in Beijing, that Li first gained a serious awareness of classical Chinese painting. In *The Immortal Liu Haichan Playing with a Toad* (pl. 85), dated 1937, he infuses realistic modeling with the spontaneous ink-wash style. Liu Haichan (whose name, Liu Haichan the Sea Toad, relates directly to the title of the painting) was a late Tang minister who retired from public life to become a Daoist recluse after the collapse of the Tang dynasty. Revered as an immortal, he was depicted as a beggarly eccentric dressed in rags and playing with a three-legged

PLATE 83

Wu Zuoren (1908–1997), *Camels*, late 1940s or early 1950s. Matted painting, ink on paper, 12 × 13½ in. (30.5 × 34.3 cm). Gift of Robert Hatfield Ellsworth, in memory of La Ferne Hatfield Ellsworth, 1986 (1986.267.393)

PLATE 84

Wu Zuoren, *Ten Thousand Green Mountains*, dated 1982. Hanging scroll, ink and color on paper, 53⅜ × 26⅝ in. (135.6 × 67.6 cm). Gift of Robert Hatfield Ellsworth, in memory of La Ferne Hatfield Ellsworth, 1986 (1986.267.389)

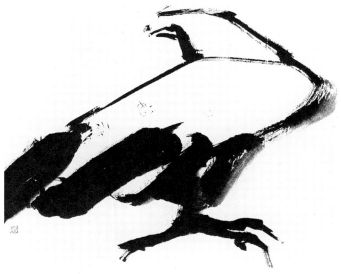

FIGURE 108

Wu Zuoren (1908–1997), *A Lofty and Far-Sighted View*, dated 1983. Hanging scroll, ink and color on paper, 73¼ × 33½ in. (186 × 85 cm).

FIGURE 109

Wu Zuoren, *Sketch of an Eagle*. Ink on paper, 44 × 47.5 cm.

224

toad, his attribute. Li Keran's rendering of the subject thus comprises his affirmation in the Chinese spirit of individualism as well as the Chan-inspired tradition of spontaneity in brush painting. In the late 1930s through the 1940s, Li painted many landscapes in the style of the seventeenth-century master Shitao.[30] He was to characterize his own work during this period as "fighting my way back into tradition... before fighting [my] way out of it."[31]

Li viewed himself as a proletarian artist, once noting, "Since both my parents were illiterate, I had no formal training. I learned through my parents' honesty and kindness, and the essential goodness of hardworking people."[32] Li's training with Qi Baishi beginning in 1947 was a turning point in his career.[33] Before this time, under the influence of Lin Fengmian

PLATE 85

Li Keran (1907–1989), *The Immortal Liu Haichan Playing with a Toad*, dated 1937. Hanging scroll, ink and color on Korean paper, 43 × 29½ in. (109.2 × 74.8 cm). Gift of Robert Hatfield Ellsworth, in memory of La Ferne Hatfield Ellsworth, 1986 (1986.267.384)

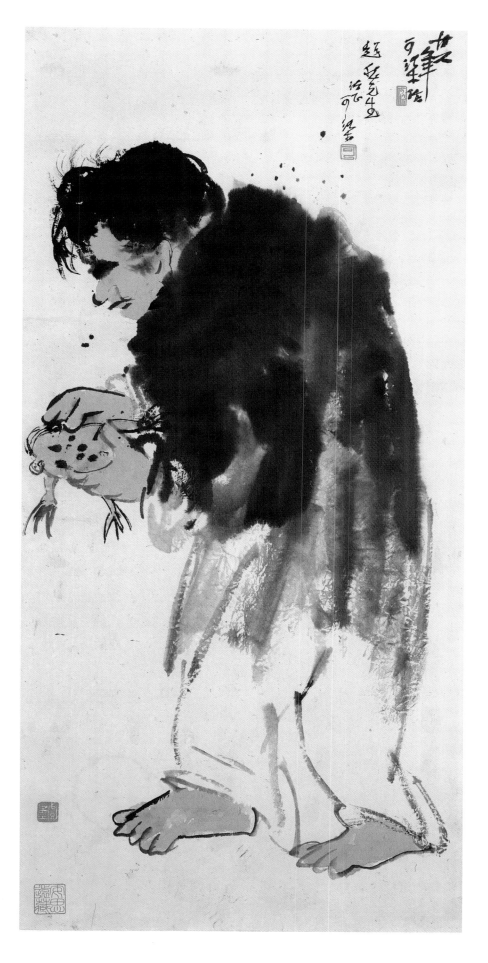

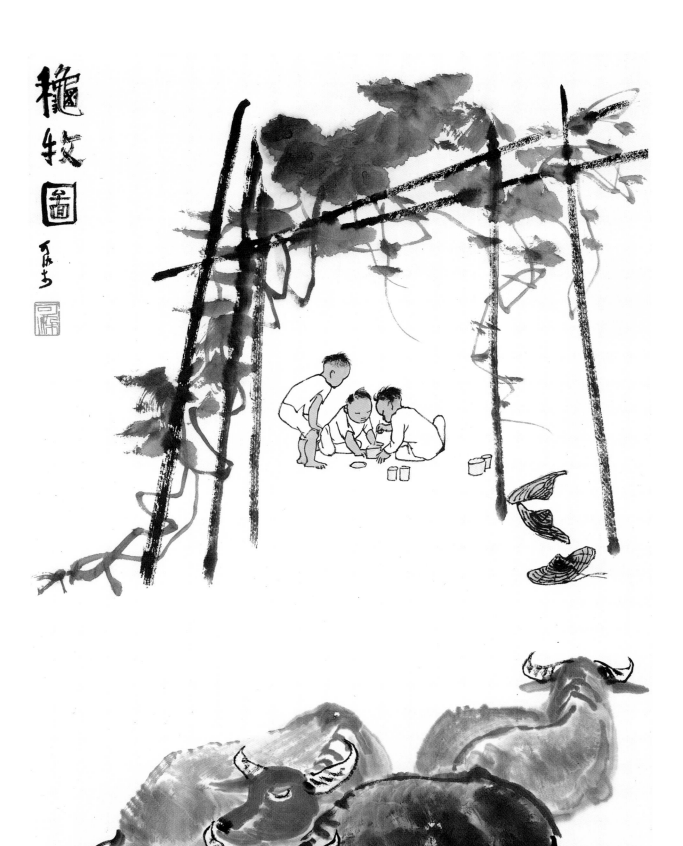

226

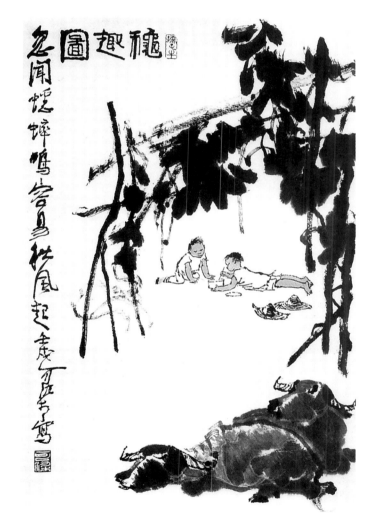

and Fu Baoshi, his drawing style was thin and cursory; now his work is focused and he uses a round, calligraphic quality. *Autumn Herd* (pl. 86), dating from the 1960s, depicts three water buffalo, one of Qi's favorite subjects (pl. 59). While the children in the background, playing under the trellis, retain an illustrational quality typical of Li's earlier work as a war propagandist, the rest of the painting reflects the influence of Qi's metal-and-stone calligraphic style. For Li the patient, toiling water buffalo was a symbol of China and its people; Hall of Learning from the Water Buffalo (Shiniu Tang) was the name of his painting studio. In *Autumn Playfulness* (fig. 110), dated 1982, which repeats the composition of *Autumn Herd*, next to the title of the painting is a small seal that says, affectionately, "[It is about] Children and Buffalo." And, in remembrance of his teacher Qi Baishi, he adds, "Suddenly I hear the chirping crickets; soon the autumn wind will come," which Qi had once inscribed on a painting of two children and a buffalo by Li, dated 1947.[34]

The Poetic Mood of Su Shi (pl. 87), dated 1962 when Li and his students were painting landscapes in Guilin (Guangxi), captures a meditative moment on a hot summer day. The inscription quotes two lines from a poem by Su Shi:

Lotus leaves reach up to the sky, endless green.
In the sun's reflection they turn a brilliant red.[35]

By this time, Li had turned his attention almost exclusively to landscape painting. Like Wu Zuoren, he was exiled to the countryside during the Cultural Revolution. Following his imprisonment, he was called back in 1972 by order of

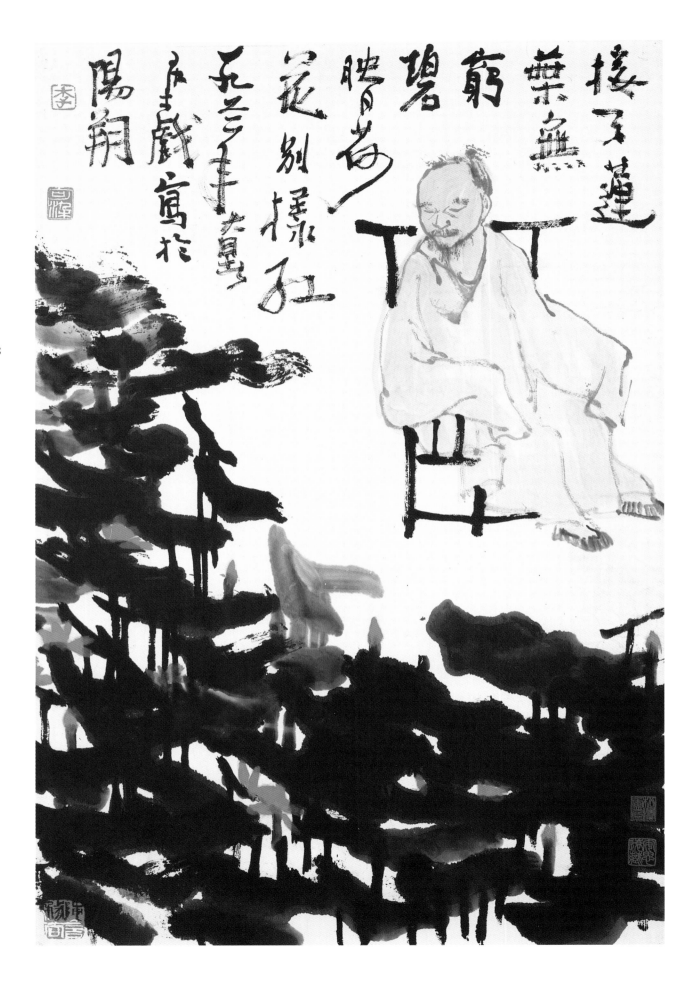

PLATE 87

Li Keran (1907–1989), *The Poetic
Mood of Su Shi*, dated 1962.
Hanging scroll, ink and color on
paper, 27⅛ × 18¼ in. (68.9 ×
46.4 cm). Gift of Robert Hatfield
Ellsworth, in memory of La
Ferne Hatfield Ellsworth, 1986
(1986.267.388)

FIGURE 111

Li Keran, *View of Yangshuo*,
dated 1972. Ink and color on paper,
83⅛ × 151¼ in. (211 × 384 cm).
Foreign Ministry Building, Beijing

Zhou Enlai. His instructions were to decorate tourist hotels and public buildings (fig. 111).[36] Two years later he was again denounced, this time by the Gang of Four during the Anti-Black Painting Campaign of 1974, for his dark, gloomy landscapes.[37]

Li's desire to create a new landscape style began in 1961, when he was assigned to teach landscape art at the Central Academy. The same year, he published an article in *The People's Daily* entitled "Practicing Art Takes Hard Work."[38] With his students he traveled to remote Guangdong and Guangxi Provinces in the south and southwest to sketch directly from nature. His conception of painting remained thoroughly traditional. Like Pan Tianshou, he described the soul of landscape as an idea state (*yijing*):

The idea state is the concentration of the essences of things. Through man's imagination, feeling and landscape are united.

FIGURE 112

Li Keran (1907–1989), pencil
sketch of *Tree-Covered Mountains*,
dated 1978. Pencil on paper.

FIGURE 113

Li Keran, *Calligraphy*, dated 1988.
Hanging scroll, ink on paper.

FIGURE 114

Fan Kuan (d. after 1023), *Travelers amid Streams and Mountains.* Hanging scroll, ink and color on silk, 81¼ × 40¾ in. (206.3 × 103.3 cm). National Palace Museum, Taipei

When we express emotion through landscape, we embody an artistic state. This poetic state is called the idea state.[39]

Painting for Li is "the use of limited means to portray a limitless objective world." Echoing Huang Binhong and Pan Tianshou, he wrote, "Chinese painting expresses not only what the artist sees but also what he knows and thinks.... In painting nature we must not only be true to life; we must also learn to improvise."[40]

Li based his work in landscape on sketches from life (fig. 112): "The purpose of sketching from life is to represent accurately the objective world. Precise delineation, light and shading, and scientific principles can only help, not hinder, the development of Chinese painting."[41] He describes how he builds forms from light to dark:

In my painting I first sketch the trees and houses, then slowly construct the rest of the painting. My colors range from zero to five, with zero representing the paper and five, the trees and houses. Then layer after layer, I build up the rest of the composition to four or five, until there is considerable depth and thickness. I call this "creating from nothing to everything, and from everything back to nothing again." I employ, alternately, [Huang Binhong's] "accumulated" and "broken" ink, using a lightly inked brush to break up the dark, and dark to model the light, allowing dark and light, bright and shaded, brush and ink to intermingle freely. As in music, painting combines gradation, rhythmic harmony, and a unifying theme in infinite variety. This is how a painting may command within a one-foot format interest and delight for the viewer.[42]

Throughout the 1960s and 1970s, Li Keran concentrated on the practice of calligraphy in the metal-and-stone style (fig. 113) and learned Li Ruiqing's method of making tremulous brushstrokes (figs. 31a–d), holding the brush tightly and using it like a stylus.[43] Applying calligraphic techniques to painting, Li's brushstrokes are, in the words of Huang Binhong, "weighty, solid, and like cast iron." In his landscape paintings (fig. 112), Li's ink-wash and dotting techniques evoke the ax-cut texture style of such Northern Song paintings as Fan Kuan's *Travelers amid Streams and Mountains* (fig. 114), the classic masterpiece that Xu Beihong had most admired.[44] Xu believed that later Chinese paintings had deviated from realistic description (*xieshi*) as exemplified by Fan Kuan. By sketching from nature and absorbing the lessons of Western realism, Li Keran now tried to restore to landscape art its essential reality.

The revolutionary artist Shilu (1919–1982) was born to a wealthy landowning family in Renshou (Sichuan). As Feng Yaheng, his given name, he first studied painting in Chengdu, and left the college in 1939 to join the Communist movement at its stronghold in Yan'an after the Long March. As an expression of his admiration for two of his cultural heroes, the seventeenth-century individualist master Shitao and the modern writer Lu Xun, he changed his name to Shilu. Dedicating himself to the revolutionary cause in the 1940s, he worked on theater designs, created cartoons and woodcuts, and promoted cultural activities in the border areas of Shaanxi, Gansu, Qinghai, and Ningxia Provinces. After the establishment of the People's Republic, he taught at the Academy of Fine Arts in Xi'an, and visited India and Egypt in 1955–56.[45] In the 1950s he embraced Soviet-style Socialist Realism,

painting large-scale works on the history of the Chinese Communist revolution. *Mountain Rain Is Coming* (pl. 88), dated 1960, shows peasants bearing heavy loads along a mountain ridge. Shilu's vast mountain view recalls a painting by Shitao (fig. 61), but Shitao shows scholarly travelers rather than peasant laborers. And unlike Shitao's painting, Shilu's reflects his mastery of Western techniques (see frontispiece).

A rebel and a romantic, Shilu was persecuted for his bourgeois upbringing during the Cultural Revolution. He was severely beaten, imprisoned, and escaped a death sentece only after he was commited to a hospital as mentally deranged.[46] When ordered in 1963 to write an essay denouncing his own actions, he composed the following defense:

People accuse me of being wild, but they merely make
 me wilder;
Only by exhausting the commonplace can I create the
 extraordinary.
They fault me for being eccentric, but how eccentric am I?
I only refuse to be enslaved and constrained.
People say I am disorderly, but I am not disorderly;
In my method of "no method," I am my own severest critic.
People chide me for making paintings that are "black,"
 but they are never black enough;
Only the blackest can strike at the heart and move the spirit.
"Wild, eccentric, disorderly, and black." What kind of
 criticism is that?
You complain with words; I account only for my heart.
If my life gives me ideas,
I must give my life expression.[47]

234

During the early 1970s, Shilu turned increasingly to the practice of calligraphy and calligraphic paintings. While *Art Is Beautiful* (fig. 115), dating from the early 1970s, is painted with jagged brushstrokes, the same brushstrokes are applied in *Movement Is Life* (fig. 116), dated 1978, as they capture the wobbly movements of three baby donkeys struggling to their feet. In *Ducks and Peach Blossoms* (pl. 89), dating from the early 1970s, flickering images of ducks dipping into the water are counterpoised by fluttering characters that read, "How ducks make merry with peach blossoms in spring water."

By 1974 Shilu, like Li Keran, was the target of the Anti-Black Painting Campaign waged by the Gang of Four. "Rehabilitated" after the fall of Jiang Qing in 1976, wracked by tuberculosis and alcoholism, Shilu continued to turn out paintings until his death in 1982, at age sixty-three. *Pines on Mount Hua* (pl. 90), dating from about 1978, is a depiction of his favorite theme:

I love the many pines on Mount Hua,
Tall, noble, and dignified,

PLATE 89

Shilu (1919–1982), *Ducks and Peach Blossoms*, early 1970s. Horizontal hanging scroll, ink and color on paper, 26¾ × 37 in. (67.9 × 94 cm). Gift of Robert Hatfield Ellsworth, in memory of La Ferne Hatfield Ellsworth, 1986 (1986.267.346)

235

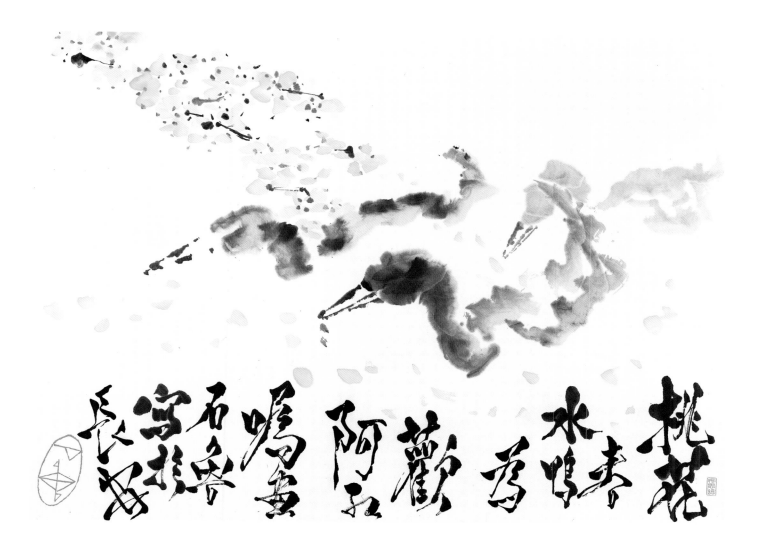

MAINLAND CHINESE PAINTING

236

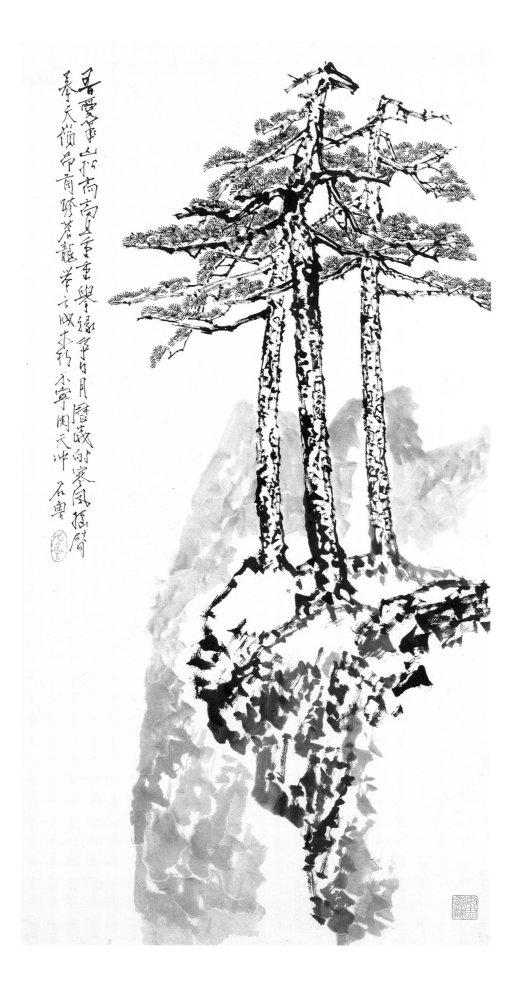

PLATE 90

Shilu (1919–1982), *Pines on
Mount Hua*, ca. 1978. Hanging
scroll, ink on paper, 53¾ × 27⅜ in.
(136.6 × 69.5 cm). Gift of Robert
Hatfield Ellsworth, in memory of
La Ferne Hatfield Ellsworth, 1986
(1986.267.351)

*Their trunks climbing skyward to compete with the sun
 and moon.*
Weathering the bitter winds,
Shaking their branches, they reach for the border of heaven.
Bestride blue dragons, they hold their heads aloft.
Lifting the clouds they stand.
Ceaselessly they push against the sky.[48]

Among the mainland Chinese painters best known in the
West is Wu Guanzhong (b. 1919), whose works have been
widely exhibited, including a solo exhibition at the British
Museum in 1992.[49] The son of a schoolteacher in Yixing
(Jiangsu), Wu studied to be an electrical engineer before
transferring to the National Hangzhou Arts Academy in 1936,
where he specialized in Western-style oil painting under Lin
Fengmian. In 1947, he was awarded a government scholar-
ship to study at the École des Beaux-Arts. In Paris he im-
mersed himself in the study of French modernism, particularly
the work of Gauguin, Cézanne, Braque, and Matisse. Re-
turning to China in 1950, he became a lecturer at the Central
Academy of Fine Arts in Beijing, but when his modernist views
conflicted with those of the academy, he was transferred to
other posts. During the Cultural Revolution, he was sent for
three years into forced labor in the country. When he re-
turned to Beijing in 1972, he went to work for the state pro-
ducing large mural paintings for hotels and public buildings.
Since late 1981 he has had exhibitions, led delegations, and
traveled widely abroad, to Africa, Japan, Europe, the United
States, and Southeast Asia.

Looking back on his career in 1987, Wu wrote about why
he returned to China:

*Because many of my teachers had studied in France, I too went
to France. It was like visiting relatives. I was so exhilarated that
I consumed everything in sight and studied hard for the next
three years. But I was not simply a student of art history. I was
also a painter. When a silkworm eats mulberry leaves it produces
silk; when a cow eats grass it produces milk. But though I was
being sustained by cow's milk, I could not produce my own. I
was feeding on other people's art, but I could not produce my
own. I was empty and frightened. Like Antaeus I felt the terror
of being lifted off the earth. And so I had to go home. There
were at the time other compelling reasons. But the principal
reason for my return was my fear of becoming Antaeus.*[50]

While during the 1950s and 1960s he painted mainly in oil
and watercolor, Wu returned in 1973 to Chinese ink on paper.
Between 1974 and 1977, he made a series of still lifes and land-
scapes with the same composition, first in oil and then in ink
and color.[51] *Seascape at Beidaihe* (pl. 91), dated 1977, is based
on a similar composition painted in oil and dated a year earlier
(fig. 117). Wu wrote about his painting in two different media:

*Although I have painted in oil for many decades, I still feel the
limitations of objective representation. I have yet to reach the
state "where the mind instructs and the hand responds." I am
in many ways freer when I turn to ink painting. My imagery
feels more relaxed, and it is easier to produce larger works. This*

PLATE 91

Wu Guanzhong (b. 1919),
Seascape at Beidaihe, dated 1977.
Hanging scroll, ink and color on
paper, 38⅛ × 45¼ in. (96.8 ×
114.9 cm). Gift of Robert Hatfield
Ellsworth, in memory of La
Ferne Hatfield Ellsworth, 1986
(1986.267.431)

238

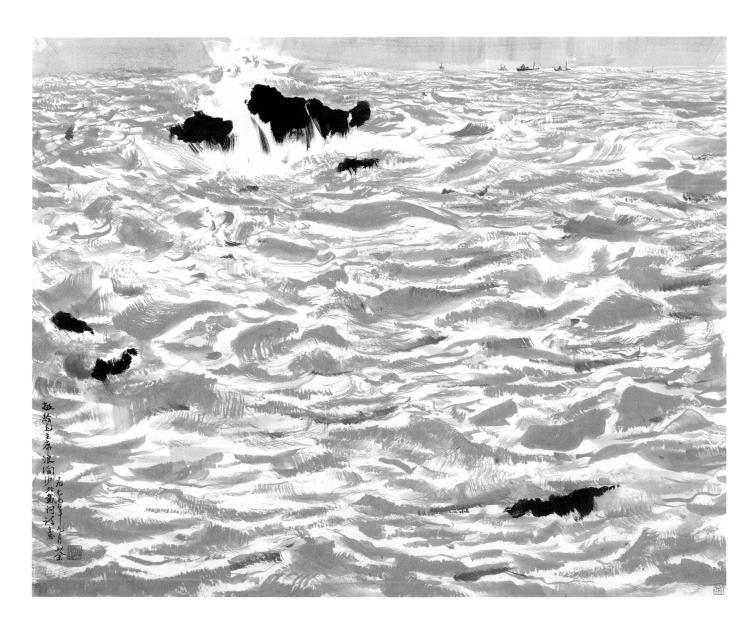

FIGURE 117
Wu Guanzhong (b. 1919), *Sea-scape at Beidaihe*, dated 1976. Oil on canvas. Private collection

is why, in recent years, I have turned to painting in Chinese ink rather than oil. Nevertheless, I believe that the method of representation in traditional Chinese painting is limited. It is far from adequate for capturing the complex phenomena of nature or for expressing the multitude of human perceptions. Thus, it is my attempt to combine the benefits of both oil and ink, knowing that they are but two different media [that serve the same purpose].[52]

Seascape at Beidaihe, painted in tribute to Mao Zedong's poem on the Beidaihe River, which was composed for the ancient tune "Waves Washing the Sands," captures Mao's heroic vision of ocean waves battering the shore. The entire surface is covered with abstract patterns of churning waves and foam. While oil paint can reproduce the transparent quality of light reflecting on the water's surface, Wu's use of brushwork and

ink combined with opaque white pigment commands a freedom that better describes the motion of the waves and makes the water palpable.

While Wu saw art as a realistic expression of nature, he also believed that abstraction as well must be bound to the real world. Michael Sullivan has written about Wu's "abstraction":

To Wu Guanzhong, abstraction means abstracting the "essence" of the form. To him, the greatest Chinese abstract painter is Bada Shanren. "He is able," he writes, "to convey his disquiet and his sorrow through the play of black against white, and through the movements of his lines.... Through figurative forms he pursues flux and transience. His rocks are top-heavy, looking as though they are about to fall and tumble. His trees are rootless, looking as though they are about to take flight.... All these contribute to a feeling of dreamlike unreality in his painting." This Wu Guanzhong calls abstraction. Since Chinese artists have always held that the forms of nature are the visible manifestations of a reality that lies behind the images, why diminish the force and meaning of the forms in the painting by removing all connections with nature? Why, in Wu Guanzhong's metaphor, cut the kite string?[53]

In his essay "Kite with Unbroken String" (1983), Wu Guanzhong writes:

Professor Sullivan recently wrote to me, saying that [my] abstraction is different from [Western] nonobjective art.... Nonobjective art has nothing to do with objective nature; it is pure geometry and pure form.... To my way of thinking all forms

240

and all phenomena, without exception, must originate with life.... I believe that nonobjective art is like a kite with a broken string. The string that connects the kite to life has been severed; that which links it to emotion and to the karma of the world is broken off. One may wish to explore such a subject...but a work of art should never lose touch with the broad stream of exchange with people. I shall always prefer my kite to a kite with a broken string.[54]

Lion Grove Garden (fig. 118), a sketch dated 1980, transforms the perennial favorite, Chinese garden rocks, into a swirl of abstract lines and shapes. Three years later, a painting with the same title (fig. 119) shows further abstraction of the forms, reducing them to a cacophony of squiggly lines and dots. In abandoning himself to an abstract expressionist mode, Wu might appear to reflect a connection to such American painters as Jackson Pollock, but his work is not nonobjective. Rather, he continues in the Chinese tradition of *xieyi*, the spontaneous writing of ideas and feelings. An expression of the artist's response to what he sees, *Lion Grove Garden* is a worthy successor to a painting by Ni Zan and Zhao Yuan (fig. 120), dating from the 1370s. Richard Barnhart has observed:

FIGURE 120

Ni Zan (1301–1374) and Zhao Yuan (active ca. 1360–75), *Lion Grove Garden*, detail, 1370s. Ink on paper. Collection unknown

241

242

PLATE 92

Lu Yanshao (1909–1993), *Sichuan Landscape*, dated 1975. Album leaf, ink and color on Japanese paper, 11¼ × 16 in. (28.6 × 40.6 cm). Gift of Robert Hatfield Ellsworth, in memory of La Ferne Hatfield Ellsworth (1986.267.396)

[Wu's painting] is fully in harmony with the romantic view of Chinese art, in which the creative process, rather than the physical result, is what counts. In his drawings one sees the creative process as it is fitfully preserved—the flowing, darting lines, the slowly forming image, the broad scene and specific colors.... For an American audience there may be a sense of dislocation or anachronism in looking at Wu Guanzhong's sketches. We have almost passed the time in which we expect an artist to look, study, sketch, preserve, and utilize what he has seen in this way. In our art the connection between seeing and depicting the natural world is mostly broken.... In this sense, the Chinese tradition remains true to itself, even today, as it now differently but nonetheless insistently maintains an unbreakable bond between the world we inhabit and the substance of the art of painting.[55]

Throughout the 1930s and 1940s, Shanghai remained a stronghold of traditional-style Chinese painting and calligraphy which, through private schools, artists' associations, and collectors, retained their popularity among the affluent. One of the ablest landscape painters was Lu Yanshao (1909–1993), who learned traditional-style landscape painting from two Shanghai masters, Wu Hufan (1894–1970) and Feng Chaoran (1882–1954). Born in the Jiading district near Shanghai, Lu began his training at the Art Institute in Wuxi (Jiangsu) before returning to Shanghai to study under Feng Chaoran, gaining over the years a solid grounding in poetry, literature, painting, calligraphy, and seal carving. He spent the years of the Sino-Japanese War in Chongqing. Finding no place for his elitist art after the Communist takeover, Lu was employed in a government workshop in Shanghai to produce cartoons and comic strips. As a resident artist at the Shanghai Academy of Chinese Painting in the 1950s, he was invited by Pan Tianshou to join the Zhejiang Academy in 1962. During the Cultural Revolution, he was prohibited from painting for nearly ten years. He was "rehabilitated" in 1978, and in 1979 restored to his professorship at the Zhejiang Academy of Fine Arts.

Sichuan Landscape (pl. 92), dated 1975, re-creates the artist's encounter with a "mysterious cave" thirty years earlier. The colophon reads:

The southwest is especially famous for the beauty of its caves and valleys. This is not because it is described as such, because of its "reputation." One day, when I was living in Sichuan in the mountains across a river, I came upon a huge and mysterious cave, with waterfalls gushing forth from the rocks, in the midst of a beautiful and serene setting. Even after more thirty years I have not forgotten it. I have now painted it to share with those who might enjoy it.

Unlike Fu Baoshi and Huang Binhong, who sketched nature at a distance, from outside (pls. 41, 65a, b), Lu is enveloped by, is within, nature. Lu's modeling of forms follows the traditional texture method of building a composition in a harmony of alternating patterns—of brush and ink, texture strokes, and ink wash, of concavity and convexity, of dark and light—that suggest the perpetual movement of nature (see page 205).

Jietai Temple (pl. 93), dated 1978, shows a view of two temples in Beijing. Lu describes his visit in the inscription:

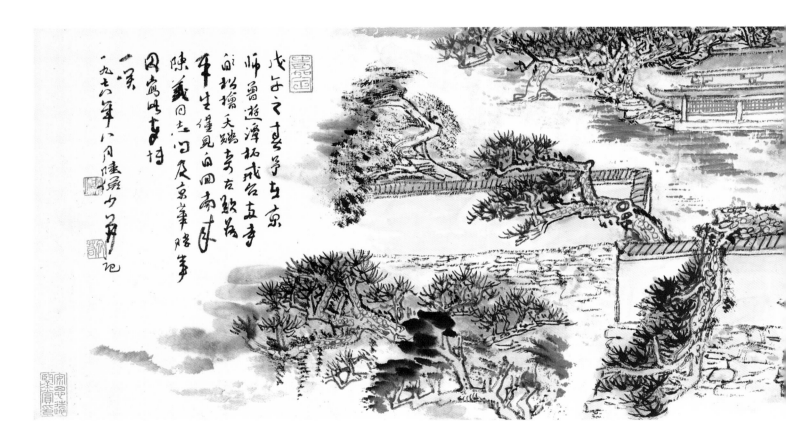

In the spring of 1978, I was in the capital and traveled to the temples Tanzhe and Jietai. Ancient pines and junipers rose in a strange, archaic manner, something I had never seen before. After I returned to the south, comrade Chen Yi asked about the sights in the capital, so I painted this to win his smile.

Lu's paintings, which derive directly from traditional Chinese landscape, display an unpretentious appreciation of nature not often found in contemporary Chinese views. In his colophon Lu describes a painting of 1980, *Clouds and Waterfalls at Yandang* (pl. 94):

Early morning clouds rest halfway up the ridge, and waterfalls are draped across the thousand peaks. How magnificent is this view of Yandang mountain. Only after a long rain can you know its wonders.[56]

PLATE 93
Lu Yanshao (1909–1993), *Jietai Temple*, dated 1978. Handscroll, ink and color on paper, 12¼ × 46½ in. (31.1 × 118.1 cm). Gift of Robert Hatfield Ellsworth, in memory of La Ferne Hatfield Ellsworth, 1986 (1986.267.398)

PLATE 94 (overleaf)
Lu Yanshao, *Clouds and Waterfalls at Yandang*, dated 1980. Horizontal hanging scroll, ink and color on paper, 21⅝ × 45¼ in. (54.9 × 114.9 cm). Gift of Robert Hatfield Ellsworth, in memory of La Ferne Hatfield Ellsworth, 1986 (1986.267.397)

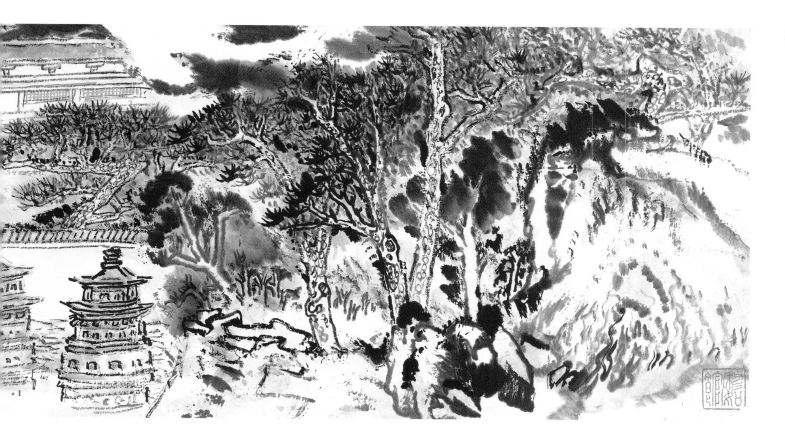

In Shanghai at this time, the populist tradition of narrative painting and woodblock-printed illustrations also continued to thrive. Cheng Shifa (b. 1921), a native of Songjiang, near Shanghai, whose parents were both doctors, began painting in 1938 in the traditional style at the Shanghai Academy of Art. After working as an illustrator of children's books at the People's Publishing House, he became a teacher in the late 1950s at the Shanghai Academy of Chinese Painting, where he combined Chinese ink-and-brush with Western pen-and-pencil techniques.

After the fall of the Gang of Four in 1976, the performing arts community in Shanghai celebrated by staging "Beating the White-Boned Demon Three Times," an operatic sketch whose simian hero, the Monkey King of the epic narrative *Journey to the West*, defends the Buddhist faith by attacking a White-Boned Demon. Jiang Qing, the leader of the Gang

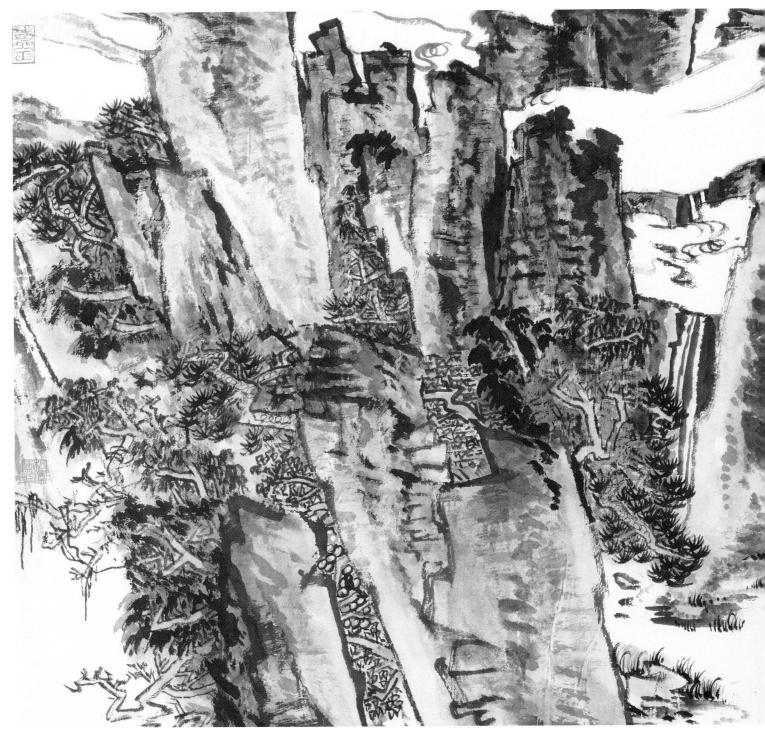

246

PLATE 94

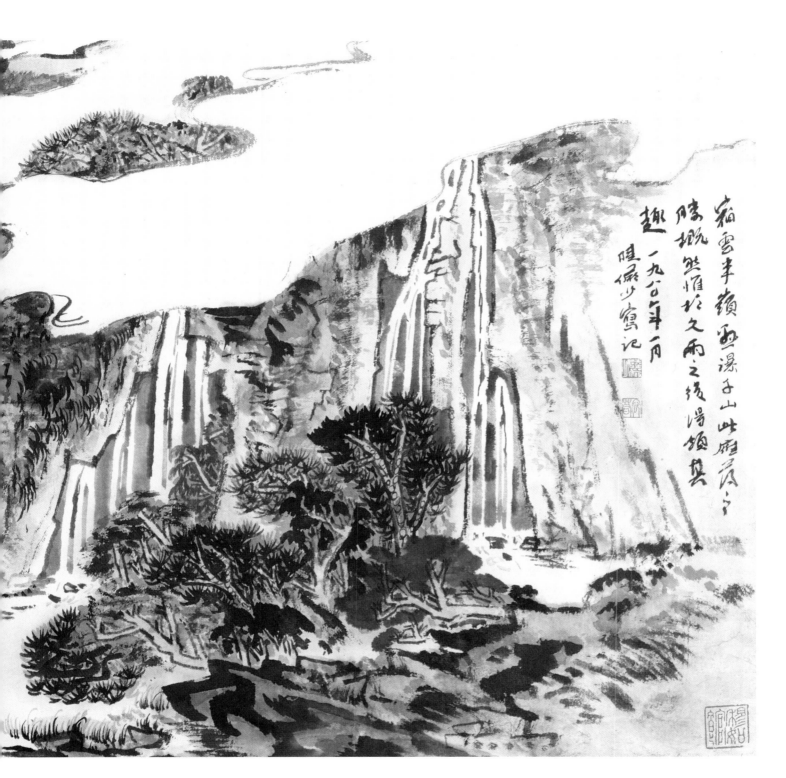

248

a

b

PLATES 95a,b
Cheng Shifa (b. 1921), "The Monkey King Beats the White-Boned Demon" and "General Zhou Bo," from the album *Various Subjects*, dated 1978. Two fan-shaped leaves from an album of fourteen, ink and color on fan paper, each approx. 4⅞ × 14 in. (12.4 × 35.6 cm). Gift of Robert Hatfield Ellsworth, in memory of La Ferne Hatfield Ellsworth, 1986 (1986.267.435b)

of Four, was often compared with the demon. "The Monkey King Beats the White-Boned Demon" (pl. 95a), one of eleven fans by Cheng Shifa in an album dated 1978, is an illustration of the play, with theatrical characters and vivacious brush drawing:

"The Monkey King Beats the White-Boned Demon" has not been performed for more than ten years. Now it is being revived. I don't care if my painting is good or not—I draw this in celebration!

"General Zhou Bo" (pl. 96b) depicts Zhou Bo, who restored the Han dynasty from the machinating Empress Lü and restored the Han dynasty. Cheng's inscription reads:

Zhou Bo, marquis of Jiang, was an honest man without much education. By defeating the Lü clan, he restored the Han dynasty. I made this image to hang high on the door so that ghosts and demons will have no way of escaping his gaze. All families shall be blessed when the universe is cleansed.[57]

The remaining leaves in the album, representing the traditional subjects of landscape, figures, flowers, and small animals, are an indication that traditional-style Chinese painting, now popularly based and holding strong, is well poised for a national revival.

NOTES

1. *The Cambridge History of China*, vol. 14, *The People's Republic, Part I: The Emergence of Revolutionary China, 1949–1965*, edited by Roderick MacFarquhar and John K. Fairbank (Cambridge: Cambridge University Press, 1987), section 2, "The Search for a Chinese Road, 1958–1965," pp. 293–525.
2. Chang-tai Hung, *War and Popular Culture: Resistance in Modern China, 1937–1945* (Berkeley and Los Angeles: University of California Press, 1994), pp. 221–69.
3. Wan Qingli, "Lin Fengmian yu tade Faguo laoshi Fernand Cormon" (Lin Fengmian and His French Teacher Fernand Cormon), in *Lin Fengmian yu ershi shiji Zhongguo meishu* (Lin Fengmian and Twentieth-Century Chinese Art), edited by Xu Jiang (Hangzhou: Zhongguo Meishu Xueyuan Chubanshe, 2000), pp. 57–65.
4. For the history of the Hangzhou Academy, see Song Zhongyuan, *Yishu yaolan* (The Cradle of Art) (Hangzhou: Zhejiang Meishu Xueyuan Chubanshe, 1988).
5. For similar compositions dating from the early 1960s, see Du Ziling, ed., *Lin Fengmian quanji* (Collected Works of Lin Fengmian), 2 vols. (Tianjin: Renmin Meishu Chuanshe, 1994), vol. 1, pls. 224, 232, vol. 2, pls. 30, 35, 41, 58.
6. John Elderfield, *Henri Matisse: A Retrospective* (exh. cat., New York: The Museum of Modern Art, 1992), pp. 85–86.
7. Ibid., pp. 360–61.
8. Lang Shaojun, "Chuangzao xinde shenmei jigou—Lin Fengmian dui huihua xingshi de tansuo" (Creating a New Aesthetic Structure:

250

Lin Fengmian's Search for a Formal Language in Painting), in *Lin Fengmian yanjiu wenji* (Collected Essays on Lin Fengmian), edited by Zheng Chao (Hangzhou: Zhongguo Meishu Xueyuan Chubanshe, 1995), pp. 215–18.

9. Lang Shaojun, "Lin Fengmian yishu de jingshen neihan" (The Spirit and Content of Lin Fengmian's Art), in *Lin Fengmian yanjiu wenji*, pp. 107–8.

10. Lang Shaojun, "Chuangzao xinde shenmei jigou," pp. 188–218.

11. Similar works by Lin from the late 1970s and 1980s are bolder and freer; see Du Ziling, *Lin Fengmian quanji*, passim.

12. Lang Shaojun, "Chuangzao xinde shenmei jigou," p. 212.

13. For a similar figure dated 1947, see Du Ziling, *Lin Fengmian quanji*, pl. 19.

14. See Wu Guanzhong, "Jimo gengyun qishinian" (Quietly Cultivating Himself for Seventy Years), in *Lin Fengmian lun* (Essays on Lin Fengmian), edited by Zheng Chao and Jin Shangyi (Hangzhou: Zhejiang Meishu Xueyuan Chubanshe, 1990), p. 40.

15. Ibid., pp. 39–42.

16. See Pan Gongkai, *Pan Tianshou huihua jifa jianxi* (A Structural Analysis of Pan Tianshou's Painting Techniques) (Hangzhou: Zhongguo Meishu Xueyuan Chubanshe, 1995).

17. Ibid., p. 71.

18. See Wan Qingli, "Pan Tianshou de yijing gediao shou" (Pan Tianshou's Theories of Idea-State and Style and Tone), in his *Huajia yu huashi* (Painters and Painting History)

(Hangzhou: Zhongguo Meishu Xueyuan Chubanshe, 1997), pp. 23–24.

19. Translation adapted from Robert H. Ellsworth, *Later Chinese Painting and Calligraphy, 1800–1950*, research and translation by Keita Itoh and Lawrence Wu (New York: Random House, 1986), vol. 1, p. 194.

20. Ibid., p. 195.

21. Huang Miaozi, *Huatan shiyou lu* (Teachers and Colleagues in Painting) (Taipei: Dongda Tushu Gongsi, 1998), p. 131.

22. Adapted from Ellsworth, *Later Chinese Painting and Calligraphy*, vol. 1, p. 208.

23. Huang Miaozi, *Huatan Shiyou lu*, p. 133.

24. See a chronology of Wu Zuoren's sixty years in art, in *Wu Zuoren de yishu* (The Art of Wu Zuoren), edited by Zheng Jingwen (Beijing: Waiwen Chubanshe, 1986).

25. Wu Zuoren, "Sumiao yu huihua mantan" (On Sketching and Painting), *Meishu yanjiu* (Fine Arts Studies), no. 3 (1979), pp. 8–15.

26. *Wu Zuoren zuopinji* (Collected Works of Wu Zuoren), edited by Ai Zhongxin (Shenyang: Liaoning Meishu Chubanshe, 1994), pl. 7.

27. Translation adapted from Zheng Jingwen, *Wu Zuoren de yishu*, p. 17.

28. Wan Qingli, *Li Keran pingzhuan* (A Critical Biography of Li Keran) (Taipei: Xiongshi Chubanshe, 1995), p. 33.

29. "Li Keran nianbiao" (Chronology of Li Keran), in ibid., pp. 240–47.

30. Ibid., figs. 56, 57.

31. Ibid., pp. 152–69.

32. Huang Miaozi, *Huatan shiyou lu*, p. 192.

33. Wan Qingli, *Li Keran pingzhuan*, pp. 96–98.

34. For Li's painting with Qi's inscription, see ibid., p. 97, fig. 27.

35. Adapted from Ellsworth, *Later Chinese Painting and Calligraphy*, vol. 1, p. 221.

36. Ellen Laing, *The Winking Owl: Art in the People's Republic of China* (Berkeley and Los Angeles: University of California Press, 1988), pp. 85–86.

37. See Wan Qingli, *Li Keran pingzhuan*, pp. 115–16.

38. Ibid., p. 111.

39. Li Keran, "Dan xue shanshui hua" (On Learning to Paint Landscape), *Meishu yanjiu*, no. 1 (1979), p. 13; quoted in Wan Qingli, *Li Keran pingzhuan*, p. 138. The term "idea state" in poetry criticism was introduced first by the Tang-dynasty scholar-official poet Wang Changlin; see Wen C. Fong, *Beyond Representation: Chinese Painting and Calligraphy, 8th–14th Century* (New York: The Metropolitan Museum of Art, 1992), p. 61.

40. Wan Qingli, *Li Keran pingzhuan*, p. 140.

41. Huang Miaozi, *Huatan shiyou lu*, p. 195.

42. Ibid., p. 190. For a good explanation of Li's idea of "creating from nothing to everything, and from everything back to nothing again," see Wan Qingli, *Li Keran pingzhuan*, pp. 191–92.

43. Wan Qingli, *Li Keran pingzhuan*, pp. 170–73.

44. Xu Boyang and Jin Shan, eds., *Xu Beihong nianpu* (Chronology of Xu Beihong) (Taipei: Yishujia Chubanshe, 1991), p. 112.

45. "Shilu nianpu" (Chronology of Shilu), in *Shilu*, edited by Wang Yushan and Cai Peixin (Beijing: Renmin Meishu Chubanshe, 1996), pp. 203–5.

46. Ibid., p. 204.

47. For the original text, see ibid., p. 4, n. 2.

48. Adapted from Ellsworth, *Later Chinese Painting and Calligraphy*, vol. 1, p. 207.

49. Anne Farrer, with contributions by Michael Sullivan and Mayching Kao, *Wu Guanzhong: A Twentieth-Century Chinese Painter* (exh. cat., London: British Museum Press, 1992).

50. Wu Guanzhong, "Cong dongfang dao xifang, you hui dao dongfang" (From the East to the West, and Again, Returning to the East), *Meishujia* (The Artist), no. 57 (August 1987), pp. 5–6.

51. See Richard Barnhart, "The Odyssey of Wu Guanzhong," in *Wu Guanzhong: A Contemporary Chinese Artist*, edited by Lucy Lim (exh. cat., San Francisco: Chinese Cultural Foundation of San Francisco, 1989), p. 13, n. 2.

52. Wu Guanzhong, "Huigu dangjin wushi nian" (Looking Back on My Painting of the Last Fifty Years), in *Wu Guanzhong huaji* (Paintings of Wu Guanzhong) (Shijiazhuang: Hebei Meishu Chubanshe, 1984); adapted from Meiching Kao, "The Art of Wu Guanzhong," in Farrer, *Wu Guanzhong*, p. 34.

53. Michael Sullivan, "Wu Guanzhong: Reflections on His Life, Thought, and Art," in Lim, *Wu Guanzhong*, p. 5.

54. Wu Guanzhong, "Fengzheng buduan xian" (Kite with Unbroken String), in *Yitu chunqiu: Wu Guanzhong wenxuan* (Collection of Wu Guanzhong's Writings), edited by Chen Ruixian (River Edge, N.J.: Global Publishing Co., 1992), pp. 19–20.

55. Barnhart, "Odyssey of Wu Guanzhong," p. 15.

56. Adapted from Ellsworth, *Later Chinese Painting and Calligraphy*, vol. 1, pp. 223–24.

57. Ibid., pp. 234–36, leaf E. For Zhou Bo, see Sima Qian (ca. 145–85 B.C.), *Shi ji* (Records of the Historian), *juan* 57.

Epilogue

Reflections on Chinese Art and History

A familiar refrain in our study of modern Chinese culture and art has been its belatedness. As David Wang points out in his study of late-Qing fiction, "What [Chinese] writers and readers thought was modern often turned out to be outdated in the European context. The Chinese literary 'modern' can be discussed only with the sense of belatedness."[1] In 1993, Michael Sullivan makes a similar comment on Chinese avant-garde art:

When finally the avant-garde exhibition was mounted [in China] in February 1989, it was out of date. Much of the excitement of the New Tide had evaporated. Sartre and Camus were gathering dust on the bookstalls, and the belief that glasnost was creating a new climate for the arts was giving way to disillusionment and cynicism. Many artists who had earned recognition from the foreign press and foreigners in China, and none at home, dreamed of escape to New York, or if that were not possible, of earning money (and a questionable reputation) in China.[2]

As we saw in chapter 4, Wu Guanzhong's artistic odyssey began in the late 1940s, when he was studying Western art in Paris. Suddenly, "like Antaeus I felt the terror of being lifted off the earth. I was feeding on other people's art, but I could not produce my own." Wu's journey ended more than thirty years later with his essay "Kite with Unbroken String" (1983), in which he reaffirms the "kite string" that connected his art to his land and its cultural traditions.[3] As with all modern Chinese painters, from Xu Beihong and Lin Fengmian to Pan Tianshou and Shilu, Wu Guanzhong understood Western art and theories through the veil of Chinese concepts. Although they have equated Western realism with *xieshi*, or "realistic description," and abstraction with *xieyi*, or "the writing of ideas and feelings," most modern Chinese painters have refrained from experimenting with nonobjective art.

REALISM VERSUS EXPRESSION

Western methods of image construction and the exploration of the relationship between Western art and ideas, being verbally construed, are bound up with the primacy of language, a focus that is alien and irrelevant to the Chinese experience. Our survey of modern Chinese painting from the 1860s to the 1980s tends to corroborate David Wang's observation that there has been a loss of "a grip on the realistic devices of traditional narrative...a breakdown of the traditional representational system."[4] Yet neither historical belatedness nor the loss of cultural memory can fully explain modern Chinese painting, which, as a crosscultural experience, has its own dynamic and generates its own energy.

While equating Western-style realism with form-likeness (*xingsi*), Xu Beihong used the term spirit-resonance (*shenyun*) to describe artistic expression. For Xu, "Both form-likeness and spirit-resonance are a matter of technique. While 'spirit' represents the essence of form-likeness, 'resonance' is the transformation of form-likeness. Thus if someone excels in form-likeness, it is not hard for him to achieve spirit-resonance."[5] Xu's abiding faith in the practice of realism as a way to "apply modern technology to a disciplined rendering of 'true' painting"[6] was inspired by nineteenth-century European positivism,

which was predicated on the validity of scientific knowledge and the rationality of ethics and aesthetic judgment.

Both Lin Fengmian and Wu Guanzhong agree with Xu Beihong that form-likeness and spirit-resonance are a matter of technique. Although Chinese painters have always been masters of the brush, never has technical skill played so important a role in their art. The ancient mystic Zhuangzi had warned about the risk involved in technique with a parable: A basket is used to catch fish; while a good fisherman catches fish, a bad one is left holding the basket. As a critical term, spirit-resonance was first made current by the Qing poet Wang Shizhen (1634–1711), who used it to describe the ineffable in poetry.[7] Recalling the story of a painting attributed to the eighth-century poet-painter Wang Wei (ca. 699–ca. 761), in which "a banana tree appeared in a snow scene," Wang Shizhen argued that Wang Wei took similar liberties in poetry, where "names of unrelated places were strung together." For Wang Shizhen, Wang Wei's spirit-resonance made "his poetry utterly different from those of the latter-day poets, whose laborious efforts read like mileage records."[8]

The use of Wang Shizhen's theory of spirit-resonance by Western-style Chinese painters shows how their mixing of Eastern and Western ideas can have a complicated, prismatic effect on their work. In his study of Lin Fengmian, the critic Lang Shaojun writes of Lin's search for a formal language comparable to Matisse's discussion of pictorial language and signs.[9] But unlike the Chinese concept of a formal language applied to painting, the Western pictorial language, as exemplified by the work of Matisse, is difficult to apply to Chinese usage.[10] Because of this difficulty, Lang confines himself to describing how Lin uses linear pattern, brushwork, color, and expressive form to capture "an elusive . . . kind of beauty [with emotion]."[11] In other words, viewers of Lin's nudes speak of the poetry and "musicality" of the artist's expressive linear style instead of female beauty. While Lin's elusive kind of beauty may be associated with Wang Shizhen's theory of spirit-resonance, his attention to linear pattern, brushwork, and color is explored by Wu Guanzhong, in an essay entitled "The Beauty of Form in Painting" (1993).[12] Wu argues that meaning and significance in art can be found *only* in the "beauty of the form," a belief that derives from his reading of nineteenth-century European aesthetics.

Creativity in the West, especially in the United States, is driven by a striving for individual innovation. The Chinese, on the other hand, see human endeavor as an expression of Dao, or the Way of the universe. Perhaps the difference between Chinese and Western views of creativity is explained by their different cosmogonic views. Unlike the Western tradition, in which the world is perceived as directed either by divine providence or by science, the Chinese universe is understood to have sprung forth spontaneously, as having no creator, ultimate cause, or will external to itself.[13] Art is perceived not as an invention, and change is effected by repossessing the past, which, because of its ultimate truth, can never be obsolete. Indeed, the purpose of man's life, in the words of Confucius, is "to transmit rather than to create" (*shuer buzhuo*). When Wu Guanzhong wrote that "all forms and all phenomena, without exception, must originate with life,"[14] he was merely restating the ancient Chinese belief that it is through the expression of Dao that both art and the self are created.

Modern Chinese artists, who struggle with a traditional Chinese historiography that is shaped by a cyclical world view based on the rise and fall of dynastic histories, seem to have difficulty finding meaning and inspiration in traditional art forms. In other words, the traditional representational system does not appear to fit the modern Chinese discourse, which sees Western history as a universal model. Having lost the use of the traditional narrative, how is the modern Chinese artist to express himself?

John K. Fairbank, in *The Cambridge History of China* (1987), has written on the socio-scientific approach that has been applied to China studies since World War II: "Because the social sciences by definition concerns principles and evidence of worldwide scope, they are essentially comparative. So it follows that the uniqueness of China has been diminished. 'Chinese exceptionalism' in subjects like social structure, the family system, religious cults . . . has been reduced by the study of China to one case among an array of cases."[15]

A contrasting view, which argues for the importance of culture and tradition, is offered by Yu Ying-shih. Yu calls attention to "those interrelated elements of historical positivism which are being most critically re-examined in recent years."[16] He writes, "Tradition particularly suffered during the [nineteen] fifties when 'modernization' was first put on the agenda of social sciences.... Unfortunately...historical positivism...coupled with Western history as the universal model [has] prevented [modern Chinese historians] from studying Chinese history in its own terms."[17] Although Yu does not advocate a return to traditional Chinese historical

concepts and methods, he believes that "it is imperative that Chinese historians begin to design and develop their own concepts and methods uniquely suited to coping with the particular shapes of Chinese historical experience."[18]

Knowledge and art are both historical and cultural in character.[19] As evidence of history, works of art are a palpable, physical presence of the past, a manifestation of culture and history that words alone cannot describe. That artists and investigators alike are culture-bound rests on the understanding that certain truths which derive from historical and cultural facts, although experienced subjectively, are not rendered irrelevant.[20]

The words of the eminent Renaissance scholar Erwin Panofsky, writing about the world view of man in the Middle Ages as distinct from that of man in post-Renaissance Europe, could also be applied to the discussion of the Chinese perspective of history:

No mediaeval man could see the civilization of antiquity as a phenomenon complete in itself, yet belonging to the past and historically detached from the contemporary world.... Just as impossible was it for them to evolve the modern idea of history, which is based on the realization of an intellectual distance between the present and the past, and thus enables the scholar to build up comprehensive and consistent concepts of bygone periods.[21]

Like the perspective of the "mediaeval man," the modern Chinese view of history is one that lacks "intellectual distance between the present and the past." The overwhelming burden of China's past, again to quote Panofsky, is "too far removed

and at the same time too strongly present to be conceived as an historical phenomenon."[22]

Panofsky's great achievement as an art historian was his ability to link art with ideas, more specifically, the Renaissance belief that man is at the center of the universe and the Renaissance understanding of art and ideas as being verbally construed meanings. In advancing our knowledge of Renaissance art, Panosky's interpretive strategy also opened up a whole new way of thinking about Western art and history. By comparison, modern Chinese artists and writers have yet to develop ideas about Chinese art and history that "build up comprehensive and consistent concepts of bygone eras."

What can Chinese art tell us about Chinese history? If Renaissance art teaches that man is the measure of all things, Chinese art, as a source of political and emotional expression, mirrors the equivocal relationship between man and the state.[23] The cyclical rise and fall of dynastic histories, the polarities between political legitimacy and individual expression, loyalty and dissent, and conservatism and innovation that constitute the underpinning of Chinese art history project a larger pattern of meaning, that of the human will to integrate itself with Heaven and Earth and with all things in the universe, but with a deep respect for history.

THE USES OF CHINESE ART AND HISTORY

There is a distinct correlation between ideological function and painting style. Anyone who looks at a scholar-painting landscape, such as Zhao Mengfu's *Twin Pines, Level Distance* (fig. 6), which dates from the early 1300s, can see immediately that the world, of which Zhao's art is the imagined reality, has changed radically from that of Guo Xi's *Early Spring* (fig. 5), dated 1072.[24] The ancient Chinese discourse on mimetic realism, or similitude, was related to both the prehistoric idea of magic realism and the Chinese conception of a universe, in which all phenomena are interrelated, signs of one another.[25] The Neo-Confucianist monumental landscape painting of the Northern Song, exemplified by *Early Spring*, symbolizes the values of a hierarchically ordered, ethical universe. Similarly, Emperor Huizong's (r. 1100–25) *Finches and Bamboo* (fig. 28), painted in the same period, embodies the ideology of the imperial state, the view that the world is an insular and timeless magical garden.[26] The rise of scholar painting in the Northern Song, in the late eleventh century, coincided with the decline of the moral authority of the imperial state, when the failure of the most ambitious court-directed social and fiscal reform resulted in a permanent schism between the ideology of the state and the private discourse of the scholar-officials. Representational art, realistic and proclamatory, served state orthodoxy and played a central role in the ritual affirmation of the imperial cult;[27] scholar painting, by contrast, was a private art, more concerned with rhetorical and symbolic values than with a descriptive function.[28] In Zhao Mengfu's *Twin Pines*, the scholar-artist living under Mongol rule used Guo Xi's earlier landscape idiom not as a technical means for realistic representation but as a symbolic language to reaffirm Chinese cultural continuity and survival under alien rule.[29]

Chinese calligraphy, an art of self-expression, was intricately tied to the political and social fabric of the Confucian imperium:

258 the formal seal, clerical, and standard scripts with state orthodoxy; the freer running and cursive scripts with the private and rebellious. After the invention of paper and the use of the brush as the writing instrument of choice in the first and second centuries, cursive script, which evolved as a way to abbreviate writing, caught the movement of the hand. This led to the rise of personal expression and the development of writing in running style as a fine art. Calligraphic theory posits that handwriting, regardless of technique and medium, is preeminently an art of expressive intent. Classical writings on calligraphy are replete with advice to allow "the hand to be moved by the heart's desire" and "the idea to precede the brush," so that the calligrapher may transform the written character into an image of the mind.[30]

From the collapse of the Han empire (A.D. 220) to the Mongol conquest under the Yuan dynasty (1260–1368), four major stylistic directions defined calligraphic history: the invention of a newly liberated running style, credited to Wang Xizhi (ca. 303–ca. 361), which represented the rejection of state orthodoxy as embodied by monumental clerical script; the co-option of the new style by the court in the creation of a monumental standard script in the early Tang (618–906); the rejection of orthodoxy for a second time and the development of a highly individualistic running style in the late Northern Song (960–1127); and the reformulation of Zhao Mengfu's monumental standard script after the 1300s and its adoption as the typeface used in printed books.[31] That no new officially sponsored standard script flourished after the Yuan period parallels and reflects the decline of the imperial Confucian system, as does its lack of innovative spirit. By contrast, wild cursive writings together with archaizing elements mirror the individualism and eccentricity of an increasingly fractured society during the late-Ming and early-Qing periods.[32]

In the wake of the Cultural Revolution, the brush paintings of Pan Tianshou and Li Kuchan, using both word and image, speak to the indomitability of the human spirit. Typical in the Chinese tradition, which compares human qualities to attributes of nature, Li Kuchan, for example, in his *Various Subjects* (pl. 80), likens himself to the humble cabbage and the lotus blossom. He inscribes the painting in a jagged handwriting, "I often chew this vegetable to toughen my teeth. That which comes out the mud without stain shall stand tall and be at peace." He then uses a bristling brushwork to create a self-portrait in the image of an eagle, ravaged but not humbled.

During the twentieth century, overriding concerns for national survival and cultural relevance caused Chinese artists to become polarized between two extreme positions: a denial of their traditional past, on the one hand, and the rejection of Western influence, on the other.[33] As China has emerged since the late 1970s as a modern nation from its self-imposed isolation, the old dichotomies of East versus West and *zhong-wai*, "native versus foreign," will come more fully into the orbit of worldwide relationships and norms in the ongoing process of interchange between cultures.

In contemporary Chinese avant-garde art, artists such as Xu Bing (b. 1955) and Gu Wenda (b. 1955) use word, image, and pseudo-writing to work through issues of language, communication, and codification, as well as of its function, public and private. Gu Wenda's *Temple of Heaven* (page 253), installed in 1998, shows four walls and a ceiling covered with pseudo-scripts based on Chinese, English, Hindi, and Arabic and

inscribed in strands of human hair. Part of the ten-year project entitled *United Nations*, begun by Gu in 1993, *Temple of Heaven* addresses concerns shared by expatriate artists such as Gu and Xu, both of whom now live in the United States. Gu has stated, "I am interested in fusing global cultures.... The miswritten language symbolizes misunderstanding as the essence of our knowledge of the material world." And Xu has written, "I have no other choice but to draw from my own cultural tradition....

I feel that to use Chinese cultural elements to address global issues...is a positive development."[34]

With the new perspective of the twenty-first century, the wealth of classical Chinese art and history becomes a profound cultural resource to be investigated and, if possible, reintegrated into modern life and history. It is hoped that Xu Bing and Gu Wenda may yet accomplish their dream of global understanding and communication.

NOTES

1. David Der-wei Wang, *Fin-de-siècle Splendor: Repressed Modernities of Late Qing Fiction, 1849–1911* (Stanford: Stanford University Press, 1997), p. 17; see also p. 33, in this publication.

2. Michael Sullivan, "Chinese Art in the Twentieth Century," in *Wu Guanzhong: A Twentieth-Century Chinese Painter*, by Anne Farrer (exh. cat., London: British Museum Press, 1992), p. 23.

3. Wu Guanzhong. "Fengzheng buduan xian" (Kite with Unbroken String), in *Yitu chunqiu: Wu Guanzhong wenxuan* (Collection of Wu Guanzhong's Writings), edited by Chen Ruixian (River Edge, N. J.: Global Publishing Co., 1992), pp. 19–20.

4. Wang, *Fin-de-siècle Splendor*, p. 43.

5. From Xu Beihong, "Dangqian Zhongguo zhi yishu wenti" (Problems Facing Today's Chinese Art), in *Xu Beihong danchen jiushi zhounian jinianji* (Collection Commemorating Xu Beihong's Ninetieth Birthday) (Beijing: Xu Beihong Memorial Museum, 1983), pp. 217–18.

6. Wang Zhen and Xu Boyang, *Xu Beihong yishu wenji* (Collection of Writings on Art by Xu Beihong) (Yinchuan: Ningxia Renmin Chubanshe, 1994), p. 11.

7. Guo Shaoyu, *Zhongguo wenxue pipingshi* (History of Chinese Literary Criticism) (Shanghai: Zhonghua Shuju, 1961, pp. 454–72.

8. Ibid., p. 468.

9. Lang Shaojun, "Chuangzao xinde shenmei jigou—Lin Fengmian dui huihua xingshi de tansuo" (Creating a New Aesthetic Structure: Lin Fengmian's Search for a Formal Language in Painting), in *Lin Fengmian yanjiu wenji* (Collected Essays on Lin Fengmian), edited by Zheng Chao (Hangzhou: Zhongguo Meishu Xueyuan Chubanshe, 1995), pp. 189ff.

10. John Elderfield, *Henri Matisse: A Retrospective* (exh. cat., New York: The Museum of Modern Art, 1992), pp. 26–33.

11. See above, p. 211 and n. 9.

12. Wu Guanzhong, "Huihua di xingshi mei" (The Beauty of Form in Painting), in *Wu Guanzhong sanwen xuan* (Collected Essays by Wu Guanzhong) (Beijing: Guoji Wenhua Chuban Gongsi, 1993), pp. 138–44.

13. Joseph Needham, with Wang Ling, *Science and Civilisation in China*, vol. 2, *History of Scientific Thought* (Cambridge: Cambridge University Press, 1956), p. 287.

260

14. Wu Guanzhong, "Fengzheng buduan xian," pp. 19–20; see above, pp. 239–40.

15. John K. Fairbank, "The Reunification of China," in *The Cambridge History of China*, vol. 14, *The People's Republic, Part I: The Emergence of Revolutionary China, 1949–1965*, edited by Roderick MacFarquhar and John K. Fairbank (Cambridge: Cambridge University Press, 1987), pp. 6–7. Fairbank speaks of the progress that has been made in the study of Chinese language, history, geography, economics, political science, anthropology, and literature, but neglects to mention that Chinese art history, though it can scarcely claim to be a social science, has also grown in recent years. See Jerome Silbergeld,"Chinese Painting Studies in the West: A State-of-the-Field Article," *Journal of Asian Studies* 46 (November 1987), pp. 840–97.

16. Ying-shih Yu, "Clio's New Cultural Turn and the Rediscovery of Tradition in Asia," Keynote Address, International Association of Historians of Asia, Twelfth Conference, June 24–28, 1991, p. 11.

17. Ibid., pp. 19, 25.

18. Ibid., p. 26.

19. As nineteenth-century positivism gives way to modern relativism, the death of scientific realism in art is paralleled by the end of "realistic" representation in historiography. The question of the "fictive" representation of "reality" in art was first posed by E.H. Gombrich, who found the origin of pictorial "realism" in Western art in the effort of Greek artists who translated into visual terms the narrative techniques of epic, tragic, and historical writers; *Art and Illusion: A Study in the Psychology of Pictorial Representation*, 2d ed. (New York: Bollingen Foundation, 1961), pp. 116–45. Later, Hayden White, basing his argument on Gombrich as well as on the writings of literary theorists on the relationship between history, myth, and the philosophy of history, would ask, "What are the 'artistic' elements of a 'realistic' historiography?" (*Metahistory: The Historical Imagination in Nineteenth-Century Europe* [Baltimore: Johns Hopkins University Press, 1974], p. 3, n. 4). The shift from representational realism to abstraction in Western art continues to be a major topic of interest in critical inquiry. In a study of Kandinsky and Mondrian, Dee Reynolds focuses on the role of imagination in subversive forms of signification (*Symbolist Aesthetics and Early Abstract Art: Sites of Imaginary Space* [Cambridge: Cambridge University Press, 1995]). The convergence of the artistic traditions of East and West is the displacement of the mimetic by the expressive. As Arthur C. Danto has observed, "The history of art [now] requires a totally different structure. It does so because there is no longer any reason to think of art as having a progressive history: there simply is not the possibility of a development sequence with the concept of expression as there is with the concept of mimetic representation" ("The End of Art," in *The Death of Art*, edited by Berel Lang [New York: Haven, 1984], p. 24).

20. Nicholas Davey, "The Hermeneutics of Seeing," in *Interpreting Visual Culture: Explorations in the Hermeneutics of the Visual*, edited by Ian Heywood and Barry Sandywell (London: Routledge, 1999), pp. 3–29.

21. Erwin Panofsky, *Studies in Iconology: Humanistic Themes in the Art of the Renaissance* (New York: Harper and Row, 1962), pp. 27–28.

22. Ibid., p. 27.

23. For a recent study of Song art and politics, see Alfreda Murck, *Poetry and Painting in Song China: The Subtle Art of Dissent,* Harvard-Yenching Institute Monograph Series, vol. 50 (Cambridge, Mass.: Harvard University Press, 2000).

24. Wen C. Fong, "Reflections on Chinese Art History," *Proceedings of the American Philosophical Society* 142, no. 1 (March 1998), pp. 47–59.

25. For the correlative universe, see Needham, *Science and Civilisation in China*, pp. 281–83.

26. Wen C. Fong, *Beyond Representation: Chinese Painting and Calligraphy, 8th–14th Century* (New York: The Metropolitan Museum of Art, 1992), pp. 182–87.

27. Peter Sturman, "Cranes above Kaifeng: The Auspicious Image at the Court of Huizong," *Ars Orientalis* 20 (1990), pp. 33–68.

28. Martin J. Powers, "Discourses of Representation in Tenth- and Eleventh-Century

China," in *The Art of Interpretation*, *Papers in Art History from the Pennsylvania State University* 8 (University Park: Pennsylvania State University, 1995).

29. For Zhao's expressed reference to Guo Xi, see Shane McCausland, "Zhao Mengfu (1254–1322) and the Revolution of Elite Culture in Mongol China" (Ph.D. dissertation, Princeton University, 2000), pp. 170–75.

30. Wen C. Fong, "Chinese Calligraphy: Theory and History," in *The Embodied Image: Chinese Calligraphy from the John B. Elliott Collection*, by Robert E. Harrist Jr. and Wen C. Fong (exh. cat., Princeton: The Art Museum, Princeton University, 1999), pp. 35, 41.

31. For "Four Calligraphic Revolutions," see ibid., pp. 37–57.

32. Ibid., pp. 72–81.

33. See Wei-ming Tu, "Iconoclasm, Holistic Vision, and Patient Watchfulness: A Personal Reflection on the Modern Chinese Intellectual Quest," *Daedalus*, spring 1987, pp. 75–94.

34. Janet A. Kaplan and Simon Leung, "Pseudo-Languages: Conversation with Wenda Gu, Xu Bing, and Jonathan Hay," *Art Journal* 58, no. 3 (fall 1999), pp. 90–91.

List of Artists

262

Chen Hengke 陳衡恪	1876–1923
Cheng Shifa 程十髮	b. 1921
Feng Zikai 豐子愷	1898–1975
Fu Baoshi 傅抱石	1904–1965
Gao Jianfu 高劍父	1878–1951
Gao Qifeng 高奇峰	1889–1933
Huang Binhong 黃賓鴻	1865–1955
Li Keran 李可染	1907–1989
Li Kuchan 李苦禪	1898–1983
Li Ruiqing 李瑞清	1867–1920
Lin Fengmian 林風眠	1900–1991
Liu Haisu 劉海粟	1896–1994
Lu Yanshao 陸儼少	1909–1993
Pan Tianshou 潘天壽	1897–1971
Qi Baishi 齊白石	1864–1957
Ren Bonian 任伯年	1840–1895
Ren Xun 任薰	1835–1893
Ren Yu 任預	1853–1901
Shilu 石魯	1919–1982
Su Renshan 蘇仁山	1814–1849
Wang Yuan 王緣 active ca.	1862–1908
Wang Zhen 王震	1867–1938
Wu Changshi 吳昌碩	1844–1927
Wu Guanzhong 吳冠中	b. 1919
Wu Zuoren 吳作人	1908–1997
Xu Beihong 徐悲鴻	1895–1953
Xugu 虛谷	1823–1896
Zeng Xi 曾熙	1861–1930
Zhang Daqian 張大千	1899–1983
Zhao Zhiqian 趙之謙	1829–1884

List of Plates

PLATE 1 Wang Yuan (active ca. 1862–1908), *Portrait of Zhao Zhiqian*, dated 1871. Hanging scroll, ink and color on paper, 41¾ × 13¼ in. (106 × 33.7 cm). Gift of Robert Hatfield Ellsworth, in memory of La Ferne Hatfield Ellsworth, 1986 (1986.267.30)

PLATE 2 Zhao Zhiqian (1829–1884), *Peony*, dated 1862. Folding fan mounted as an album leaf, ink and color on gold-flecked paper, 7 × 20¾ in. (17.8 × 52.7 cm). Gift of Robert Hatfield Ellsworth, in memory of La Ferne Hatfield Ellsworth, 1986 (1986.267.27)

PLATE 3 Zhao Zhiqian (1829–1884), *Peony and Peach Blossoms*, ca. 1862. Folding fan mounted as an album leaf, ink and color on gold-flecked paper, 7½ × 21½ in. (19.1 × 54.6 cm). Gift of Robert Hatfield Ellsworth, in memory of La Ferne Hatfield Ellsworth, 1986 (1986.267.28)

PLATE 4 Xugu (1823–1896), *Squirrel on an Autumn Branch*, ca. 1880s. Folding fan mounted as an album leaf, ink and color on alum paper, 7¼ × 19 in. (18.4 × 48.3 cm). Gift of Robert Hatfield Ellsworth, in memory of La Ferne Hatfield Ellsworth, 1986 (1986.267.54)

PLATE 5 Xugu (1823–1896), *Sailing in Autumn*, dated 1893. Album leaf, ink and color on paper, 14⅛ × 35⅞ in. (35.9 × 91.1 cm). Gift of Robert Hatfield Ellsworth, in memory of La Ferne Hatfield Ellsworth, 1986 (1986.267.53)

PLATE 6 Ren Xun (1835–1893), *Bird on a Rock by a Flowering Branch*, dated 1879. Folding fan mounted as an album leaf, ink and color on alum paper, 7 × 20⅞ in. (17.8 × 53 cm). Gift of Robert Hatfield Ellsworth, in memory of La Ferne Hatfield Ellsworth, 1986 (1986.267.46)

PLATE 7 Ren Xun (1835–1893), *Scholar in the Wind*, ca. 1880. Folding fan mounted as an album leaf, ink and color on alum paper, 6½ × 9⅜ in. (16.7 × 23.8 cm). Gift of Robert Hatfield Ellsworth, in memory of La Ferne Hatfield Ellsworth, 1986 (1986.267.45)

PLATE 8 Ren Bonian (1840–1896), *Scholar on a Rock*, ca. 1880. Folding fan mounted as an album leaf, ink and color on alum paper, 7½ × 21¼ in. (19.1 × 53.8 cm). Gift of Robert Hatfield Ellsworth, in memory of La Ferne Hatfield Ellsworth, 1986 (1986.267.49)

PLATE 9 Ren Bonian (1840–1896), *Cranes, Pine Tree, and Lichen*, dated 1885. Hanging scroll, ink and color on paper, 56½ × 14¾ in. (143.5 × 37.5 cm). Gift of Robert Hatfield Ellsworth, in memory of La Ferne Hatfield Ellsworth, 1988 (1988.324.1)

PLATE 10 Ren Bonian (1840–1896), *Man on a Bridge*, dated 1889. Hanging scroll, ink on bark paper, 36⅞ × 24¼ in. (93.7 × 61.6 cm). Gift of Robert Hatfield Ellsworth, in memory of La Ferne Hatfield Ellsworth, 1986 (1986.267.50)

PLATE 11 Ren Bonian (1840–1896), *Herdboy and Water Buffalo*, dated 1890. Folding fan mounted as an album leaf, ink and color on alum paper, 7½ × 21⅜ in. (19.1 × 54.3 cm). Gift of Robert Hatfield Ellsworth, in memory of La Ferne Hatfield Ellsworth, 1986 (1986.267.48)

PLATE 12 Ren Yu (1853–1901), *Buddha of Longevity*, early 1890s. Hanging scroll, ink and color on paper, 53 × 20½ in. (134.6 × 66 cm). Gift of Robert Hatfield Ellsworth, in memory of La Ferne Hatfield Ellsworth, 1986 (1986.26.72)

PLATE 13 Ren Yu (1853–1901), *Meditation in a Cave*, ca. 1899. Hanging scroll, ink and color on paper. Gift of Robert Hatfield Ellsworth, in memory of La Ferne Hatfield Ellsworth, 1986 (1986.267.71)

PLATE 14 Li Ruiqing (1867–1920), *Blossoming Plum*, ca. 1915. Hanging scroll, ink and color on paper, 70½ × 18⅞ in. (179.1 × 47.9 cm). Gift of Robert Hatfield Ellsworth, in memory of La Ferne Hatfield Ellsworth, 1986 (1986.267.98)

PLATE 15 Li Ruiqing (1867–1920), *Buddha of Longevity*, dated 1917. Hanging scroll, ink and color on paper, 41¼ × 20½ in. (104.8 × 52.1 cm). Gift of Robert Hatfield Ellsworth, in memory of La Ferne Hatfield Ellsworth, 1986 (1986.267.99)

PLATE 16 Zeng Xi (1861–1930), *Old Pine Shrouded in Clouds*, dated 1922. Hanging scroll, ink and color on paper, 33 × 25⅞ in. (83.8 × 65.7 cm). Gift of Robert Hatfield Ellsworth, in memory of La Ferne Hatfield Ellsworth, 1986 (1986.267.132)

PLATE 17 Wu Changshi (1844–1927), *Spring Offering*, dated 1919. Hanging scroll, ink and color on paper, 57⅜ × 31¼ in. (145.7 × 79.4 cm). Gift of Robert Hatfield Ellsworth, in memory of La Ferne Hatfield Ellsworth, 1988 (1988.324.2)

263

PLATE 18 Wu Changshi (1844–1927), *Brewing Tea*, dated 1918. Handscroll, ink on paper, 15½ × 54 in. (39.5 × 137.2 cm). Gift of Robert Hatfield Ellsworth, in memory of La Ferne Hatfield Ellsworth, 1986 (1986.267.124)

PLATE 19 Wang Zhen (1867–1938), *Two Goats*, dated 1914. Hanging scroll, ink and color on paper, 57½ × 15⅝ in. (146.1 × 39.7 cm). Gift of Robert Hatfield Ellsworth, in memory of La Ferne Hatfield Ellsworth, 1986 (1986.267.154)

PLATE 20 Wang Zhen (1867–1938), *Returning Fisherman*, dated 1917. Hanging scroll, ink and color on paper, 70 × 37 in. (177.8 × 94 cm). Gift of Robert Hatfield Ellsworth, in memory of La Ferne Hatfield Ellsworth, 1986 (1986.267.155)

PLATE 21 Wang Zhen (1867–1938), *Buddhist Sage*, dated 1928. Hanging scroll, ink and color on paper, 78½ × 36⅞ in. (199.4 × 93.7 cm). Gift of Robert Hatfield Ellsworth, in memory of La Ferne Hatfield Ellsworth, 1986 (1986.267.156)

PLATE 22 Su Renshan (1814–1849), *The Immortal Li Tieguai*, late 1840s. Hanging scroll, ink on paper, 45½ × 15¾ in. (115.6 × 40 cm). Gift of Robert Hatfield Ellsworth, in memory of La Ferne Hatfield Ellsworth, 1986 (1986.267.9)

PLATE 23 Su Renshan (1814–1849), *Monk Gazing at Clouds*, late 1840s. Hanging scroll, ink on paper, 37⅜ × 15 in. (94.9 × 38.1 cm). Gift of Robert Hatfield Ellsworth, in memory of La Ferne Hatfield Ellsworth, 1986 (1986.267.8)

PLATE 24 Gao Jianfu (1878–1951), *Ancient Warrior*, dated 1931. Hanging scroll, ink and color on alum paper, 38½ × 19 in. (97.8 × 48.3 cm). Gift of Robert Hatfield Ellsworth, in memory of La Ferne Hatfield Ellsworth, 1986 (1986.267.183)

PLATE 25 Gao Jianfu (1878–1951), *Ancient Tree with Golden Gourds*, dated 1935. Hanging scroll, ink and color on paper, 52½ × 17¼ in. (13.2 × 43.8 cm). Gift of Robert Hatfield Ellsworth, in memory of La Ferne Hatfield Ellsworth, 1986 (1986.267.187)

PLATE 26 Gao Jianfu (1878–1951), *Junks*, dated 1945. Hanging scroll, ink and color on alum paper, 29 × 35⅛ in. (73.7 × 89.2 cm). Gift of Robert Hatfield Ellsworth, in memory of La Ferne Hatfield Ellsworth, 1986 (1986.267.186)

PLATE 27 Gao Qifeng (1889–1933), *Woodpecker*, dated 1927. Hanging scroll, ink and color on alum paper, 32⅝ × 13⅜ in. (82.9 × 34 cm). Gift of Robert Hatfield Ellsworth, in memory of La Ferne Hatfield Ellsworth, 1986 (1986.267.141)

PLATE 28 Gao Qifeng (1889–1933), *Tiger*, late 1920s. Hanging scroll, ink and color on alum paper, 49½ × 25 in. (125.7 × 63.5 cm). Gift of Robert Hatfield Ellsworth, in memory of La Ferne Hatfield Ellsworth, 1986 (1986.267.142)

PLATE 29 Xu Beihong (1895–1953), *Grazing Horse*, dated 1932. Hanging scroll, ink on paper, 20½ × 14¾ in. (52.1 × 37.5 cm). Gift of Robert Hatfield Ellsworth, in memory of La Ferne Hatfield Ellsworth, 1986 (1986.267.192)

PLATE 30 Xu Beihong (1895–1953), *Cypress Tree*, dated 1935. Hanging scroll, ink and light color on paper, 38⅞ × 12½ in. (98.7 × 31.8 cm). Gift of Robert Hatfield Ellsworth, in memory of La Ferne Hatfield Ellsworth, 1986 (1986.267.193)

PLATE 31 Xu Beihong (1895–1953), *A Spotted Cat*, dated 1938. Folding fan mounted as an album leaf, ink and color on gold-flecked paper, 7½ × 20 in. (19.1 × 50.8 cm). Gift of Robert Hatfield Ellsworth, in memory of La Ferne Hatfield Ellsworth, 1986 (1986.267.194)

PLATE 32 Liu Haisu (1896–1994), *Pine Cliff and Waterfall*, dated 1964. Hanging scroll, ink on bark paper, 75 × 26 in. (190.5 × 66 cm). Gift of Robert Hatfield Ellsworth, in memory of La Ferne Hatfield Ellsworth, 1986 (1986.267.366)

PLATE 33 Liu Haisu (1896–1994), *Lotus Peak*, dated 1975. Album leaf, ink on paper, 11⅜ × 16⅛ in. (28.9 × 41 cm). Gift of Robert Hatfield Ellsworth, in memory of La Ferne Hatfield Ellsworth, 1986 (1986.267.365)

PLATE 34 Fu Baoshi (1904–1965), *Man in a Forest*, early 1940s. Hanging scroll, ink and color on paper, 41½ × 18 in. (105.4 × 45.7 cm). Gift of Robert Hatfield Ellsworth, in memory of La Ferne Hatfield Ellsworth, 1986 (1986.267.276)

PLATE 35 Fu Baoshi (1904–1965), *Portrait of Tao Yuanming*, dated 1947. Hanging scroll, ink and color on paper, 17¾ × 16¾ in. (45 × 42.6 cm). Robert H. Ellsworth Collection

PLATE 36 Fu Baoshi (1904–1965), *Goddess of the River Xiang*, dated 1947. Album leaf, ink and color on paper, 10½ × 12⅞ in. (26.7 × 32.7 cm). Gift of Robert Hatfield Ellsworth, in memory of La Ferne Hatfield Ellsworth, 1986 (1986.267.277)

PLATE 37 Fu Baoshi (1904–1965), *Playing the Qin and Watching Geese in Flight*, dated 1948. Hanging scroll, ink and color on bark paper, 14¼ × 23¾ in. (36.2 × 60.3 cm). Gift of Robert Hatfield Ellsworth, in memory of La Ferne Hatfield Ellsworth, 1986 (1986.267.278)

PLATE 38 Fu Baoshi (1904–1965), *Playing Weiqi at the Water Pavilion*, ca. 1945. Hanging scroll, ink and color on Korean paper, 49¾ × 29½ in. (126.4 × 74.9 cm). Gift of Robert Hatfield Ellsworth, in memory of La Ferne Hatfield Ellsworth, 1988 (1988.324.3)

PLATE 39 Fu Baoshi (1904–1965), *Fisherman*, dated 1945. Hanging scroll, ink and color on paper, 21 × 17⅜ in. (53.4 × 44.2 cm). Robert H. Ellsworth Collection

PLATE 40 Fu Baoshi (1904–1965), *Visiting the Mountain*, ca. 1945. Hanging scroll, ink and color on paper, 42½ × 23⅝ in. (108 × 60 cm). Robert H. Ellsworth Collection

PLATE 41 Fu Baoshi (1904–1965), *Yangzi Gorge*, dated 1947. Hanging scroll, ink and color on paper, 40½ × 20¼ in. (102.9 × 56.5 cm). Robert H. Ellsworth Collection

PLATE 42 Feng Zikai (1898–1975), *Drunken Old Farmer*, ca. 1947. Hanging scroll, ink and color

on paper, 25⅞ × 12⅞ in. (65.7 × 32.7 cm). Gift of Robert Hatfield Ellsworth, in memory of La Ferne Hatfield Ellsworth, 1986 (1986.267.324)

PLATE 43 Feng Zikai (1898–1975), *Reading by the Window*, ca. 1940. Hanging scroll, ink and color on paper, 19 × 13 in. (48.3 × 33 cm). Robert H. Ellsworth Collection

PLATE 44 Feng Zikai (1898–1975), *Portrait of the Priest Hongyi*, dated 1943. Hanging scroll, ink on paper, 23¼ × 14¼ in. (59.1 × 36.2 cm). Gift of Robert Hatfield Ellsworth, in memory of La Ferne Hatfield Ellsworth, 1986 (1986.267.327)

PLATE 45 Feng Zikai (1898–1975), *Victory in Sight*, 1945. Hanging scroll, ink on paper, 30⅜ × 15⅝ in. (77.2 × 39.7 cm). Gift of Robert Hatfield Ellsworth, in memory of La Ferne Hatfield Ellsworth, 1986 (1986.267.326)

PLATE 46 Chen Hengke (1876–1923), *Strange Rock and Tree Trunk*, ca. 1920. Hanging scroll, ink and color on paper, 53⅞ × 13¼ in. (136.8 × 33.7 cm). Gift of Robert Hatfield Ellsworth, in memory of La Ferne Hatfield Ellsworth, 1986 (1986.267.112)

PLATE 47 Chen Hengke (1876–1923), "Studio by the Water," dated 1921. Album leaf, ink and color on paper, 13¼ × 18¾ in. (33.7 × 47.6 cm). Gift of Robert Hatfield Ellsworth, in memory of La Ferne Hatfield Ellsworth, 1986 (1986.267.104)

PLATE 48 Qi Baishi (1864–1957), *Bodhidharma*, dated 1913. Hanging scroll, ink and

color on paper, 32⅝ × 17⅞ in. (82.9 × 45.4 cm). Gift of Robert Hatfield Ellsworth, in memory of La Ferne Hatfield Ellsworth, 1986 (1986.267.208)

PLATE 49 Qi Baishi (1864–1957), *Scuttling Crab*, dated 1919. Hanging scroll, ink on paper, 20¼ × 14½ in. (51.4 × 36.7 cm). Gift of Robert Hatfield Ellsworth, in memory of La Ferne Hatfield Ellsworth, 1986 (1986.267.209)

PLATE 50 Qi Baishi (1864–1957), *Shrimp*, dated 1927. Hanging scroll, ink on paper, 38⅜ × 18¾ in. (97.5 × 47.6 cm). Gift of Robert Hatfield Ellsworth, in memory of La Ferne Hatfield Ellsworth, 1986 (1986.267.212)

PLATE 51 Qi Baishi (1864–1957), "Viewing Antiquities at the Studio of Humility," dated 1930. Album leaf, ink and color on paper, 11 × 13¼ in. (28.1 × 33.7 cm). Gift of Robert Hatfield Ellsworth, in memory of La Ferne Hatfield Ellsworth, 1986 (1986.267.214)

PLATE 52 Qi Baishi (1864–1957), *Lamp-lit Pavilion on a Rainy Night*, dated 1933. Hanging scroll, ink and color on paper, 21⅞ × 18⅜ in. (55.6 × 46.7 cm). Gift of Robert Hatfield Ellsworth, in memory of La Ferne Hatfield Ellsworth, 1986 (1986.267.215)

PLATE 53 Qi Baishi (1864–1957), *Catfish*, dated 1937. Hanging scroll, ink on wrapping paper, 21⅛ × 17⅛ in. (53.7 × 43.5 cm). Gift of Robert Hatfield Ellsworth, in memory of La Ferne Hatfield Ellsworth, 1986 (1986.267.222)

PLATE 54 Qi Baishi (1864–1957), "Persimmon," early 1940s. Album leaf, ink on paper, 11⅞ × 12¼ in. (30.2 × 3.1 cm). Robert H. Ellsworth Collection

PLATE 55 Qi Baishi (1864–1957), *Eagle on a Pine Tree*, ca. 1940. Hanging scroll, ink on paper, 68⅛ × 21½ in. (173 × 54.6 cm). Gift of Robert Hatfield Ellsworth, in memory of La Ferne Hatfield Ellsworth, 1986 (1986.267.216)

PLATE 56 Qi Baishi (1864–1957), *The Immortal Li Tieguai*, early 1940s. Hanging scroll, ink and color on paper, 33¾ × 22½ in. (85.8 × 57.2 cm). Robert H. Ellsworth Collection

PLATE 57 Qi Baishi (1864–1957), *Weeping Willow*, ca. 1937. Hanging scroll, ink on paper, 31⅞ × 13 in. (81 × 33 cm). Gift of Robert Hatfield Ellsworth, in memory of La Ferne Hatfield Ellsworth, 1986 (1986.267.221)

PLATE 58 Qi Baishi (1864–1957), *Water Buffalo Under a Willow Tree*, ca. 1937. Hanging scroll, ink on wrapping paper, 34⅜ × 11 in. (87.2 × 27.9 cm). Gift of Robert Hatfield Ellsworth, in memory of La Ferne Hatfield Ellsworth, 1986 (1986.267.223)

PLATE 59 Qi Baishi (1864–1957), *Five Water Buffalo*, ca. 1937. Hanging scroll, ink on paper, 53¼ × 13¼ in. (135.3 × 33.7 cm). Gift of Robert Hatfield Ellsworth, in memory of La Ferne Hatfield Ellsworth, 1986 (1986.267.219)

PLATES 60a–d Qi Baishi (1864–1957), *Water Life*, dated 1940. Set of four hanging scrolls,

ink on paper, 25½ × 6 in. (64.9 × 15.2 cm). Gift of Robert Hatfield Ellsworth, in memory of La Ferne Hatfield Ellsworth, 1986 (1986.267.234a–d)

PLATE 61 Qi Baishi (1864–1957), *Two Hens*, dated 1942. Folding fan, ink and color on alum paper, 7½ × 20¼ in. (18.9 × 51.4 cm). Gift of Robert Hatfield Ellsworth, in memory of La Ferne Hatfield Ellsworth, 1986 (1986.267.230ab)

PLATES 62a–e Qi Baishi (1864–1957), *Insects and Plants*, dated 1943. Album of twelve leaves, ink on paper, 10⅛ × 13½ in. (25.7 × 34.3 cm). Gift of Robert Hatfield Ellsworth, in memory of La Ferne Hatfield Ellsworth, 1986 (1986.267.237a–l)

PLATE 63 Qi Baishi (1864–1957), *Peaches and Buddha Hands*, dated 1955. Folding fan mounted as an album leaf, ink and color on alum paper, 7¼ × 20½ in. (18.4 × 52.2 cm). Gift of Robert Hatfield Ellsworth, in memory of La Ferne Hatfield Ellsworth, 1986 (1986.267.236)

PLATE 64 Huang Binhong (1865–1955), *Ten Thousand Valleys in Deep Shade*, dated 1933. Hanging scroll, ink and color on paper, 67½ × 18 in. (171.5 × 45.7 cm). Gift of Robert Hatfield Ellsworth, in memory of La Ferne Hatfield Ellsworth, 1986 (1986.267.200)

PLATES 65a,b Huang Binhong (1865–1955), *Sketches of Twelve Strange Mountain Peaks*, ca. 1935. Album of twelve leaves, ink on paper, 22 × 16½ in. (55.9 × 41.9 cm). Gift of Robert

Hatfield Ellsworth, in memory of La Ferne Hatfield Ellsworth, 1986 (1986.267.203a–l)

PLATE 66 Huang Binhong (1865–1955), *Black Landscape*, late 1940s. Album leaf mounted as a hanging scroll, ink and color on paper, 10¼ × 9½ in. (26 × 24.1 cm). Robert H. Ellsworth Collection

PLATE 67 Huang Binhong (1865–1955), *Landscape in the Style of Dong Qichang*, late 1940s. Album leaf mounted as a hanging scroll, ink and color on paper, 10¼ × 9½ in. (26 × 24.1 cm). Gift of Robert Hatfield Ellsworth, in memory of La Ferne Hatfield Ellsworth, 1988 (1988.324.4)

PLATE 68 Huang Binhong (1865–1955), *Dwelling in the Xixia Mountains*, dated 1954. Hanging scroll, ink on paper, 47⅜ × 23½ in. (120.3 × 59.7 cm). Gift of Robert Hatfield Ellsworth, in memory of La Ferne Hatfield Ellsworth, 1986 (1986.267.201)

PLATES 69a,b Huang Binhong (1865–1955), *Flowers*, early 1940s. Album of eight leaves, ink and color on paper, 10⅝ × 10⅛ in. (27 × 25.7 cm). Gift of Robert Hatfield Ellsworth, in memory of La Ferne Hatfield Ellsworth, 1986 (1986.267.202a–h)

PLATES 70a,b Huang Binhong (1865–1955), *Insects and Flowers*, dated 1948. Album of ten leaves, ink and color on gold-flecked paper, 12½ × 14 in. (31.8 × 35.6 cm). Gift of Robert Hatfield Ellsworth, in memory of La Ferne Hatfield Ellsworth, 1986 (1986.267.204a–j)

PLATE 71 Zhang Daqian (1899–1983), *Buddha's Manifestation of Joyfulness*, dated 1946. Hanging scroll, ink and color on bark paper, 59½ × 28 in. (151.1 × 71.2 cm). Gift of Robert Hatfield Ellsworth, in memory of La Ferne Hatfield Ellsworth, 1986 (1986.267.360)

PLATE 72 Zhang Daqian (1899–1983), *Yang Guifei with a Parrot*, dated 1946. Hanging scroll, ink on old paper, 64½ × 32½ in. (163.8 × 82.6 cm). Gift of Robert Hatfield Ellsworth, in memory of La Ferne Hatfield Ellsworth, 1986 (1986.267.359)

PLATE 73 Zhang Daqian (1899–1983), *Listening to a Waterfall*, dated 1949. Hanging scroll, ink and color on paper, 12 × 19⅝ in. (30.5 × 49.9 cm). Robert H. Ellsworth Collection

PLATE 74 Zhang Daqian (1899–1983), *Splashed-Color Landscape*, dated 1965. Hanging scroll, ink and color on paper, 23¾ × 37¾ in. (60.3 × 95.9 cm). Gift of Robert Hatfield Ellsworth, in memory of La Ferne Hatfield Ellsworth, 1986 (1986.267.361)

PLATE 75 Lin Fengmian (1900–1991), *Seated Woman*, early 1960s. Hanging scroll, ink and color on paper, 28 × 32 in. (71.1 × 81.3 cm). Gift of Robert Hatfield Ellsworth, in memory of La Ferne Hatfield Ellsworth, 1986 (1986.267.372)

PLATE 76 Lin Fengmian (1900–1991), *Gladioli*, 1960s. Hanging scroll, ink and color on paper, 24 × 27¼ in. (61 × 69.2 cm). Gift of Robert Hatfield Ellsworth, in memory of La Ferne Hatfield Ellsworth, 1986 (1986.267.375)

PLATE 77 Lin Fengmian (1900–1991), *Mountain Village*, undated. Hanging scroll, ink and color on paper, 27 × 15¾ in. (68.6 × 40 cm). Robert H. Ellsworth Collection

PLATE 78 Lin Fengmian (1900–1991), *Nude*, late 1970s. Hanging scroll, ink and color on paper, 27 × 25¾ in. (68.6 × 65.4 cm). Gift of Robert Hatfield Ellsworth, in memory of La Ferne Hatfield Ellsworth, 1986 (1986.267.374)

PLATE 79 Pan Tianshou (1897–1971), *Various Subjects,* dated 1959. Handscroll, ink on paper, 8¾ × 8 ft. (22.2 × 274.6 cm). Gift of Robert Hatfield Ellsworth, in memory of La Ferne Hatfield Ellsworth, 1986 (1986.267.315)

PLATE 80 Li Kuchan (1898–1983), *Various Subjects*, dated 1972. Handscroll, ink and color on Japanese paper, 15⅜ in. × 14 ft. 2 in. (39.1 × 4.3 m). Gift of Robert Hatfield Ellsworth, in memory of La Ferne Hatfield Ellsworth, 1986 (1986.267.355)

PLATE 81 Li Kuchan (1898–1983), *Cormorants,* dated 1979. Horizontal scroll, ink and color on paper, 26 × 51¾ in. (66 × 131.4 cm). Gift of Robert Hatfield Ellsworth, in memory of La Ferne Hatfield Ellsworth, 1986 (1986.267.354)

PLATE 82 Wu Zuoren (1908–1997), *Charging Yak*, dated 1946. Matted painting, ink and color on paper, 11¼ × 12⅞ in. (28.6 × 32.7 cm). Gift of Robert Hatfield Ellsworth, in memory of La Ferne Hatfield Ellsworth, 1986 (1986.267.391)

PLATE 83 Wu Zuoren (1908–1997), *Camels*, late 1940s or early 1950s. Matted painting, ink on

paper, 12 × 13½ in. (30.5 × 34.3 cm). Gift of Robert Hatfield Ellsworth, in memory of La Ferne Hatfield Ellsworth, 1986 (1986.267.393)

PLATE 84 Wu Zuoren (1908–1997), *Ten Thousand Green Mountains*, dated 1982. Hanging scroll, ink and color on paper, 53⅜ × 26⅝ in. (135.6 × 67.6 cm). Gift of Robert Hatfield Ellsworth, in memory of La Ferne Hatfield Ellsworth, 1986 (1986.267.389)

PLATE 85 Li Keran (1907–1989), *The Immortal Liu Haichan Playing with a Toad*, dated 1937. Hanging scroll, ink and color on Korean paper, 43 × 29½ in. (109.2 × 74.8 cm). Gift of Robert Hatfield Ellsworth, in memory of La Ferne Hatfield Ellsworth, 1986 (1986.267.384)

PLATE 86 Li Keran (1907–1989), *Autumn Herd*, 1960s. Hanging scroll, ink and color on paper, 27⅜ × 18¼ in. (69.5 × 46.4 cm). Gift of Robert Hatfield Ellsworth, in memory of La Ferne Hatfield Ellsworth, 1986 (1986.267.385)

PLATE 87 Li Keran (1907–1989), *The Poetic Mood of Su Shi*, dated 1962. Hanging scroll, ink and color on paper, 27⅛ × 18¼ in. (68.9 × 46.4 cm). Gift of Robert Hatfield Ellsworth, in memory of La Ferne Hatfield Ellsworth, 1986 (1986.267.388)

PLATE 88 Shilu (1919–1982), *Mountain Rain Is Coming*, dated 1960. Hanging scroll, ink and color on paper, 55½ × 32⅛ in. (141 × 81.6 cm). Gift of Robert Hatfield Ellsworth, in memory of La Ferne Hatfield Ellsworth, 1986 (1986.267.344)

PLATE 89 Shilu (1919–1982), *Ducks and Peach Blossoms*, early 1970s. Horizontal hanging scroll,

ink and color on paper, 26¾ × 37 in. (67.9 × 94 cm). Gift of Robert Hatfield Ellsworth, in memory of La Ferne Hatfield Ellsworth, 1986 (1986.267.346)

PLATE 90 Shilu (1919–1982), *Pines on Mount Hua*, ca. 1978. Hanging scroll, ink on paper, 53¾ × 27⅜ in. (136.6 × 69.5 cm). Gift of Robert Hatfield Ellsworth, in memory of La Ferne Hatfield Ellsworth, 1986 (1986.267.351)

PLATE 91 Wu Guanzhong (b. 1919), *Seascape at Beidai*, dated 1977. Hanging scroll, ink and color on paper, 38⅛ × 45¼ in. (96.8 × 114.9 cm). Gift of Robert Hatfield Ellsworth, in memory of La Ferne Hatfield Ellsworth, 1986 (1986.267.431)

PLATE 92 Lu Yanshao (1909–1993), *Sichuan Landscape*, dated 1975. Album leaf, ink and color on Japanese paper, 11¼ × 16 in. (28.6 × 40.6 cm). Gift of Robert Hatfield Ellsworth, in memory of La Ferne Hatfield Ellsworth (1986.267.396)

PLATE 93 Lu Yanshao (1909–1993), *Jietai Temple*, dated 1978. Handscroll, ink and color on paper, 12¼ × 46½ in. (31.1 × 118.1 cm). Gift of Robert Hatfield Ellsworth, in memory of La Ferne Hatfield Ellsworth, 1986 (1986.267.398)

PLATE 94 Lu Yanshao (1909–1993), *Clouds and Waterfalls at Yangang*, dated 1980. Horizontal hanging scroll, ink and color on paper, 21⅝ × 45¼ in. (54.9 × 114.9 cm). Gift of Robert Hatfield Ellsworth, in memory of La Ferne Hatfield Ellsworth, 1986 (1986.267.397)

PLATES 95a,b Cheng Shifa (b. 1921), "The Monkey King Beats the White-Boned Demon" and "General Zhou Boo," from the album *Various Subjects*, dated 1978. Two fan-shaped album leaves from an album of fourteen, ink and color on Japanese paper, each approx. 4⅞ × 14 in. (12.4 × 35.6 cm). Gift of Robert Hatfield Ellsworth, in memory of La Ferne Hatfield Ellsworth, 1986 (1986.267.435b)

Bibliography

Acker, William R.B. *Some Tang and Pre-Tang Texts on Chinese Painting*. Leiden: E.J. Brill, 1954.

Andrews, Julia F., trans. "Cai Yuanpei, 'Replacing Religion with Aesthetic Education.'" In *Modern Chinese Literary Thought: Writings on Literature, 1893–1945*, edited by Kirk A. Denton, pp. 182–89. Stanford: Stanford University Press, 1996.

Andrews, Julia F., and Kuiyi Shen. *A Century in Crisis: Modernity and Tradition in the Art of Twentieth-Century China*. Exh. cat. New York: Guggenheim Museum Soho; Bilbao: Guggenheim Museum, 1998.

Bada Shanren huaji. Jiangxi: Jiangxi Meishu Chubanshe, 1985.

Bai Qianshen. "Fu Shan (1607–1684/85) and the Transformation of Chinese Calligraphy in the Seventeenth Century." Ph.D. dissertation, Yale University, New Haven, 1996.

———. "Qingchu jinshixue de fuxing dui Bada Shanren wannian shufeng de yingxiang" (The Impact of the Revival of the Metal-and-Stone Studies during the early Qing on the Late Calligraphic Style of Bada Shanren). *Gugong xueshu jikan* (Palace Museum Research Quarterly) 12, no. 3 (1995), pp. 89–124.

Bao Shichen. "Yizhou shuangji" (Two Oars of the Ship of Art; 1848). In *Yilin mingzhu congkan* (Collection of Famous Writings on Art), pp. 72–117. Shanghai: Shijie Shuju, 1936.

Barnhart, Richard. "The Odyssey of Wu Guanzhong." In *Wu Guanzhong: A Contemporary Chinese Artist*, edited by Lucy Lim. Exh. cat. San Francisco: Chinese Cultural Foundation of San Francisco, 1989.

———. *Painters of the Great Ming: The Imperial Court and the Zhe School*. Exh. cat. Dallas: Dallas Art Museum, 1993.

———. "Reading the Paintings and Calligraphy of Bada Shanren." In *Master of the Lotus Garden: The Life and Art of Bada Shanren, 1626–1705*, edited by Wang Fangyu, Richard M. Barnhart, Judith Smith, pp. 83–218. Exh. cat. New Haven: Yale University Art Gallery, 1990.

———. "The 'Wild and Heterodox School' of Ming Painting." In *Theories of the Arts in China*, edited by Susan Bush and Christian F. Murck, pp. 365–96. Princeton: Princeton University Press, 1983.

Belting, Hans. *The End of the History of Art?* Translated by Christopher S. Wood. Chicago: University of Chicago Press, 1987.

Bi Keguan. "Jindai meishu de xianqu zhe Li Shutong" (A Forerunner of Modern Art: Li Shutong). *Meishu yanjiu* (Fine Art Studies), no. 4 (1984), pp. 68–75.

Bol, Peter K. *"This Culture of Ours": Intellectual Transitions in T'ang and Sung China*. Stanford: Stanford University Press, 1992.

Brooks, Van Wyck. *Fenollosa and His Circle, with Other Essays in Biography*. New York: E.P. Dutton, 1962.

Brown, Claudia, and Ju-hsi Chou, eds. *Transcending Turmoil: Painting at the Close of China's Empire, 1796–1911*. Exh. cat. Phoenix: Phoenix Art Museum, 1992.

Brown, Delmer M. *Nationalism in Japan: An Introductory Historical Analysis*. Berkeley and Los Angeles: University of California Press, 1955.

Bryson, Norman. *Vision and Painting: The Logic of the Gaze*. New Haven: Yale University Press, 1983.

Bush, Susan. *The Chinese Literati on Painting: Su Shih (1037–1101) to Tung Ch'i-ch'ang (1555–1636)*. Cambridge, Massachusetts: Harvard University Press, 1971.

Cachin, Françoise. *Cézanne*. Exh. cat. Philadelphia: Philadelphia Museum of Art, 1996.

Cahill, James, "Continuations of Ch'an Ink Painting into Ming-Ch'ing and the Prevalence of Type Images." *Archives of Asian Art* 50 (1997–98), pp. 17–41.

———. "The Early Style of Kung Hsien (Gong Xian)." *Oriental Art* 16, no. 1 (spring 1970), pp. 51–71.

———. *Tessai: The Works of Tomioka Tessai*. Exh. cat. Berkeley: Art Museum, University of California, 1968.

Cai Yuanpei. "Yi meishu dai zongjiao shuo" (Replacing Religion with Aesthetic Education). *Xin qingnian* (New Youth) 3, no. 6 (1917), pp. 509–13.

The Cambridge History of China, vols. 14, 15, *The People's Republic*. Edited by Roderick MacFarquhar and John K. Fairbank. Cambridge: Cambridge University Press, 1987, 1991.

Chang, Hao. "Intellectual Change and the Reform Movement, 1890–8." In *The Cambridge History of China*, vol. 11, *Late Ch'ing, 1800–1911, Part 2*, edited by John K. Fairbank and Kwang-ching Liu, pp. 274–338. Cambridge: Cambridge University Press, 1980.

270

Chang Lin-sheng. "The National Palace Museum: A History of the Collection." In *Possessing the Past: Treasures from the National Palace Museum, Taipei*, by Wen C. Fong and James C.Y. Watt, pp. 3–25. Exh. cat. New York: The Metropolitan Museum of Art; Taipei: National Palace Museum, 1996.

Chang, Pang-mei Natasha. *Bound Feet and Western Dress / Xiaojiao yu xifu*. Chinese translation by Dan Jiayu. [Taipei]: Triumph Publishing Co., 1996.

Chen Hengke. *Zhongguo wenrenhua zhi yanjiu* (A Study of Chinese Scholar Painting). Reprint. Tianjin: Tianjin Guji Shudian, 1992. Originally published 1922.

Chen Ruixian, ed. *Yitu chunqiu: Wu Guanzhong wenxuan* (Collection of Wu Guanzhong's Writings). River Edge, New Jersey: Global Publishing Co., 1992.

Chen Xiangpu, *Gao Jianfu de huihua yishu* (Gao Jianfu: His Life and His Paintings). Taipei: Taipei Fine Arts Museum, 1991.

Cheng Linsheng, ed. *Shitao tihualu* (Colophons on Shitao's Paintings). 2 vols. [Shanghai]: N.p., 1925.

Chinese Fine Arts Gallery. *Ren Bonian jingpinji* (Masterpieces of Ren Yi). Beijing: Renmin Meishu Chubanshe, 1993.

Chisholm, Lawrence W. *Fenollosa: The Far West and American Culture*. New Haven: Yale University Press, 1963.

Chu, Christina. "The Lingnan School and Its Followers: Radical Innovation in Southern China." In *A Century in Crisis: Modernity and Tradition in the Art of Twentieth-Century China*, edited by Julia F. Andrews and Kuiyi Shen, pp. 64–79. Exh. cat. New York: Guggenheim Museum Soho; Bilbao: Guggenheim Museum, 1998.

Clunas, Craig. *Pictures and Visuality in Early Modern China*. Princeton: Princeton University Press, 1997.

———. *Superfluous Things: Material Culture and Social Status in Early Modern China*. Urbana-Champaign: University of Illinois Press, 1991.

Cohen, Paul. *Discovering History in China: American Historical Writing on the Recent Chinese Past*. New York: Columbia University Press, 1984.

Cohen, Warren I. *East Asian Art and American Culture: A Study in International Relations*. New York: Columbia University Press, 1992.

Conant, Ellen P., with Steven D. Owyoung and J. Thomas Rimer. *Nihonga, Transcending the Past: Japanese-Style Painting, 1868–1968*. Exh. cat. Saint Louis: Saint Louis Art Museum; Tokyo: Japan Foundation, 1995.

"Conflict and Consensus in Twentieth-Century Chinese Art." Symposium, Solomon R. Guggenheim Museum, New York, May 23, 1998.

Croizier, Ralph. *Art and Revolution in Modern China: The Lingnan (Cantonese) School of Painting, 1906–1951*. Berkeley and Los Angeles: University of California Press, 1988.

Danto, Arthur C. "The End of Art." In *The Death of Art*, edited by Berel Lang. New York: Haven, 1984.

Davey, Nicholas. "The Hermeneutics of Seeing." In *Interpreting Visual Culture: Explorations in the Hermeneutics of the Visual*, edited by Ian Heywood and Barry Sandywell, pp. 3–29. London: Routledge, 1999.

de Bary, W. Theodore. "Individualism and Humanitarianism in Late Ming Thought." In *Self and Society in Ming Thought*, by W. Theodore de Bary et al., pp. 188–225. New York: Columbia University Press, 1970.

Deng Chun. *Huaji* (A Continuation of the History of Painting; preface dated 1167). In *Zhongguo hualun leibian* (Classified Compilation of Writings on Chinese Painting Theories), edited by Yu Jianhua vol. 1. Beijing: Zhongguo Gudian Yishu, 1957.

Deng Yaoping and Liu Tianshu. "Er Gao yu yinjin" (The Two Gaos and Their Derivations). *Zhongguo shuhua bao* (Newspaper of Chinese Calligraphy and Painting), no. 343–45 (1993).

Denton, Kirk A., ed. *Modern Chinese Literary Thought: Writings on Literature, 1893–1945*. Stanford: Stanford University Press, 1996.

Dianshizhai huabao (Dianshizhai Pictorial). 10 vols. Published three times a month, Shanghai, 1884. Reprint. Hong Kong: Guangjiao Jing Chubanshe, 1983.

Ding Xiyuan. Preface and "Chronology of Wu Changshi." In *Wu Changshi*. Tianjin: Tianjin Renmin Meishu Chubanshe, 1996.

———. "Xugu yanjiu yu jianshang" (A Study and Appreciation of Xugu). *National*

Palace Museum Monthly of Chinese Art 14 (1996), pp. 4–37.

Dong Qichang. *Huayan* (The Eye of Painting). In *Yishu congbian* (Collected Works on Chinese Art), compiled by Yang Jialuo, ser. 1, vol. 12. Reprint. Taipei: Shijian Shuju, 1967.

Dong Yulong, ed. *Huang Binhong jingpinji* (Selected Masterworks by Huang Binhong). Beijing: Renmin Meishu Chubanshe, 1991.

———, ed. *Qi Baishi huihua jingpin xuan* (Selected Masterworks by Qi Baishi). Beijing: Renmin Meishu Chubanshe, 1991.

Dong Yuping. "Zhongguo shanshuihua dajia Huang Binhong" (The Great Landscape Master Huang Binhong). In *Huang Binhong jingpinji*, edited by Dong Yulong. Beijing: Renmin Meishu Chubanshe, 1991.

Du Ziling, ed. *Lin Fengmian quanji* (Collected Works of Lin Fengmian). 2 vols. Tianjin: Renmin Meishu Chubanshe, 1994.

Duiker, William J. *Ts'ai Yuan-p'ei: Educator of Modern China*. University Park: Penn State University Press, 1977.

Elderfield, John. *Henri Matisse: A Retrospective*. Exh. cat. New York: The Museum of Modern Art, 1992.

Ellsworth, Robert H. *Later Chinese Painting and Calligraphy, 1800–1950*. Research and translation by Keita Itoh and Lawrence Wu. 3 vols. New York: Random House, 1986.

Farrer, Anne, with contributions by Michael Sullivan and Mayching Kao. *Wu Guanzhong: A Twentieth-Century Chinese Painter*. Exh. cat. London: British Museum Press, 1992.

Feng Yiyin et al., eds. *Feng Zikai zhuan* (Biography of Feng Zikai). Hangzhou: Zhejiang Renmin Chubanshe, 1983.

Feng Youheng. *Xingxiang zhi wai: Zhang Daqian de shenghuo yu yishu* (Beyond Form and Representation: The Life and Art of Zhang Daqian). Taipei: Jiuge Chubanshe, 1983.

Feng Zikai. *Feng Zikai manhua* (Feng Zikai's Cartoons), 4 vols. Shanghai: Kaiming Shudian, 1931–39.

———. "Hongyi fashi" (The Buddhist Priest Hongyi). In *Feng Zikai zizhuan* (Autobiography of Feng Zikai), edited by Feng Chenbao and Yang Ziyun, pp. 68–82. Nanking: Jiangsu Wenyi Chubanshe, 1996.

———. *Manhua de miaofa* (Cartooning Methods). Reprint. Shanghai: Kaiming Shudian, 1947. Originally published 1943.

———. *Zikai manhua quanji* (A Complete Collection of Feng Zikai's Cartoons). 6 vols. Reprint. Shanghai: Kaiming Shudian, 1946. Originally published 1941.

Fenollosa, Ernest. "Bijutsu shinsetsu." In *Bijutsu* (Art), edited by Aoki Shigeru and Sakai Tadayasu, Nihon kindai shisō taikei (Modern Japanese Thought Series), vol. 17, pp. 35–65. Tokyo: Iwanami Shoten, 1989.

———. "Greco-Buddhist Art in Japan." In *Epochs of Chinese and Japanese Art: An Outline History of East Asiatic Design*, vol. 1, pp. 90–115. London: William Heinemann, 1912.

Fong, Wen C. *Beyond Representation: Chinese Painting and Calligraphy, 8th–14th Century*. New York: The Metropolitan Museum of Art, 1992.

———. "A Chinese Album and Its Copy." *Record of The Art Museum, Princeton University* 27, no. 2 (1969), pp. 74–78.

———. "Chinese Calligraphy: Theory and History." In *The Embodied Image: Chinese Calligraphy from the John B. Elliott Collection*, by Robert E. Harrist Jr. and Wen C. Fong, pp. 29–84. Exh. cat. Princeton: The Art Museum, Princeton University, 1999.

———. "*Ch'i-yün-sheng-tung*: 'Vitality, Harmonious Manner, and Aliveness.'" *Oriental Art*, n.s., 12, no. 3 (autumn 1966), pp. 159–64.

———. "A Letter from Shih-t'ao to Pa-ta-shan-jên and the Problem of Shih-t'ao's Chronology." *Archives of the Chinese Art Society of America* 13 (1959), pp. 22–53.

———. "The Literati Artists of the Ming Dynasty." In *Possessing the Past: Treasures from the National Palace Museum, Taipei*, by Wen C. Fong and James C.Y. Watt, pp. 369–97. Exh. cat. New York: The Metropolitan Museum of Art; Taipei: National Palace Museum, 1996.

———. "Modern Art Criticism and Chinese Painting History." In *Tradition and Creativity: Essays on East Asian Civilization: Proceedings of the Lecture Series on East Asian Civilization*, edited by Ching-I Tu, pp. 98–108. New Brunswick: Rutgers, State University of New Jersey, 1987.

———. "The Orthodox School of Painting." In *Possessing the Past: Treasures from the National Palace Museum, Taipei*, by Wen C. Fong and James C.Y. Watt, pp. 473–91.

Exh. cat. New York: The Metropolitan Museum of Art; Taipei: National Palace Museum, 1996.

————. "Pictorial Representation in Chinese Landscape Painting." In *Images of the Mind: Selections from the Edward L. Elliott Family and John B. Elliott Collections of Chinese Calligraphy and Painting at The Art Museum, Princeton University*, by Wen C. Fong et al., pp. 20–73. Exh. cat. Princeton: The Art Museum, Princeton University, 1984.

————. "The Problem of Forgeries in Chinese Painting." *Artibus Asiae* 25, nos. 2–3 (1962), pp. 95–140.

————. "Reflections on Chinese Art History." *Proceedings of the American Philosophical Society* 142, no. 1 (March 1998), pp. 47–59.

————. "A Reply to James Cahill's Queries about the Authenticity of *Riverbank*." *Orientations* 31, no. 3 (March 2000), pp. 95–140.

————. "Reply to Professor Soper's Comments on Tao-chi's Letter to Chu Ta." *Artibus Asiae* 29, no. 4 (1967), pp. 351–57.

————. *Returning Home: Tao-chi's Album of Landscapes and Flowers*. New York: George Braziller, 1976.

————. "*Riverbank*: From Connoisseurship to Art History." In *Issues of Authenticity in Chinese Art*, edited by Judith Smith and Wen C. Fong, pp. 261–73. New York: The Metropolitan Museum of Art, 1999.

————. "Stages in the Life and Art of Chu Ta (1626–1705)." *Archives of Asian Art* 40 (1987), pp. 15–18.

————. "The Time of Qianlong (1736–1795)." In *Chinese Painting under the Qianlong Emperor: The Symposium Papers in Two Volumes*, edited by Ju-hsi Chou and Claudia Brown, pp. 9–16. *Phoebus* 6, no. 1. Tempe: College of Fine Arts, Arizona State University, 1988.

————. "Toward a Structural Analysis of Chinese Landscape Painting." *Art Journal* 28, no. 4 (summer 1969), pp. 388–97.

Fong, Wen C., et al. *Images of the Mind: Selections from the Edward L. Elliott Family and John B. Elliott Collections of Chinese Calligraphy and Painting at The Art Museum, Princeton University*. Exh. cat. Princeton: The Art Museum, Princeton University, 1984.

Fong, Wen C., with Marilyn Fu. *Sung and Yuan Paintings*. New York: The Metropolitan Museum of Art, 1973.

Frazer, Sir James. *The Golden Bough*. Part 1, *The Magic and Evolution of Kings*. London: Macmillan, 1913.

Freedberg, David. *The Power of Images: Studies in the History and Theory of Response*. Chicago: University of Chicago Press, 1989.

Fu Baoshi. *Shitao shangren nianpu* (A Chronology of the Eminent Priest Shitao). Nanjing: Jinwu Zhoukan She, 1948.

Fu Hōseki: Nijusseiki Chūgoku gadan no kyoshō. Nicchū bijutsu kōryū no kakehashi (Fu Baoshi: A Great Master of Twentieth-Century Chinese Painting. A Bridge of Japan-China Artistic Exchange). Exh. cat. Tokyo: Shibuya Kuritsu Shōtō Bijutsukan, 1999.

Fu Hua and Cai Geng, eds. *Xugu huace* (Album of Paintings by Xugu). Beijing: Renmin Meishu Chubanshe, 1986.

Fu, Marilyn, and Shen C.Y. Fu. *Studies in Connoisseurship: Chinese Painting from the Arthur M. Sackler Collection in New York and Princeton*. Princeton: The Art Museum, Princeton University, 1973.

Fu, Shen C.Y. "Huang Binhong's Shanghai Period Landscape Paintings and His Late Floral Works in the Arthur M. Sackler Gallery." *Orientations* 18, no. 9 (September 1987), pp. 66–78.

Fu, Shen C. Y., and Jan Stuart. *Challenging the Past: The Paintings of Chang Dai-chien*. Exh. cat. Washington, D.C.: Arthur M. Sackler Gallery, Smithsonian Institution, 1991.

Fukuzawa Yukichi. "Datsu-A Ron" (Essay on Dissociating from Asia [1885]). In *Fukuzawa Yukichi zenshū* (The Complete Works of Fukuzawa Yukichi), vol. 10, pp. 238–40. Tokyo: Iwanami Shoten, 1960.

Gao Jianfu. "Wo de xiandai huihua guan" (My Views on Contemporary Painting). In *Lingnan huapai yanjiu* (Study of the Lingnan School of Painting), edited by Yu Feng, vol. 1. Guangdong: Lingnan Meishu Chubanshe, 1987.

Gao Jianfu huaji (Paintings of Gao Jianfu). Guangzhou: Lingnan Meishu Chubanshe, 1991.

Gao Lingmei, ed. *Chinese Painting; with the Original Paintings and Discourses on Chinese Art by Professor Chang Dai-chien*. Hong Kong: Dongfang Yishu Gongsi, 1961. In English and Chinese.

Gao Minglu, ed. *Inside/Out: New Chinese Art*. Exh. cat. San Francisco: San Francisco Museum of Modern Art; New York: Asia Society Galleries, 1998.

Gao Qifeng xiansheng yi hua ji (Collected Works of the Late Gao Qifeng). Shanghai: Huaqiao Tushu Yinshua Gongsi, 1935. Unpaginated.

Gendai Nihon bijutsu zenshu (Album of Contemporary Japanese Art). 18 vols. Tokyo: Shueisha, 1971–74.

Gombrich, E.H. *Art and Illusion: A Study in the Psychology of Pictorial Representation*. 2d ed. New York: Bollingen Foundation, 1961.

Gong Chanxing. "Ren Bonian nianbiao" (Chronology of Ren Yi). In *Ren Bonian jingpinji* (Masterpieces of Ren Yi). Beijing: Renmin Meishu Chubanshe, 1993.

———. "Xugu qiren qihua" (Xugu, the Man and His Painting). *Meishu shilun* (Studies in Art History), no. 31 (1989, no. 3), pp. 56–61, 107.

Greenberg, Clement. "Modernist Painting." In *Modern Art and Modernism: A Critical Anthology*, edited by Francis Frascina and Charles Harrison. New York: Harper and Row, 1982.

Gugong shuhua tulu (Illustrated Catalogue of Painting and Calligraphy in the National Palace). 13 vols. Taipei: National Palace Museum, 1989– .

Gulik, Robert van. *Chinese Pictorial Art as Viewed by the Connoisseur: Notes on the Means and Methods of Traditional Chinese Connoisseurship of Pictorial Art, Based upon a Study of the Art of Mounting Scrolls in China and Japan*. Rome: Istituto Italiano per il Medio ed Estremo Oriente, 1958.

Guo Shaoyu. *Zhongguo wenxue pipingshi* (History of Chinese Literary Criticism). Beijing: Zhonghua Shuju, 1961.

Han Chengwu and Zhang Zhimin, eds. *Du Fu shi quanji* (Explications of Du Fu's Poetry). Shijiazhuang: Hebei Renmin Chubanshe, 1997.

Harbsmeier, Christoph. *The Cartoonist Feng Zikai: Social Realism with a Buddhist Face*. Oslo: Universitetsforlaget, 1984.

Hawkes, David. *Ch'u Tz'u: The Songs of the South*. Oxford: Clarendon Press, 1959.

Hay, John. "Some Questions Concerning Classicism in Relation to Chinese Art." *Art Journal* 47, no. 1 (spring 1988), pp. 26–34.

He Baoyin. *Haishang si Ren jingpin, Gugong bowuguan cang* (Masterpieces of the Four Ren in the Collection of the Palace Museum). [Beijing]: Hebei Meishu Chubanshe, 1992.

Hearn, Maxwell K., and Wen C. Fong. *Along the Riverbank: Chinese Paintings from the C.C. Wang Family Collection*. Exh. cat. New York: The Metropolitan Museum of Art, 1999.

Hegel, Georg Wilhelm Friedrich. *The Philosophy of History*. New York: Dover, 1956.

Hightower, James R., trans. *The Poetry of T'ao Ch'ien*. Oxford: Clarendon Press, 1970.

Hong Kong Museum of Art. *Gao Qifeng de yishu / The Art of Gao Qifeng*. Exh. cat. Hong Kong: Urban Council, 1981.

Hosono Masanobu, ed. *Yokoyama Taikan*. Gendai Nihon bijutsu zenshu (Compilation of Modern Japanese Fine Art), vol. 2. Tokyo: Shueisha, 1972.

Hou Jingchang. "Qing Daoren qiren qimu" (Li Ruiqing: The Man and His Grave). *Shupu* (Chronicles of Calligraphy), no. 72 (1986, no. 5), pp. 64–67.

Hu Zhiliang. *Fu Baoshi zhuan* (Biography of Fu Baoshi). Nanchang: Baihua Zhou Wenyi Chubanshe, 1994.

Huang Dade. "Guanyu Lingnan pai de diaocha cailiao" (Research Materials on the Lingnan School of Painting). *Meishu shilun* (Studies in Art History) 53 (1995), pp. 15–28.

Huang Dufeng. "Tan Lingnan Huapai: Lingnan huapai zhi youlai" (On the Lingnan School of Painting: The Origin of the Lingnan School of Painting). *Zhongguo hua yanjiu* (Study of Chinese Painting), no. 3 (1983), pp. 182–91.

Huang Miaozi. "From Carpenter to Painter: Recalling Qi Baishi." *Orientations* 20, no. 4 (April 1989), pp. 85–87.

———. *Huatan shiyou lu* (Teachers and Colleagues in Painting). Taipei: Dongda Tushu Gongsi, 1998.

Huang Yongchuan. *Duhai sanji shouzhan* (Collector's Exhibition of Three Masters): *Zhang Daqian, Pu Xinyu, Huang Junbi*. Exh. cat. Taipei: Guoli Lishi Bowuguan, 1993.

Huang Zhufu. "Huang Binhong huaniao hua chutan" (A Preliminary Study of Huang Binhong's Flower Painting). *Meishu shilun* (Studies in Art History), no. 29 (1989, no. 1), pp. 65–68.

Hung Chang-tai. "War and Peace in Feng Zikai's Wartime Cartoons." *Modern China* 16, no. 1 (January 1990), pp. 39–83.

274

———. *War and Popular Culture: Resistance in Modern China, 1937–1945*. Berkeley and Los Angeles: University of California Press, 1994.

Jiang Fucong and Liang Shiqiu, eds. *Xu Zhimo quanji* (Collected Works of Xu Zhimo). 6 vols. Taipei: Zhuanji Wenxue Chubanshe, 1969.

Jianghu. "Deng Shiru di shengping" (The Life of Deng Shiru). *Shupu* (Chronicles of Calligraphy), no. 39 (1981, no. 4), pp. 34–61.

Jianzhai. "Huang Binhong bixiade Xianggang shanshui" (Under Huang Binhong's Brush: The Landscape of Hong Kong). *Meishujia* (The Artist), no. 51 (1986), pp. 50–55.

Kang Youwei. "Guang yizhou shuangji" (Expanding on [Bao Shichen's] Two Oars of the Ship of Art; 1889). In *Yilin mingzhu congkan* (Collection of Famous Writings on Art), pp. 1–66. Shanghai: Shijie Shuju, 1936.

Kao, Mayching. "The Beginning of the Western-Style Painting Movement in Relationship to Reform of Education in Early Twentieth-Century China." *New Asia Academic Bulletin* 4 (1983), pp. 373–400.

———. "Reforms in Education and the Beginning of the Western-Style Painting Movement in China." In *A Century in Crisis: Modernity and Tradition in the Art of Twentieth-Century China*, edited by Julia F. Andrews and Kuiyi Shen, pp. 146–61. Exh. cat. New York: Guggenheim Museum Soho; Bilbao: Guggenheim Museum, 1998.

———, ed. *Su Liupeng Su Renshan shu hua / The Art of Su Liupeng and Su Renshan*. Hong Kong: Hongkong Zhongwen Daxue Zhongguo Wenhua Yanjiusuo Wenwuguan, 1990.

Kaplan, Janet A., and Simon Leung. "Pseudo-Languages: Conversation with Wenda Gu, Xu Bing, and Jonathan Hay." *Art Journal* 58, no. 3 (fall 1999), pp. 86–99.

Kinbara Seigo and Fu Baoshi. *Tang Song zhi huihua* (Painting of the Tang and Song Periods). Shanghai: Shangwu Yinshuguan, 1935.

Kohara Hironobu. "Riben de Zhongguohua shoucang yu yanjiu" (The Collection and Studies of Chinese Painting in Japan). *Duoyun*, no. 40 (January 1994).

———. *Sekitō to Ōzan hasshō gasatsu* (Shitao's 'Eight Views of Yellow Mountains'). Tokyo: Chikuma Shobō, 1970.

Kopf, David. *British Orientalism and the Bengal Renaissance: The Dynamics of Indian Modernization, 1773–1835*. Berkeley and Los Angeles: University of California Press, 1969.

Kuo, Jason C. *Innovation within Tradition: The Painting of Huang Pin-hung*. Exh. cat. Hong Kong: Hanart Gallery; Williamstown, Massachusetts: Williams College Museum of Art, 1989.

Laing, Ellen. *The Winking Owl: Art in the People's Republic of China*. Berkeley and Los Angeles: University of California Press, 1988.

Lang Shaojun. "Chuangzao xinde shenmei jigou — Lin Fengmian dui huihua xingshi de tansuo" (Creating a New Aesthetic Structure: Lin Fengmian's Search for a Formal Language in Painting). In *Lin Fengmian yanjiu wenji* (Collected Essays on Lin Fengmian), edited by Zheng Chao, pp. 188–218. Hangzhou: Zhongguo Meishu Xueyuan Chubanshe, 1995.

———. "Lin Fengmian yishu de jingshen neihan" (The Spirit and Content of Lin Fengmian's Art). In *Lin Fengmian yanjiu wenji* (Collected Essays on Lin Fengmian), edited by Zheng Chao, pp. 95–113. Hangzhou: Zhongguo Meishu Xueyuan Chubanshe, 1995.

———. "Qi Baishi zhaoqi huihua, 1878–1909" (On the Early Period of Qi Baishi's Painting). *Meishu shilun* (Studies in Art History), no. 43 (1992, no. 3), pp. 8–19.

Ledderose, Lothar. *Ten Thousand Things: Module and Mass Production in Chinese Art*. Princeton: Princeton University Press, 2000.

Lee, Leo Ou-tan. *The Romantic Generation of Modern Chinese Writers*. Cambridge, Massachusetts: Harvard University Press, 1973.

Li, Chu-tsing. "Su Jen-shan (1814–1849): The Rediscovery and Reappraisal of a Tragic Cantonese Genius." *Oriental Art* 16, no. 4 (winter 1970), pp. 349–60.

———. *Trends in Modern Chinese Painting: The C.A. Drenowatz Collection*. Ascona, Switzerland: Artibus Asiae, 1979.

Li, Chu-tsing, and Wan Qingli. *Zhongguo xiandai huihua shi* (A History of Contemporary Chinese Painting). Taipei: Shitou Chuban Gufen Youxian Gongsi, 1998.

Li Hua, Li Shusheng, and Ma Ke, eds. *Zhongguo xinxing banhua yundong wushinian, 1931–81* (Fifty Years' Development of the Chinese Woodcut Movement,

1931–81). Shenyang: Liaoning Meishu Chubanshe, 1982.

Li Keran. "Dan xue shanshui hua" (On Learning to Paint Landscape). *Meishu yanjiu* (Fine Art Studies), no. 1 (1979), pp. 3–15.

Li Lincan. *Zhongguo huashi yanjiu lunji* (Essays on Chinese Art History). Taipei: Taiwan Commercial Press, 1970.

Liang Congjie, ed. *Lin Huiyin wenji* (Collected Works of Lin Huiyin). Taipei: Yuanjian Chuban Gufen Youxian Gongsi, 2000.

Lingnan huapai (Lingnan School of Painting). Taipei: Yishu Tushu Gongsi, 1983.

Liu Haisu. "Ouzhou Zhongguo huazhan shimo" (An Account of the Exhibition of Chinese Paintings in Europe). In *Liu Haisu yishu wenxian*, edited by Zhu Jinlou and Yuan Zhihuang, pp. 153–62. Shanghai: Renmin Meishu Chubanshe, 1987.

Loehr, Max. "Some Fundamental Issues in the History of Chinese Painting." *Journal of Asian Studies* 23, no. 2 (February 1964), pp. 185–93.

Lou Shibai. "Qi Baishi huihua jifa" (Qi Baishi's Painting Techniques). *Zhongguo shuhua bao* (Journal of Chinese Painting and Calligraphy), nos. 66–103 (869–906) (1999).

"Lun Zhepai" (On the Zhejiang School [of Seal Carvers]). *Shupu* (Chronicles of Calligraphy), no. 84 (1988), pp. 17–19.

Lyell, William A., Jr. *Lu Hsun's Vision of Reality*. Berkeley and Los Angeles: University of California Press, 1976.

Ma Guoquan. "Zhao Zhiqian jiqi yishu" (Zhao Zhiqian and His Art). *Shupu* (Chronicles of Calligraphy), no. 65 (1984, no. 2), pp. 16–33.

McCausland, Shane. "Zhao Mengfu (1254–1322) and the Revolution of Elite Culture in Mongol China." Ph.D. dissertation, Princeton University, 2000.

Meng Yan and Jin Shan. "Qi Baishi huihua yishu daolu chuyi" (Preliminary Discussion of Qi Baishi's Artistic Direction). In *Qi Baishi huihua jingpin xuan* (Selected Masterworks by Qi Baishi), edited by Dong Yulong. Beijing: Renmin Meishu Chubanshe, 1991.

Michener, James A., ed. *The Hokusai Sketchbooks: Selections from the Manga*. Rutland, Vermont: Charles E. Tuttle, 1958.

Mote, Frederick W. *Imperial China: 900–1800*. Cambridge, Massachusetts: Harvard University Press, 1999.

Munakata, Kiyohiko. "Concepts of *Lei* and *Kan-lei* in Early Chinese Art Theory." In *Theories of the Arts in China*, edited by Susan Bush and Christian F. Murck, pp. 105–31. Princeton: Princeton University Press, 1983.

Murck, Alfreda. "*Eight Views of the Hsiao and Hsiang Rivers*, by Wang Hung." In *Images of the Mind: Selections from the Edward L. Elliott Family and John B. Elliott Collections of Chinese Calligraphy and Painting at The Art Museum, Princeton University*, by Wen C. Fong et al., pp. 214–35. Princeton: The Art Museum, Princeton University, 1984.

———. *Poetry and Painting in Song China: The Subtle Art of Dissent*. Harvard-Yenching Institute Monograph Series, vol. 50. Cambridge, Massachusetts: Harvard University Press, 2000.

Nagahara Oriharu. "Hachidai Sanjin ni ataeta Sekitō shokan ni tsuite" (On Shitao's letter to Bada Shanren). *Bijutsu* (Art [Magazine], Tokyo) 10, no. 12 (1928), pp. 56–57.

———. *Sekitō Hachidai Sanjin / Shitao and Bada Shanren*. Tokyo: Keibunkan, 1961.

Nagahiro Toshio. *Tonko: Tun-huang Painting*. Chugoku no meiga, no. 2. Tokyo: Heibonsha, 1957.

Naquin, Susan, and Evelyn S. Rawski. *Chinese Society in the Eighteenth Century*. New Haven: Yale University Press, 1987.

Needham, Joseph, with Wang Ling. *Science and Civilisation in China. Vol. 2, History of Scientific Thought*. Cambridge: Cambridge University Press, 1956.

"Nihon seiyō ryō gafū no setchū" (The Middle Path between Eastern and Western Art). *Taiyō* (The Sun) 2, no. 14 (July 20, 1896), pp. 109–10.

Odakane, Tarō. *Tessai: Master of the Literati Style*. Translated and adapted by Money Hickman. Tokyo: Kodansha International, 1965.

Ogawa Hiromitsu. "Tō Sō sansuiga shi ni okeru imajinēshon—hatsuboku kara Sōshunzu, Shōshō gayū zukan made" (Imagination in the History of Tang and Song Landscape Painting—from *Pomo* to *Early Spring* and *Dream Journey on the Xiao and Xiang Rivers*). *Kokka*, no. 1034 (June 1980), pp. 5–17, no. 1036 (July 1980), pp. 25–36.

Okakura Kakuzō (Tenshin). *The Book of Tea*. London and New York: Putnam's Sons, 1906.

275

————. *The Ideals of the East, with Special Reference to the Art of Japan.* New York: E.P. Dutton, 1903.

Owen, Stephen, ed. and trans. *An Anthology of Chinese Literature: Beginnings to 1911.* New York and London: W.W. Norton, 1996.

Pan Gongkai. *Pan Tianshou huihua jifa jianxi* (A Structural Analysis of Pan Tianshou's Paintings). Hangzhou: Zhongguo Meishu Xueyuan Chubanshe, 1995.

Panofsky, Erwin. *Studies in Iconology: Humanistic Themes in the Art of the Renaissance.* New York: Harper and Row, 1962.

Plaks, Andrew. *The Four Masterworks of the Ming Novel: Ssu ta ch'i-shu.* Princeton: Princeton University Press, 1987.

Powers, Martin J. "Discourses of Representation in Tenth- and Eleventh-Century China." In *The Art of Interpretation: Papers in Art History from the Pennsylvania State University* 8. University Park: Pennsylvania State University, 1995.

Priest, Alan. *An Exhibition of Modern Chinese Paintings.* Exh. cat. New York: The Metropolitan Museum of Art, 1943.

Qian Juntao. "Zhao Zhiqian de yishu chengjiu" (The Artistic Accomplishments of Zhao Zhiqian). *Wenwu* (Cultural Relics), no. 268 (1978, no. 9), pp. 56–67.

Qiu Dingfu. *Zhongguohua jindai gejia zongpai fengge yu jifa zhi yanjiu* (A Study of Modern Chinese Painting, Its Schools, Styles, and Techniques). Taipei: Chinese Culture University, 1984.

Qiu Zhuchang. *Huang Binhong zhuanji nianpu hebian* (Huang Binhong's Biography and Chronology). Beijing: Renmin Meishu Chubanshe, 1985.

Reynolds, Dee. *Symbolist Aesthetics and Early Abstract Art: Sites of Imaginary Space.* Cambridge: Cambridge University Press, 1995.

Rimer, J. Thomas. "'Teiten' and After, 1919–1935." In *Nihonga, Transcending the Past: Japanese-Style Painting, 1868–1968,* by Ellen P. Conant, pp. 45–56. Exh. cat. Saint Louis: Saint Louis Art Museum; Tokyo: Japan Foundation, 1995.

Ryckmans, Pierre. *The Life and Work of Su Renshan: Rebel, Painter and Madman, 1814–1849?* Translated by Angharad Pimpaneau. 2 vols. Paris: Université de Paris, 1970.

Shan Guolin. "Painting of China's New Metropolis: The Shanghai School, 1850–1900." In *A Century in Crisis,* by Julia F. Andrews and Kuiyi Shen. Exh. cat. New York: Guggenheim Museum Soho; Bilbao: Guggenheim Museum, 1998.

Shodō zenshū (Compilation of Calligraphic Works). 26 vols. Tokyo: Heibonsha, 1958–71.

Shoseki meihin sōkan (Series of Masterpieces of Calligraphy). 208 vols. to date. Tokyo: Nigensha, 1958– .

Sickman, Laurence, and Jean-Pierre Dubosc. *Great Chinese Painters of the Ming and Ch'ing Dynasties, XV to XVIII Centuries.* Exh. cat. New York: Wildenstein, 1949.

Silbergeld, Jerome. "Chinese Painting Studies in the West: A State-of-the-Field Article." *Journal of Asian Studies* 46 (November 1987), pp. 840–97.

Sirén, Osvald. *Chinese Painting: Leading Masters and Principles.* 7 vols. New York: Ronald Press, 1956–58.

Smedley, Agnes. *Battle Hymn of China.* New York: Alfred A. Knopf, 1943.

Song Zhongyuan. *Yishu yaolan* (The Cradle of Art). Hangzhou: Zhejiang Meishu Xueyuan Chubanshe, 1988.

Soper, Alexander C. "The Letter from Shih-t'ao to Pa-ta-shan-jen." *Artibus Asiae* 29, no. 2/3 (1967), pp. 267–69.

Sturman, Peter. "Cranes above Kaifeng: The Auspicious Image at the Court of Hui-zong." *Ars Orientalis* 20 (1990), pp. 33–68.

Su Yinghui. "Chang Dai-chien and Tun-huang." In *Zhang Daqian, Pu Xinyu shi shuhua xue shutao lunhui / The International Conference on the Poetry, Calligraphy, and Painting of Chang Dai-chien and P'u Hsin-yu: Proceedings.* Taipei: National Palace Museum, 1994.

Sullivan, Michael. *Art and Artists of Twentieth-Century China.* Berkeley and Los Angeles: University of California Press, 1996.

————. *Chinese Art in the Twentieth Century.* Berkeley and Los Angeles: University of California Press, 1959.

————. "Chinese Art in the Twentieth Century." In *Wu Guanzhong: A Twentieth-Century Chinese Painter,* by Anne Farrer. Exh. cat. London: British Museum, 1992.

————. *The Meeting of Eastern and Western Art.* 2d ed. Berkeley and Los Angeles: University of California Press, 1989. Originally published 1973.

————. "Wu Guanzhong: Reflections on His Life, Thought, and Art." In *Wu Guanzhong: A Contemporary Chinese Artist,* edited by Lucy Lim. Exh. cat. San

Francisco: Chinese Cultural Foundation of San Francisco, 1989.

Sun, Shirley Hsiao-ling. "Lu Hsün and the Chinese Woodcut Movement, 1929–1936." Ph.D. dissertation, Stanford University, 1974.

Takashina, Shūji, J. Thomas Rimer, and Gerald D. Bolas. *Paris in Japan: The Japanese Encounter with European Painting.* Exh. cat. Tokyo: Japan Foundation; Saint Louis: Washington University, 1987.

Tan Dihua. "Su Renshan jieqi sixiang yu yishu" (The Thoughts and Art of Su Renshan). *Meishujia* (The Artist), no. 34 (1983).

Tapati Guha-Thakurta. *The Making of a New "Indian" Art: Artists, Aesthetics, and Nationalism in Bengal, c. 1850–1920.* Cambridge: Cambridge University Press, 1992.

Tsao Hsing-yuan. "A Forgotten Celebrity: Wang Zhen (1867–1938), Businessman, Philanthropist, and Artist." In *Art at the Close of China's Empire,* pp. 94–109. *Phœbus,* vol. 8. Tempe: Arizona State University, 1998.

Tsuruta Takeyoshi. "Ryūnichi bijutsu gakusei: Kin hyakunen rai Chūgoku kaigashi kenkyū" (Chinese Art Students in Japan: Research on the History of Chinese Painting of the Past 100 Years), Part 5. *Bijutsu kenkyū* (Journal of Art Studies), no. 367 (1997), pp. 127–39.

Tu, Wei-ming. "Iconoclasm, Holistic Vision, and Patient Watchfulness: A Personal Reflection on the Modern Chinese Intellectual Quest." *Daedalus,* spring 1987, pp. 75–94.

Vinograd, Richard. *Boundaries of the Self: Chinese Portraits, 1600–1900.* Cambridge: Cambridge University Press, 1992.

Wan Qingli. "Cai Yuanpei yu jindai Zhongguo meishu jiaoyu" (Cai Yuanpei and Modern Chinese Art Education). In *Ershi shiji Zhongguo meishu jiaoyu* (Twentieth-Century Chinese Art Education), pp. 1–7. Shanghai: Shanghai Shuhua Chubanshe, 1999.

———. *Huajia yu huashi* (Painters and Painting History). Hangzhou: Zhongguo Meishu Xueyuan Chubanshe, 1997.

———. *Li Keran pingzhuan* (A Critical Biography of Li Keran). Taipei: Xiongshi Chubanshe, 1995.

———. "Lin Fengmian yu tade Faguo laoshi Fernand Cormon" (Lin Fengmian and His French Teacher Fernand Cormon). In *Lin Fengmian yu ershi shiji Zhongguo meishu* (Lin Fengmian and Twentieth-Century Chinese Art), edited by Xu Jiang, pp. 57–65. Hangzhou: Zhongguo Meishu Xueyuan Chubanshe, 2000.

———. "Pan Tianshou de yijing gediao shou" (Pan Tianshou's Theories of Idea-State and Style and Tone). In his *Huajia yu huashi* (Painters and Painting History). Hangzhou: Zhongguo Meishu Xueyuan Chubanshe, 1997.

Wang Bomin. *Cheng huai gudao / Homage to Tradition / Huang Binhong.* Exh. cat. Hong Kong: Hong Kong Museum of Art, 1995.

———. *Huang Binhong.* Shanghai: Renmin Meishu Chubanshe, 1979.

———, ed. *Huang Binhong huayulu* (The Paintings and Recorded Sayings of Huang Binhong). Shanghai: Shanghai Renmin Meishu Chubanshe, 1961.

Wang Chunfu and Wang Yanchao, eds. *Qi Baishi huihua jingcui* (The Essence of Qi Baishi's Art). Changchun: Jilin Meishu Chubanshe; Shanghai: Xinhua Bookstore, 1994.

Wang, David Der-wei. *Fin-de-siècle Splendor: Repressed Modernities of Late Qing Fiction, 1849–1911.* Stanford: Stanford University Press, 1997.

Wang Jingxian. "Ren Bonian qiren qiyi" (Ren Yi, the Man and His Art). In Chinese Fine Arts Gallery, *Ren Bonian jingpinji* (Masterpieces of Ren Yi). Beijing: Renmin Meishu Chubanshe, 1993.

Wang Yanchao. "Chronology of Qi Baishi." In *Qi Baishi huihua jingcui* (The Essence of Qi Baishi's Art), edited by Wang Chunfu and Wang Yanchao. Changchun: Jilin Meishu Chubanshe; Shanghai: Xinhua Bookstore, 1994.

Wang Yichang, ed. *China Art Year Book: 1946, 1947.* Shanghai: Committee for Shanghai Municipal Cultural Movement, 1948.

Wang Yushan and Cai Peixin, eds. *Shilu.* Beijing: Renmin Meishu Chubanshe, 1996.

Wang Zhen and Xu Boyang. *Xu Beihong yishu wenji* (Collection of Writings on Art by Xu Beihong). Yinchuan: Ningxia Renmin Chubanshe, 1994.

White, Hayden. *Metahistory: The Historical Imagination in Nineteenth-Century Europe.* Baltimore: Johns Hopkins University Press, 1974.

Worswick, Clark, and Jonathan Spence. *Imperial China: Photographs, 1850–1912.*

Exh. cat. New York: Asia House Gallery; circulated by American Federation of the Arts; New York: Pennwick, 1978.

Wu Guanzhong. "Cong dongfang dao xifang, you hui dao dongfang" (From the East to the West and again Returning to the East). *Meishuijia* (The Artist), no. 57 (August 1987), pp. 4–8.

———. "Fengzheng buduan xian" (Kite with Unbroken String). In *Yitu chunqiu: Wu Guanzhong wenxuan* (Collection of Wu Guanzhong's Writings), edited by Chen Ruixian. River Edge, New Jersey: Global Publishing Co., 1992.

———. "Huigu dangjin wushi nian" (Looking Back on My Painting of the Last Fifty Years). In *Wu Guanzhong huaji* (Paintings of Wu Guanzhong). Shijiazhuang: Hebei Meishu Chubanshe, 1984.

———. "Jimo gengyun qishinian" (Quietly Cultivating Himself for Seventy Years). In *Lin Fengmian lun* (Essays on Lin Fengmian), edited by Zheng Chao and Jin Shangyi. Hangzhou: Zhejiang Meishu Xueyuan Chubanshe, 1990.

———. *Wu Guanzhong sanwen xuan* (Collected Essays by Wu Guanzhong). Beijing: Guoji Wenhua Chuban Gongsi, 1993.

Wu Guanzhong huaji (Paintings of Wu Guanzhong). Shijiazhuang: Hebei Meishu Chubanshe, 1984.

Wu Hung. "Han Mingdi, Wei Wendi de lizhi gaige yu Handai huaxuang yishu zhi shengshuai" (The Ritual Reforms of Emperor Ming of the Han and Emperor Wen of the Wei and the Rise and Fall of Han Pictorial Art). *Jiuzhou xuekan* (Chinese Cultural Quarterly) 3, no. 2 (1989), pp. 31–44.

———. *Transience: Chinese Experimental Art at the End of the Twentieth Century.* Exh. cat. Chicago: David and Alfred Smart Museum of Art, University of Chicago, 1999.

Wu Zuoren. "Sumiao yu huihua mantan" (On Sketching and Painting). *Meishu yanjiu* (Fine Art Studies), no. 3 (1979), pp. 8–15.

Wu Zuoren yishuguan cang pin ji (An Album of Pictures by Wu Zuoren Collected by the Wu Zuoren Art Gallery). Hong Kong: Guwu Xuan Chubanshe, 1994.

Wu Zuoren zuopin ji: Zhongguo hua juan (Collected Works of Wu Zuoren). Edited by Ai Zhongxin. Shenyang: Liaoning Meishu Chubanshe, 1994.

Xiao Fengji. "Haishang huajia Wang Zhen shengping shiji" (The Life Story of the Shanghai Painter Wang Zhen). *Duoyun* 49 (1996), pp. 47–53.

Xie Jiaxiao. *Zhang Daqian di shijie* (The World of Zhang Daqian). Taipei: Zhengxin Xinwenbao, 1968.

Xie Zhiliu. *Dunhuang yishu xulu* (Dunhuang Cave Antiquities). Shanghai: Shanghai Chuban Gongsi, 1955.

Xu Beihong. "Dangqian Zhongguo zhi yishu wenti" (Problems Facing Today's Chinese Art). In *Xu Beihong danchen jiushi zhounian jinianji* (Collection Commemorating Xu Beihong's Ninetieth Birthday). Beijing: Xu Beihong Memorial Museum, 1983.

———. "Da Yang Zhumin xiansheng" (A Reply to Mr. Yang Zhumin; dated 1951). In *Xu Beihong yishu wenji* (Collection of Writings on Art by Xu Beihong), edited by Wang Zhen and Xu Boyang, pp. 602–4. Yinchuan: Ningxia Renmin Chubanshe, 1994.

———. "Zhongguo hua gailiang lun" (Essay on Reforming Chinese Painting). *Huihua zazhi* (Painting Magazine; Beijing University), June 1920.

Xu Beihong canghua xuanji / Selections from Xu Beihong's Collection of Paintings. 2 vols. Beijing: Xu Beihong Memorial Museum, 1991–92.

Xu Beihong de yishu (The Art of Xu Beihong). Hong Kong: Hong Kong Museum of Art, 1988.

Xu Beihong huaji (Paintings of Xu Beihong). Shijiazhuang: Hebei Meishu Chubanshe, 1985.

Xu Boyang. "Xu Beihong yu huajia: Jinian fuqin shishi ershiqi zhounian erzhou" (Xu Beihong and the Painter: Commemorating the 27th Anniversary of My Father's Death). *Xiongshi meishu Monthly*, no. 130 (1970), pp. 82–92.

Xu Boyang and Jin Shan, eds. *Xu Beihong nianpu* (Chronology of Xu Beihong). Taipei: Yishujia Chubanshe, 1991.

Xu Jiang, ed. *Lin Fengmian yu ershi shiji Zhongguo meishu* (Lin Fengmian and Twentieth-Century Chinese Art). Hangzhou: Zhongguo Meishu Xueyuan Chubanshe, 2000.

Yamamoto Teijiro, Norishige Koichi, and Fu Baoshi. *Mingmo minzu yiren zhuan.* (Biographies of Nationalistic Artists of the Late Ming Period; preface dated 1938). 1939; reprint, Hong Kong: Liwen Chubanshe, 1971.

Yang Yi. *Haishang molin* (The Forest of Ink of Shanghai). Shanghai: Yuyuan Shuhua, 1928.

Yang Zhumin. "Zhongguo shanshui hua di fazhan he chengjiu" (The Development and Achievements of Chinese Landscape Painting). In *Xu Beihong yishu wenji*, edited by Wang Zhen and Xu Boyang, pp. 605–13. Yinchuan: Ningxia Renmin Chubanshe, 1994.

Ye Zonggao, ed. *Fu Baoshi meishu wenji* (Fu Baoshi's Writings on Art). [Nanjing]: Jiangsu Wenyi Chubanshe, 1986.

Yu Huali and Ji Lin. *Fu Baoshi*. Tianjin: Tianjin Renmin Meishu Chubanshe, 1996.

Yu, Ying-shih. "Clio's New Cultural Turn and the Rediscovery of Tradition in Asia." Keynote address, International Association of Historians of Asia, Twelfth Conference, 24–28 June 1991.

Yuen, Aida Yuen. "Inventing Eastern Art in Japan and China, ca. 1890s to 1930s." Ph.D. dissertation, Columbia University, New York, 1999.

Zengetsu-daishi juroku-rakan (*Sixteen Lohans*, by Master Chanyue). Tokyo: Shimbi Shoin, 1914.

Zhang Daqian, ed. *Dafeng Tang mingji* (Masterpieces of Chinese Painting from the Great Wind Hall Collection). 4 vols. Kyoto: Benrido, 1955–56.

Zhang Daqian Pu Xinyu shi shu hua xueshu taolun hui (The International Conference on the Poetry, Calligraphy, and Painting of Chang Dai-Chien and P'u Hsin-yu). Taipei: National Palace Museum, 1994.

Zhang Guoying. *Fu Baoshi yanjiu* (The Study of Fu Baoshi). Taipei: Taipei Municipal Art Museum, 1991.

Zhang Yanyuan. *Lidai minghua ji* (Record of Famous Paintings in Successive Dynasties; completed 847). In *Huashi congshu* (Compendium of Painting Histories), edited by Yu Anlan, vol. 1. Shanghai: Renmin Meishu Chubanshe, 1963.

Zhao Erchang. "Zhao Zhiqian xiansheng nianpu" (Chronology of Zhao Zhiqian). *Shupu* (Chronicles of Calligraphy), no. 65 (1984, no. 2), pp. 16–33.

Zhao Guide and Wu Shouming, eds. *Ren Xiong, Ren Xun, Ren Yi, Ren Yu*. Shijiazhuang: Hebei Meishu Chubanshe, 1995.

Zheng Chao, ed. *Lin Fengmian yanjiu wenji* (Collected Essays on Lin Fengmian). Hangzhou: Zhongguo Meishu Xueyuan Chubanshe, 1995.

Zheng Chao and Jin Shangyi, eds. *Lin Fengmian lun* (Essays on Lin Fengmian). Hangzhou: Zhejiang Meishu Xueyuan Chubanshe, 1990.

Zheng Jingwen, ed. *Wu Zuoren de yishu* (The Art of Wu Zuoren). Beijing: Waiwen Chubanshe, 1986.

Zheng Zhenduo. Preface. In *Feng Zikai manhua* (Feng Zikai's Cartoons), vol. 1. Shanghai: Kaiming Shudian, 1931.

Zhongguo jin xian dai mingjia huaji: Fu Baoshi (Paintings of Famous Modern and Contemporary Chinese Artists: Fu Baoshi). Tianjin: Tianjin Renmin Meishu Chubanshe, 1996.

Zhongguo jin xian dai mingjia huaji: Xu Beihong (Paintings of Famous Modern and Contemporary Chinese Artists: Xu Beihong). Tianjin: Tianjin Renmin Meishu Chubanshe, 1996.

Zhongguo lidai huihua: Gugong bowuyuan canghua ji (Chinese Paintings from Successive Dynasties: Paintings in the Collection of the Palace Museum). Vol. 1. Beijing: Renmin Meishu Chubanshe, 1978.

Zhongguo shufa: Longmen shi er pin (Chinese Calligraphy: Twelve Works from Longmen). Beijing: Wenwu Chubanshe, 1980.

Zhongguo shufa dacidian (Dictionary of Chinese Calligraphy). 2 vols. Hong Kong: Shupu Chubanshe, 1982.

Zhu Jianxin. *Jinshixue* (Metal-and-Stone Studies; preface dated 1938). In *Renren wenku* (Everyone's Library), edited by Wang Yunwu. Taipei: Shangwu Yinshuguan, 1966.

Zhu Jingxuan. *Tangchao minghua lu* (Record of Famous Painters of the Tang Dynasty; ca. 840). In *Meishu congkan* (Collected Reprints on Fine Arts), compiled by Yu Junzhi, vol. 1. Taipei: Zhonghua Congshu Weiyuan Hui, 1956.

Zhu Jinlou and Yuan Zhihuang, eds. *Liu Haisu yishu wenxian* (Collected Writings on Art by Liu Haisu). Shanghai: Renmin Meishu Chubanshe, 1987.

Zhuo Shengge. *Xu Beihong yanjiu* (A Study of Xu Beihong). Taipei: Taipei Municipal Art Gallery, 1989.

Index

Abe Fusajirō 阿部房次郎 (1858–1937), 13

Anhui Public School 安徽公學, 162

Ajanta (India), 84, 180, 191

Bada Shanren 八大山人 (1626–1705), 11, 12, 14, 26, 67, 103, *107*, 109, *109*, 111, 149–51, *149–51*, *153*, 163, 180, 181, 183–84, *184*, 186, 217, 218, 239

Bao Shichen 包世臣 (1775–1855), 26–27, 28, 70, 163

Barnhart, Richard, 152, 240

Beijing 北京, 52, 84, 142, 153

 Academy of Art (now The Central Academy of Fine Arts), 88, 91, 100, 142, 206, 209, 218, 219, 221, 222, 229, 237

 Great Hall of the People, 118

 Historical Museum, 54

 Palace Museum (before 1949, National Palace Museum), 12, 222

 Peking University (Beijing daxue) 北京大學, 12, 76, 88, 138

 Rongbaozhai studio 榮寶齋, 145

 Xu Beihong Memorial Museum 徐悲鴻紀念館, 92, 93

Berlin, 88, 101

Bigelow, William Sturgis (1850–1926), 78

Bodhidharma, Patriarch, 65, 66–67, 72n50

Boney, Alice, ix

Braque, Georges (1882–1963), 237

Brussels, 101; Académie Royale de Belgique, 219

Bryson, Norman, 5, 7, 11, 96

Cai Yuanpei 蔡元培 (1868–1940), 76, 80, 90, 100, 138

Calcutta, 84

Canton 廣州. *See* Guangdong 廣東

Cézanne, Paul (1838–1906), 17, 91, 101, 103, 172, *173*, 175, 237

Chang Dai-chien. *See* Zhang Daqian

Chen Duxiu 陳獨秀 (1879–1942), 12, 24, 76, 162, 181

Chen Hengke 陳衡恪 (Chen Shizeng 陳師曾; 1876–1923), 14–15, 17, 25, 138–40, *138*, *139*, 142, 149, 163, 172, 199n5, 215

Chen Hongshou 陳洪綬 (1598–1652), 4, *10–11*, *11*, 37, *37*, 42, *42*, 45, 180

Chen Shizeng. *See* Chen Hengke

Cheng Linsheng 程霖生, 181

Cheng Shifa 程十髮 (b. 1921), 245–49, *248–49*

Cheng Sui 程邃 (active ca. 1650–80), 40

Chiang Kai-shek 蔣介石 (1887–1975), 52, 91, 106–7

Chongqing 重慶, 111, 222, 243

Cixi, Empress Dowager 慈禧太后 (r. 1898–1908), 24

Claudot, André (1892–1982), 222

Cleveland Museum of Art, 16

Cohen, Paul, 17

Confucius, 27, 254

Constable, John (1776–1837), 5, 6

Cormon, Fernand, 209, 210

Crawford, John M., ix

Dagnan-Bouveret, Pascal (1852–1929), 88, 91, 97

Danto, Arthur C., 260n19

Daoguang emperor 道光皇帝 (r. 1821–51), 163

Daumier, Honoré (1808–1879), 123

Degas, Edgar (1834–1917), 91

Delacroix, Eugène (1798–1863), 91, 94

Deng Shiru 鄧石如 (1743–1805), 27, 32, 69

Denis, Maurice (1870–1943), 175

Di Baoxian 狄葆賢 (Bingzi 平子; 1872–ca. 1940s), 182

Dillon, C. Douglas, ix

Dong Qichang 董其昌 (Tung Ch'i-ch'ang; 1555–1636), 6, 14, 90, 94, 109, 162, 164, 168, 170, 175, 181

Dong Yuan 董源 (active 930s–60s), 93–94, *93*, 149, 163, 164

Du Fu 杜甫 (712–770), 111, 133n92, 151

Dufy, Raoul (1877–1953), 213

Dunhuang 敦煌 (Gansu Province 甘肅), 13, 180, *185–87*, 188, 191

Eight Eccentrics of Yangzhou 揚州八怪, 4, 12, 14, 34, 37, 118, 163

Elliot, John B., ix

Ellsworth, Robert H., ix

Fairbank, John K., 256, 260n15

Fan Kuan 范寬 (died after 1023), 132n52, *231*, 233

Feng Chaoran 馮超然 (1882–1954), 243

Feng Yaheng 馮亞珩. *See* Shilu

Feng Zikai 豐子愷 (1898–1975), 69, 122–29, *124–28*, 134–35n120, 140, 199n5, 214

Fenollosa, Ernest (1853–1908), 15, 16, 76–79, 130n9

Ferguson, John C. (1866–1945), 16

Flameng, François (1856–1923), 88

Four Wangs 四王, 76, 90

Frankfurt, 101

Frazer, Sir James, 19n15

Freer, Charles Lang (1856–1919), 16, 29

Fry, Roger, 6

Fu Baoshi 傅抱石 (1904–1965), 74–75, 107–22, *109*, 111–22, 133n89, *92*, 134n100, 102, 222, 227, 243

Fu Shan 傅山 (1607–1684/85), 26

Fu Shen 傅申, 191

Fukuzawa Yukichi 福沢諭吉 (1835–1901), 79

Gang of Four 四人幫, 229, 234. *See also* Jiang Qing

Gao Jianfu 高劍父 (1878–1951), 79–87, *80*, *82*, *83*, *85*, 107, 111

Gao Qifeng 高奇峰 (1889–1933), 80–83, *80*, *86*, 87–88, *87*, *89*

Gauguin, Paul (1848–1903), 237

Gérôme, Jean Léon (1824–1904), 94

Gombrich, E. H., 6, 9, 260*n19*

Gong Xian 龔賢 (ca. 1619–ca. 1689), 164

Goya, Francisco de (1746–1828), 100, 123

Greenberg, Clement, 18

Grosz, George (1893–1959), 123

Gu Kaizhi 顧愷之 (ca. 344–ca. 406), 6, 8, 113, 188

Gu Wenda 谷文達 (b. 1955), 253, 258–59

Guan Shanyue 關山月 (1912–2000), 118

Guan Tong 關仝 (active ca. 907–23), 93, 183, 191

Guangdong 廣東 (Canton 廣州), 67, 79, 84
 Lingnan University 嶺南大學, 80

Guangxu emperor 光緒皇帝 (r. 1875–1908), 24, 28

Guanxiu 貫休 (832–912), *10–11*, *11*

Guilin 桂林 (Guangxi Province 廣西), 92, 94, 165, 227

Guo Moruo 郭沫若 (1892–1978), 107, 108, 222

Guo Xi 郭熙 (ca. 1000–ca. 1090), 8, 10, 11, 66, 118, 132*n52*, 257

Guo Xu 郭詡 (1456–1532), 175

Han Gan 韓幹 (active ca. 742–56), 7, 10, 188

Han Huang 韓滉 (721–787), 157, *157*

Hangzhou 杭州, 29, 91, *128*, *129*
 The Zhejiang Academy of Fine Arts (before 1949, The Hangzhou Academy of Art), 163, 206, 209, 214, 218, 222, 237, 243
 Eighteen Art Society of West Lake, 22
 Shengyin si 聖因寺, *10*
 See also Zhejiang

Harbsmeier, Christoph, 125

Hashimoto Kansetsu 橋本関雪 (1883–1945), 14, 109, 202*n80*

Hegel, Georg Wilhelm Friedrich, 5

Hengfeng 衡鋒, 35, 36, 129, 142

Hishida Shunsō 菱田春草 (1874–1911), 78, 80

Hokusai (葛飾) 北齋斎 (1760–1849), 123

Hongren 弘仁 (active 1610–64), 40, 180

Hongyi 弘一. *See* Li Shutong

Hu Shi 胡適 (1891–1962), 12, 25, 27, 181

Hua Yan 華喦 (1682–ca. 1765), 37, *37*

Huang Binhong 黃賓虹 (1865–1955), *136–37*, *162–78*, *164–71*, *174–80*, 180–83, 200*n24*, 209, 222, 231, 233, 243

Huang Gongwang 黃公望 (1269–1354), 163, 164

Huang Shen 黃慎 (b. 1687), 145

Huang Tingjian 黃庭堅 (1045–1105), 70

Huang Xiang 皇象 (active ca. 220–79), 53, *53*

Huike 慧可, Patriarch, 66, 67, 69

Huineng 慧能, Patriarch (638–713), 69

Huizong 徽宗 (r. 1100–25), *40–41*, 257

Ikeno Taiga 池大雅 (1723–1776), 78

Jiang Qing 江青 (1914–1991), 209, 234, 245

Jiang Song 蔣嵩, 175

Jin Nong 金農 (1687–1764), 48, 72*n50*, 92, 93–94, 145

Jing Hao 荊浩 (ca. 870–930), 93, 183, 188

Jiu Fanggao 九方皋, 96–97

Ju Lian 居廉 (1828–1904), 80

Juran 巨然 (active ca. 960–80), 93, 163, 164, 191

Kampf, Arthur (1864–1950), 88

Kanehara Shōgo 金原省吾, 109

Kang Youwei 康有爲 (1858–1927), 24, 27–29, 67, 90

Kangxi emperor 康熙皇帝 (r. 1662–1722), 12, 28, 152, 164

Kano Motonobu 狩野元信 (1476–1559), 78

Kano Takanobu 狩野孝信 (1571–1618), 117

Kansas City (Missouri): Nelson-Atkins Museum of Art, 16

Kimura Buzan 木村武山 (1876–1942), 80, *81*, 131*n24*

Kishi Chikudō 岸竹堂 (1826–1897), 87, *88*

Kollwitz, Käthe (1867–1945), 123

Kuncan 髡殘 (1612–ca. 1673), 180

Kuroda Seiki 黒田清輝 (1855–1924), 122

Kuwana Tetsujō 桑名鉄城 (1854–1938), 14

Kyoto Imperial University 京都帝国大學, 13

Lane, Gardiner M., 16

Lang Shaojun 郎紹君, 211, 214, 255

Laozi 老子, 46

Ledderose, Lothar, 7, 99

Lee, Sherman E., 16

Lenin, Vladimir, 106

Li Bo 李白 (701–762), 112, *112*

Li Cheng 李成, 66

Li Gonglin 李公麟 (ca. 1041–1106), 26, 180

Li Jian 李健 (Zhongqian 仲乾; 1881–1956), 56

Li Keran 李可染 (1907–1989), 17, 209, 221–33, *225–30*, 234

Li Kuchan 李苦禪 (1898–1983), 217–19, *218–19*, 258

Li Ruiqi 李瑞奇 (ca. 1870–ca. 1940), 182–83, *182*

Li Ruiqing 李瑞清 (1867–1920), 52–56, *52*, *54–55*, 60, 61, 70, 72*n50*, 138, 162, 179–83, 187, 202*n76*, 233

Li Shan 李鱓 (active ca. 1711–62), 32, 34

Li Shutong 李叔同 (Hongyi 弘一; 1880–1942), 122–23, 125, 127, 129, 214

Li Songan 李松庵, 183

282 Li Tieguai 李鐵枴, 153

Li Zhi 李贄 (1527–1602), 129

Li Zonghan 李宗瀚 (1769–1831), 202n76

Liang Kai 梁楷 (active 1st half 13th century), 67, 69, 69, 112

Liang Qichao 梁啓超 (1873–1929), 24, 67

Lin Fengmian 林風眠 (1900–1991), 91, 206–8, 209–14, 210–11, 224, 237, 254, 255

Lin Huiyin 林徽音 (1904–1955), 92

Liu Daoshi 劉道士, 191

Liu E 劉鶚 (1850–ca. 1910), 29

Liu Haichan 劉海蟾, 222–24

Liu Haisu 劉海粟 (1896–1994), 100–106, 102, 104, 209, 213, 222

London
British Museum, 92, 191, 237
Burlington House, 16

Longmen 龍門 (Loyang, Henan Province), 29, 32

Low, David (1891–1963), 123

Loyang 洛陽 (Henan Province 河南), 7. See also Longmen

Lu Xun 魯迅 (1881–1936), 90, 123, 222, 233

Lu Yanshao 陸儼少 (1909–1993), 204–5, 242, 243–44, 244–47

Luell, Walter A., Jr., 90

Luo Zhenyu 羅振玉 (1866–1940), 13, 29, 182

Ma Yuan 馬遠 (active ca. 1190–1264), 175

Maeda Seison 前田青邨 (1885–1977), 140

Major, Frederick, 36

Manet, Édouard (1832–1883), 91

Mao Zedong 毛澤東 (1893–1976), 106, 118, 123, 142, 153, 206, 209, 239

Maruyama Ōkyo 円山応挙 (1733–1798), 87

Matisse, Henri (1869–1954), 91, 101, 206, 209–11, 211, 237, 255

Meiji emperor 明治天皇 (r. 1868–1912), 76

Meiqing 梅清 (1623–1697), 180

Meissonier, Ernest (1815–1891), 94

Mi Fu 米芾 (1052–1107), 109, 149, 181, 184

Monet, Claude (1840–1926), 91

Morgan, J. P. (1837–1913), 16

Morse, Earl, ix

Museum of Fine Arts, Boston, 15–16, 78, 191

Mutsuhito. See Meiji emperor

Nagahara Oriharu 永原織治 (1893–after 1961), 109, 109, 111, 184

Naitō Konan 内藤湖南 (1866–1934), 13

Nanjing 南京, 84
Jiangsu Provincial National Painting Academy, 118, 206
National Central University, 53, 81, 88, 92, 107, 108, 209, 219

New York City: Wildenstein Gallery, 16

Ni Zan 倪瓚 (1301–1374), 240, 241

Ogawa Chikanosuke 小川睦之輔, 13

Okakura Kakuzō 崗倉覚三 (Tenshin 天心; 1862–1913), 15, 16, 77–79, 84

Ōmura Seigai 大村西崖 (1867–1927), 14, 25, 138

Osaka
Municipal Museum of Art, 13
Takashimaya department store, 60

Ouyang Xun 歐陽詢 (557–645), 54

Pan Gongkai 潘公凱, 214

Pan Tianshou 潘天壽 (1897–1971), 175, 213–16, 214–18, 229, 231, 243, 254, 258

Panofsky, Erwin, 256–57

Paris, 94
École des Beaux-Arts, 88, 206, 209, 219, 237
Musée Cernuschi, 188
Musée du Louvre, 92

Parrish, Maxfield (1870–1966), 10

Picasso, Pablo (1881–1973), 6, 17, 91, 101

Pollock, Jackson (1912–1956), 172, 198, 240

Princeton University, The Art Museum, 186

Qi Baishi 齊白石 (1864–1957), ix, 2–3, 5, 13, 72n50, 97, 140–62, 141–49, 155–63, 180, 199n6, 200n8, 209, 218–19, 221, 222, 224, 227

Qianlong emperor 乾隆皇帝 (r. 1736–95), 12, 28, 191

Qing Daoren 清道人. See Li Ruiqing

Qiu Ying 仇英 (ca. 1495–1552), 180

Qu Yuan 屈原 (343–278 B.C.), 78, 111, 112, 117

Rembrandt van Rijn (1606–1669), 94

Ren Bonian 任伯年 (Ren Yi 任頤; 1840–1895), 42–49, 45–48, 53, 56–60, 57–58, 62, 94, 180

Ren Xiong 任熊 (1823–1857), 40–42, 40, 48

Ren Xun 任薰 (1835–1893), 40, 42–45, 42–43, 48

Ren Yu 任預 (1853–1901), 40, 48–51, 50, 51, 67

Renoir, Pierre-Auguste (1841–1919), 91, 101

Reynolds, Dee, 260n19

Rodin, Auguste (1840–1917), 91

Rockwell, Norman (1894–1978), 10

Ruan Yuan 阮元 (1764–1849), 26–28, 70

Rubens, Peter Paul (1577–1640), 94

Schulz, Charles (1922–2000), 129

Seurat, Georges (1859–1891), 101

Shangguan Zhou 上官周 (1665–ca. 1749), 67

Shanghai 上海, 34–35, 45, 53, 56, 58, 62, 80, 84, 91–92, 106, 181–82, 243
Academy of Art (Meizhuan), 88, 91, 100, 103–4, 206, 209, 222, 243, 245

First National Exhibition of Chinese Art, 91

Preparatory School for Overseas Study in the United States, 162

South China Academy of Art (Nanguo Academy of Art), 88, 219

Studio for Painting Scenic Backgrounds, 100

Shen Shichong 沈士充, 170

Shike 石恪 (ca. 965), 69

Shilu 石魯 (Feng Yaheng 馮亞珩; 1919–1982), 17, 232–37, 233–37, 254

Shimomura Kanzan 下村観山 (1873–1930), 78

Shitao 石濤 (1642–1707), 11, 12, 12, 14, 15, 61, 103–6, 103, 105, 107, 109, 111, 133n89, 163, 170, 181–84, 182, 183, 186, 198, 224, 233

Sickman, Laurence, 16

Song Ke 宋克 (1327–1387), 53

Su Renshan 蘇仁山 (1814–1849), 66, 67–70, 68, 129

Su Shi 蘇軾 (1037–1101), 10, 17, 19n23, 25, 227, 228–29

Sullivan, Michael, 16, 97, 122, 239, 253

Sun Yat-sen 孫逸仙 (1866–1925), 24, 52, 67, 76, 80, 106

Tagore, Abanindranath, 84

Tagore, Rabindranath, 84

Taikan. See Yokoyama Taikan

Taipei 台北

 National Museum of History, 198

 National Palace Museum, 16, 162

Takehisa Yumeji 竹久夢二 (1884–1934), 123

Takeuchi Seihō 竹内栖鳳 (1864–1942), 87, 87

Tang, Oscar L., ix

Tang, P. Y. and Kinmay W., family, ix

Tang Di 唐棣 (1287–1355), 63, 66

Tang Yin 唐寅 (1470–1524), 191, 193

Tao Yuanming 陶淵明 (365–427), 79, 111, 153

Tenshin. See Okakura Kakuzō

Tian Han 田漢, 95

Tokyo 東京

 Agency for Cultural Affairs (Bunkachō) 文化庁 (National Office for the Protection of Cultural Properties), 77

 Imperial Academy of Fine Arts (Teikoku Bijutsuin) 帝国美術院, 100, 107

 Imperial Museum (Teikoku Hakubutsukan) 帝国博物館 (now Tokyo National Museum), 15, 77

 Imperial University (Tokyo Teikoku Daigaku) 東京帝国大学, 15, 76

 Japan Art Institute (Nihon Bijutsuin) 日本美術院, 78

 Kawabata Painting School (Kawabata Gagakkō) 川端画学校, 123

 Kyukyo-dō Art Gallery – Kyukyodō Art Gallery 鳩居堂ギャラリー, 109

 Musashino Fine Arts University 武藏野美術大学, 107

 Normal School 東京師範学校, 53

 School of Fine Arts (Tokyo Bijutsu Gakkō) 東京美術学校, 14, 15, 77, 78, 80, 122

 Technical Art School (Kōbu Tokyo Bijitsu Gakkō) 工部美術学校, 76, 77

Tomioka Tessai 富岡鉄斎 (1837–1924), 14, 15, 140

Turner, J. M. W. (1775–1851), 93

Utrillo, Maurice (1883–1955), 213

van Gogh, Vincent (1853–1890), 67, 101, 172

Velázquez, Diego Rodríguez de Silva (1599–1660), 100

Vlaminck, Maurice de (1876–1958), 209

Wan Qingli 萬青力, 17

Wang, C. C. (Wang Jiqian 王季遷; b. 1907), ix, 29

Wang, David 王德威, 24–25, 67, 70n3, 254

Wang Gai 王概 (1642–ca. 1710), 67

Wang Guowei 王國維 (1877–1927), 29

Wang Hui 王翬 (1632–1717), 12, 34, 76, 94, 164, 165

Wang Jian 王鑒 (1598–1677), 76

Wang Meng 王蒙 (ca. 1308–1385), 163

Wang Mo 王墨 (active 8th century), 118, 195–98

Wang Shimin 王時敏 (1592–1680), 76, 164

Wang Shizhen 王士禎 (漁洋) (1634–1711), 255

Wang Shu 王澍 (1668–1743), 26

Wang Wei 王維 (ca. 699–ca. 761), 172, 172, 255

Wang Xizhi 王羲之 (ca. 303–ca. 361), 26, 258

Wang Yuan 王緣 (active ca. 1862–1908), 27, 30

Wang Yuanlu 王圓籙, 13

Wang Yuanqi 王原祁 (1642–1715), 12, 76

Wang Zhen 王震 (1867–1938), 58, 61–62, 62, 64, 65, 66–67

Washington (D.C.)

 Arthur M. Sackler Gallery (Smithsonian Institution), 186

 Freer Gallery of Art (Smithsonian Institution), 16

Weng Tonghe 翁同龢, 163

White, Hayden, 260n19

Wu Changshuo 吳昌碩 (1844–1927), 13, 56–62, 58–61, 138, 142, 180, 214, 216

Wu Dacheng 吳大澂 (1835–1902), 29

Wu Daozi 吳道子 (active 710–60), 180

Wu Guanzhong 吳冠中 (b. 1919), 209, 213, 237–43, 238–40, 254, 255

Wu Hufan 吳湖帆 (1894–1968), 29, 243

Wu Jiayou (Wu Youru 吳友如), 36, 94, 132n56

Wu Wei 吳偉 (1459–1508), 175

Wu Xizai 吳熙載, 163

Wu Zuoren 吳作人 (1908–1997), 219–21, 220–24, 227

Xia Gui 夏圭 (active 1st half 13th century), 175

Xi'an 西安: Academy of Fine Arts, 233

Xianfeng emperor 咸豐皇帝 (r. 1851–61), 163

Xiaozong, Emperor 孝宗皇帝 (r. 1162–89), 125, *125*

Xie He 謝赫 (active ca. 479–502), 8, 14, 84, 101, 188

Xu Bangda 徐邦達 (b. 1911), 29

Xu Beihong 徐悲鴻 (1895–1953), 4–5, 88–101, *95–101*, 107, 111, 132*nn*45, 52, 187, 202*n*66, 209, 218, 219, 222, 233, 254–55

Xu Bing 徐冰 (b. 1955), 258, 259

Xu Wei 徐渭 (1521–1593), 175, 180, 217, 218

Xu Zhimo 徐志摩 (1896–1931), 91–92

Xugu 虛谷 (1823–1896), 35–39, *36–40*, 48, 56, 129, 142, 145

Yamamoto Teijirō 山本悌二郎 (1879–1937), 13, 109

Yan Yanzhi 顏延之 (384–456), 7

Yan Zhenqing 顏眞卿 (709–785), 12, 13, 32

Yang Guifei 楊貴妃 (d. 756), 193

Yang Qiting 楊憩亭, 26, *30*

Yangzhou 揚州 (Jiangsu province), 4, 12, 14, 34. *See also* Eight Eccentrics of Yangzhou

Ye Jianying 葉劍英, 221

Yokoyama Taikan 橫山大觀 (1868–1958), 77, *78–80*, *79*, 111–13, 117, 118, 122–23, 134*n*112

Yongzheng emperor 雍正皇帝 (r. 1723–35), 12

Yosa Buson 与謝蕪村 (1716–1783), 78

Yu Ying-shih 余英時, 256

Yuan Shikai 袁世凱 (1859–1916), 24, 52, 76

Yujian 玉澗 (active mid-13th century), 195

Yun Shouping 惲壽平 (1633–1690), 32, 34

Yun Xiang 惲向 (1586–1655), 164, *165*

Zao Wouki 趙無極 (b. 1921), 209

Zeng Xi 曾熙 (1861–1930), 52, 55–56, *56*, 61, 179–81

Zha Shibiao 查士標, 162

Zhang Daqian 張大千 (Chang Dai-chien; 1899–1983), ix, 5, 13, 17, 53, 93–94, *107–9*, *109*, *178–98*, *181*, 183–90, *192–97*, 199, 202*nn*77, 80, 83

Zhang Lu 張路 (ca. 1490–ca. 1563), 175

Zhang Muhan 張目寒, 93

Zhang Qun 張群, 198

Zhang Shanzi 張善孖 (1883–1940), 179

Zhang Yanyuan 張彥遠 (ca. 815–ca. 880), 9

Zhang Yu 張雨 (1283–1350), 164

Zhao Lingrang 趙令穰 (active ca. 1070–after 1100), 172

Zhao Mengfu 趙孟頫 (1254–1322), 9, 10–11, 17, 18, 109, 181, 257, 258

Zhao Yuan 趙原 (active ca. 1360–75), 240, *241*

Zhao Zhiqian 趙之謙 (1829–1884), 22–23, 26–28, 29–34, *30*, *31*, *33*, 60, 142, 163, 180

Zhao Zuo 趙左, 170

Zhejiang 浙江
 Academy of Fine Arts, 214, 243
 First Normal College, 122
 See also Hangzhou

Zheng Xie 鄭燮 (1693–1765), 14, 217

Zheng Zhenduo 鄭振鐸 (1898–1958), 123

Zhong You 鐘繇 (151–230), 26

Zhou Bo 周勃, 249

Zhou Chen 周臣 (ca. 1450–ca. 1535), 132*n*52

Zhou Enlai 周恩來 (1898–1976), 227–29

Zhou Fang 周昉 (active ca. 780–ca. 810), 195

Zhu Huairen 朱懷仁. *See* Xugu

Zhuangzi 莊子 (4th century B.C.), 255

Photograph Credits

Andrews and Shen, *A Century in Crisis, Modernity and Tradition in the Art of Twentieth-Century China*, 1998
FIG. 34: pl. 12

Bada Shanren huaji, 1985
FIG. 77: p. 42

John Blazejewski, Department of Art and Archaeology, Princeton University
FIG. 3

Cachin, *Cézanne*, 1996
FIG. 85: pl. 93

Chinese Fine Arts Gallery, *Ren Bonian jingpinji*, 1993
FIG. 30: pl. 21

Cohen, *East Asian Art and American Culture*, 1992
FIG. 12: fig. 2
FIG. 13: fig. 4

Conant, *Nihonga, Transcending the Past: Japanese-Style Painting, 1868-1968*, 1995
FIG. 48: pl. 96

Croizier, *Art and Revolution in Modern China*, 1988
FIG. 45: pl. 33

Deng Yaoping and Liu Tianshu, "Er Gao yu yinjin," *Zhongguo shuhua bao*, no. 343–45 (1993)
FIG. 47

Elderfield, *Henri Matisse: A Retrospective*, 1992
FIG. 105: pl. 215

Farrer, *Wu Guanzhong: A Twentieth-Century Chinese Painter*, 1992
FIG. 118: p. 33
FIG. 119: p. 61

Clem Fiori, Princeton, New Jersey
FIG. 83

Feng Zikai, *Zikai manhua quanji*, 1946.
FIG. 72: pl. 1.7

Fong et al. *Images of the Mind*, 1984
FIG. 2: p. 13, fig. 3

Fu Hua and Cai Geng, eds., *Xugu huace*, 1986
FIG. 23: pl. 63

Fu and Fu, *Studies in Connoisseurship*, 1973
FIG. 90: p. 219

Fu and Stuart, *Challenging the Past: The Paintings of Chang Dai-chien*, 1991
FIG. 97: p. 197
FIG. 100: p. 273

Gao Jianfu huaji, 1991
FIG. 46: pl. 27

Gao Lingmei, ed., *Chinese Painting with the Original Paintings and Discourses on Chinese Art By Professor Chang Dai-chien*, 1961
FIG. 92: p. 83
FIG. 99: p. 95

Gombrich, *Art and Illusion: A Study in the Psychology of Pictorial Representation*, 1960
FIG. 1: pl. 5.

Gugong shuhua tulu, 1990
FIG. 38: vol. 4, p. 225

He Baoyin, *Haishang si Ren jingpin, Gugong bowuguan cang*, 1992
FIG. 27: pl. 1

Hosono Masanobu, ed., *Yokohama Taikan*, 1972
FIG. 41: pl. 5

Huang Miaozi, ed., *Huatan shiyou lu*, 1998
FIG. 66: p. 152

Huang Yongchuan, *Duhai sanji shouzhan: Zhang Daqian, Pu Xinyu, Huang Junbi*, 1993
FIG. 101: pl. 36

Kohara Hironobu, *Sekitō to Ōzan hasshō gasatsu*, 1970
FIG. 60: p. 10

Li Chu-tsing and Wan Qingli, *Zhongguo xiandai huihua shi*, 1998
FIG. 37: p. 124

Lingnan huapai, 1983
FIG. 49: pl. 77

Paul Macapia, Seattle
FIG. 69

Museum of Fine Arts, Boston
FIG. 12
FIG. 13

Nagahara Oriharu, *Sekitō Hachidai Sanjin / Shitao and Bada Shanren*, 1961
FIG. 63: pl. 6
FIG. 64: pl. 5
FIG. 91: pl. 5, detail

Nagahiro Toshio, *Tun-huang Painting*, Chugoku no Meiga series, 1957
FIG. 94: pl. 2

Pan Gongkai, *Pan Tianshou huihua jifa jianxi*, 1995
FIG. 106: p. 64, fig. 76

Photo Archive of the Far Eastern Seminar Room, Department of Art and Archaeology Princeton University
FIG. 61
FIG. 84
FIG. 102
FIG. 120

Shodō zenshū, 1965.
FIG. 36: vol. 1, pl. 131

Shoseki meihin sōkan, 1958–
FIG. 10: vol. 8, no. 86, pl. 1

Shupu, no. 2 (1984)
FIG. 15: p. 25

285

286 *Shupu*, no. 5 (1986)
FIG. 14: p. 24
FIG. 17: p. 14

Sullivan, *Art and Artists of ·
Twentieth-Century China*, 1996
FIG. 55: p.71, fig. 7.4
FIG. 57: p 69, fig. 7.1
FIG. 58: p 70, fig. 7.2
FIG. 70: pl. 31
FIG. 110: p. 245, fig. 23.6
FIG. 115: p. 251, fig. 23.16

Wan Qingli, *Li Keran pingzhuan*,
1995
FIG. 111: p. 117, pl. 40
FIG. 112: p. 194, pl. 88.
FIG. 113: p. 173, pl.. 69

Bruce White Photography,
Caldwell, New Jersey
FIG. 103

Graydon Wood
FIG. 104

Worswick and Spence, *Imperial
China: Photographs 1850–1912*,
1978
FIG. 21: p. 77

Wu Guanzhong huaji, 1984
FIG. 117: p. 25

Wu Zuoren yishuguan cang pin ji,
1994
FIG. 107: p. 35

*Wu Zuoren zuopin ji: Zhongguo
hua juan*, 1994
FIG. 108: p.7

Xie Zhiliu, *Dunhuang yishu xulu*,
1955
FIG. 95: pl. 23.

Xu Beihong canghua xuanji,
1991
FIG. 51: pl. 83

Xu Beihong de yishu, 1988
FIG. 56: pl. 21

Xu Beihong huaji, 1985
FIG. 53: vol. 3, pl. 9

*Yuanban chuyin Jieziyuan huapu,
di yi ji, si* (1689?)
FIG. 74

Zengetsu-daishi juroku-rakan,
1914
FIG. 7: appendix, no. 11

*Zhang Daqian Pu Xinyu shi shu
hua xueshu taolun hui*, 1993
FIG. 93: p. 65
FIG. 98: p. 40

Zheng Jingwen, ed., *Wu Zuoren
de yishu*, 1986
FIG. 109: p. 17

*Zhongguo shufa: Longmen shi er
pin*, 1980
FIG. 16: pl. 3

Zhongguo shufa dacidian, 1982
FIG. 32: vol. 2, p. 1074

*Zhongguo jin xian dai mingjia
huaji: Shilu*, 1996
FIG. 116: p. 198

*Zhongguo jin xian dai mingjia
huaji: Xu Beihong*, 1996
FIG. 54: pl. 1

*Zhongguo jin xian dai mingjia
huaji: Fu Baoshi*, 1996
FIG. 65: pl. 7
FIG. 67: pl. 52

*Zhongguo lidai huihua: Gugong
bowuyuan canghua ji*, 1978
FIG. 80: vol. 1, p. 46.